STAR COMMERCIAL SPACES

STAR COMMERCIAL SPACES

Àlex Sánchez Vidiella
Daniela Santos Quartino

HARPER
DESIGN

An Imprint of HarperCollinsPublishers

First Edition published in 2012 by
Harper Design
An Imprint of HarperCollins*Publishers*
10 East 53rd Street
New York, NY 10022
Tel.: (212) 207-7000
Fax: (212) 207-7654
harperdesign@harpercollins.com
www.harpercollins.com

Distributed throughout the world by
HarperCollins*Publishers*
10 East 53rd Street
New York, NY 10022
Fax: (212) 207-7654

Packaged by
LOFT Publications
Via Laietana 32, 4º, Of. 92
08003 Barcelona, Spain
Tel.: +34 932 688 088
Fax: +34 932 687 073
loft@loftpublications.com
www.loftpublications.com

Editorial coordination:
Aitana Lleonart Triquell

Project coordination:
Àlex Sánchez Vidiella

Editor and texts:
Àlex Sánchez Vidiella, Daniela Santos Quartino

Art director:
Mireia Casanovas Soley

Design and layout coordination:
Claudia Martínez Alonso

Cover layout:
María Eugenia Castell Carballo

Layout:
Cristina Simó Perales

Translation:
Cillero & de Motta

ISBN: 978-0-06-211359-7
Library of Congress Control Number: 2012939948

Printed in Hong Kong

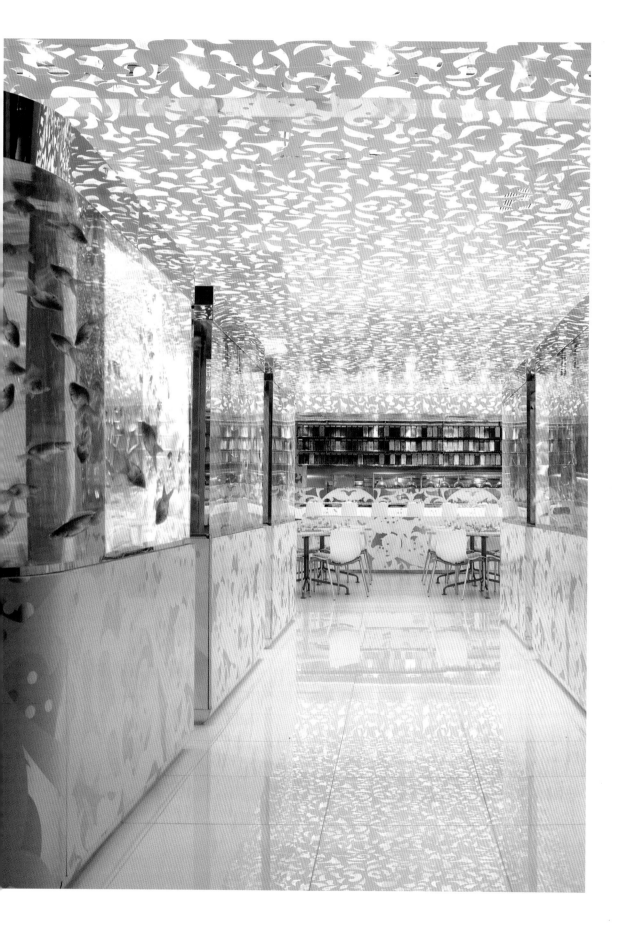

Introduction

A great deal has changed in shopping centers, or shopping malls, since the 1980s—the decade when major cities worldwide started to build shopping centers. Some centers were complementary to the traditional, local stores, while others were located out-of-town, creating a microcosm of consumption close to cities. In the early 1990s, large buildings called retail parks wore built in which multiplex cinemas and leisure facilities formed an important component. Later, factory outlets appeared, where manufacturers sold their products directly with heavy discounts. In the twenty-first century, there has been strong growth in the development and construction of shopping center architecture. Architecture marked important trends, innovative designs were created which established their unique characteristics and identity.

The basic idea common to all shopping centers is not new and it was not imported from the United States. In fact, the concept was originally based on the big shopping centers opened in the second half of the nineteenth century in many European cities. These centers were noteworthy for their iron structures: some examples of these include the Galleria Vittorio Emanuele II in Milan (1865), the Kaisergalerie in Berlin (1873), and the GUM store in Moscow (1888). In the twentieth century, the forerunners of modern shopping centers began to appear in the United States. The Northgate Center (1950), the first large-scale shopping center built in the modern style, was constructed in Seattle. Victor Gruen, the architect, is considered to be the "father" of modern shopping centers as he developed the standard structure: a central corridor (mall) with a warehouse located at one end and a roof convering the entire complex, allowing people to shop in any weather.

It was from the 1960s onwards that shopping centers proliferated in the United States and spread to other countries. Today, the basic shopping center structure is based on a hypermarket: a mall housing the big fashion brands, a zone for multiplex cinemas, and a food court

containing bars and restaurants. Moreover, shopping centers are often instrumental in urban planning in new areas or areas being redeveloped. They are meant to be a space that allows everyone—children, teenagers, the elderly, families, singles, people with disabilities, etc.—to shop easily and conveniently, and to carry out leisure activities.

The relentless rise of consumerism and the proliferation of brands and new products have forced companies to compete for a good position in the market and to differentiate themselves from the competition. Customizing the design of retail spaces has become one of the most popular and effective ways to achieve that desired visibility and differentiation. In this sense, architecture and design have revolutionized the interior design of commercial spaces to make them into real points of reference. Combining accessibility, functionality, and exclusivity, stores, boutiques, showrooms, bars, restaurants, cinemas, libraries, etc., have built up an important relationship between the customer and the product.

Within the pages of *Star Commercial Spaces*, there is a common theme linking all the architects and designers, the signs. This visual communication system is used in retail spaces where international signs or symbols are placed to guide, direct, inform, or organize a person or group of people in places presenting potential dilemmas. This book is a compilation of the best architects and interior designers of international renown, showcasing their unique settings and constructions, which are able to transform the projects of their clients into emblematic and identifying buildings. The reader will note there are a large number of shopping centers, shops, bars, restaurants, boutiques, museums, cinemas, auditoriums, etc., where the product is treated and displayed as a work of art. The architects create spectacular architectural forms and volumes, while the interior designers explore stimulating and functional ways to attract high numbers of shoppers.

Acconci Studio

Vito Acconci

20 Jay Street #215
New York 11201
New York
United States
Tel.: +1 718 852 6591
www.acconci.com

Acconci Studio, led by Vito Acconci, was established in 1988. Under the influence and training of its founder as both a poet and conceptual artist, the firm describes itself as "a mixture of poetry and geometry, digital writing and calligraphy, narrative and biology, chemistry and social sciences." The studio addresses a wide range of jobs, from furniture design to the architecture of buildings, public spaces, streets and squares, gardens and parks, and transport stations.

Mur Island
Graz, Austria / 2003 / © Harry Schiffler, Elvira Klamminger, Acconci Studio

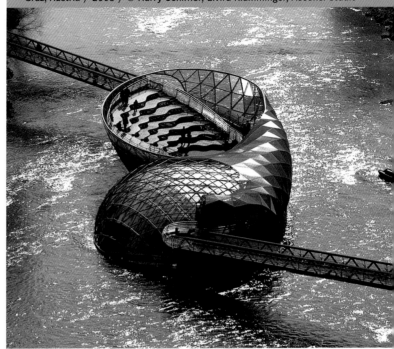

This structure, which was built over the River Mur in 2003 when the city of Graz was named the European Capital of Culture, is both a piece of art and architecture. Its spiral shape is home to an open-air auditorium, a restaurant, and a playground.

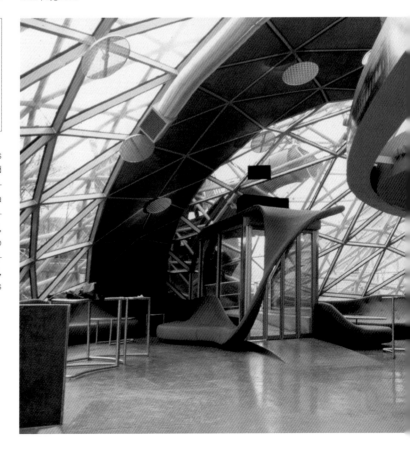

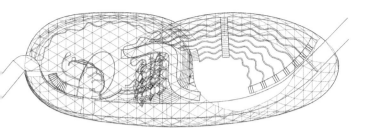

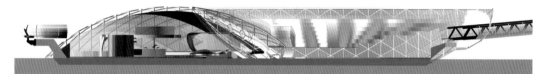

Floor plan, section, and diagram

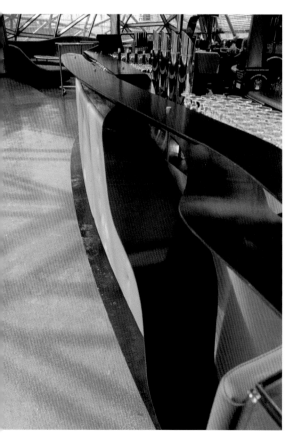

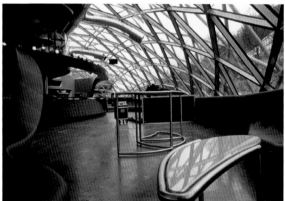

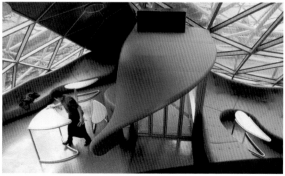

Under the dome sector, there is a cafe/restaurant run by the traditional bakery Sorger Graz. The building can accommodate up to 300 people.

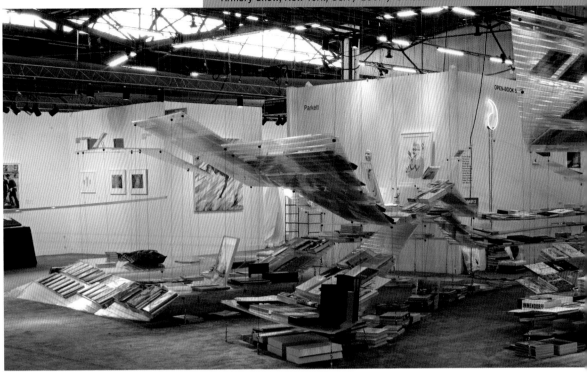

This temporary bookstore, which was built for an art fair, has been designed around horizontal planes composed of transparent acrylic sheets suspended from cables.

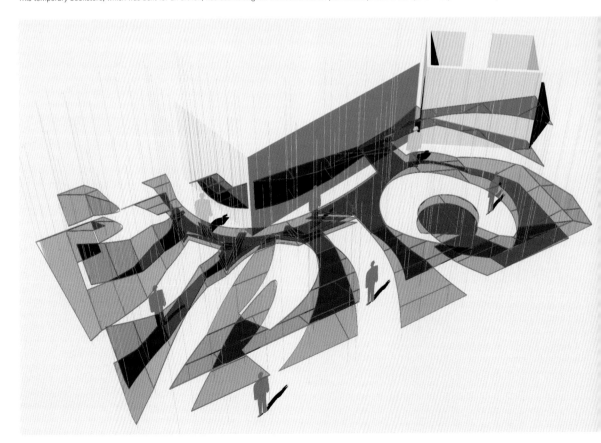

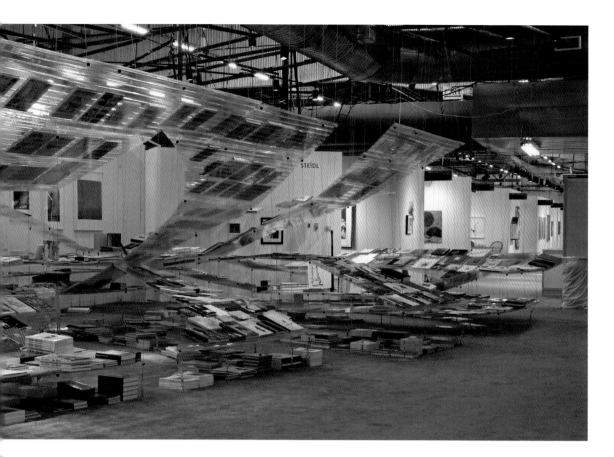

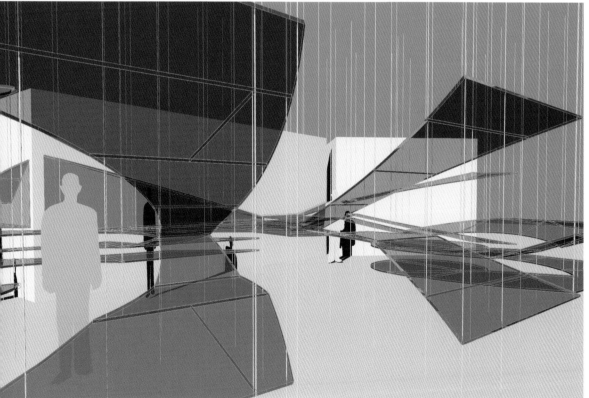

The planes are deployed in the air and intersect each other as they rise from the ground. The books seem to float with the transparent surfaces.

United Bamboo Store
Tokyo, Japan / 2003 / © Ryota Atarashi, Sergio Pirrone

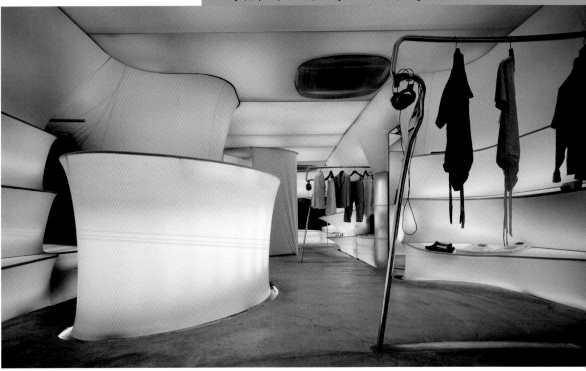

This clothing store, which is located in an old building, has been remodeled with a second skin of stainless steel mesh that surrounds the balcony and reshapes the building.

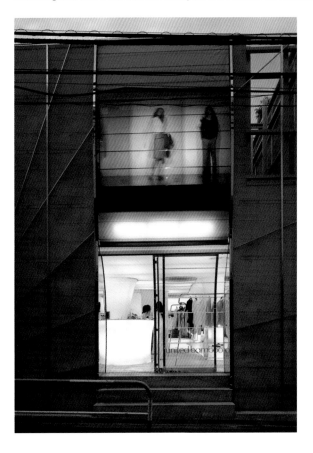

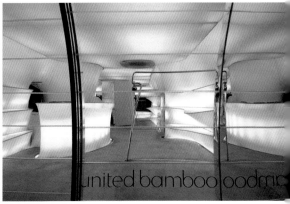

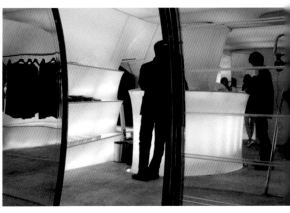

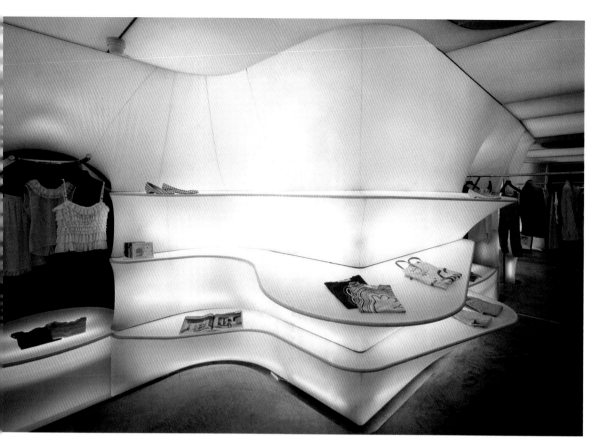

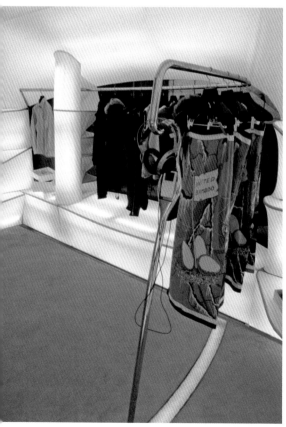

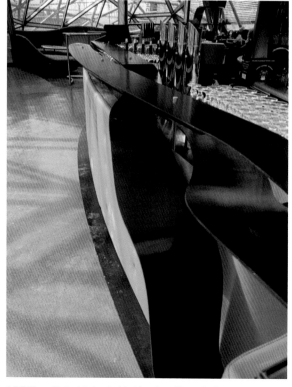

A PVC film molds the interior, stretched from the ceiling to the floor, becoming shelves and counters. The surface sparkles and diffuses throughout the entire space thanks to fluorescent lights behind the sheets.

Alonso, Balaguer y Arquitectos Asociados

Luis Alonso, Sergio Balaguer

Carretera de la Riba, núm. 36
08950 Esplugues de Llobregat
Spain
Tel.: + 34 93 303 41 60
Fax: + 34 93 303 41 61
www.alonsobalaguer.com

Created in 1978 by Luis Alonso and Sergio Balaguer, this architectural studio has its headquarters in Barcelona, as well as offices in Madrid, New York, and Lima. The studio is made up of more than sixty people who form a multidisciplinary team of architects, urban planners, and interior, industrial, and graphic designers. Its international expansion has resulted in customers from around the world, demanding more than 700 projects geographically dispersed in eleven countries: Chile, Colombia, Peru, Honduras, Kazakhstan, Brazil, Ukraine, Poland, Morocco, Algeria, and China. Its projects include high-rise buildings, sports centers, hotels, medical centers, recreational complexes, shopping malls, houses, wineries, multi-functional buildings, and so on.

Hotel Hesperia Tower
Hospitalet de Llobregat, Spain / 2006 / © Josep Ma. Molinos, Pedro Pegenaute

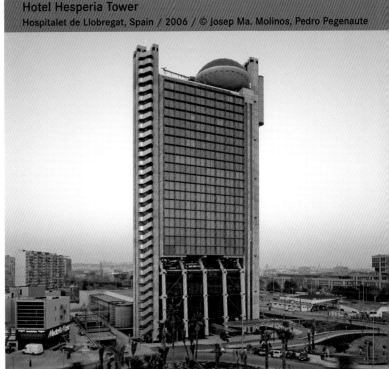

The avant-garde skyscraper is an example of urban regeneration and of a contemporary hotel. In only a few years, it has become a recognized symbol in the Barcelona metropolitan skyline. The new Hesperia building is composed of a 105 m (344 ft) 29-story tower.

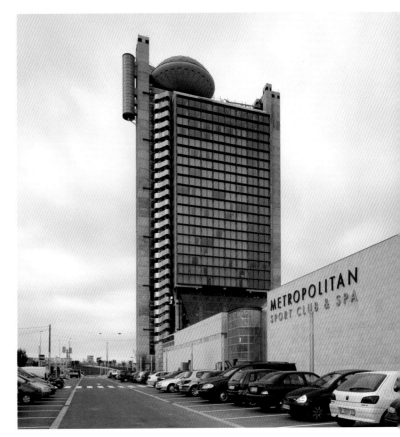

Plans

his architectural complex comprises a hotel with 280 deluxe rooms, twelve duplex suites with hot tubs in the bedroom, seven executive suites, a presidential suite, a congress nd convention center, meeting rooms, auditorium, sports club, urban spa, gym, and Hesperia Hotels headquarters.

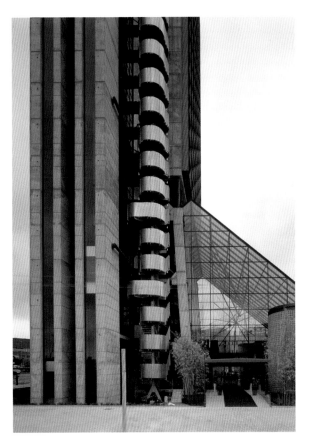

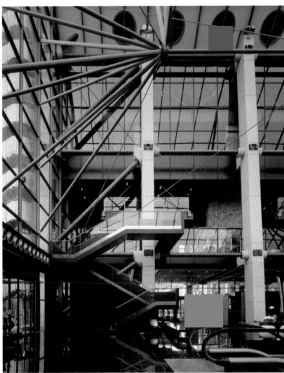

All vertical conveyance elements, such as elevators, escalators, and service elevators, as well as installation of pipelines, have been designed on the exterior, freeing up the ground plan for use, while converting these elements into authentic sculptures.

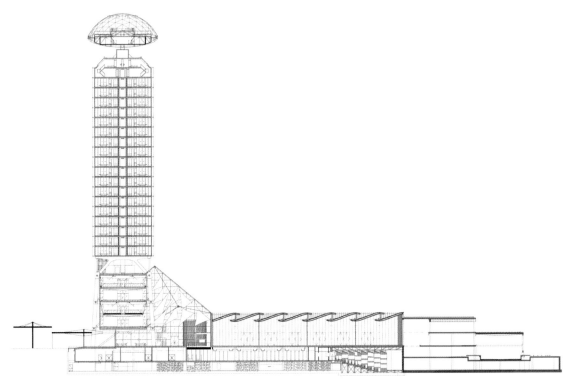

Section

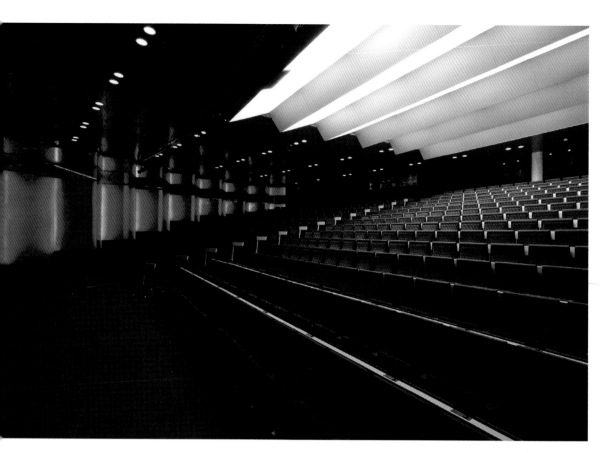

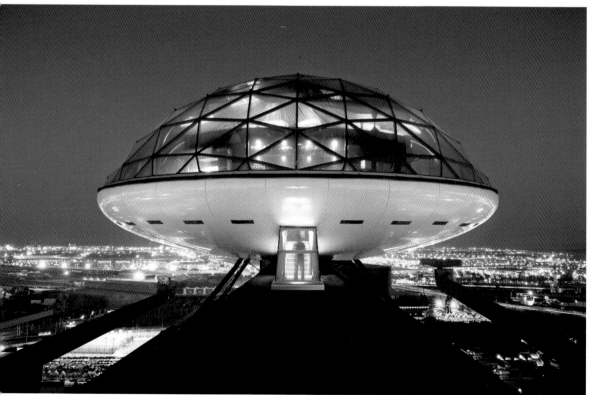

The tower culminates with a stunning futuristic glass dome that houses the restaurant EVO. This structure represents a visual icon of the metropolitan cities and offers spectacular 360° panoramic views from its interior.

Hotel Ohla
Barcelona, Spain / 2011 / © Josep Ma. Molinos

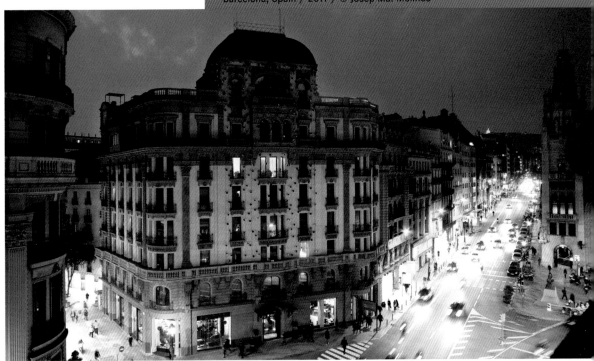

Since the construction of Casa Heribert Salas in 1926, the building has had many uses, from various department stores to a police station. The latest conversion performed by the architectural studio has been the creation of a hotel in one of the city's main arteries.

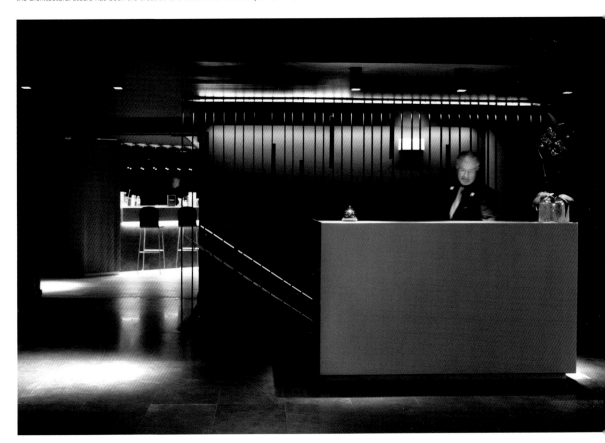

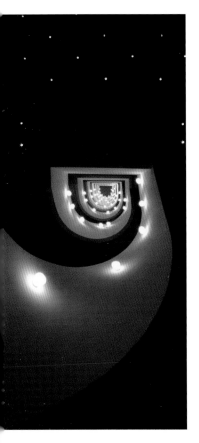
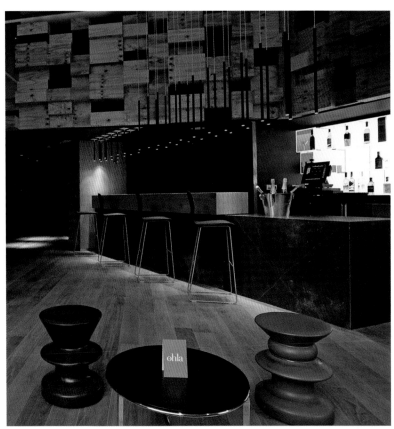
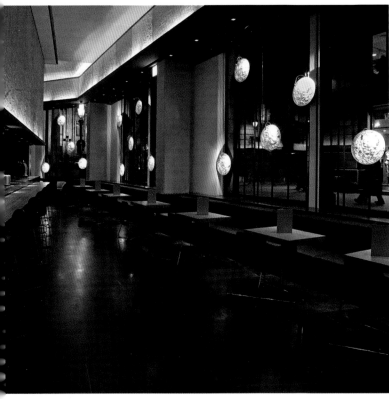
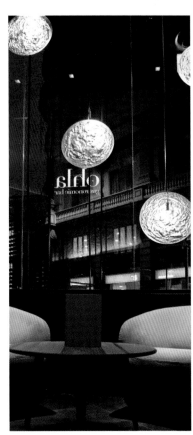

The use of discrete light to separate spaces, such as in the bathrooms of the rooms, in the two restaurants, and in the lobby, stands out.

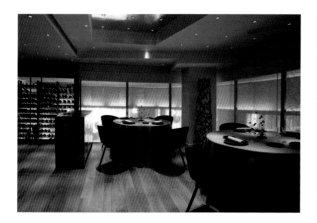

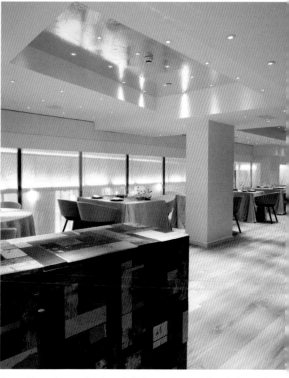

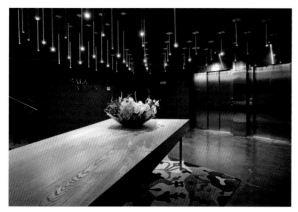

The need to create a new interior and add three underground floors to the complex—one for convention facilities and hotel services, one for parking, and a third for water tanks—led to the demolition of the interior and the creation of a supporting structure that left the façade suspended in the air.

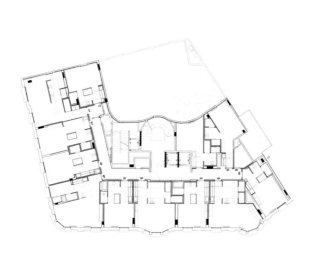

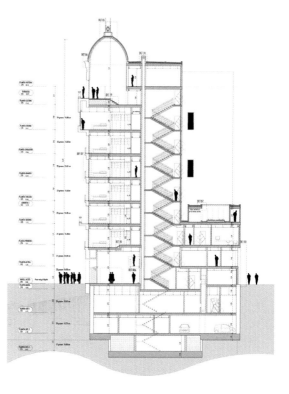

Plans and section

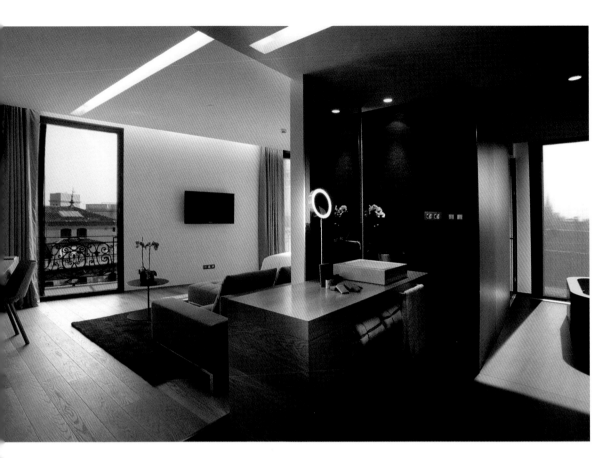

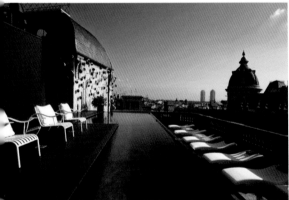

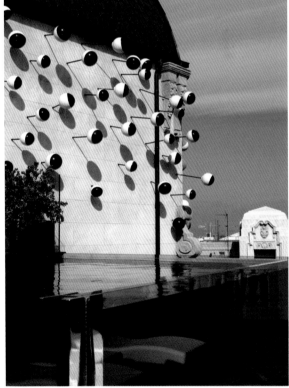

A spectacular pool closed on two sides by glass walls has been place in this terrace with awesome views. The decorative eyes on the wall stand out.

Arenas de Barcelona
Barcelona, Spain / 2011 / © Josep Ma. Molinos

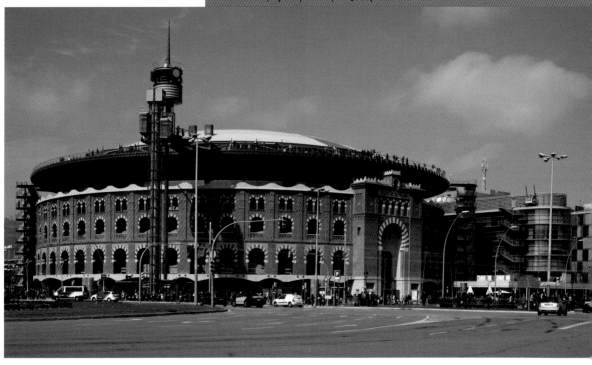

Built in 1899, this former neo-Mudejar style bullring, which has sat in disuse since 1989, is situated in a strategic position, and has been renovated to become a circular shopping mall. To preserve the historical evidence, the "red drum" was kept with its characteristic façade.

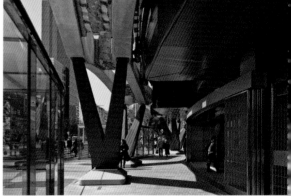

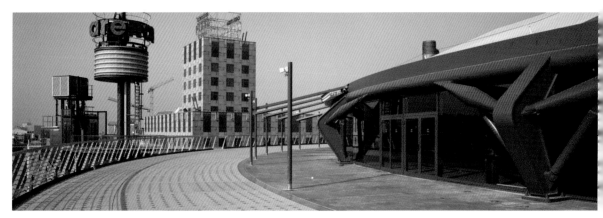

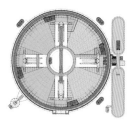
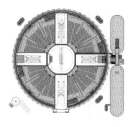

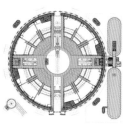
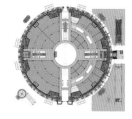
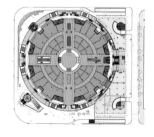
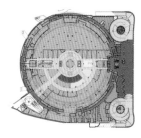

Plans

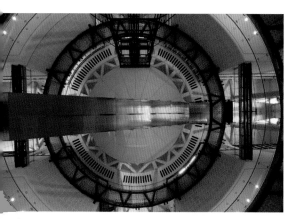

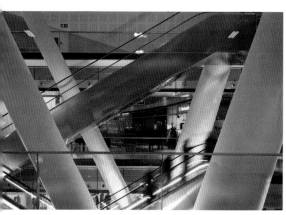

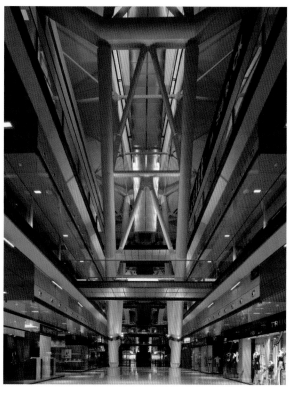

Inside, there are four support units each comprising of two pillars for a total of eight pillars that form a treelike configuration. They branch off as they ascend to extend their support to the dome.

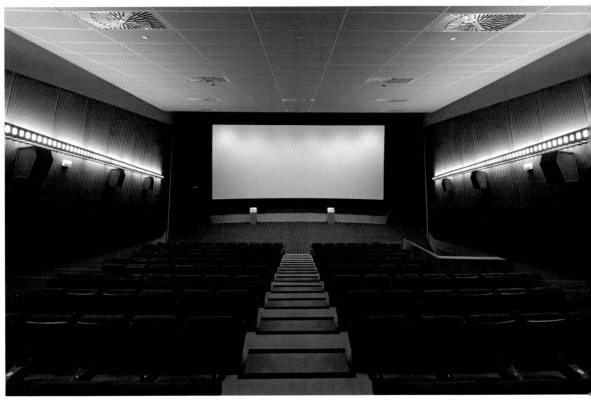

The Arenas de Barcelona covers 105,000 m² (1,130,210 ft²) and contains 116 establishments over six floors: three dedicated to retail and three to entertainment. In the entertainment area, a multiplex cinema, a Rock Museum, a spa and fitness center, and an auditorium have been installed.

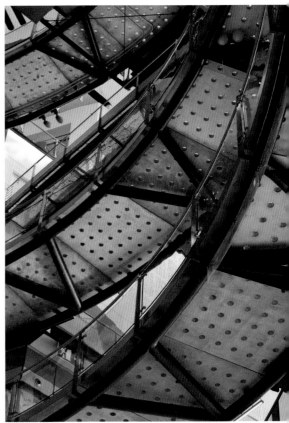

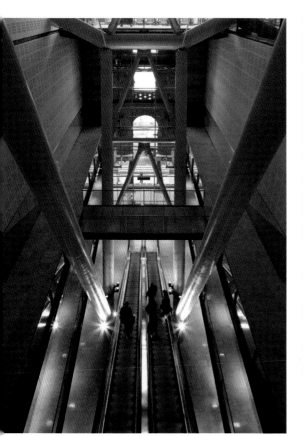

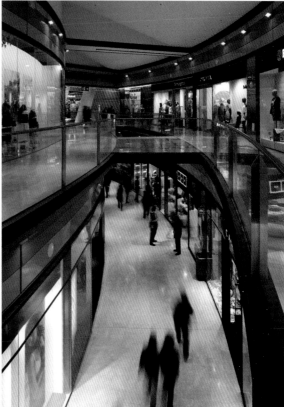

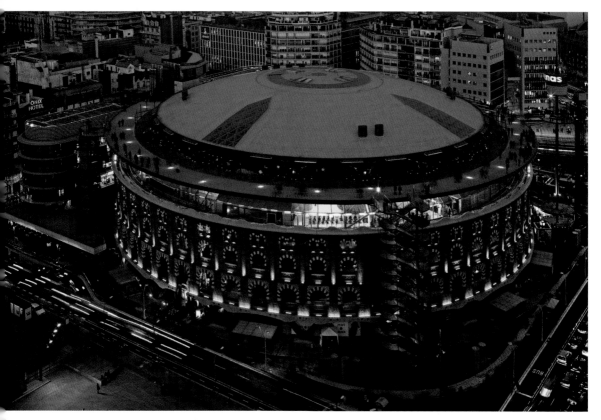

The hallmark of the center is the twenty-seven meter (88 ft) high dome, where the food court is located and which serves as a viewpoint for the Montjuïc mountain and Joan Miró park.

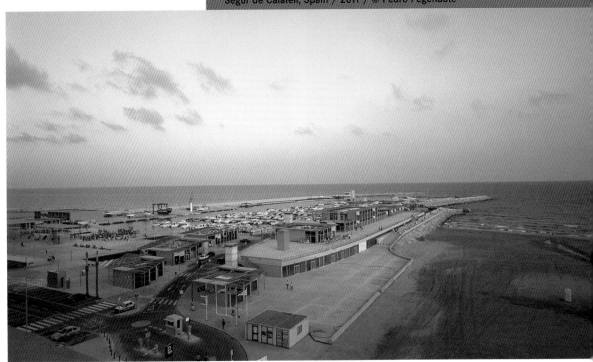

At the marina, a new public space and set of buildings have been built on both sides of the entrance of the new architectural complex. Due to the large size of the site, the objective was to provide unity to the whole architectural complex.

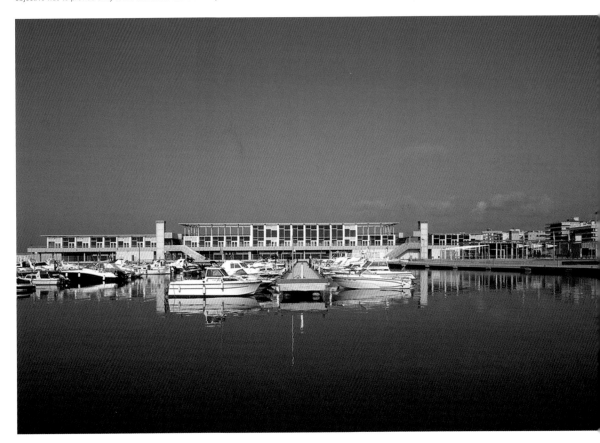

Site plan

Floor plan

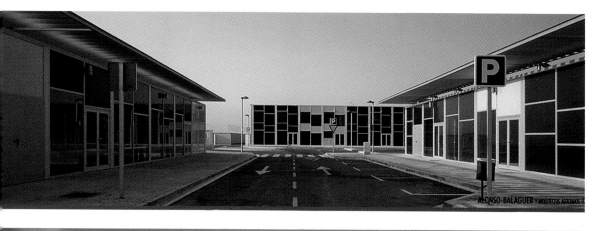

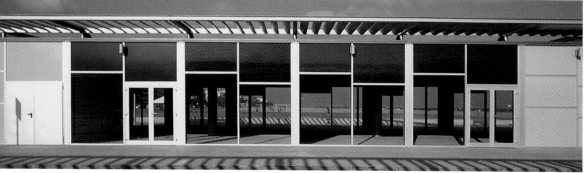

The façades are ever-changing and enhance the movement that the perspective confers. They adapt to the specific requirements of each of the premises, which resemble ship containers, relating them to port and maritime activities.

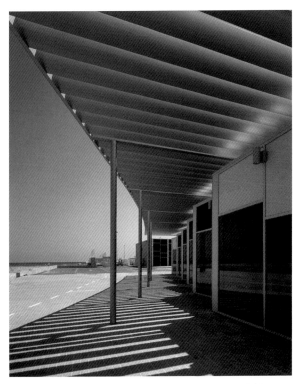

The façades are partially opaque and the finishes have been constructed with corrugated aluminum sheets, aluminum metalwork, and panels of different colors. Spaces were created to install signage of the different businesses in the blind spots, and to leave the glass façade clear.

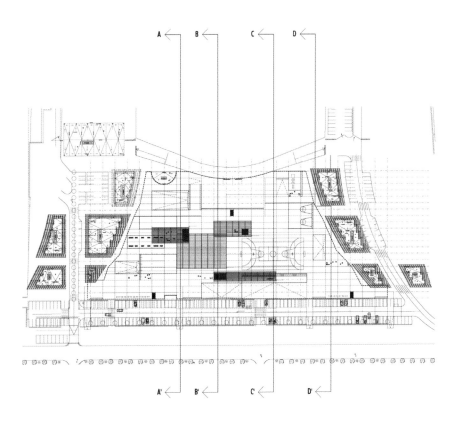

Floor plan

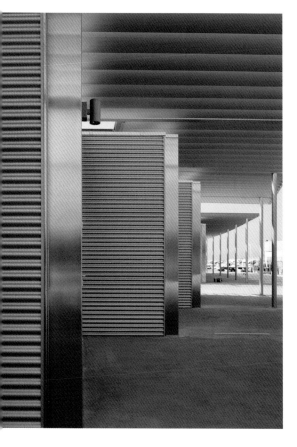

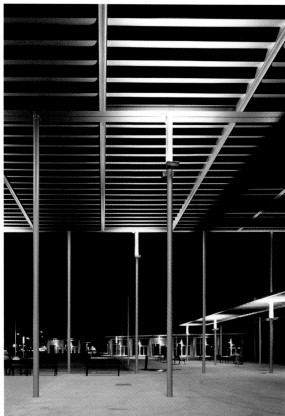

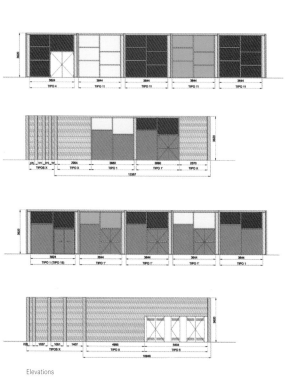

Elevations

The buildings were designed to be modular and adaptable to their particular use and to the users needs.

André Kikoski Architect

André Kikoski

© Marius Bugge

180 Varick Street, suite 1316
10014 New York
New York
United States
Tel.: + 1 212 647 0240
www.akarch.com

The architecture and design studio André Kikoski Architect is committed to artistic innovation, regardless of the budget or nature of the project. They work with any style or language to create coherent and authentic designs. They design spaces, buildings, and products that are unique. The firm's commitment to researching materials, attention to detail, and satisfying customers has made them the first company to be awarded three of the most prestigious design awards for one project in the same year: Design Magazine's Best of Year Award, the James Beard Foundation Award, and the Gold Key Award. The company has completed twenty-two public and cultural projects, twenty-six resorts, restaurants and hotels, thirty-two luxury apartments, townhouses, lofts, duplexes and attics, and twenty-two homes in singular buildings.

The Wright at the Guggenheim Museum
New York City, NY, USA / 2010 / © Peter Aaron/ESTO

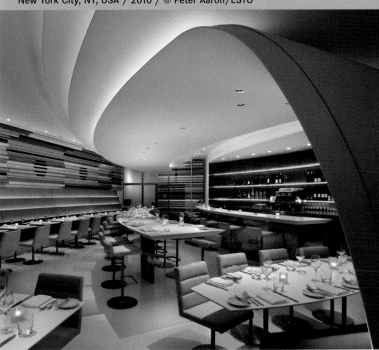

The studio created a contemporary solution to complement the memorable architecture of the building with a modest budget and 1,600 m² (17,222 ft²) of workspace. The cheerful aspect of these curved forms provides a dynamic experience for visitors. The curved walls have been turned into comfortable seating.

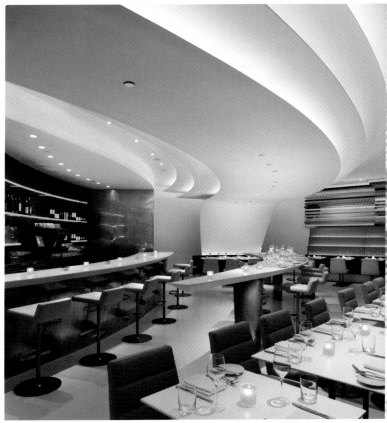

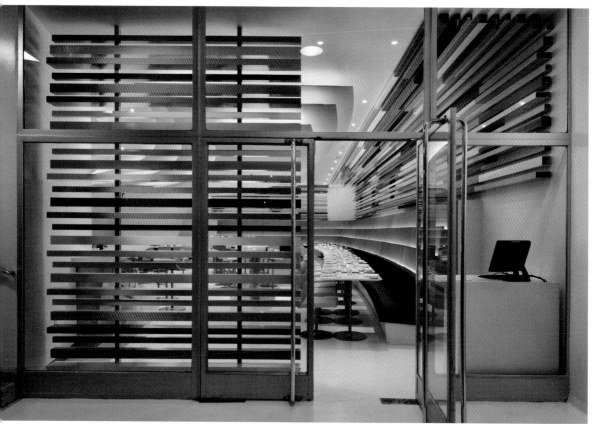

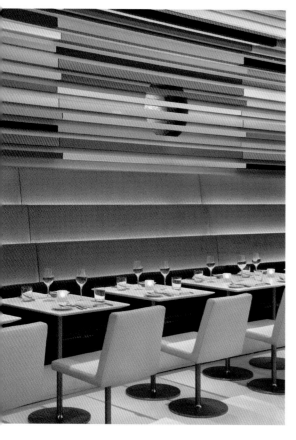

This project was developed with innovative materials such as walnut walls illuminated with fiber optics and a shiny metal skin.

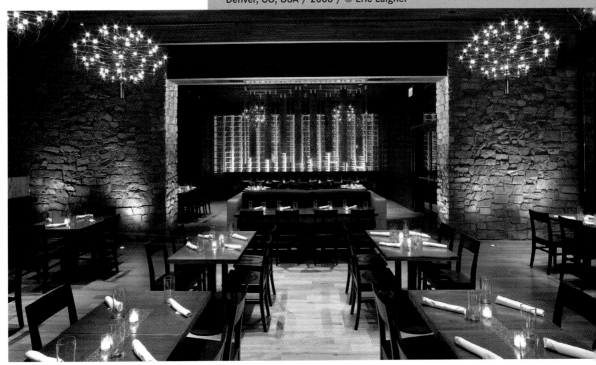

The restaurant owner asked the design team to create a place that evokes the feeling of being in a guest house or vacation home, rather than that of a typical hotel restaurant. The Rocky Mountains and local art were used as inspiration for the design.

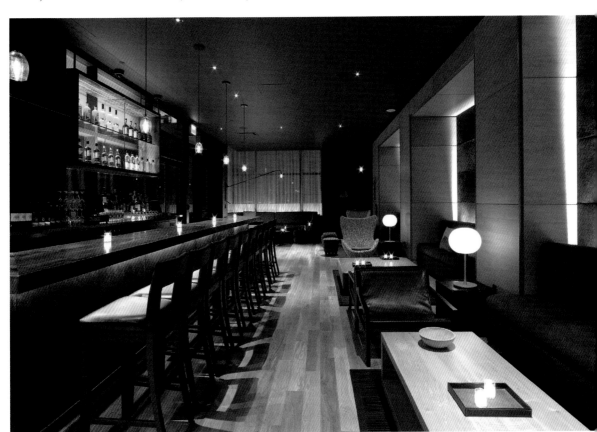

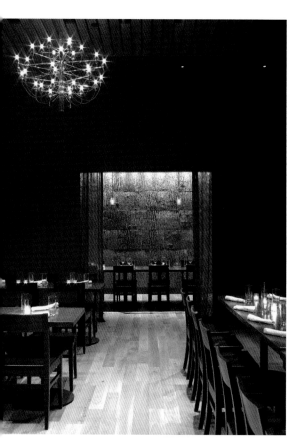

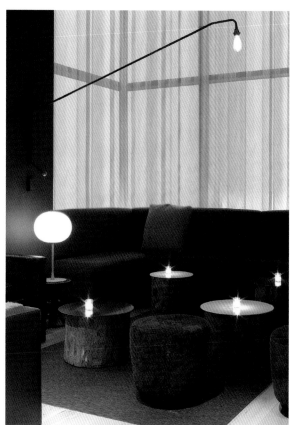

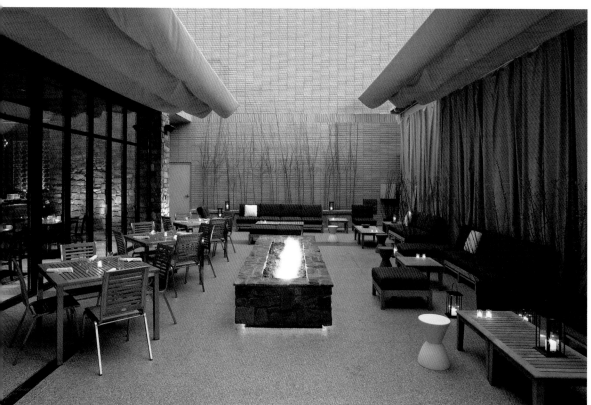

They used rich textures like pony leather upholstery, paneled walls, bark tiles, stone, stainless steel, and glass.

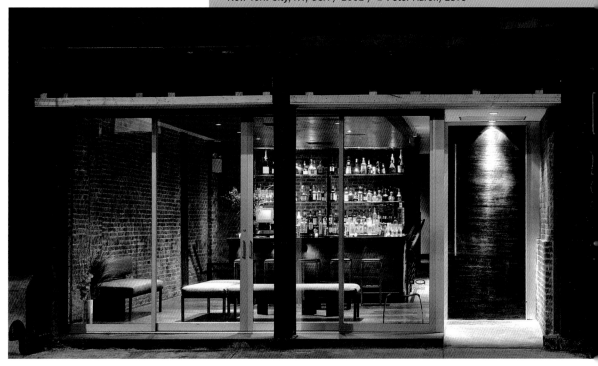

In the restaurant Suba, diners are transported from the gritty setting of the Lower East Side of Manhattan to an architectural fantasy inspired by the Romanticism of the Alhambra in Granada, Spain, or Fellini's Rome. The restaurant is divided into three main areas.

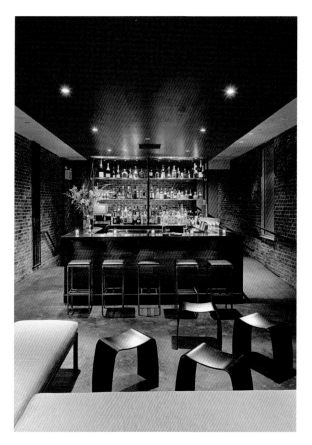

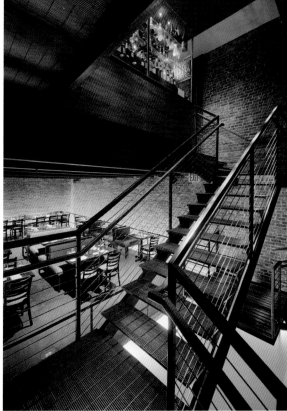

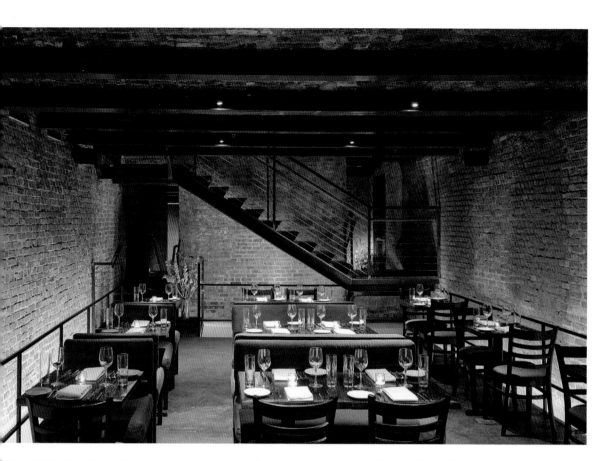

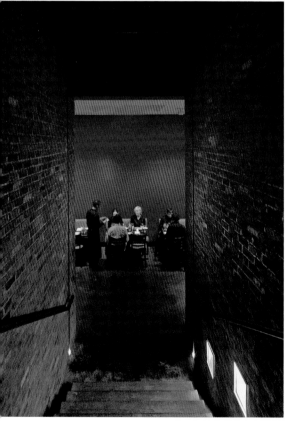

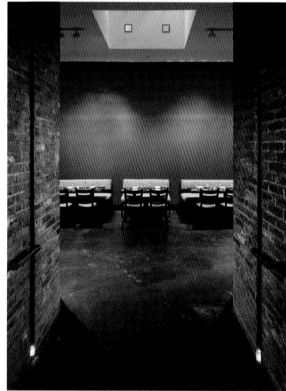

Suba has an innovative and elegant atmosphere that captivates the imagination with its sensual and well-lit grotto-like dining room.

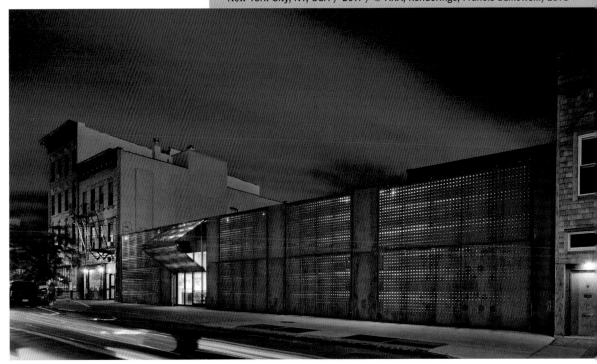

This project is an example of economic renewal and the adaptation of two abandoned warehouses for new uses to create a commercial and cultural space. The place is marked by the industrial past and becomes a center of art and creativity with innovative design.

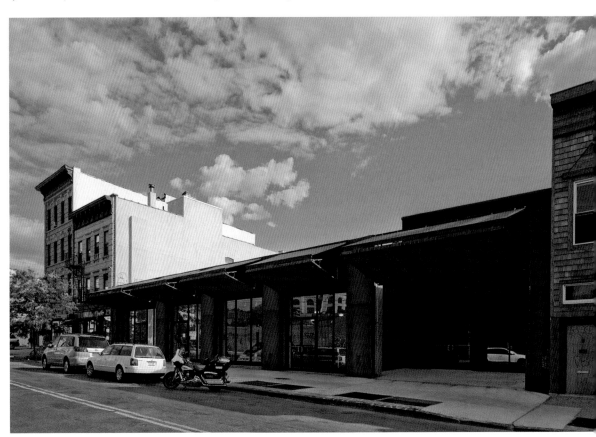

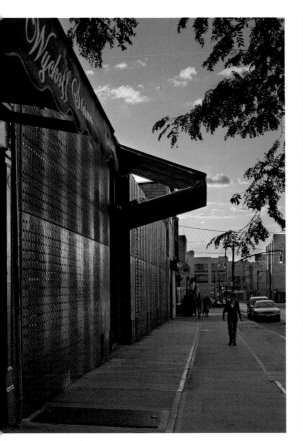

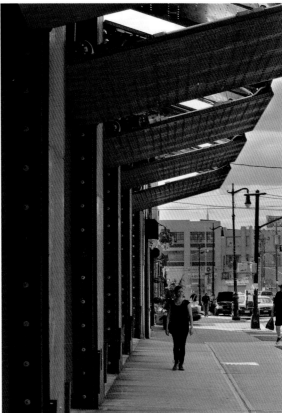

The design is based on five pairs of motorized scissor doors or panels. The panels consist of a frame covered by an outer layer of COR-TEN steel and an inner layer of stainless steel.

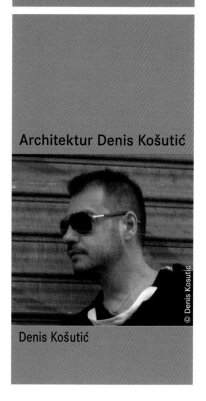

Architektur Denis Košutić

Denis Košutić

Florianigasse, 7/8
1080 Vienna
Austria
Tel.: +43 699 19479990
www.deniskosutic.com

Denis Košutić was born in 1969 in Zagreb, Croatia. His work is characterized by an "anti-traditional" perception of the role of architecture today. In his self-described "prêt-à-porter architecture," Košutić translates trends in fashion and design to everyday language, and in this process he sees architecture as an object of consumption rather than a monument for eternity. The studio has designed restaurants, clubs, stores, homes, hotels, and furniture. He also works with graphic designers, PR consultants, and furniture makers. His planning includes the development of new strategies, building corporate images and identities, and the invention and establishment of codes that help people. The brands are both unique and in-demand.

Six Hotel Apartments
Vienna, Austria / 2011 / © Lea Titz

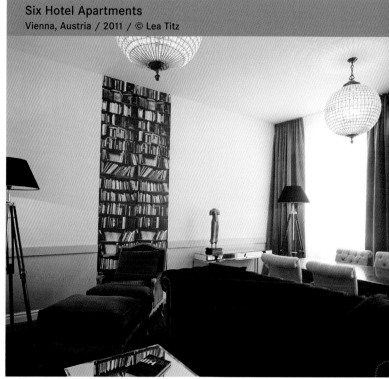

These hotel apartments are inspired by Jackie Kennedy's style and her timeless influence on 20th century American aesthetics, to create elegant, classic spaces with fun details. The atmosphere is defined by an array of pastel colors, beige, and gray.

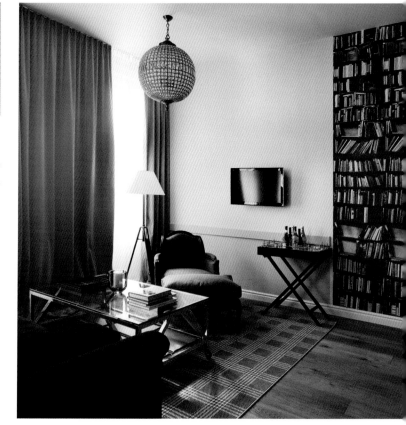

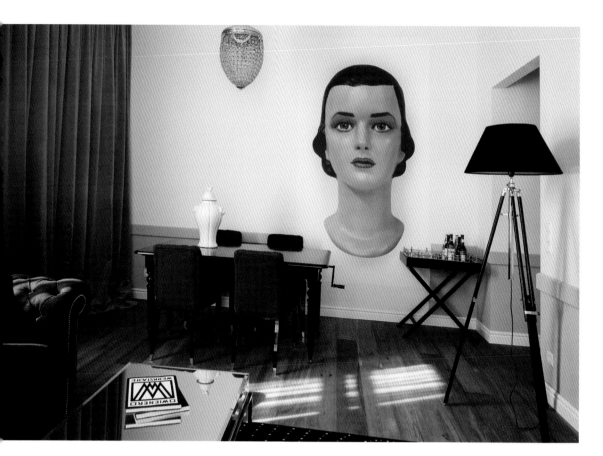

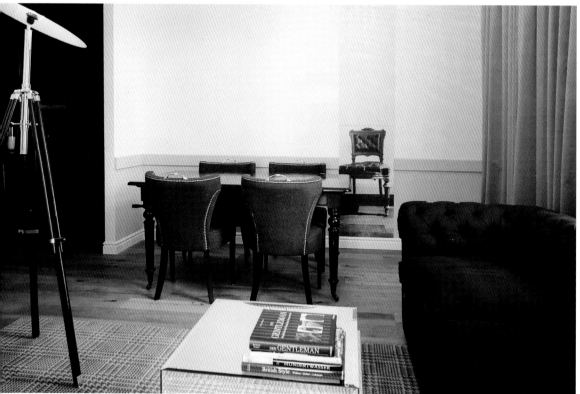

strategically located, the wallpapers break and simultaneously reinforce the prevailing monochrome in the rooms. The motifs have a humorous and nostalgic effect, opening imaginary windows to existing spaces.

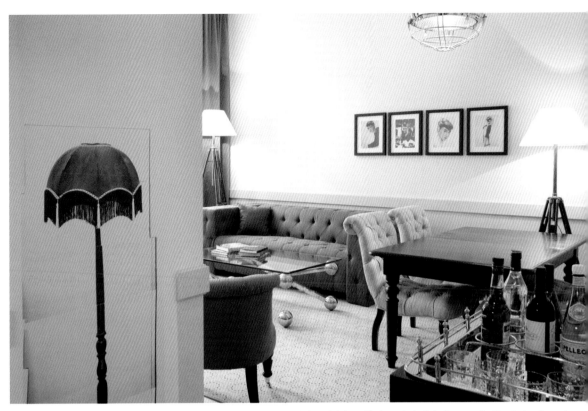

Smooth surfaces and materials such as velvet, linen, wool, and cashmere in curtains, upholstered chairs, and bedspreads dominate the space. The Glencheck pattern only appears in the carpets.

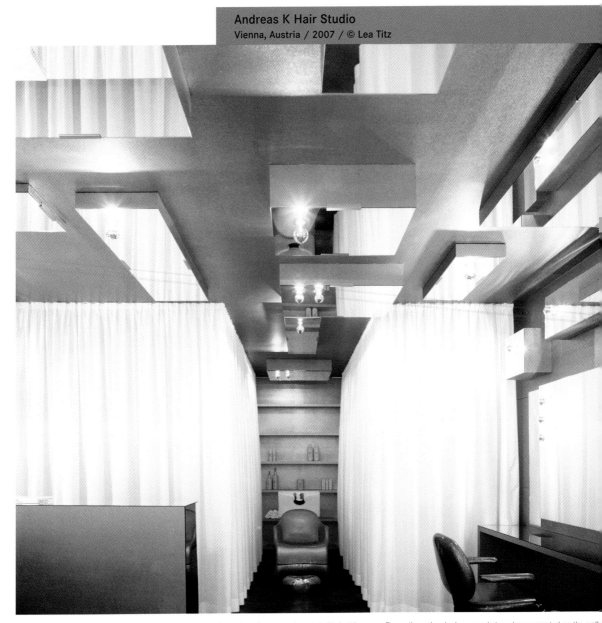

Different materials in a single color and glossy effects and surfaces have been experimented with in this space. Three-dimensional mirror panels have been mounted on the wall and ceiling, while other panels with mirrors and integrated lighting create new dimensions and surprising perspectives.

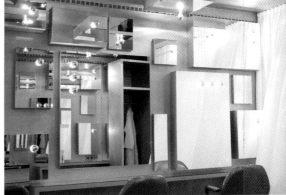

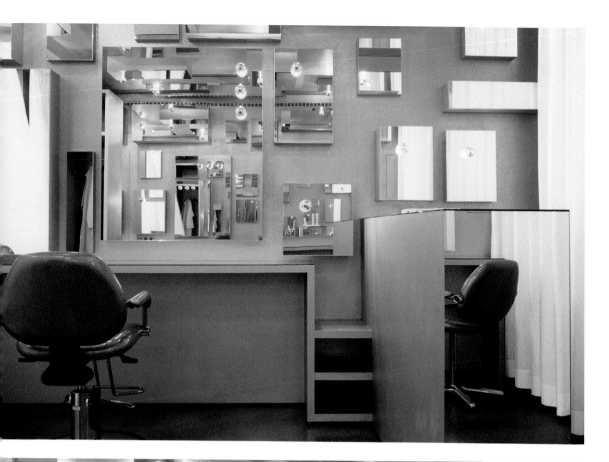

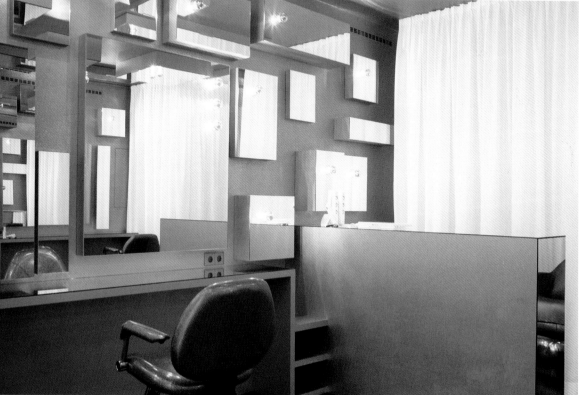

White curtains made with a special fabric serve as dividers within the space, creating a cozy and intimate ambience, filtering in soft light suitable for this type of establishment.

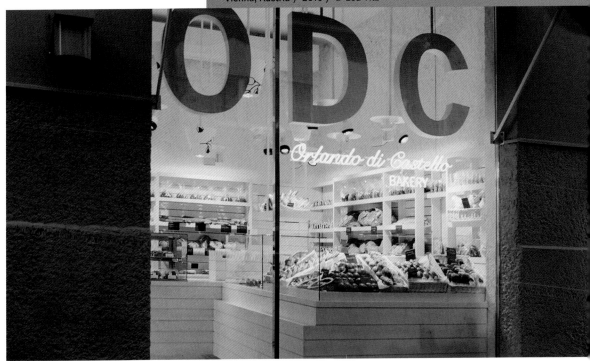

ODC Bakery
Vienna, Austria / 2010 / © Lea Titz

The wide range of products in this bakery has been integrated into the interior design concept. The result is a logical arrangement of products and storage containers that give character to the space not only for how they individually work but also how they are interrelated.

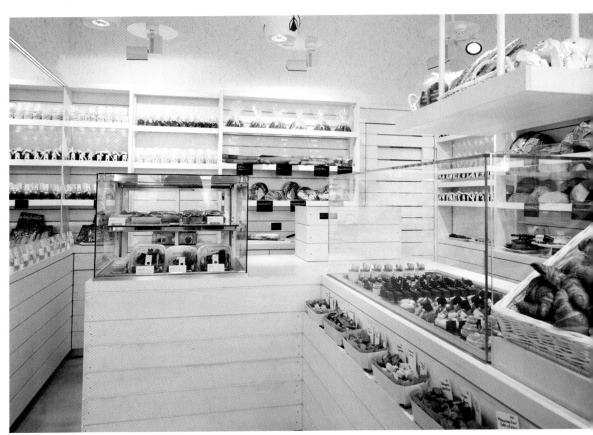

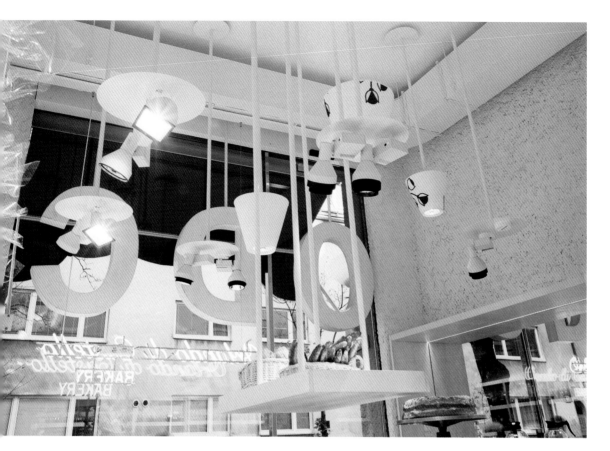

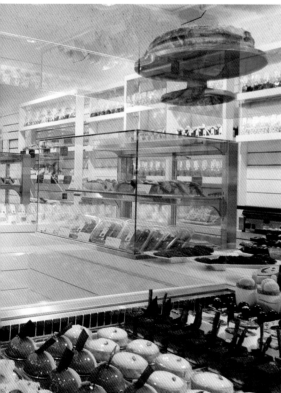

The design basis is established on a few simple and familiar materials. The surfaces are maintained in a natural state.

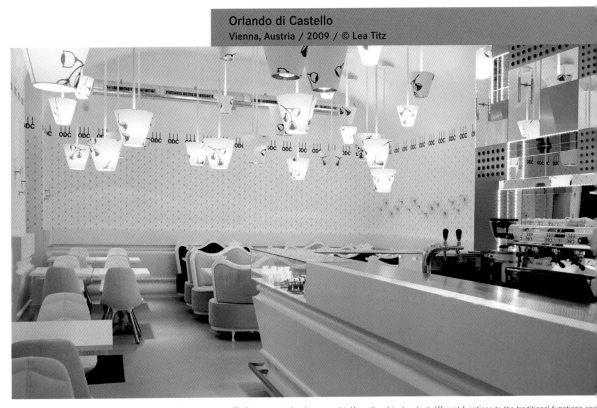

In the reconstruction of this restaurant, a composition between conflicting concepts has been sought. Here, the objects adopt different functions to the traditional functions and create a surreal atmosphere full of surprises and irony.

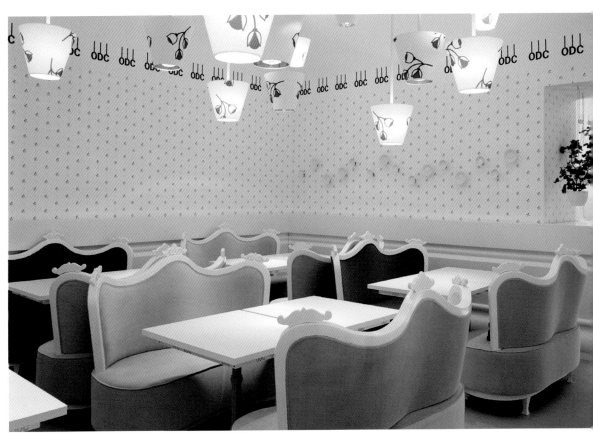

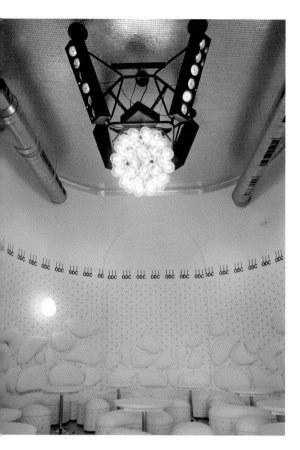

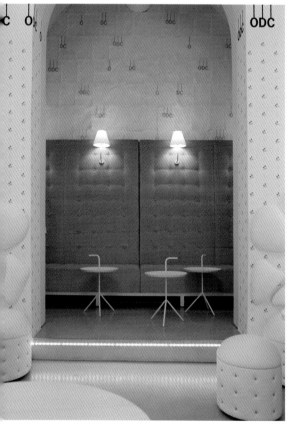

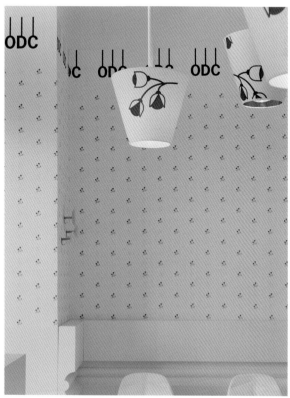

The color white is common in all areas. Throughout the room, the lighting changes as does the furniture, such as the different seating for each area.

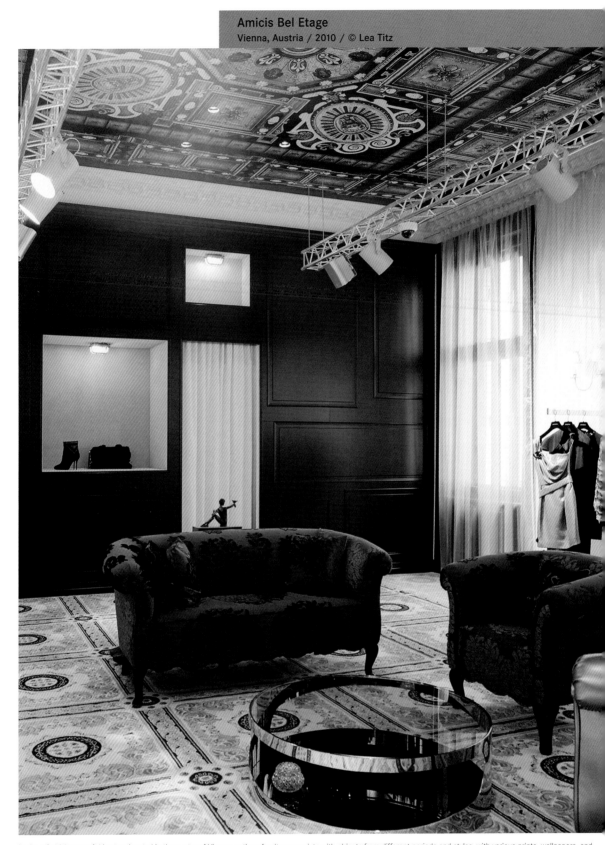

In the refurbishment of this store located in the center of Vienna, antique furniture coexists with objects from different periods and styles, with various prints, wallpapers, and photo collages to form an elegant setting ideal for a fashion establishment.

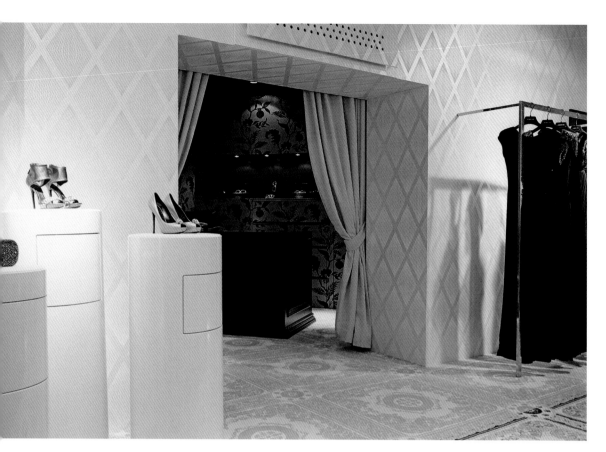

There is a careful selection of materials, the lattices, ornaments, and surfaces of which create a sort of third dimension, and stand out from the new technological elements and contemporary furniture.

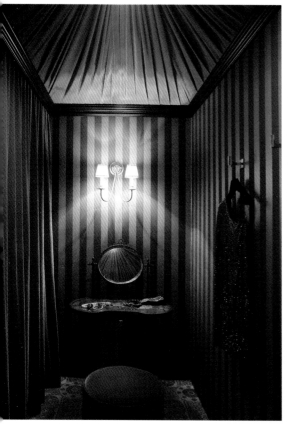
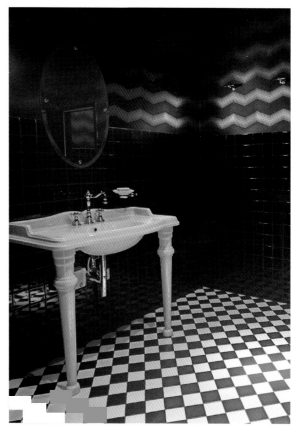

Arrhov Frick Arkitektkontor

Johan Arrhov, Hemik Frick

Banérgatan 54
115 26 Stockholm
Sweden
Tel.: + 46 703 78 09 22
www.arrhovfrick.se

Arrhov Frick Arkitektkontor is an architectural studio created by Johan Arrhov and Henrik Frick, with offices in Stockholm. The firm works with a wide variety of projects in the fields of architecture and urban planning. Its purpose is to create clear and powerful architecture that combines innovation with rational thought, and to give added value to the context of each project.

Très Bien shop, Headquarters
Malmö, Sweden / 2011 / © Åke E:son Lindman

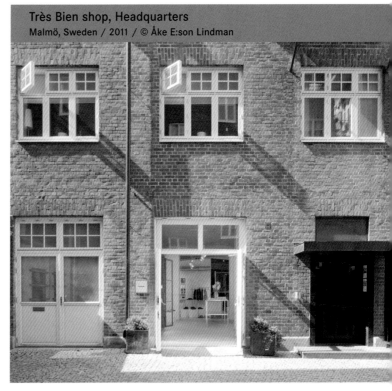

Located in a building in the center of Malmö, the space where the store is installed once housed a textile factory and a flea market, and contains many rooms of different sizes. The new architectural concept conceived by Arrhov Frick lends flexibility to the space.

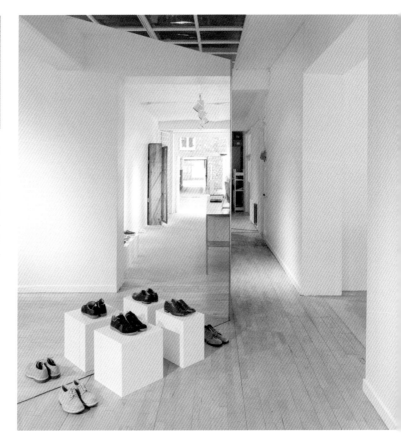

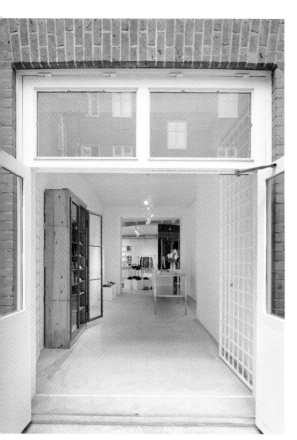

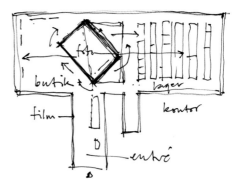

Sketch

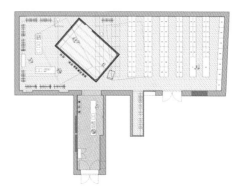

Floor plan

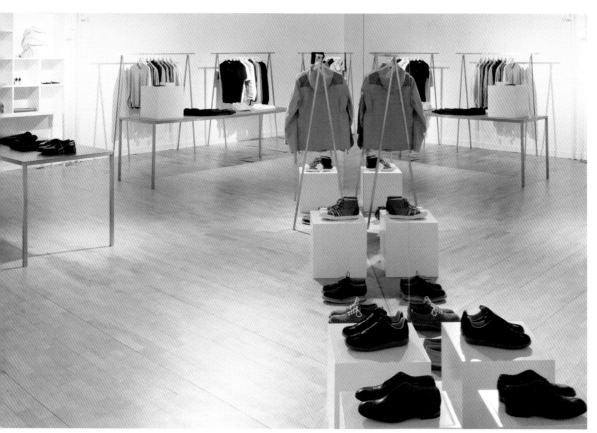

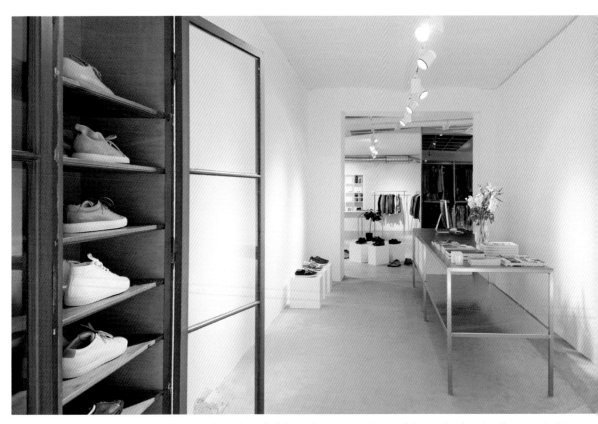

Flexibility is a key factor in this design, whether it is to meet the growing needs of the brand or to accommodate a small photo studio to keep the online store up-to-date.

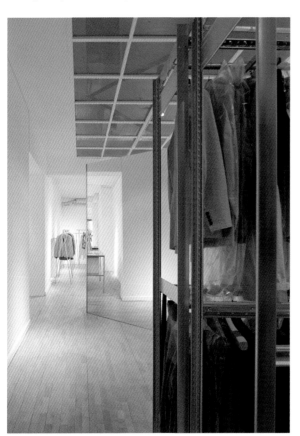

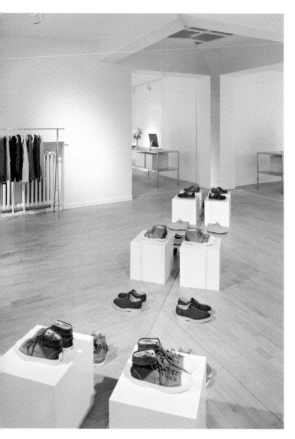

The photo studio is mobile and can be placed in different positions. The exterior of this studio is paneled with mirrors.

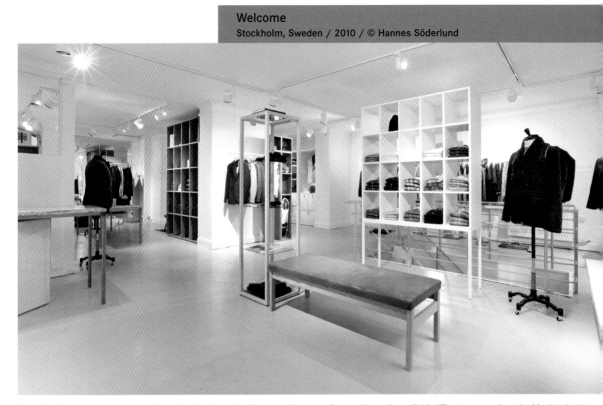

From this collaboration between two brands, the idea has been to develop a general concept of a store that can be applied in different contexts. A matrix of furniture has been established with a total of sixty-four variants that display the collections in many different ways.

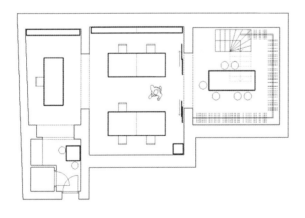

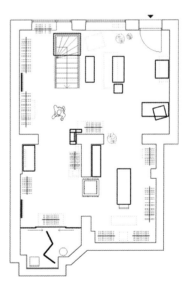

Plans

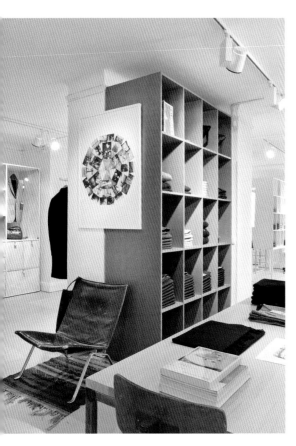

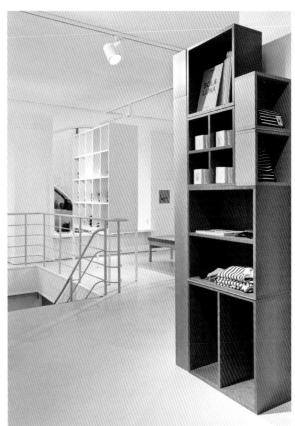

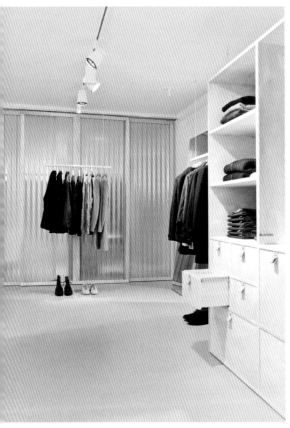

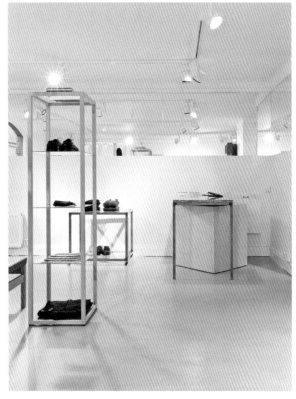

Materials such as cement, wood, plastic, marble, and steel are clearly defined, with sharp contrasts.

ATP Architects and Engineers

ATP Architects and Engineers team

Heiliggeiststrasse 16
6010 Innsbruck
Austria
Tel.: + 43 512 53 70 0
Fax: + 43 512 53 70 1100
www.atp.ag

This firm, specializing in complex architectural projects, is considered one of the largest in Europe. It has offices in Germany, Austria, Switzerland, Zagreb, and Budapest, and it operates in the entire German-speaking region, besides having presence in Central Europe and Eastern and Southeast Asia. It employs over 450 employees spread across different locations. ATP's purpose is the creation of sustainable, innovative, and intelligent buildings. The methodology of the company is based on integrated design: the interdisciplinary architect maintains simultaneous cooperation with all the elements of architecture and engineering necessary for the project. In 2009 and 2010 it received prestigious international awards.

Atrio
Villach, Austria / 2007 / © Thomas Jantscher, Elke Visciotti/ATP

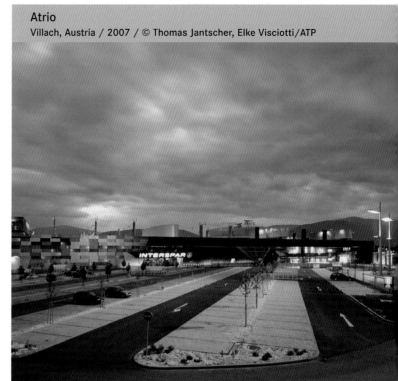

Atrio is an unusual shopping mall, both conceptually and architecturally. A large, isolated, red and silver sculpture dominates the south entrance to the city of Villach, welcoming visitors.

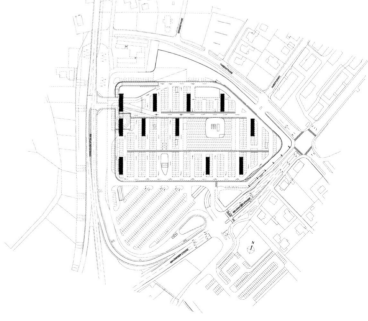

Site plan

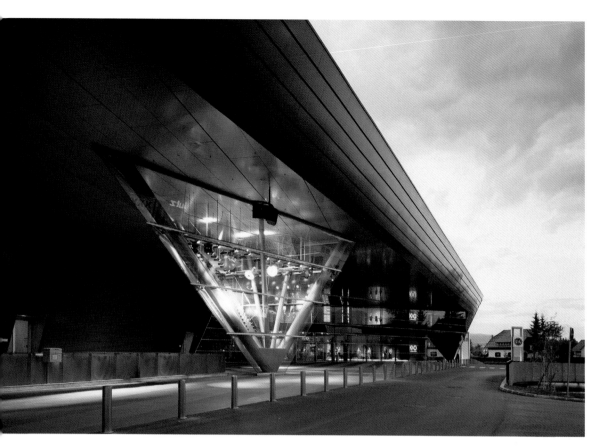

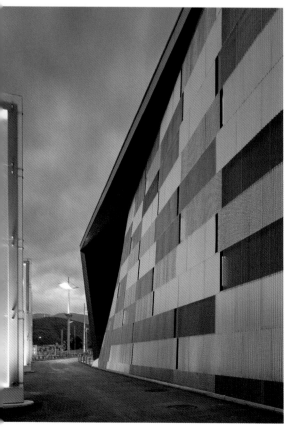

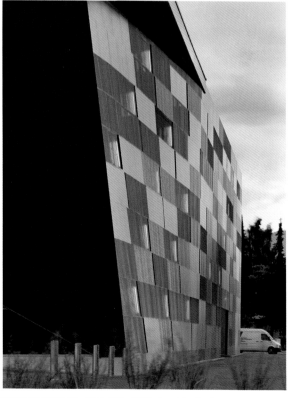

The almost square (50 x 60 m / 164 x 196 ft) glass atrium has become a new landmark in the city.

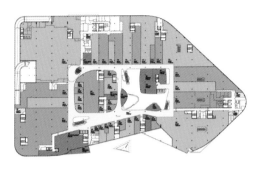

First floor plan

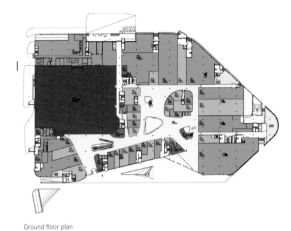

Ground floor plan

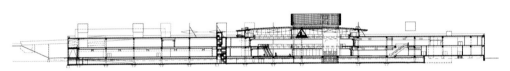

Longitudinal section

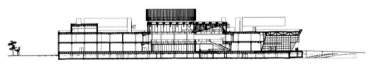

Cross section

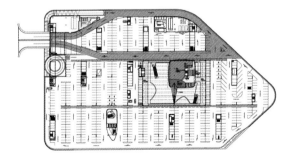

Street level parking plan

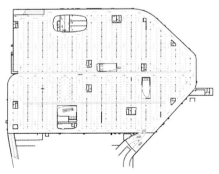

Underground parking plan

The original architectural structure was designed to enjoy the usual activities of a mall, such as shopping, eating, entertainment, socializing, or going for a stroll.

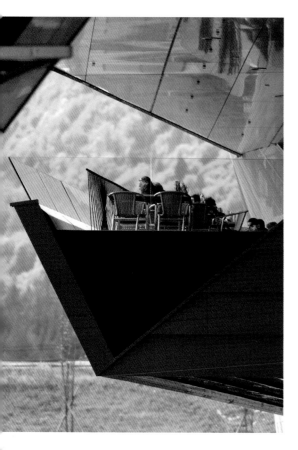

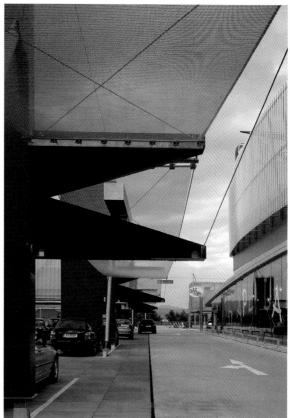

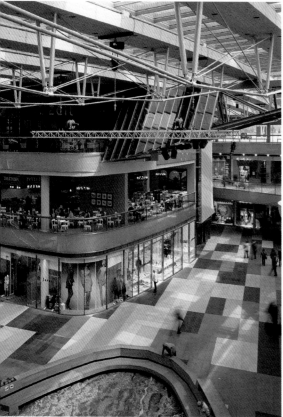

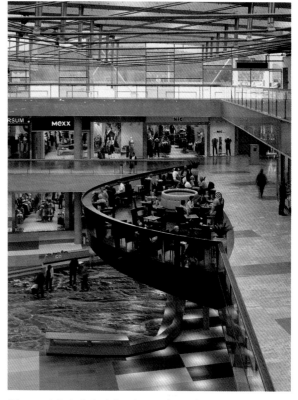

Atrium was devised with the desire to integrate three regions separated by international borders: Carinthia (Austria), Friuli (Italy), and Goriška (Slovenia).

KOMM

Offenbach, Germany / 2009 / © Jean-Luc Valentin/www.foto-valentin.de

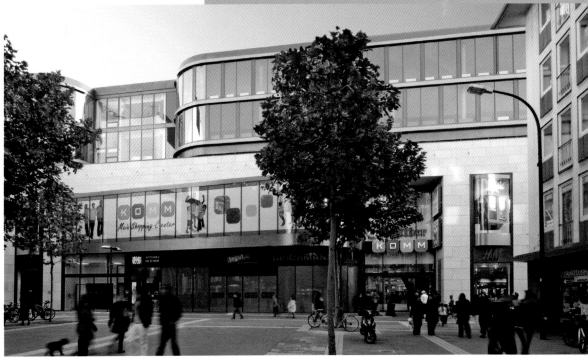

The opening of KOMM represented a new architectural landmark for the city of Offenbach. The mall is a new urban identity element that revitalizes peripheral pedestrian streets and routes. The ecological aspects are taken into account to minimize the building's energy needs.

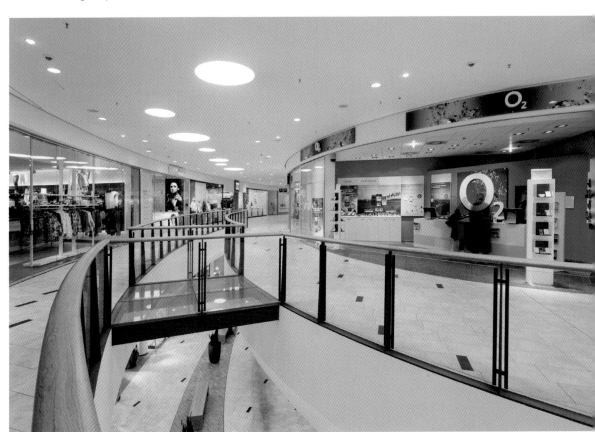

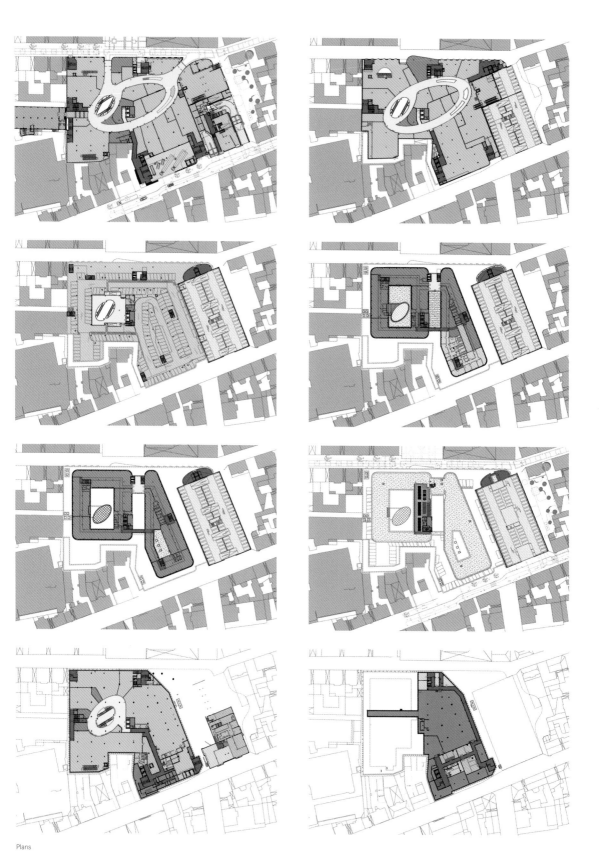

Plans

he elliptical form of the project stands out. The mall and parking lot are directly connected to the pedestrian zone. The seven levels are divided into two upper floors for offices, nedical consultants, and a fitness center, four levels for shopping, and one level for a parking lot.

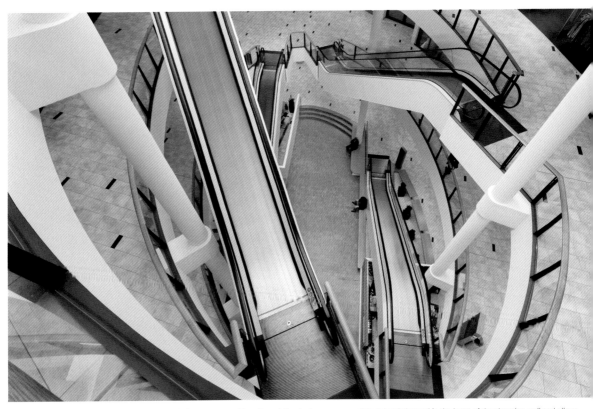

The project is characterized by creating a bright and pleasant space with a clear, defined urban presence. This atrium is located in the heart of the shopping mall and allows shoppers to enjoy the changing and theatrical perspectives of the complex.

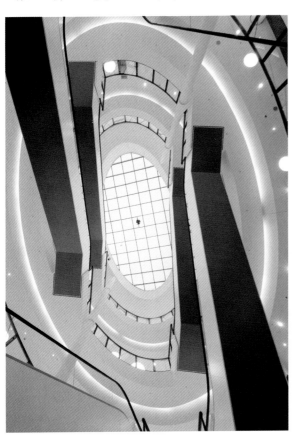

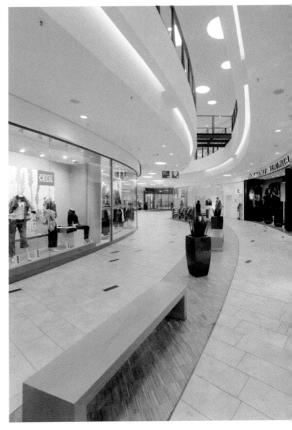

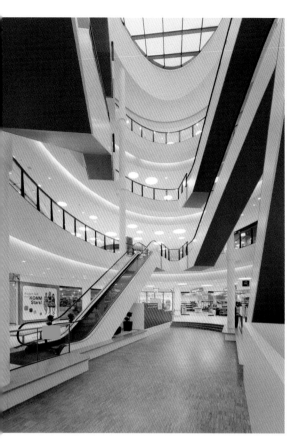

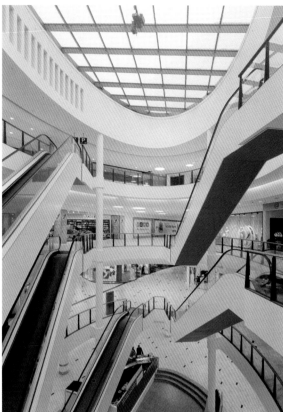

Natural stone and glass on the exterior have been selected to reflect the qualities of the surrounding cityscape and, thus, provide a link with modernity.

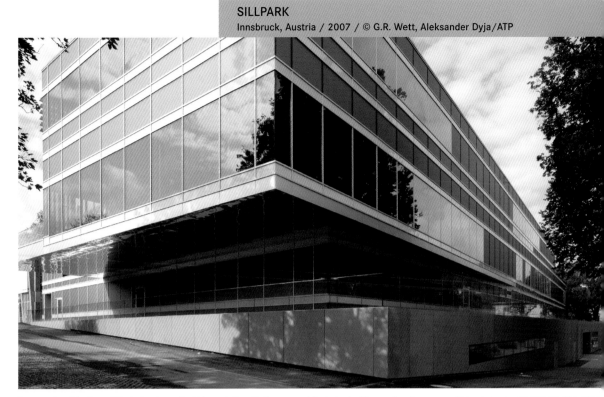

The extension of the former Sillpark shopping mall, which was designed by the same architects, involved the creation of a new monolithic volume separate from the old building. The new space has been integrated into the environment and has established the link between the public square of the enclosure and access to the city center.

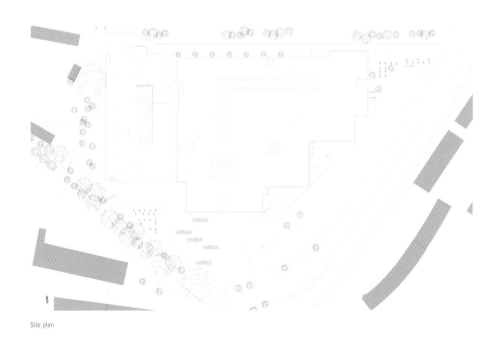

Site plan

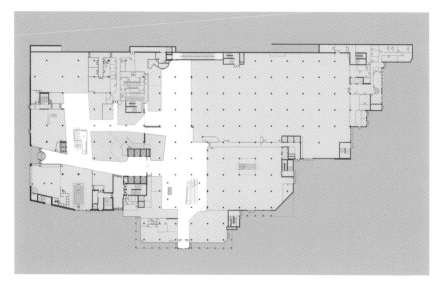

Ground floor plan

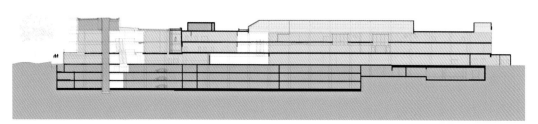

Section

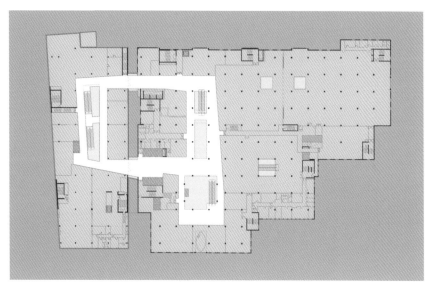

Second floor plan

The two floors of space are covered by a glass roof. The thickness of the glass panels varies and some are glazed. The reason for this design is purely ecological, because it allows a reduction of the energy required to air-condition the space.

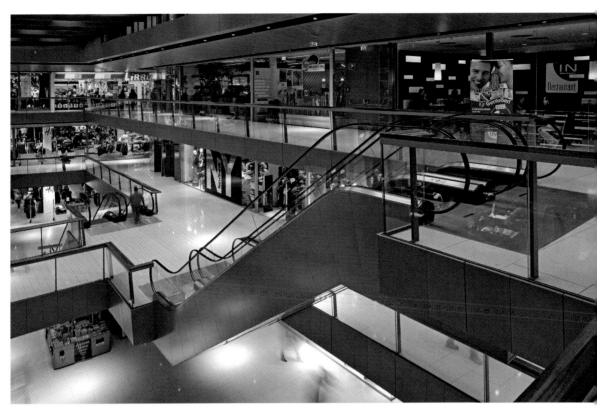

The architectural elements and lighting effects were selected to create a dramatic quality: glass cubes flood all floors with daylight, glass columns with variable intensity LED lighting recreate the exterior façade, and the illuminated ceilings create the illusion of day and night.

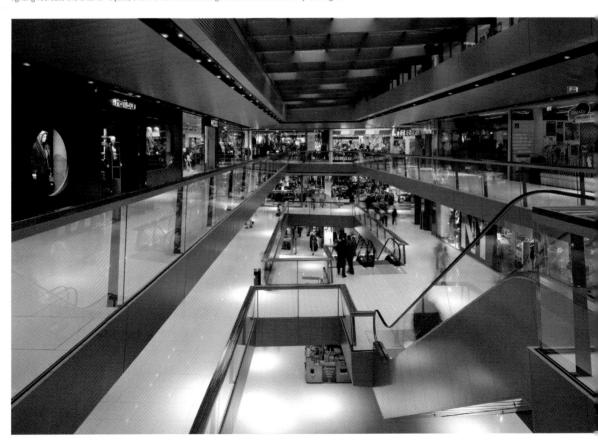

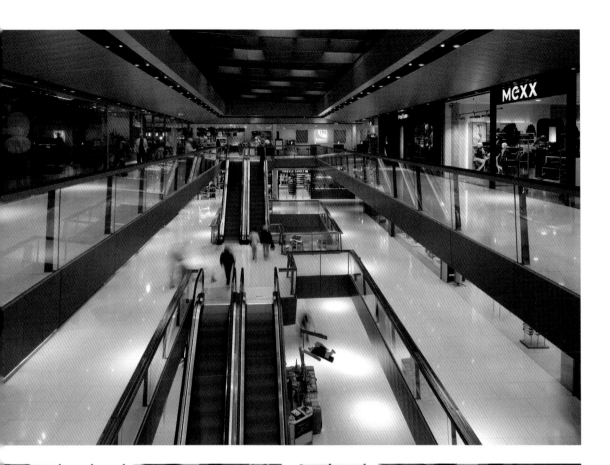

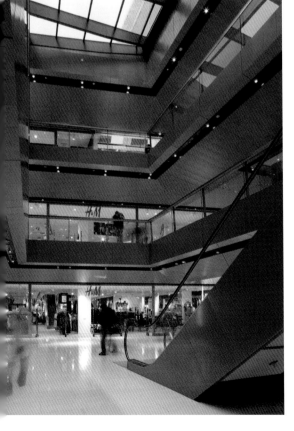

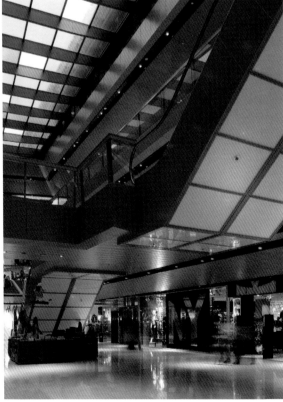

A commercial gallery ensures continuity between the old and the new building.

Varena

Vöcklabruck, Austria / 2010 / © Engelhardt/Sellin Architekturfotografie

The geographical location of the mall, next to the B1 highway on the edge of Vöcklabruck and just a few kilometers from Austria's main East-West motorway, allows it to form a modern counterpoint to the historic city center.

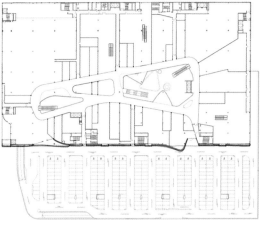

Ground floor plan

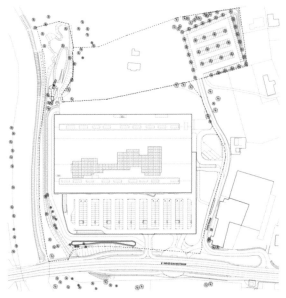

Site plan

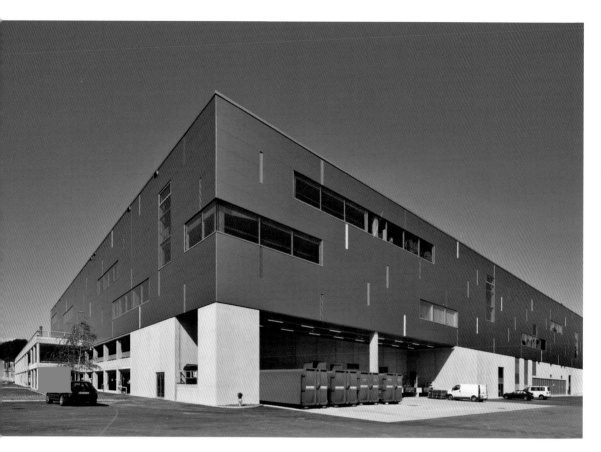

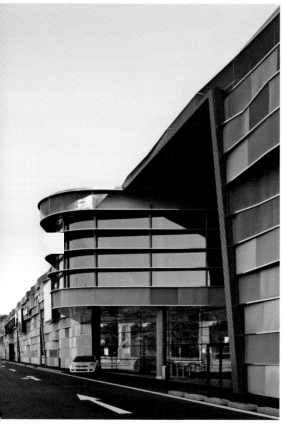

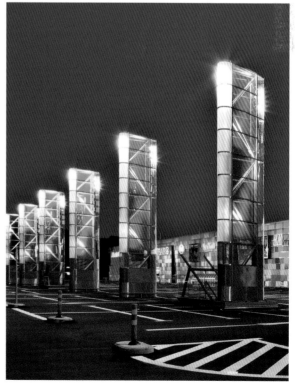

Ten colored Plexiglass lighting columns have been placed in front of the façade. The east, west, and south façades of the building are clad in sandwich panels, which are occasionally interspersed with small elements of color.

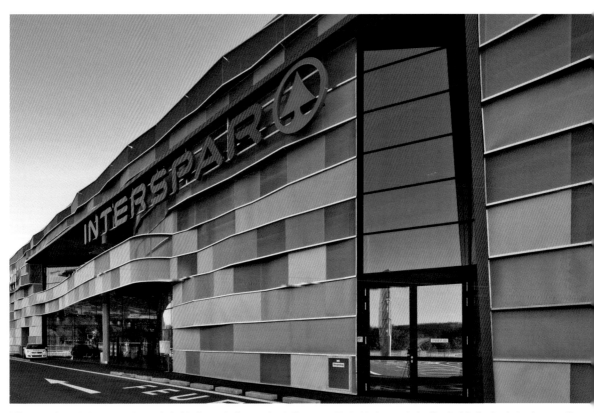

Different architectural elements stand out on the inside: the wooden beams painted white are combined with glass panels that filter the light flooding the interior space. These elements give the mall an elegant, sustainable, and modern aspect.

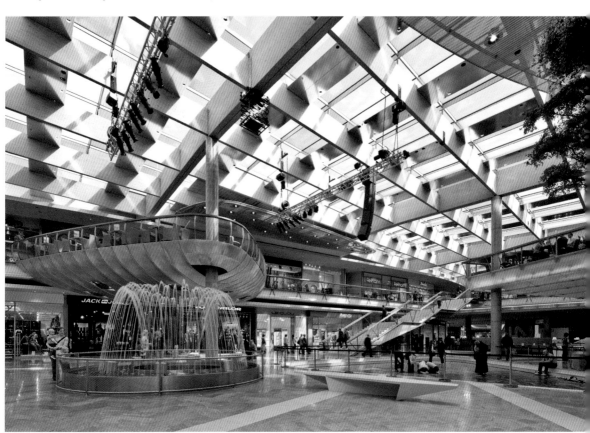

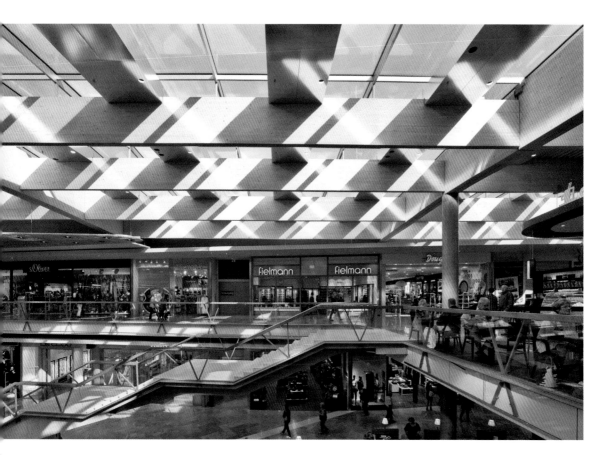

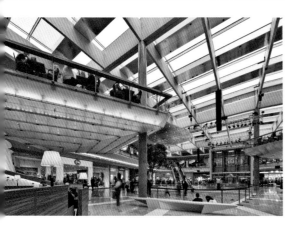

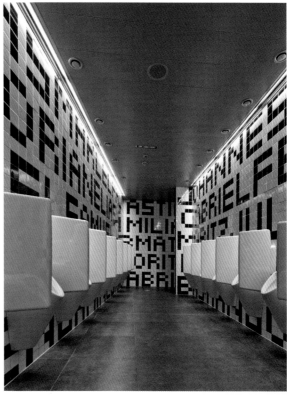

The mall has a three story parking lot with 1900 spaces. The parking deck creates the 8 m (26 ft) high base upon which the shopping mall stands.

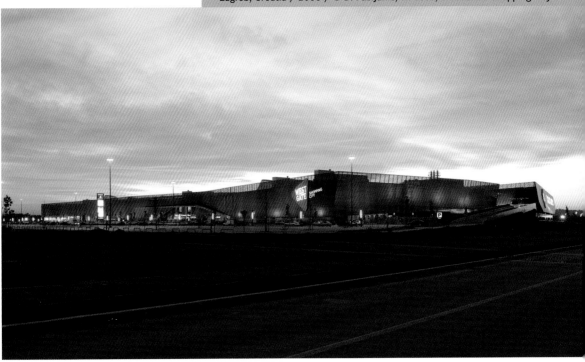

The project consists of a large structure with a façade that reinterprets the barcode, the symbol of the shopping experience. The façade appears to be wrapped up in a red steel scarf. The Croatian landscape is the main design theme as it is evident in the façades and interior spaces.

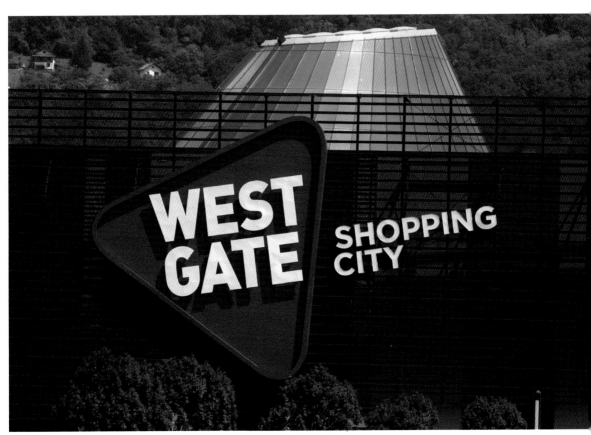

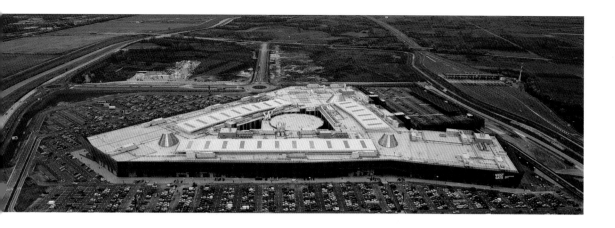

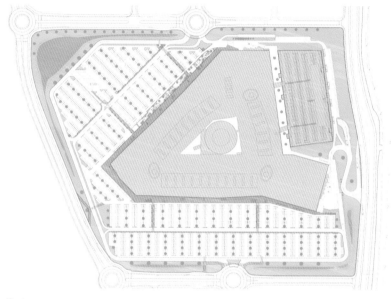

Site plan

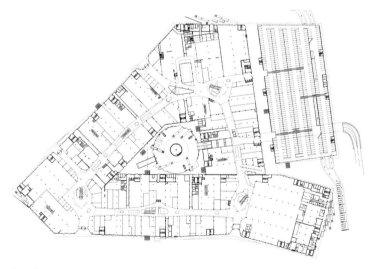

Ground floor plan

fluid connection has been sought between the mall and the adjoining racetrack. Elliptical parking allows visitors to park around the entire building.

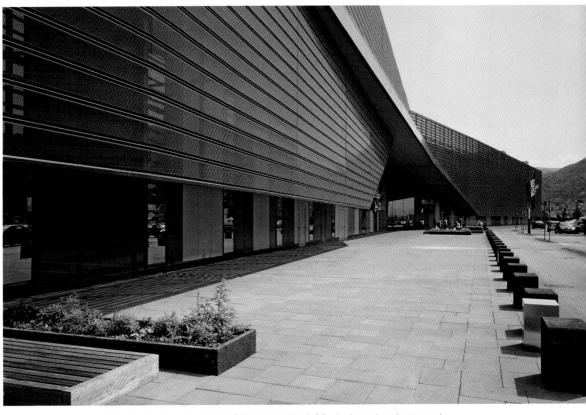

The skin of the façade is a perforated red steel band. Like a giant scarf, it wraps around the building, but leaves the main entrance clear.

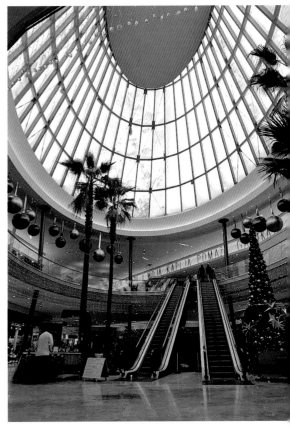

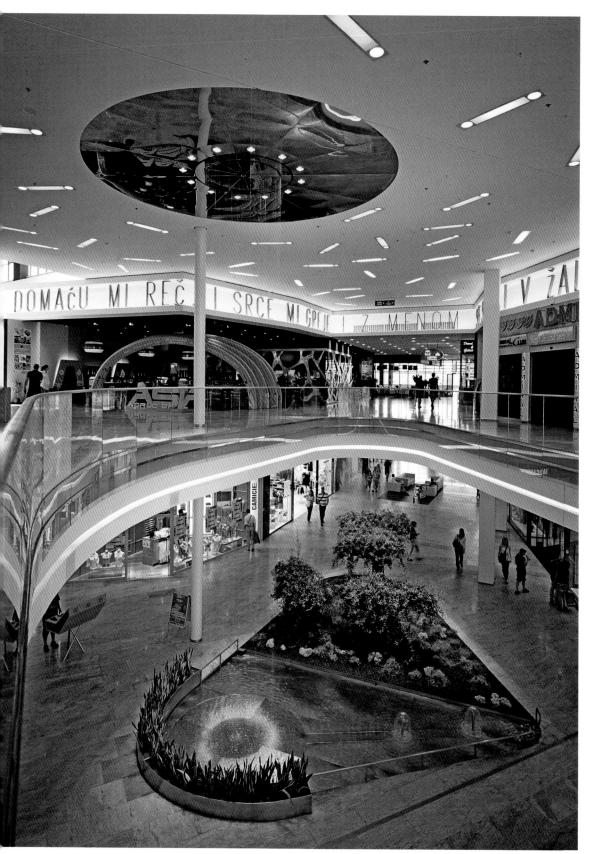

White has not been used in the interior spaces on purpose. Instead an ivory tone has been used, which is more Mediterranean and glossy.

Baudizzone – Lestard & Asociados Arquitectos

Jorge Lestard, Miguel Baudizzone

City Center Rosario Rosario, Argentina
2009 / © Daniela Mac Adden, MyA Producciones, Alejandro Leveratto

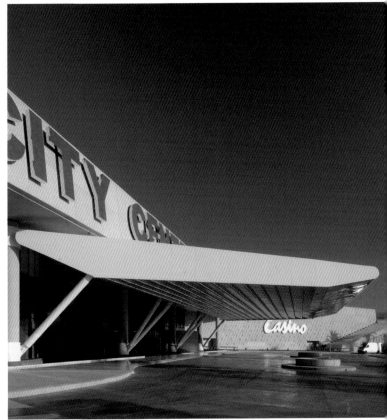

The entire building—home to a hotel-casino and convention center—creates a fun and different world, which contrasts with its surroundings, expressing its character as an urban landmark and becoming integrated with the surrounding park.

Arroyo, 828 4º piso
C1007AAB Buenos Aires
Argentina
Tel.: + 5411 43 27 13 83
www.baudizzone-lestard.com

Since its founding in 1964, the Baudizzone Lestard and Associates studio has been involved in intense activities that cover the project areas and construction management, architecture, urban design, and interior design. Its field of action covers public and private works of all kinds of complexity. The team has participated in numerous competitions and has received over fifty awards. The studio's experience in the area of urban design includes large-scale projects. Moreover, most of the commissioned public or private works comprise highly complex architecture: hotels, industrial buildings, laboratories, hospitals, auditoriums, sports facilities, shopping malls, large office buildings, and urban and suburban housing.

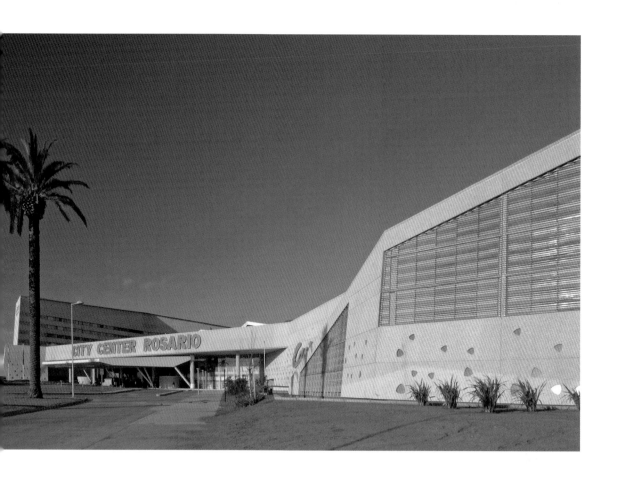

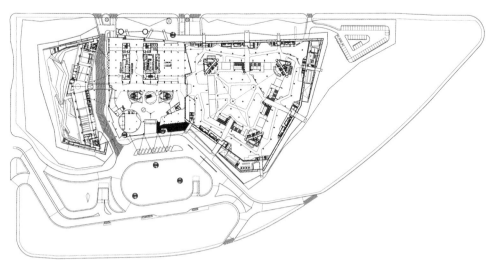

Floor plan

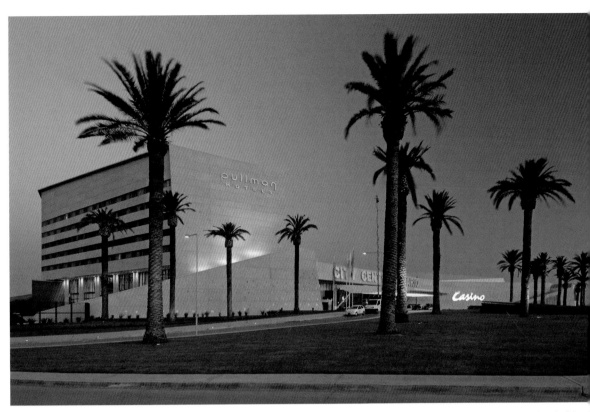

The building is designed as a clear-colored, mono-chromatic sculpture. The main materials used are precast, reinforced concrete covered with white stone and glass. At night, a exterior lighting system generates various combinations of color.

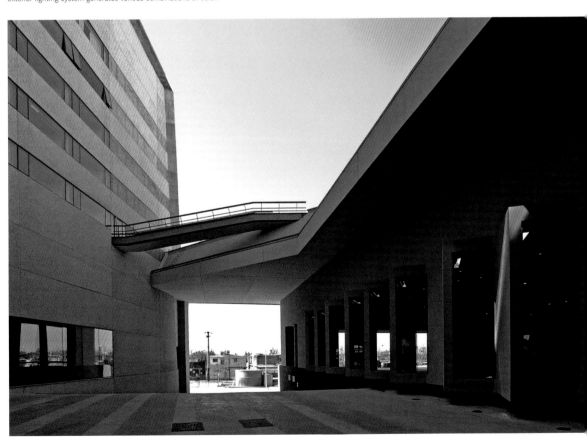

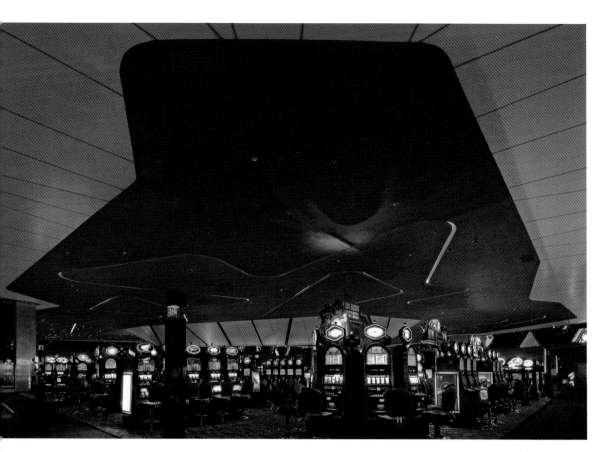

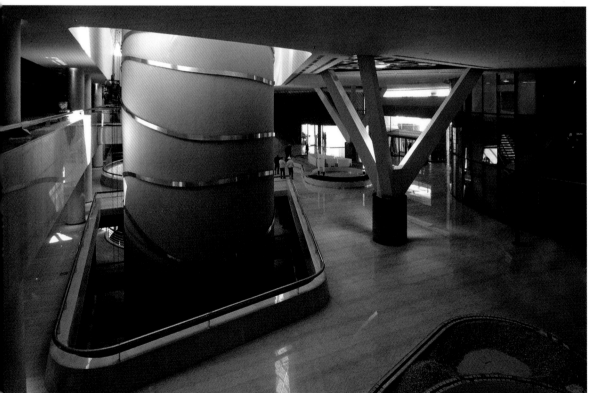

The roof is treated as a fifth façade and has a large terrace that contains a gym and a series of swimming pools, plus a walkway around the edge with views of the surrounding park.

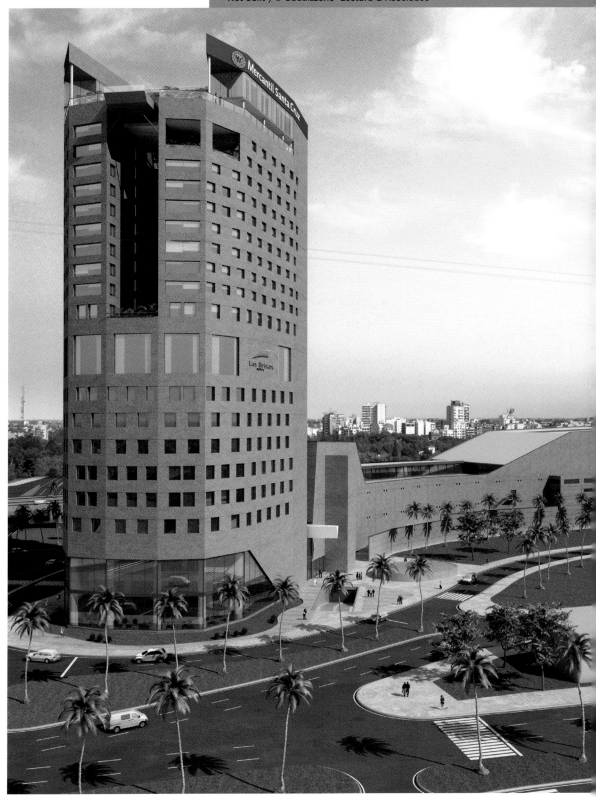

In a site located opposite the city's first three-level junction, a multi-use building complex has been designed in order to create a new center of attraction. The building consists of a mall, a hotel, and a bank.

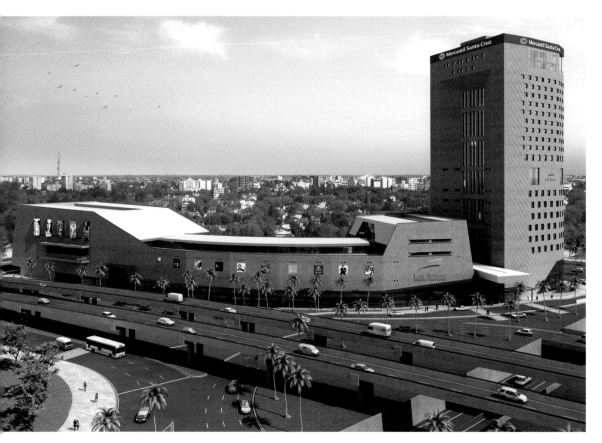

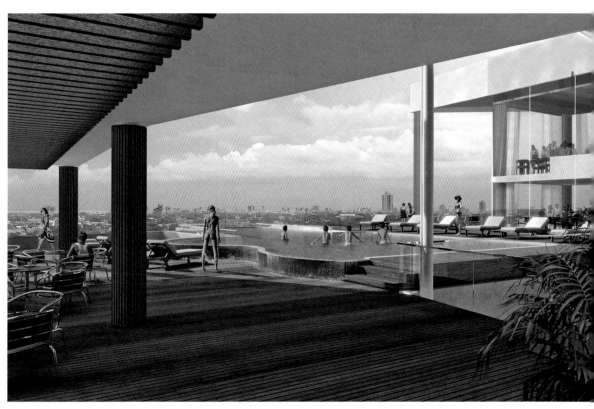

The bank, located on the first floor, has its customer service area in a large room with only two central columns and a triple perimeter height that opens up like a mouth towards the end of the site.

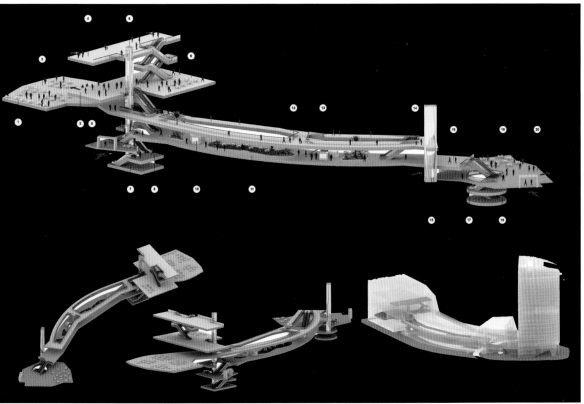

xonometric diagrams

BDP

© BDP

Terry Davenport, Dan Smyth & Jeremy Sweet

16 Brewhouse Yard
EC1V 4LJ London
United Kingdom
Tel.: + 44 0 20 7812 8028
Fax: + 44 0 20 7812 8391
www.bdpcom

BDP is considered one of the most important interdisciplinary firms of architects, designers, engineers, and urban planners in Europe. Its philosophy is to maintain, at all times, a close relationship with users, customers, and communities to create special and unique places to live, work, go shopping, educate yourself, and learn. Its work includes the construction of architectural projects across Europe, Africa, Asia, and Australia. Founded in 1961, it boasts a pool of over 1000 professionals including architects, designers, engineers, urban planners, sustainability experts, lighting designers, and acousticians, distributed throughout sixteen studios in the UK, Ireland, Holland, United Arab Emirates, India, and China.

Liverpool One Liverpool, United Kingdom / 2008
© David Barbour/BDP, David Millington, David Thrower, Grosvenor, Paul McMullin

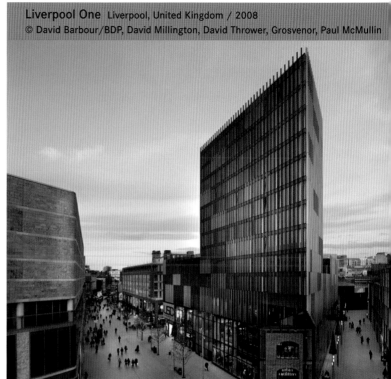

Liverpool's city center has become a vibrant and interesting place to live, work, and relax. This has been made possible by the construction of Liverpool One. Designed by BDP, it creates a mixed-use development of new and refurbished buildings, streets, and spaces.

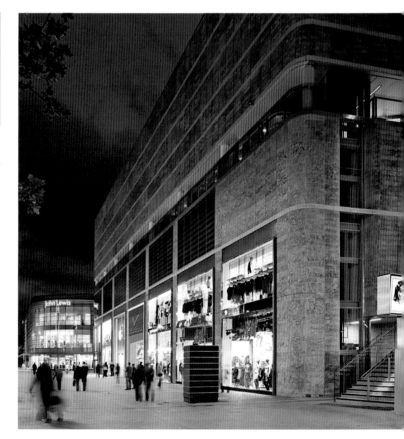

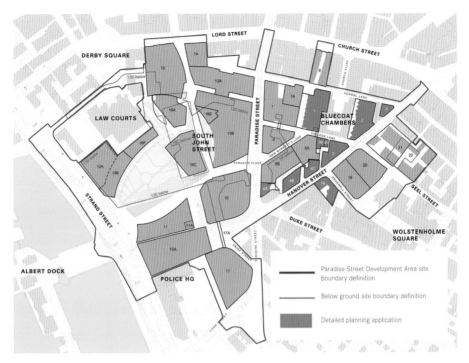

Site plan

Paradise Street Development Area site boundary definition

Below ground site boundary definition

Detailed planning application

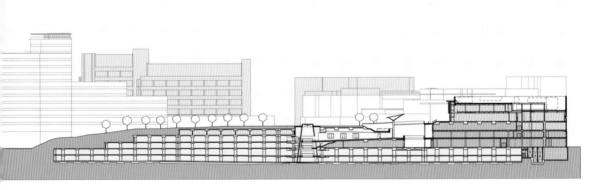

est cross sention

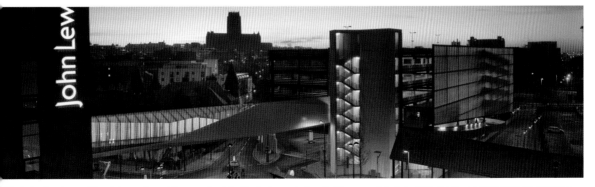

DP acted as the planner of the whole complex and the concept architect for five large mixed-use buildings, as well as designing the lighting and landscaping. The rest of the esign has been carried out by local, national, and international architects.

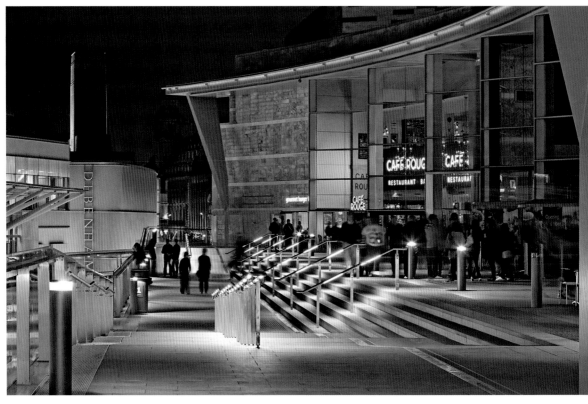

The shopping area is spread over 149,000 m² (1,603,822 ft²) and is attached to the main shopping streets of the city. A wide variety of cafes, bars, and restaurants and a multiplex cinema complex have been built on the upper level.

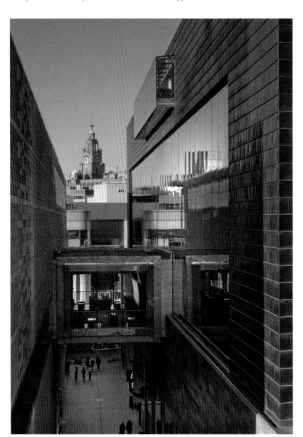

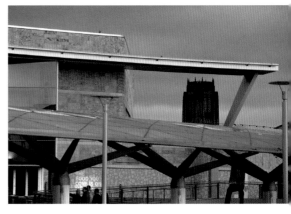

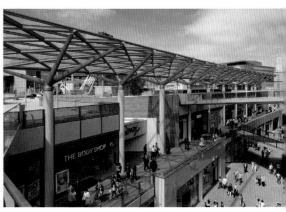

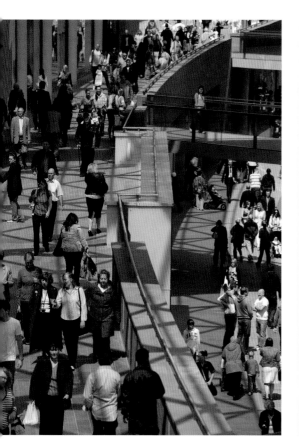

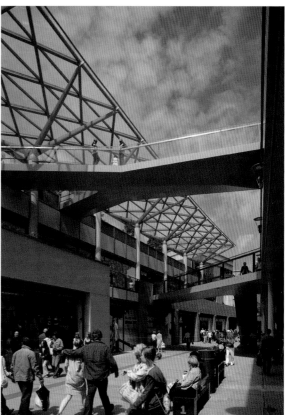

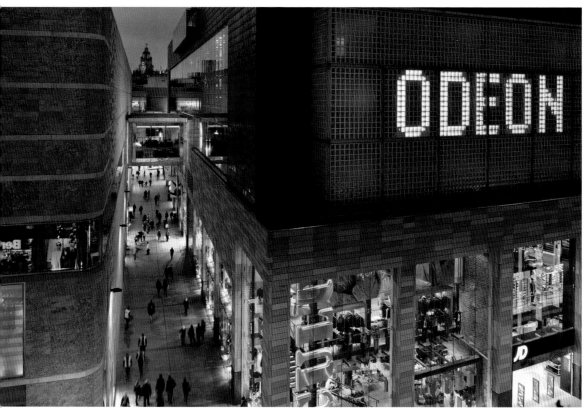

The architectural studio BDP was commissioned to design the lighting throughout the complex. Neon bright colors and theatrical lighting are the main design features.

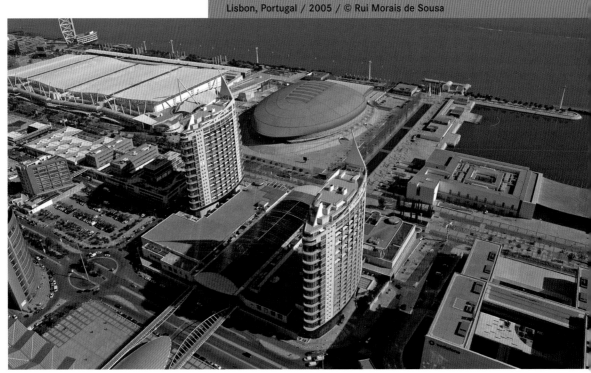

The mall is a major intervention in the heart of a new district of Lisbon. It was created for the 1991 Lisbon World Exposition from the regeneration of disused docklands situated along the banks of the River Tagus. BDP won an international competition to build a leisure and residential space there.

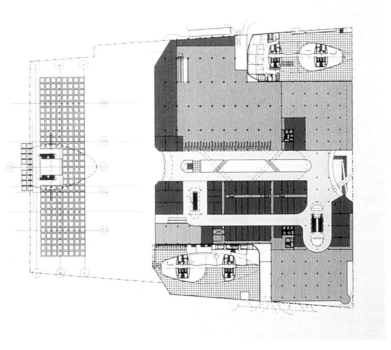

Floor plan

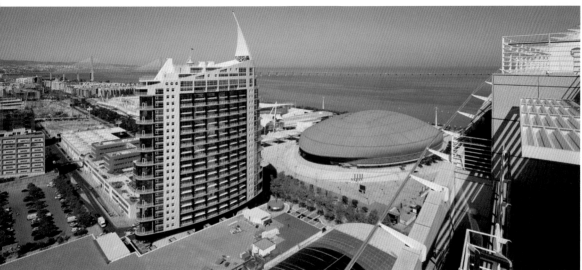

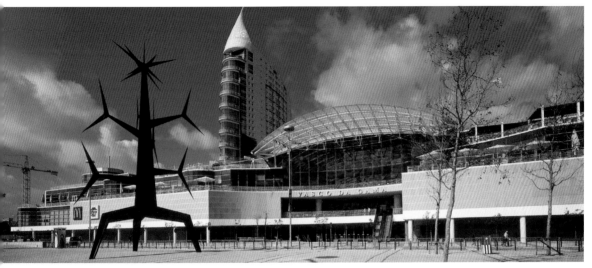

The city's Expo 1998 theme—the oceans—drew inspiration from the sail-form tower cross-sections. This nautical theme influenced everything from the silhouette of the towers to the smallest detail of the mall.

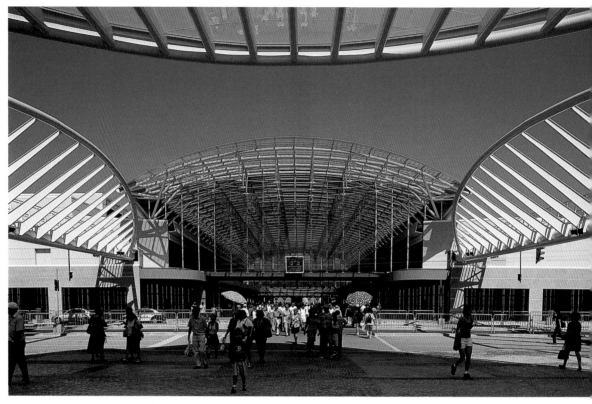

The scheme comprises a covered 60,000 m² (645,800 ft²) retail and leisure building over four floors, featuring a dramatic central space and external dining overlooking the waterfront. The development's two 24 story residential towers, San Gabriel and San Rafael, contain 300 apartments ranging from studios to four-bedroom penthouses.

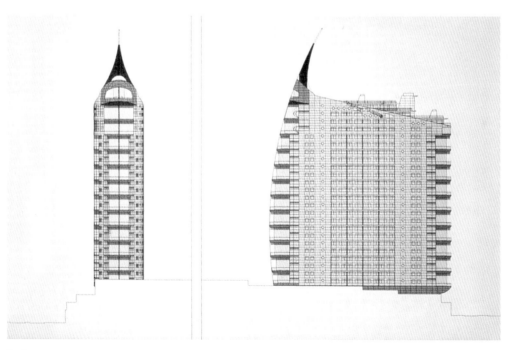

Elevations

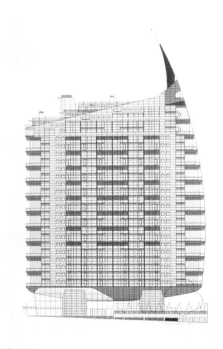

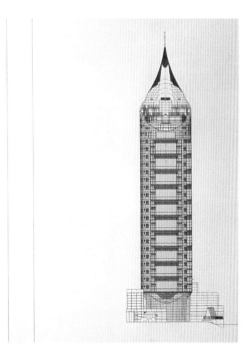

Elevations

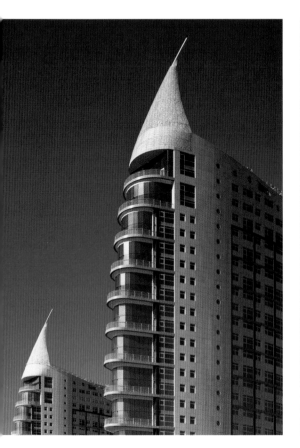

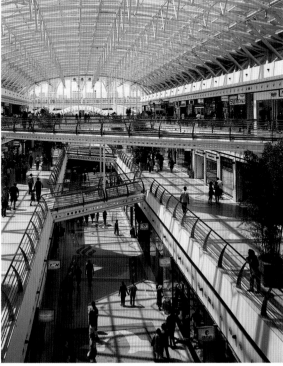

The building has become a distinctive landmark in the city, visible from the air in the direction of Lisbon airport and from the road at various points in the city. In the interior design, visual transparency emphasizing the oceans theme from the Expo 1998 prevails.

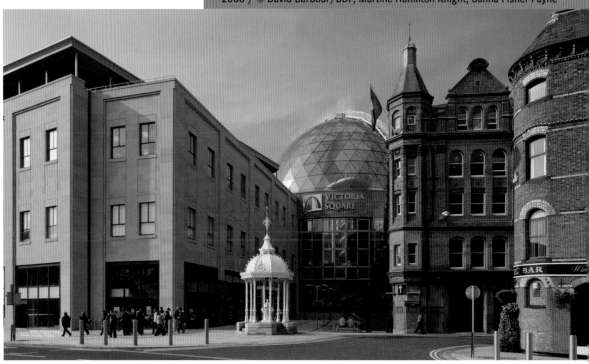

The shopping mall comprises 63,000 m² (678,126 ft²) of retail floor space spread over three floors with a multi-screen cinema, a food court, restaurant terrace, apartments, and two levels of basement parking.

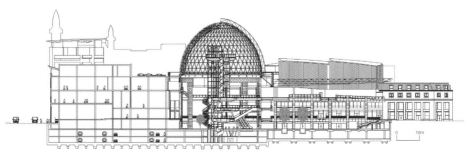

Sections

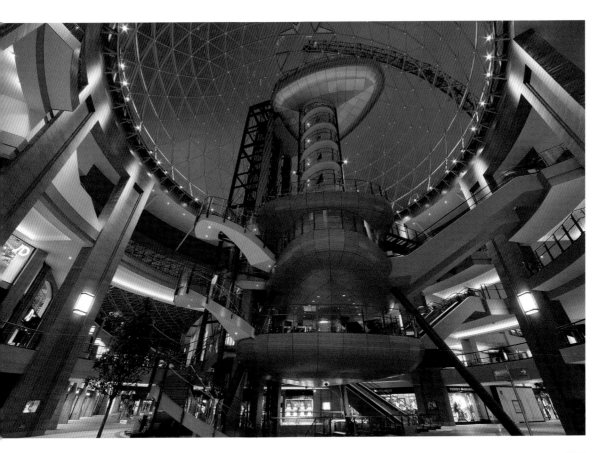

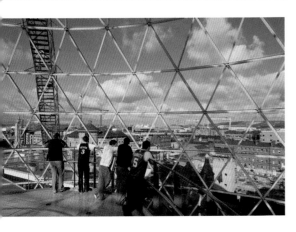

With its spectacular glass dome, Victoria Square in the center of the city has become a local icon that changed the city's skyline.

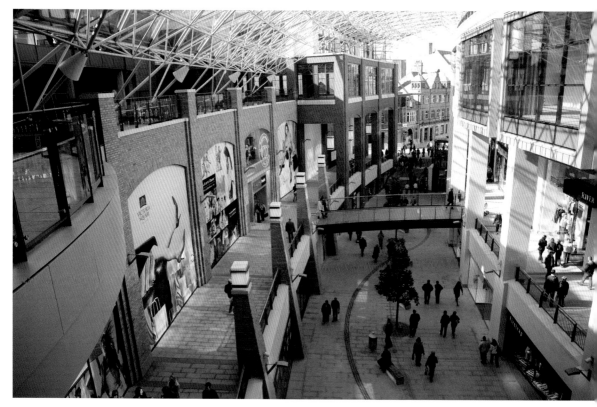

The scheme is based on an open street model very common in European cities—it is more like an urban landscape than an independent mall. The building is permanently connected to the city and thus establishes different relationships with the urban fabric.

Site plan

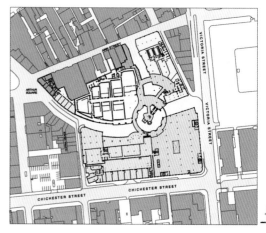

Upper ground floor plan

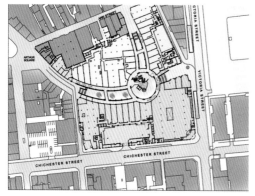

Level 02 plan

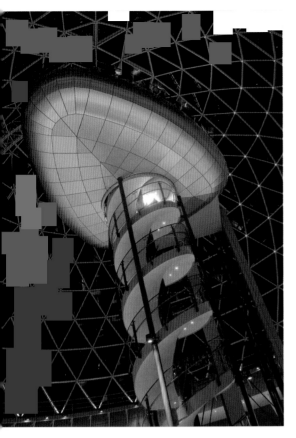

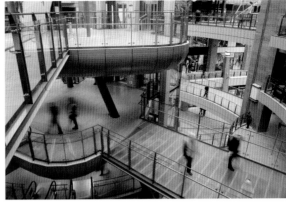

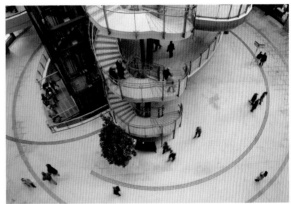

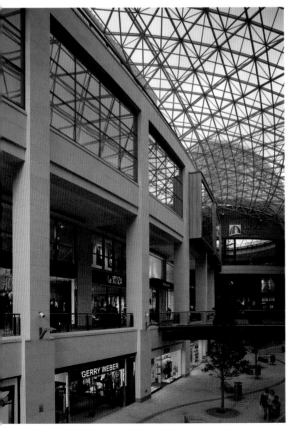

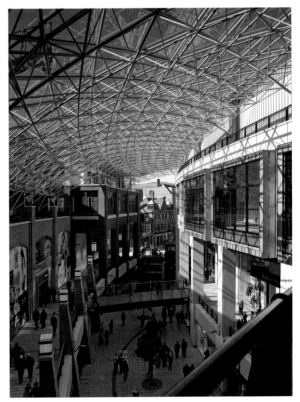

The dome has a diameter of 37 m (121 ft), a height of 45 m (147 ft), and consists of 635 glazed triangular panels.

C. F. Møller Arkitektfirmaet

C. F. Møller arkitektfirmaet team

Europaplads 2, 11
8000 Aarhus C
Denmark
Tel.: +45 8730 5300
www.cfmoller.com

C. F. Møller Arkitektfirmaet is one of the oldest firms in Scandinavia. Since its founding in 1924, the studio has won a host of national and international competitions, as well as awards in places like RIBA in London, the Venice Biennale, the Danish Centre for Architecture, and the Danish Cultural Institute in Beijing.

The firm's work covers a wide range of areas, from programmatic analysis, urban planning, and architecture of all kinds, including landscaping, development, and building components. The studio has a long tradition of internal and external cooperation in which all parties involved in a project work towards a common architectural goal. The central office is located in Aarhus, and the firm has offices in Copenhagen, Aalborg, Oslo, Stockholm, London, and a limited company in Iceland.

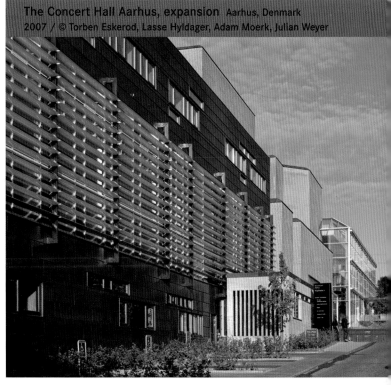

The Concert Hall Aarhus, expansion Aarhus, Denmark
2007 / © Torben Eskerod, Lasse Hyldager, Adam Moerk, Julian Weyer

The Aarhus Concert Hall was designed by Kjær & Richter and opened in 1982. With this expansion, including a Symphony Hall, another rhythmic music hall, and a chamber music room, the site doubles in size and incorporates features that make it a concert hall and exceptional educational institution.

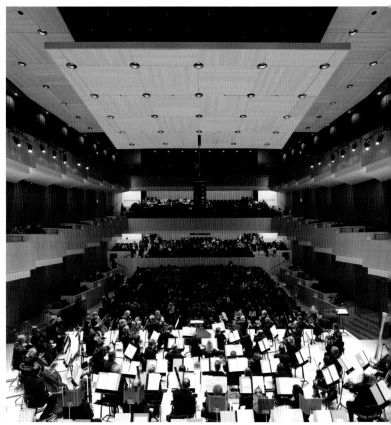

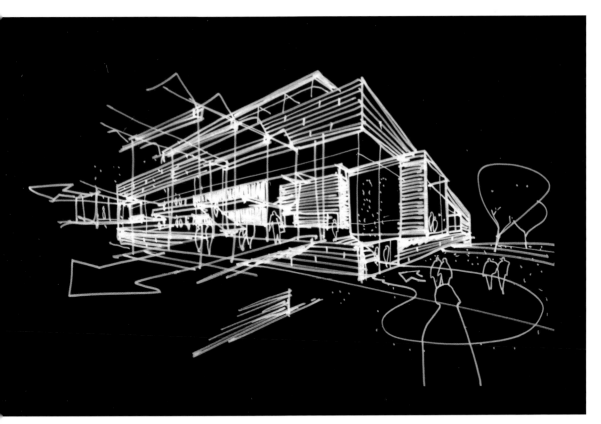

Sketch

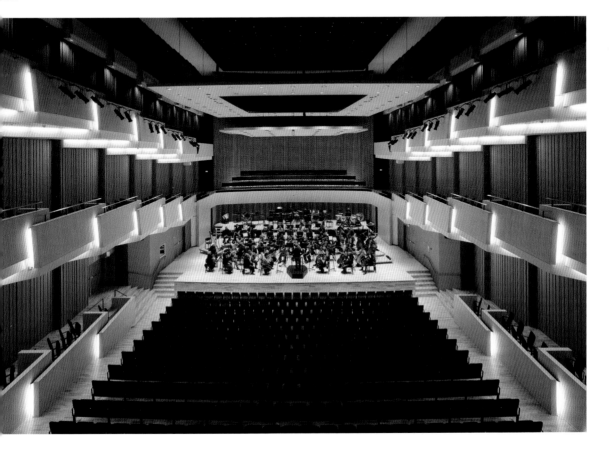

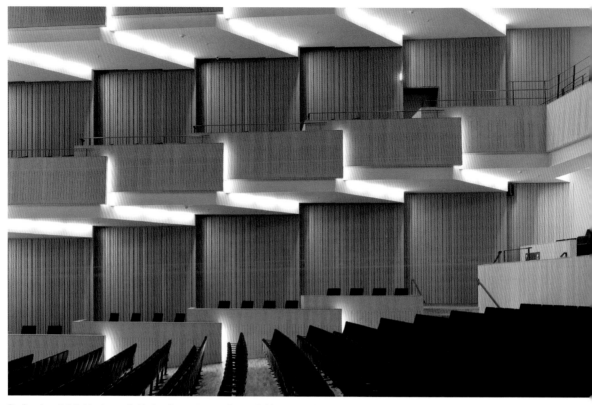

The Symphony Hall that has been added to the site operates as a giant musical instrument whose sound can be adjusted with movable walls, carpets, and acoustic panels. The Nordic colors of the light wood, gray, and black are predominant design features.

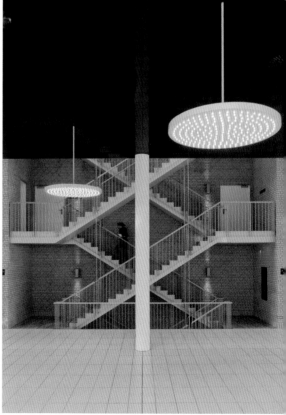

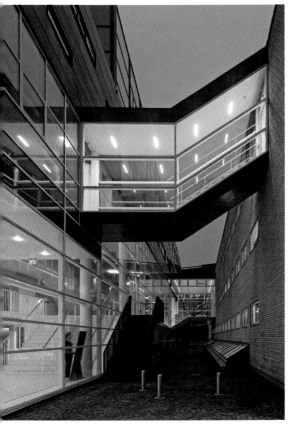

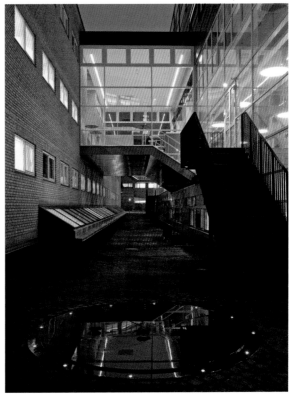

Everything has the same simple and light color scheme and materials in order to create a contrast with the yellow brick walls.

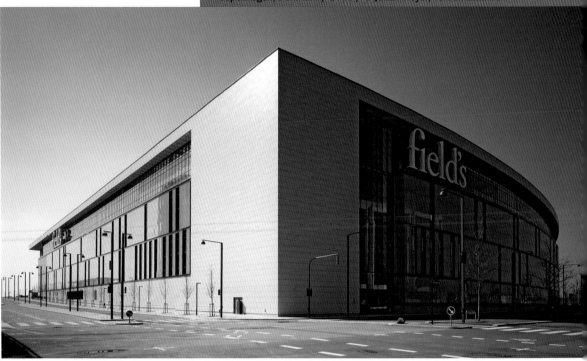

Field's is a shopping and entertainment center. The building consists of two floors of parking, three floors for retail, and two floors for offices. With a shopping area equivalent to twenty-eight football fields and featuring 110 stores, Field's is the largest shopping center in Scandinavia.

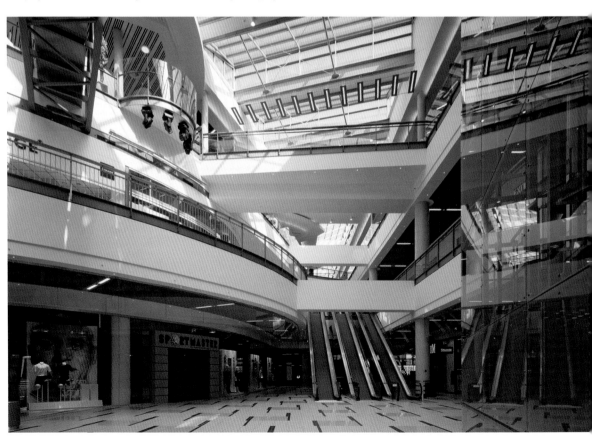

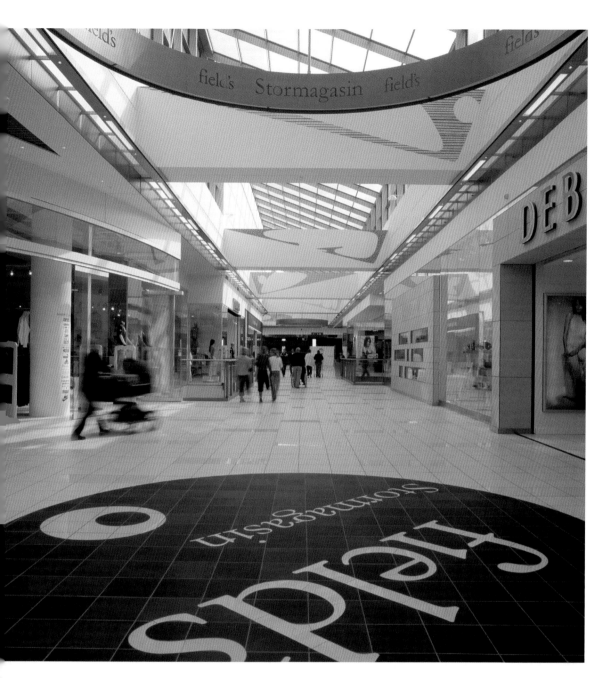

The transparent glass façades are welcoming despite the introverted nature of the building.

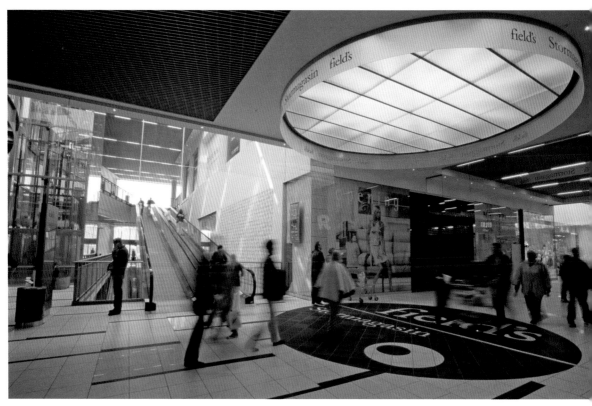

The light rays filter into the mall through the different floors and glass walls. The seven meter (22 ft) wide corridors with its many indoor squares emphasize the open and transparent nature of the complex.

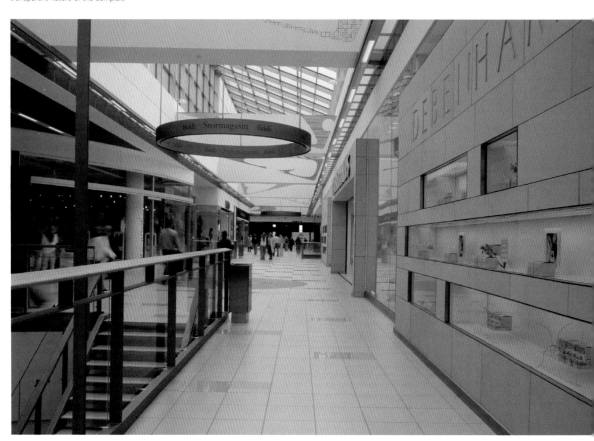

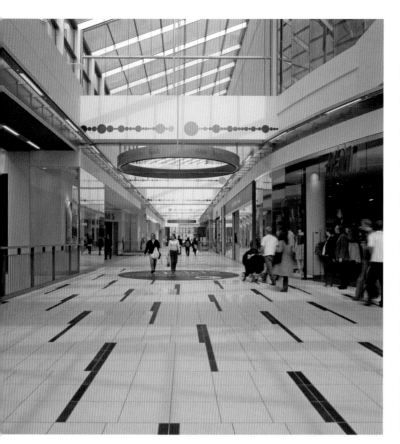

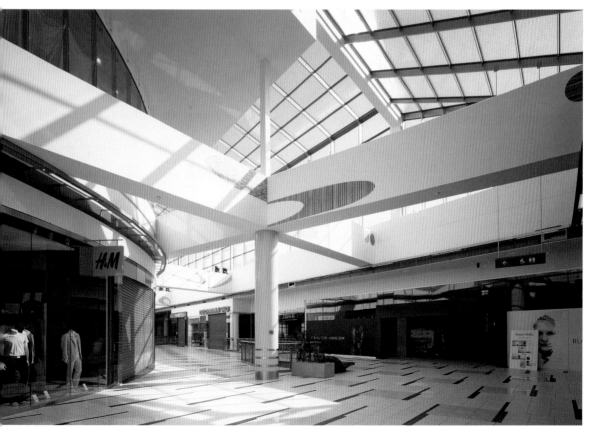

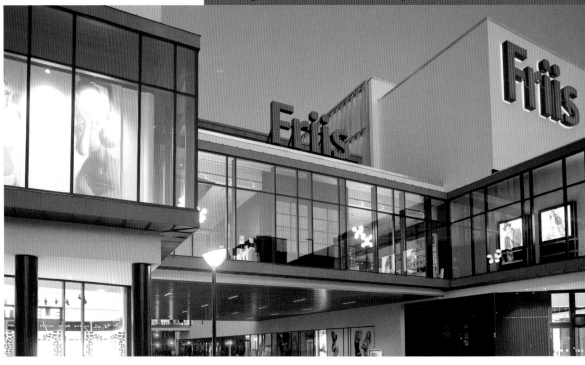

Friis is a combination shopping mall, parking lot, hotel, business center, and office complex. The building unifies a large part of the center of Aalborg that otherwise would have remained separated by the main traffic artery. It consists of a new building and a renovated building that was a former department store.

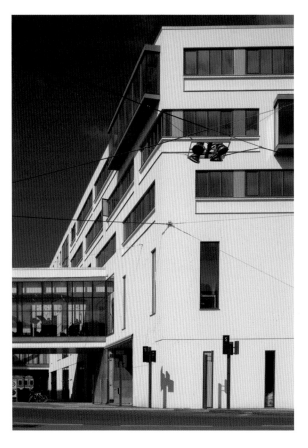

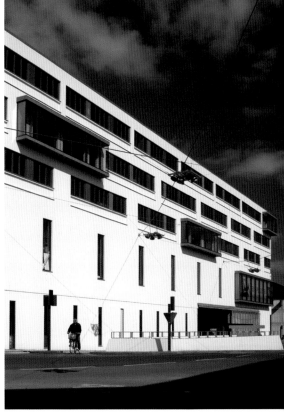

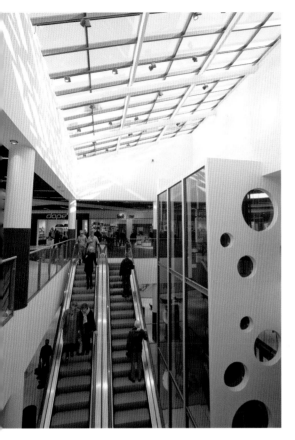

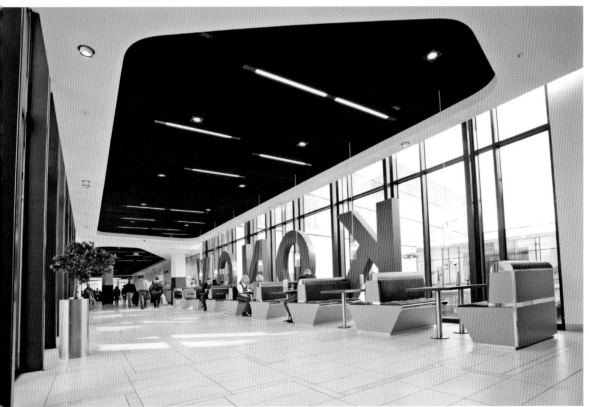

The two buildings are connected by two bridges, one of which has space for a store and a restaurant. Both offer magnificent views of the city.

The dominant features of this shopping mall include the different sections of the building, the variety of different formats used for the windows, and the materials used on the surfaces, which reflect the city.

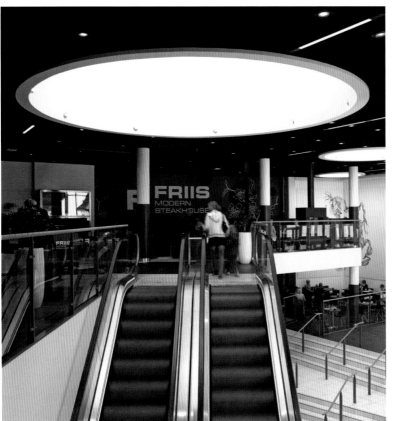

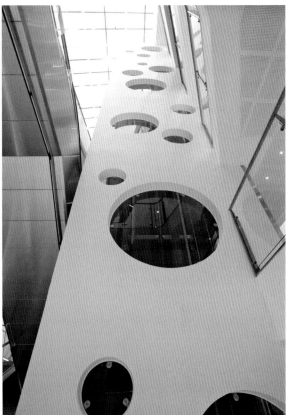

58,000 people visited the mall on the day of its opening in March 2010. Since then, it has continued to attract very high levels of daily attendance.

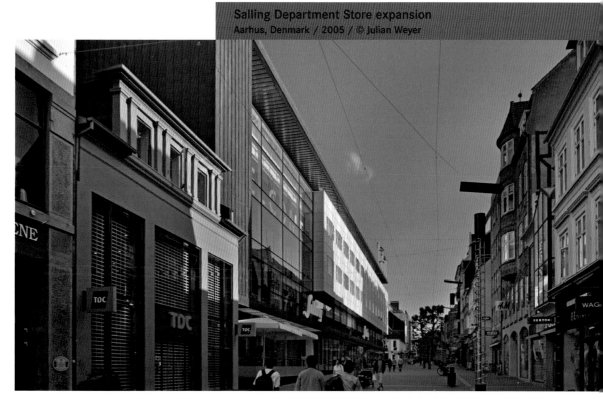

Located on the main shopping street in Aarhus, this department store has become part of the identity of the area. For C. F. Møller Architects it was especially gratifying to have won the tender for its extension, since the building had been designed by the same studio fifty years ago.

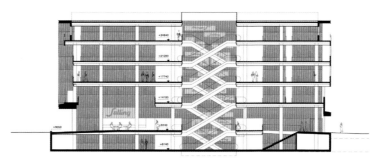

Atrium section

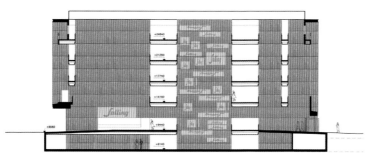

Entrance section

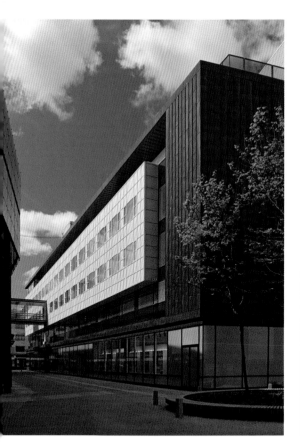

The project included a restructuring of the existing floors and the entrance area, as well as the total renovation of the façade.

With the atrium in the center of the building, the new spaciousness reaches all levels through a section on the floor plans that also contains the stairs.

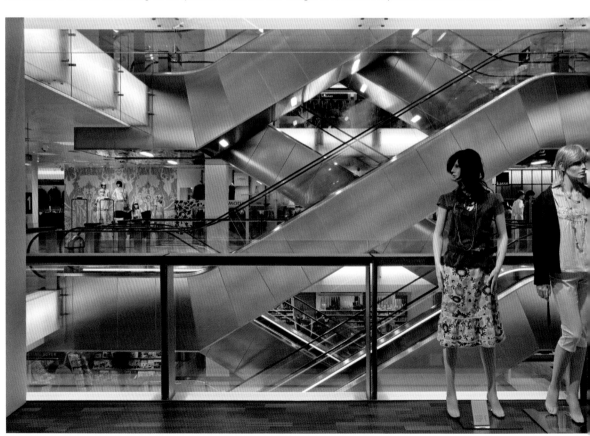

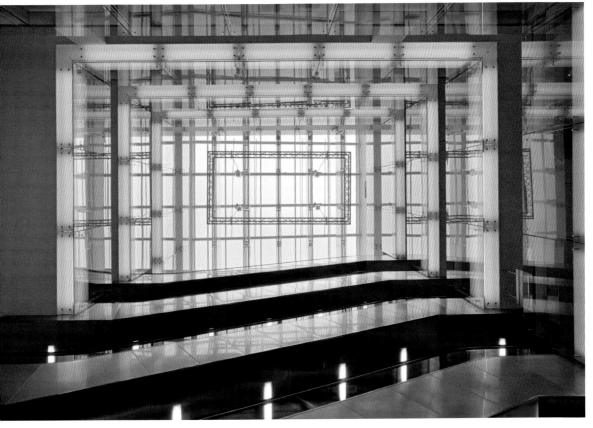

Concrete Architectural Associates

Concrete Architectural Associates team

Rozengracht 133 III
1016 LV Amsterdam
Netherlands
Tel.: + 31 0 20 5 200 200
Fax: + 31 0 20 5 200 201
www.concreteamsterdam.nl

With the slogan "There are no problems, only solutions," Concrete Architectural Associates builds specific identities that make them unique in the worldwide architectural scene. Their multidisciplinary work ranges from urban planning to interior design, and from architecture to product design. Originally, Concrete was founded in 1997 by Rob Wagemans, Gilian Schrofer, and Erik van Dillen to design a central office in Amsterdam for the Cirque du Soleil, an unrealized project. In 2004, Schrofer left the company to start her own business. With the arrival of Erikjan Vermuelen, the architectural studio was re-founded in 2006, and their work in architecture and urban landscaping was reinforced with other disciplines.

Bibliotheek Almere
Almere, Netherlands / 2010 / © Wim Ruigrok, Concrete Architectural Associates

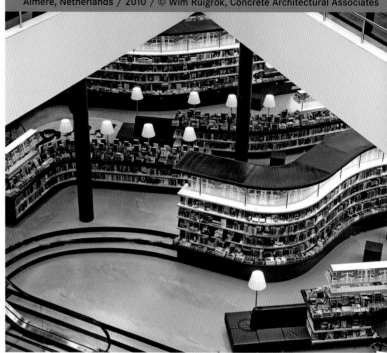

The main challenge of the architects was to design all the public spaces in the new Almere library. Complementary facilities and shelves, such as counters, Internet connection areas, a cafeteria-reading area, study areas, and a multimedia department, were set.

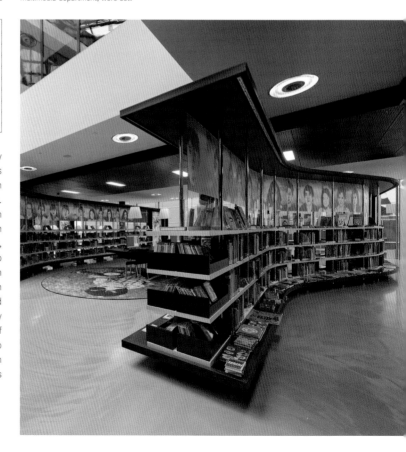

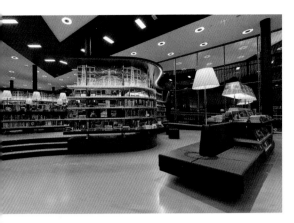

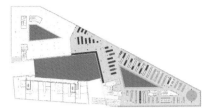

Third floor plan

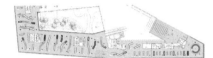

Second floor plan

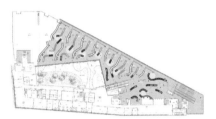

First floor plan

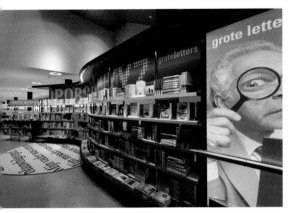

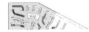

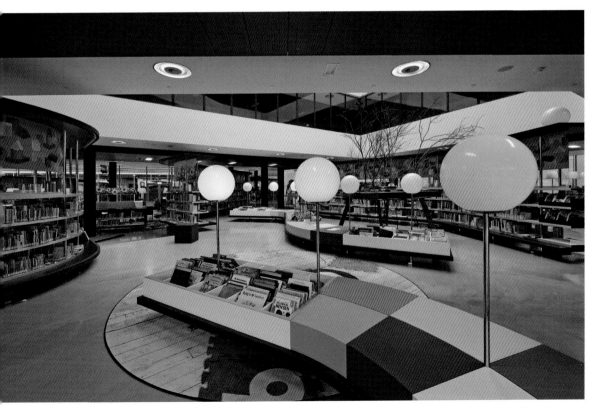

Instead of a standard library, the design concept was focused on developing a space where books are arranged according to each section: youth, culture, health, travel, etc., and not by call number as would be usual.

CitizenM Hotel Glasgow Glasgow, United Kingdom
2010 / © Richard Powers, Concrete Architectural Associates

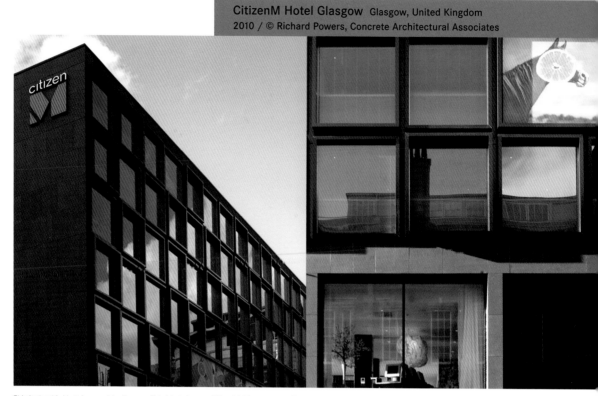

This is the third hotel opened by the new Dutch hotel group CitizenM. The concept of this type of hotel is to eliminate all unnecessary costs and elements in order to offer their customers a sense of luxury at an affordable price. The hotel has been constructed with prefabricated and easy-to-transport pieces.

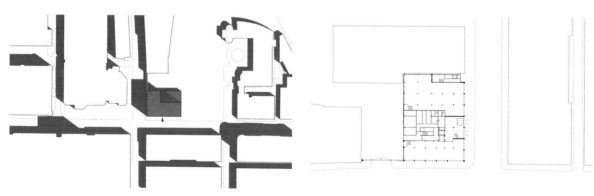

Site plan

Second floor plan

First floor plan

Ground floor plan

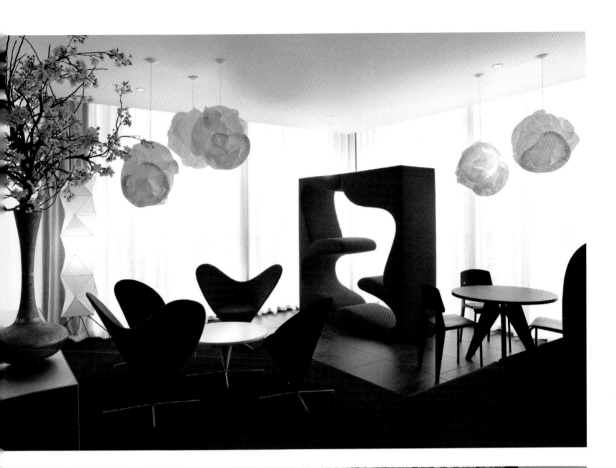

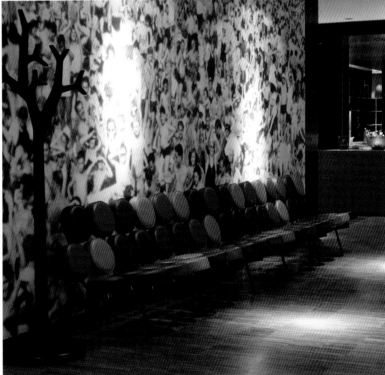

The hotel consists of 198 rooms over eight floors, a dynamic entry hall, a lounge, and conference rooms. The CitizenM design concept is simple, but luxurious. Its rooms and bathrooms are furnished with the minimum indispensable elements.

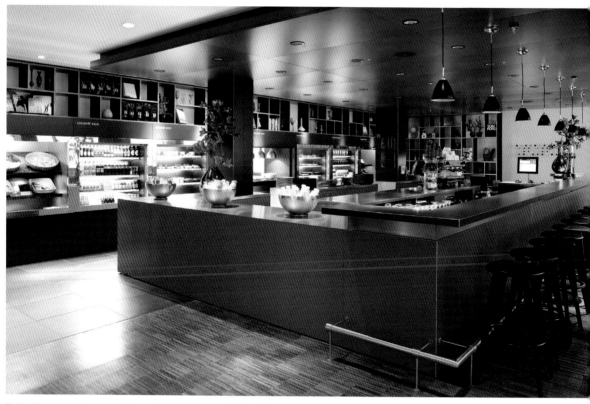

The first floor is home to a commercial space with the hotel entrance. In the public area of the second floor there are several lounges, creating a second home for visitors. There is also a self-service restaurant and a library.

The furniture in the bedroom has been designed specifically for the space and a theatrical atmosphere has been created through the lighting.

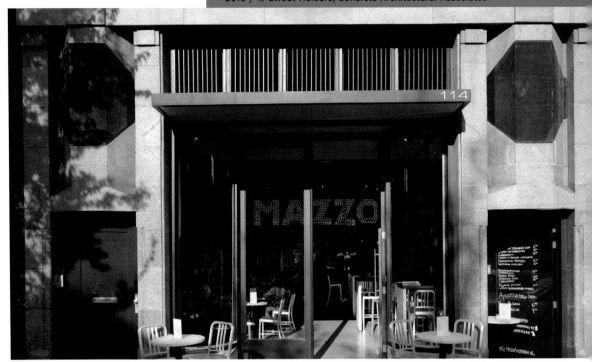

The restaurant is located in a typical Amsterdam building—deep, narrow spaces that merge with the floor and ceiling. The part located on Rozengracht street consists of the ba
area, where clients can order a quick coffee, while the second part consists of the restaurant, as it is wider.

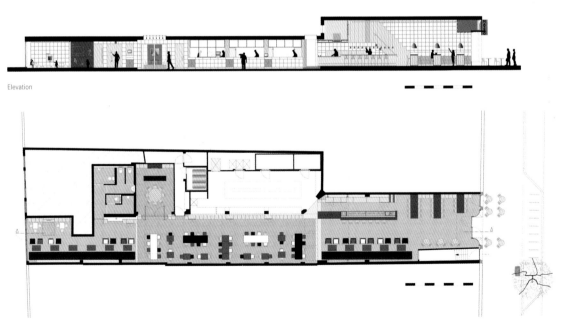

Elevation

Floor plan

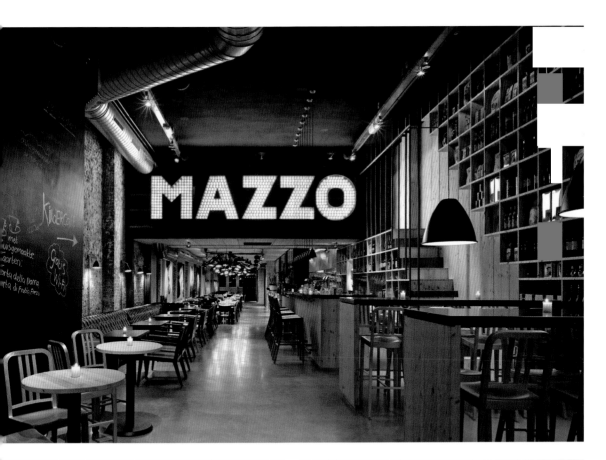

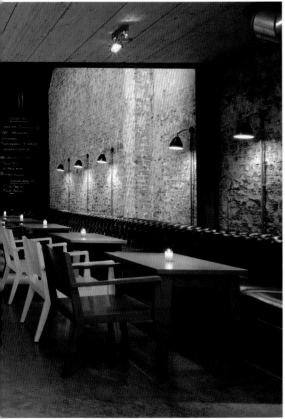

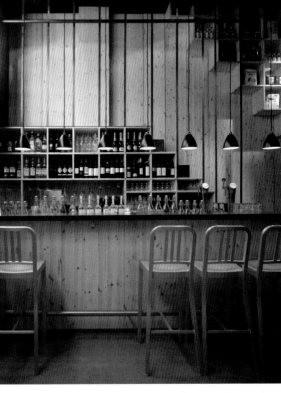

The diversity of the spaces are linked through a connecting element—huge wooden closets located throughout the restaurant.

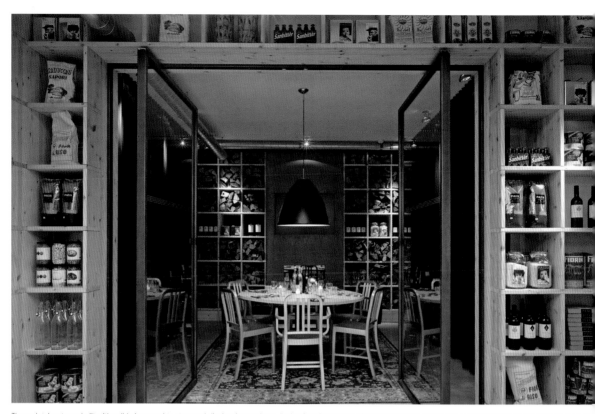

The main closet was built with solid pine wood to store and display the products. It also functions as a stairway to the mezzanine floor. A small room is equipped to be used as boardroom, or a place for intimate celebrations.

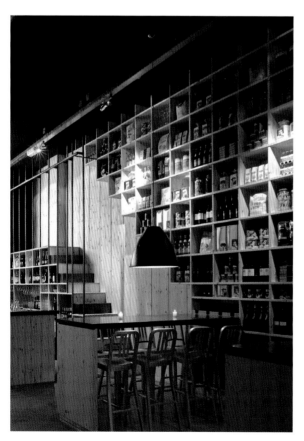

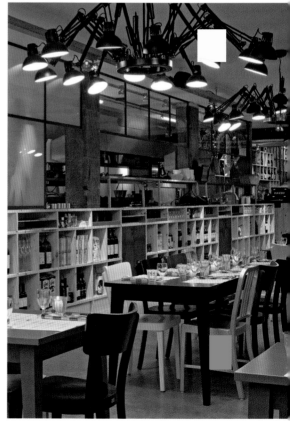

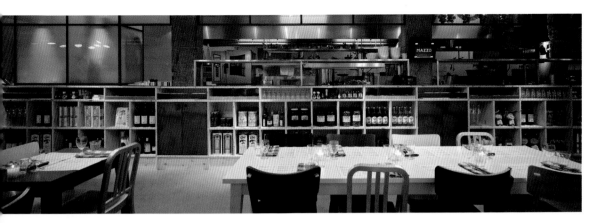

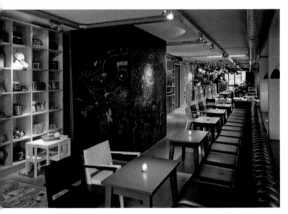

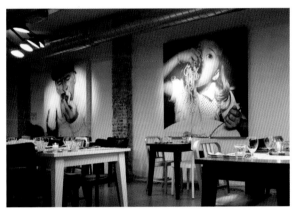

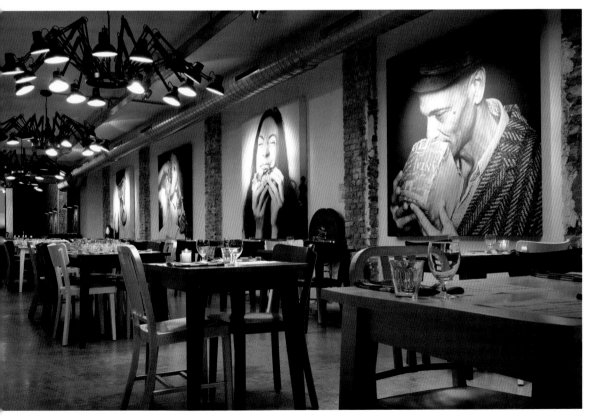

...e part facing Bloemstraat narrows until it reaches a small back room where children can play during the meal under the supervision of their parents.

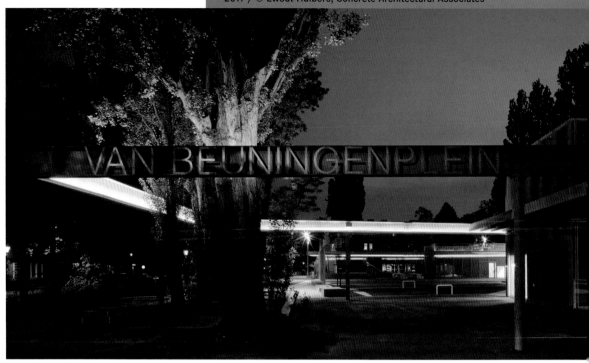

In this square, the architects were asked to create various sports facilities. Concrete is the main material used in the complex which is divided into different areas for specific functions and age groups.

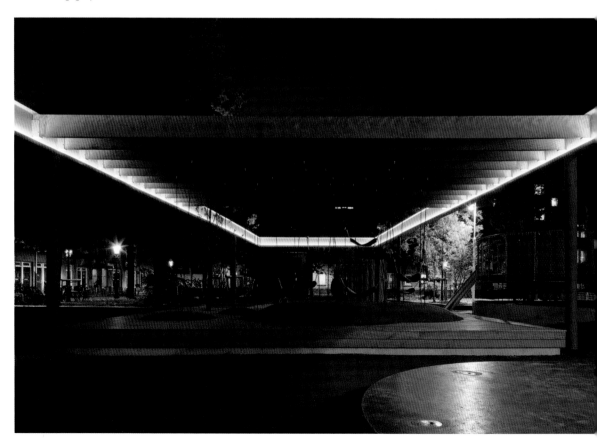

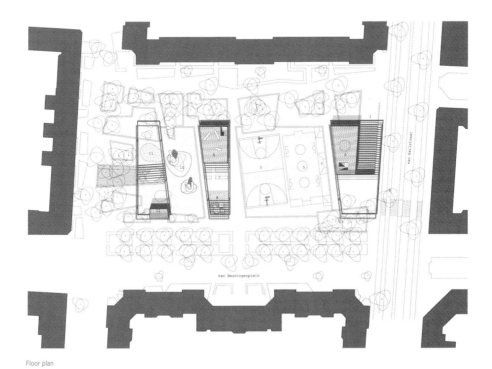

Floor plan

The construction of a two-story parking lot was the reason to redesign the entire square. Wooden beams at right angles form the entrance pergola.

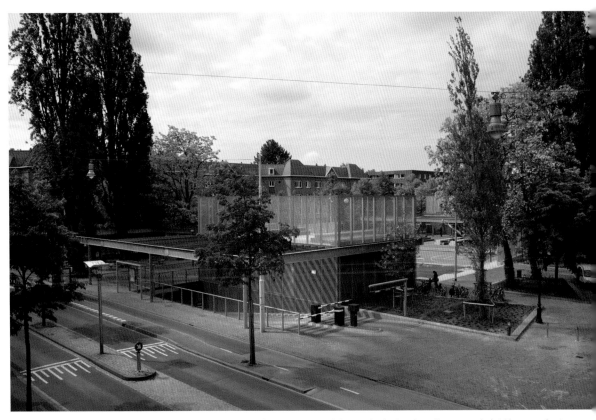

The fitness center houses an entrance built with a steel structure, a pavilion for teenagers, several playgrounds, skateboard practice areas, a picnic table area, and a stage.

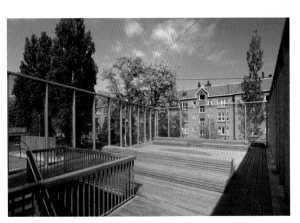

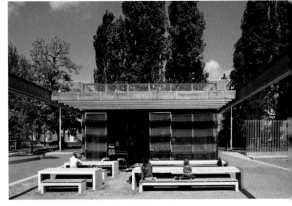

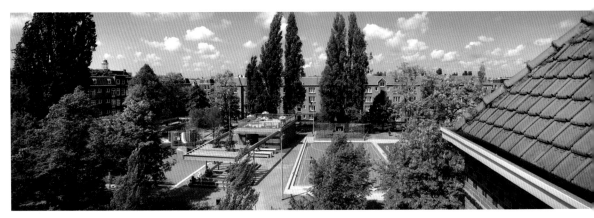

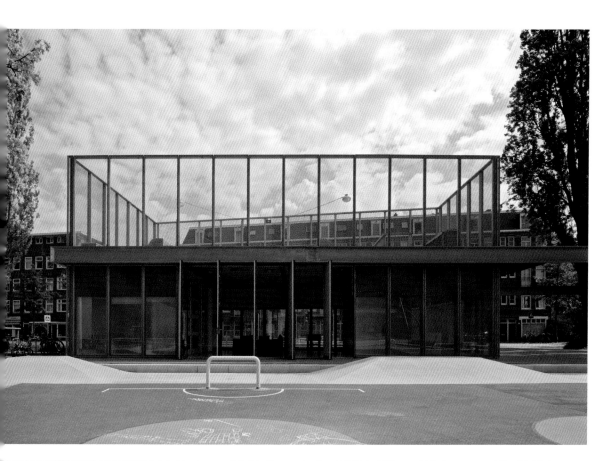

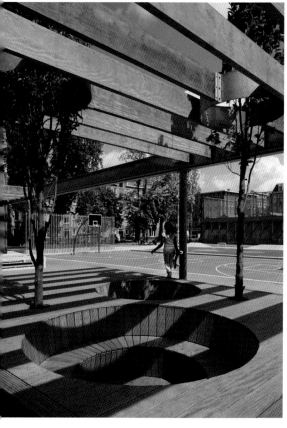

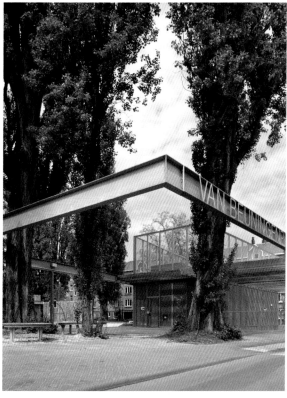

The most commonly used materials in the sports complex are the red wood, asphalt painted blue, playground rubber matting, glass, steel mesh, and concrete.

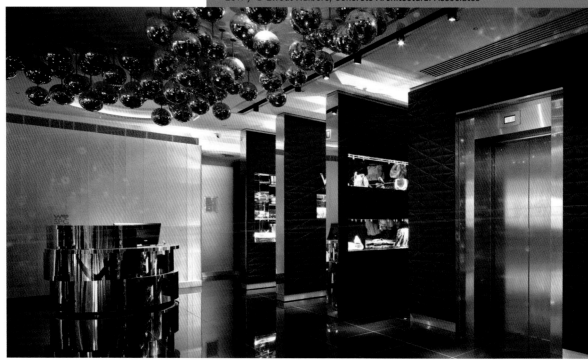

This hotel has invented a new kind of luxury hotels by mixing a stardard room design with typical London cultural and entertainment experiences. It is a mixture between private and social, work and play, formality and partying, day and night.

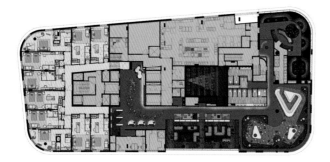

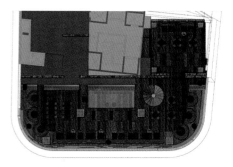

Plans and section

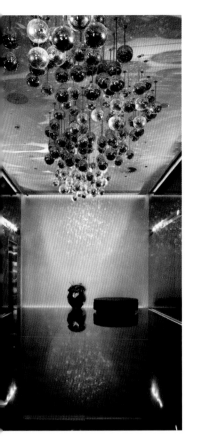

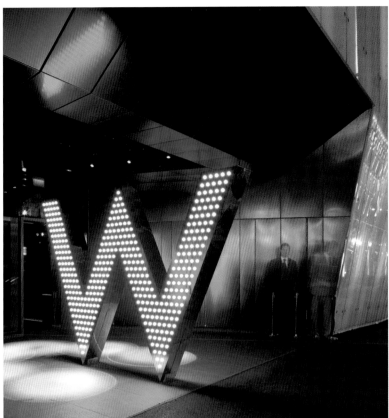

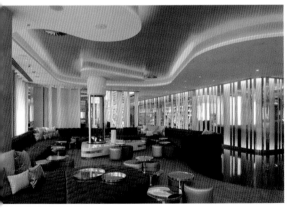

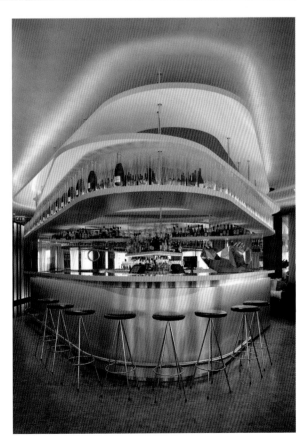

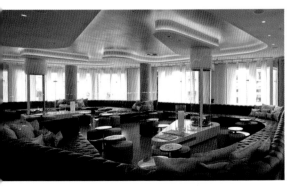

he golden ceiling and oak floor reflects a luxurious and sinuous landscape. The two-tory bar unit that emphasizes the careful selection of drinks is a prominent feature.

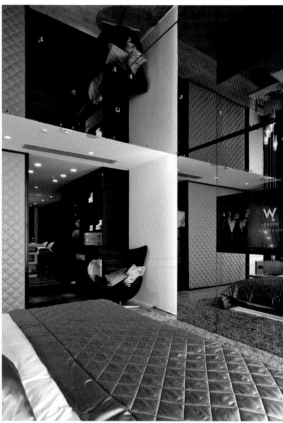

In the lounge bar, even the smallest detail has been taken care of. The ochers, blacks, and reds that dominate the design have also been used for this space. Varied furniture and cylindrical lamps hanging from the ceiling are characteristic elements.

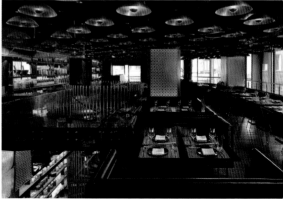

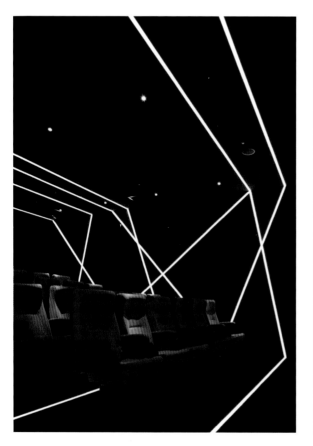

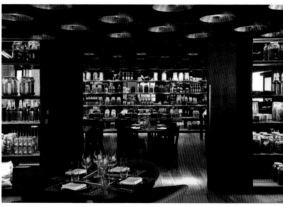

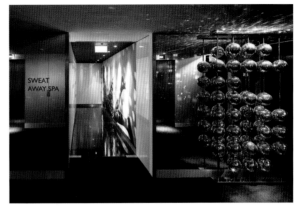

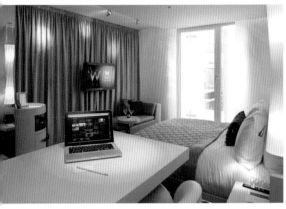

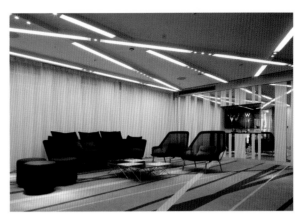

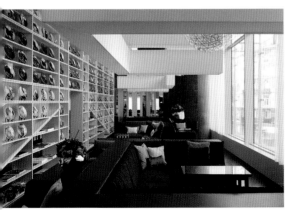

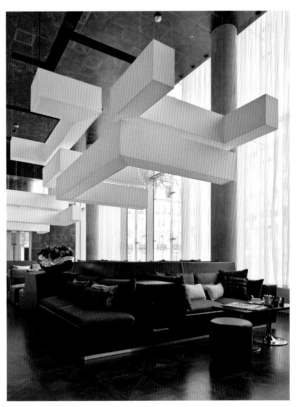

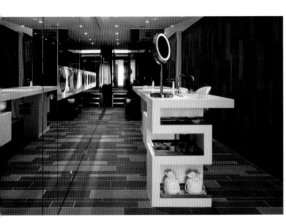

The hotel has its own screening room as it is located in London's famous West End district. It is characterized by red seats, black carpet, and dramatic lighting.

Coop Himmelb(l)au

Wolf D. Prix

Spengergrasse 37
1050 Vienna
Austria
Tel.: +43 (0) 1 546 60-0
www.coop-himmelblau.at

Founded in Vienna by Wolf D. Prix, Helmut Swiczinsky, and Michael Holzer in 1968, Coop Himmelb(l)au is active in the areas of architecture, urban planning, design, and art. In 1988, a second studio in Los Angeles was opened, and subsequently other offices in Frankfurt, Paris, and Hong Kong were added. Its best known projects are the renovation of the roof of Falkestraße in Austria, the master plan for the city Melun-Sénart in France, the East pavilion of the Groninger Museum in The Netherlands, the UFA Cinema Center, the BMW Welt, and the Pavilion 21 MINI Space Opera in Germany, and, in the United States, the Akron Art Museum and the Ramon C. Cortines School Of Visual and Performing Arts in Los Angeles. The studio has received numerous inter-national awards and its work is featured regularly in exhibitions throughout the world.

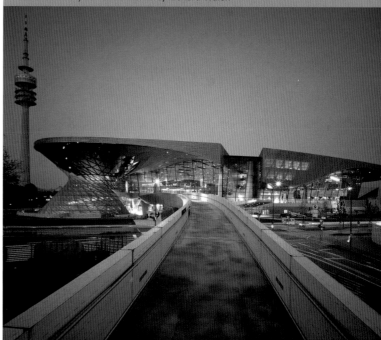

The BMW Group building is a car delivery center and is located very close to the company's headquarters and museum. One of the main design ideas was to expand the pre-existing BMW Tower and the adjacent museum to create a unique assembly space.

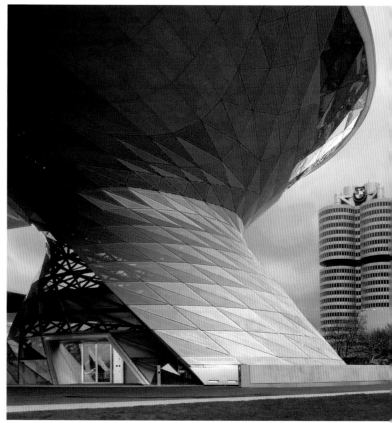

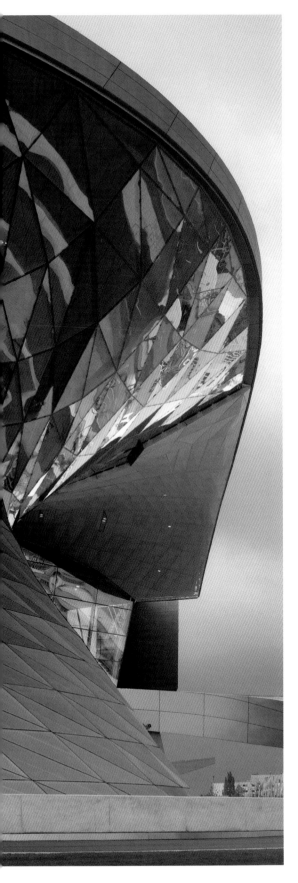

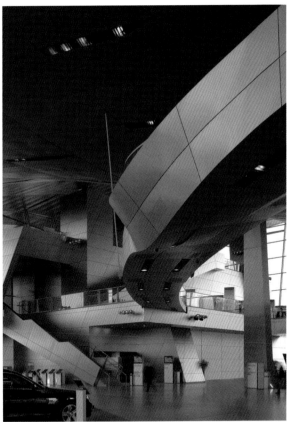

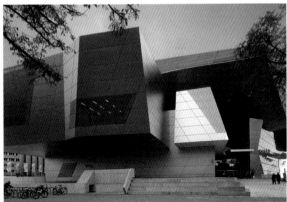

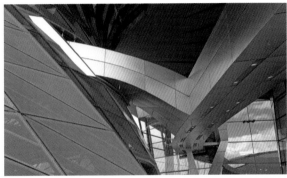

The design consists of a large transparent hall with a sculptural roof and a double cone that responds to the pre-existing shape of the office building.

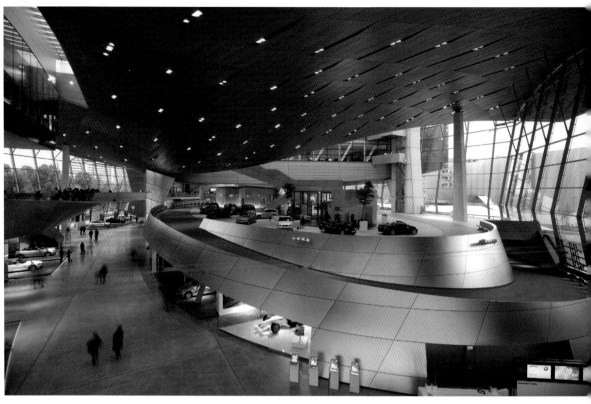

The entire building is designed on principles of sustainability in order to make maximum use of natural resources. Consequently, it can operate with very low power consumption

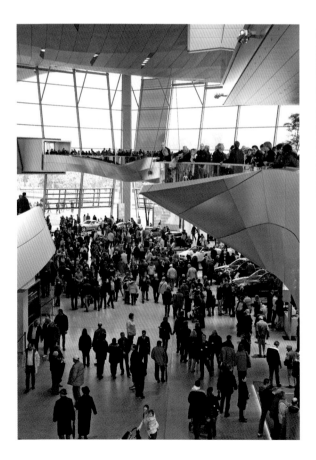

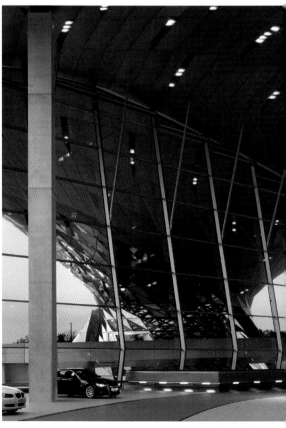

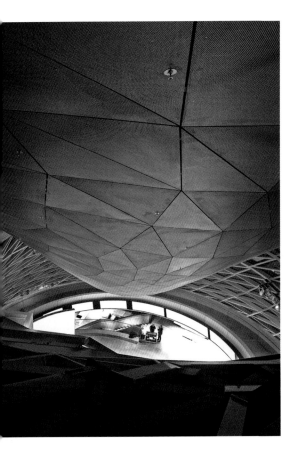
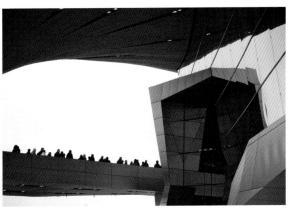
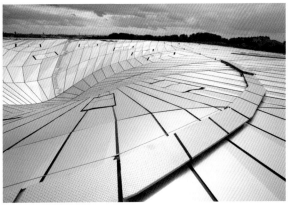
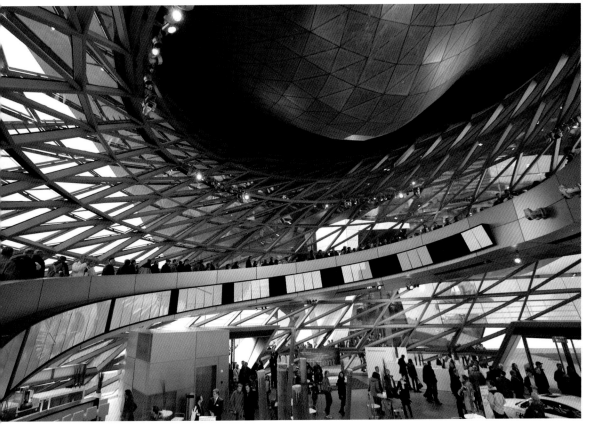

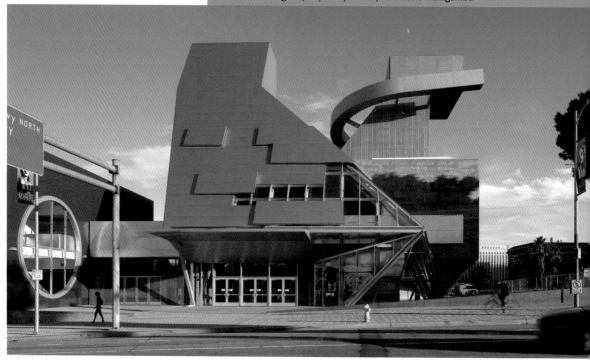

Three sculptural buildings have been placed as chess pieces to accommodate the campus of an arts high school in Los Angeles, which includes a professional theater in addition to a broad spectrum of arts facilities.

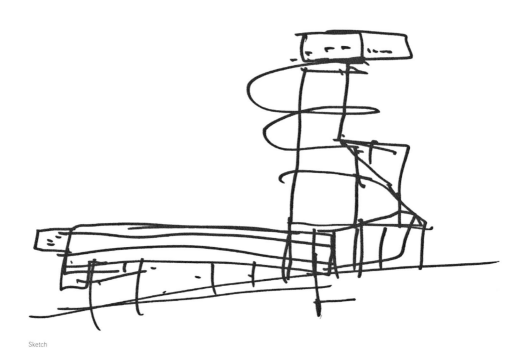

Sketch

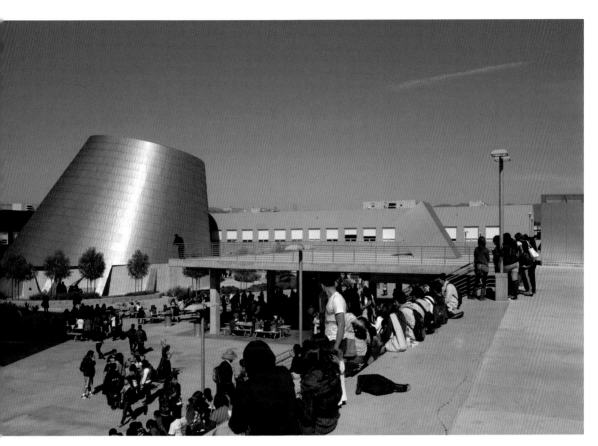

The theater complex has a tower that visually connects with other surrounding buildings and a lobby that serves as a public entrance connecting the cultural facilities at the other side of the road.

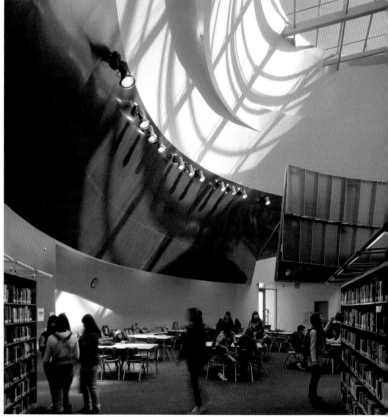

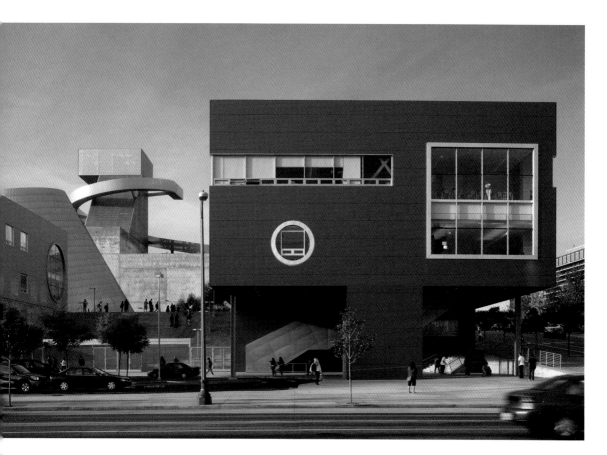

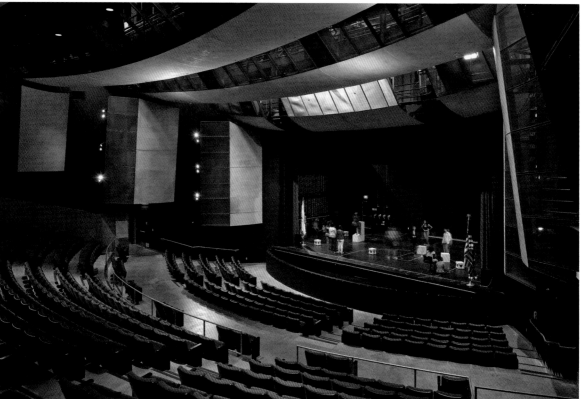

The theater is used for educational purposes and is open to the public and other institutions. It is fully equipped with a stage, orchestra pit, and stage machinery.

Pavilion 21 MINI Opera Space
Munich, Germany / 2010 / © Duccio Malagamba

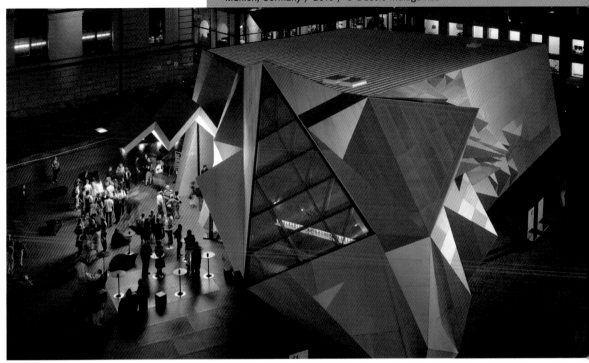

This demountable, mobile pavilion has a capacity for 300 seated spectators or 700 standing, and is home to the experimental performances of the Bavarian State Opera. Despite its seasonal nature, the building has the acoustics of a concert hall thanks to its pyramidal shape and the materials used.

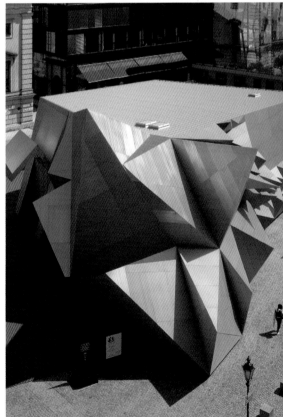

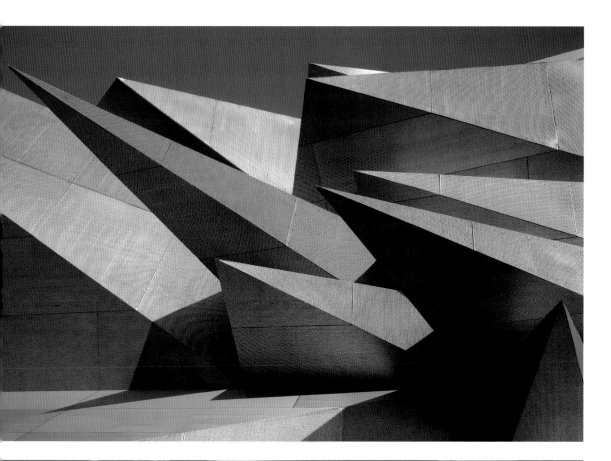

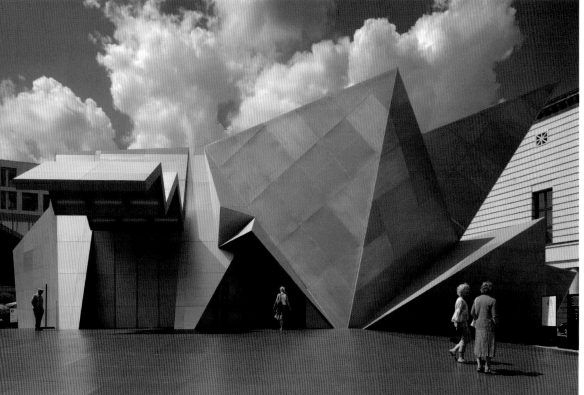

The walls and ceilings are covered with perforated sandwich panels that absorb and soften the sound.

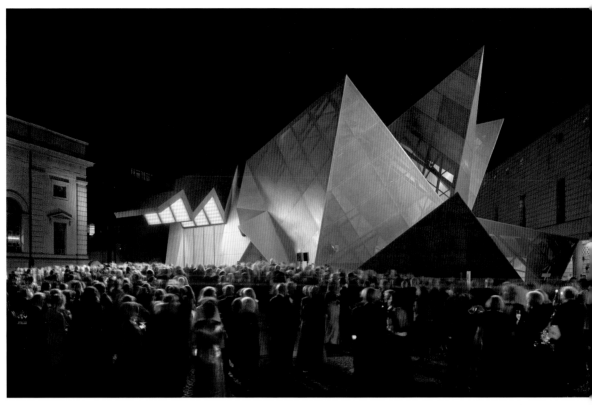

The tips that emerge from the building as spikes are the result of a 3D model created by computer by combining sequences of the song *Purple Haze* by Jimi Hendrix and a passage from Mozart's *Don Giovanni*.

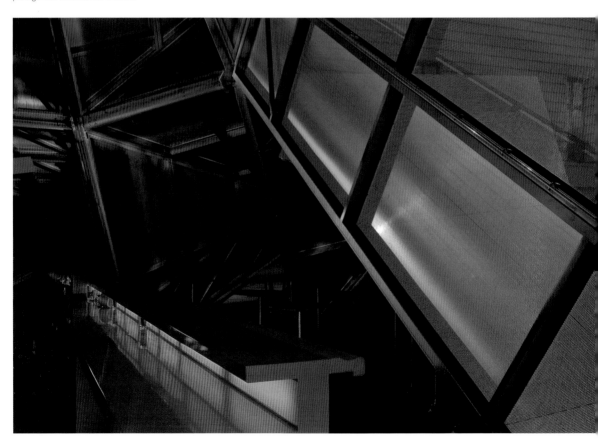

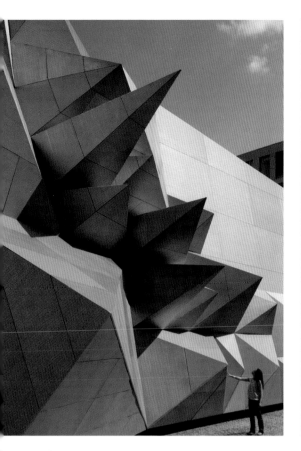

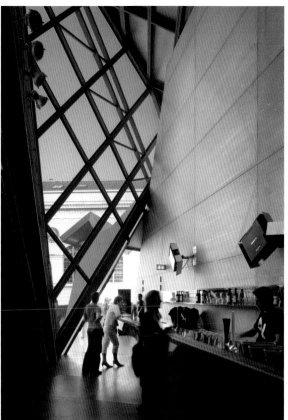

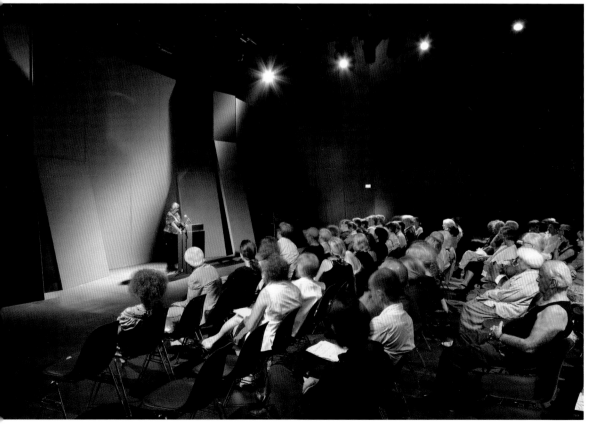

CCS Architecture

Cass Calder Smith

180 Varick Street #902
10014 New York
New York
USA
Tel.: + 1 212 274 1121
Fax: + 1 212 274 1121
www.ccs-architecture.com

Cass Calder Smith established the architectural studio that bears his name in 1990, and in 2006 Barbara Vickroy joined. Born in 1961, Smith obtained his degree in architecture from the University of Berkeley. His early years were influenced by the intellectuals of New York's historic Greenwich Village and the rural artisans in California. Smith is recognized internationally for his architecture, interior decoration, and design. His work is firmly grounded in modernism and inspired by the great architects of history and epic filmmakers of the twentieth century. Since its inception, CCS has designed a wide range of public and private buildings. The firm has gained international recognition for the architectural and commercial success of its restaurant designs.

25 Lusk
San Francisco, CA, USA / 2010 / © Paul Dyer

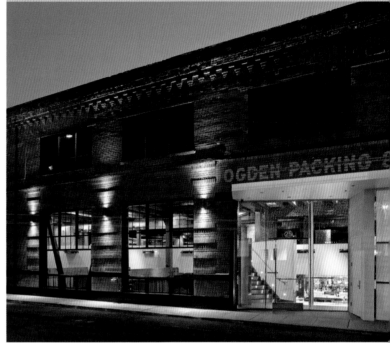

An old smoking chamber from 1917, located in the Lusk alley south of San Francisco, has been restored and is now a restaurant. Seating for 265 diners and the American-style bar are now a new, unexpected gem in the urban fabric of this North American city.

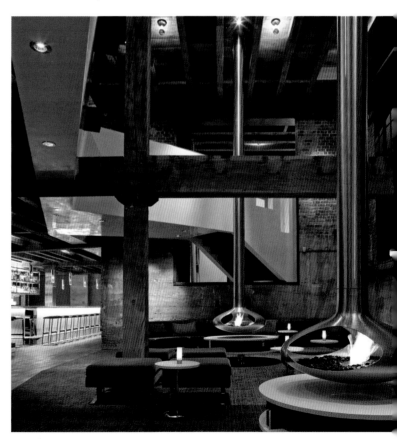

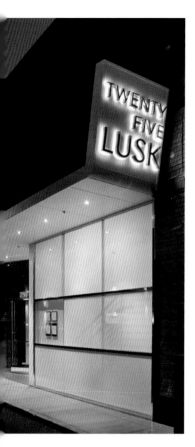

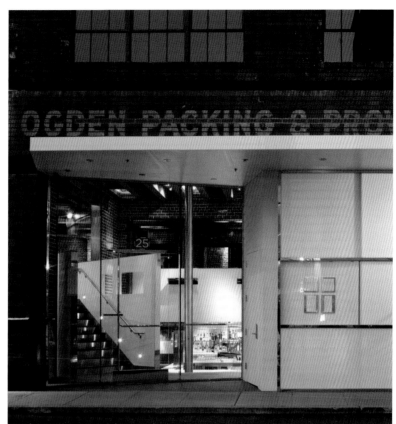

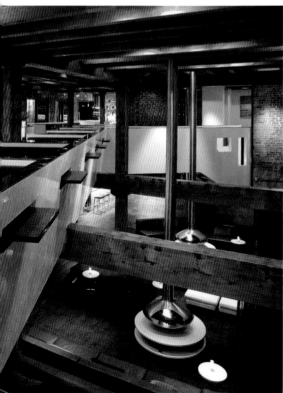

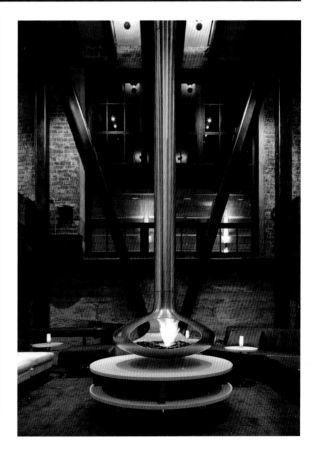

The interior design emphasizes the use of various materials used in a harmonious way: stainless steel, glass, plaster, leather, slate, brick, concrete, and wood.

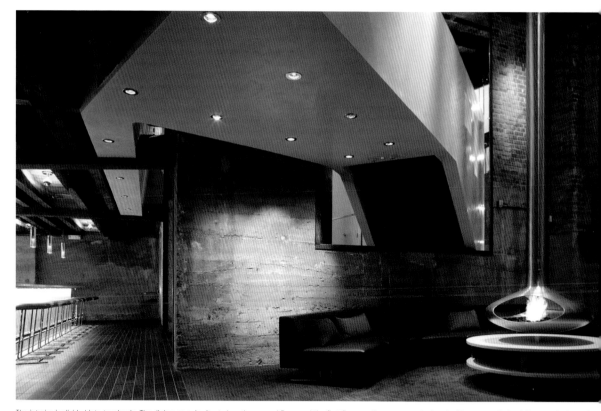

The interior is divided into two levels. The dining room is situated on the second floor, and the first floor seating areas are designed with a suspended stainless steel sphere that serves as a fireplace.

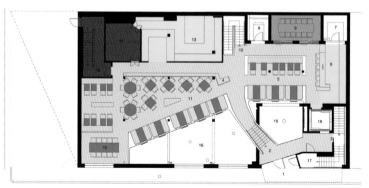

Upper level

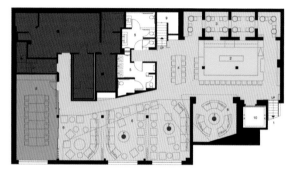

Lower level

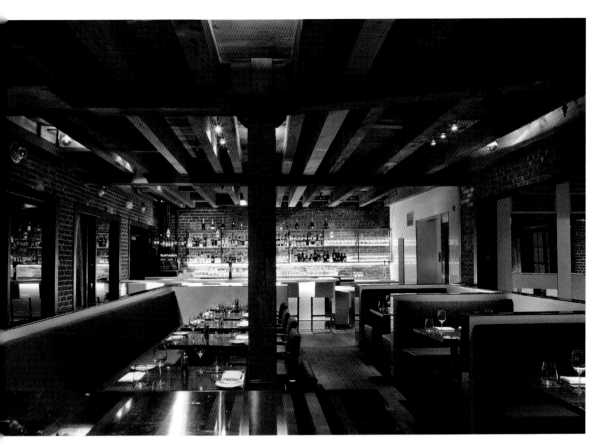

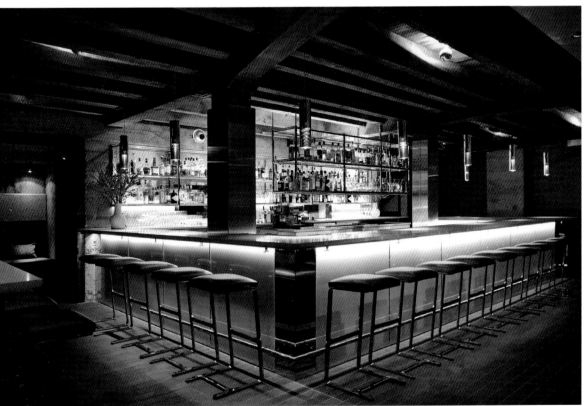

The architecture provides a striking contrast between the dramatic space dominated by the vertical accesses and the single height areas.

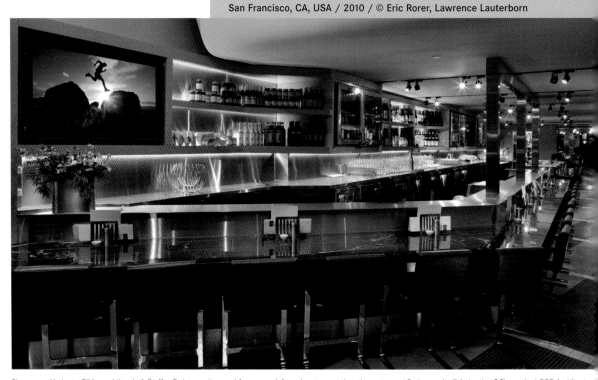

The owner, Umberto Gibin, and the chef, Staffan Terje, saw the need for a more informal restaurant than the restaurant Perbacco—its "big brother." They asked CCS Architecture to create a space that functions as a trattoria during the day and a wine bar at night.

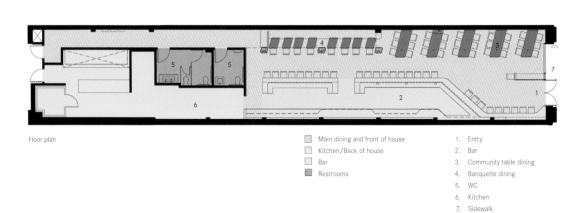

Floor plan

Main dining and front of house
Kitchen/Back of house
Bar
Restrooms

1. Entry
2. Bar
3. Community table dining
4. Banquette dining
5. WC
6. Kitchen
7. Sidewalk

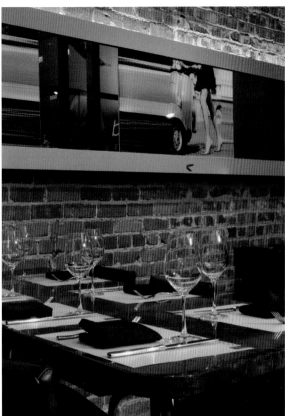

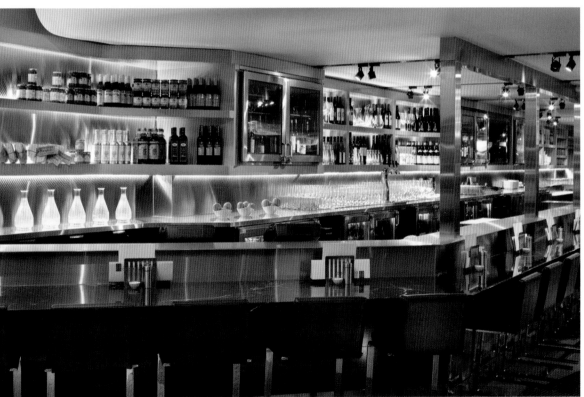

arbacco was built in the 1912 Hind building and has seating for sixty-six, distributed throughout a long hall. Inspired by the traditional bars in Milan and Rome, the space is
legant, gracious, and welcoming.

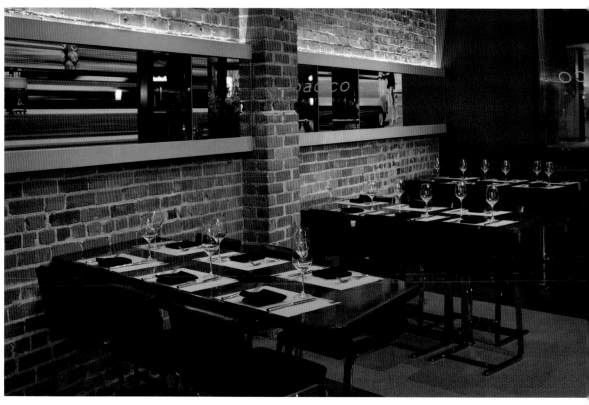

Vibrant yellow is combined with duller colors to complement the exposed brick wall. The black stone and stainless steel Marquina creates an industrial environment, combined with the chrome details of the tables and chairs reminiscent of the dashboard of luxury cars.

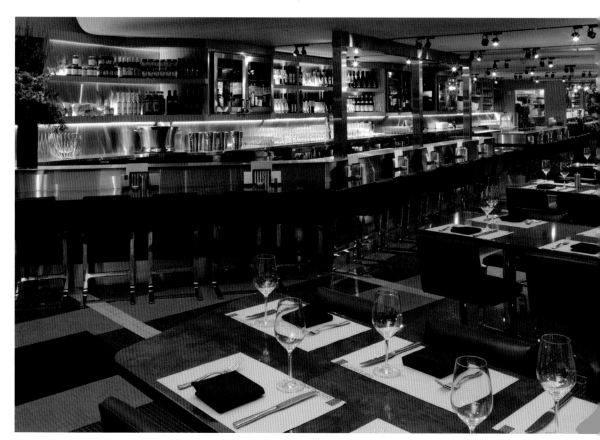

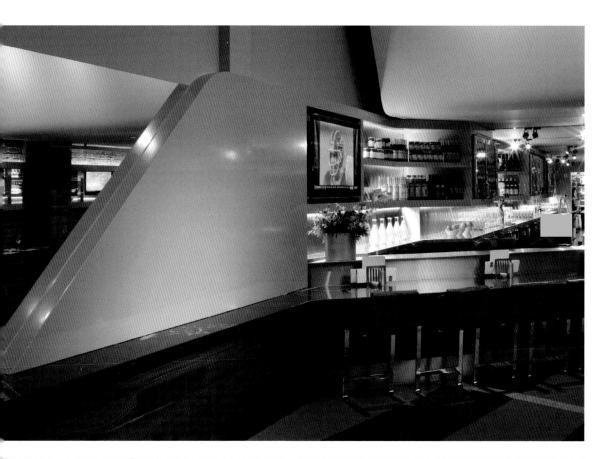

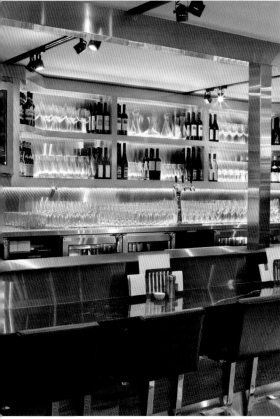

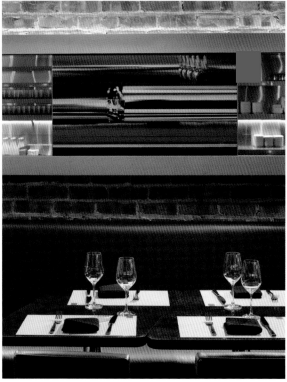

The forms, details, colors, and art celebrate and pay homage to Italian culture, cinema, and design. Blurred images of the Vespa, wine barrels, and Italian movie stars are decorative elements.

Sandton Sun
Johannesburg, South Africa / 2010 / © Alfred Lor

CCS Architecture was in charge of designing a restaurant in the famous Sandton Sun hotel. The project reinvents the existing dining spaces on the sixth floor, where the hotel, which consists of 334 rooms, meets the business district.

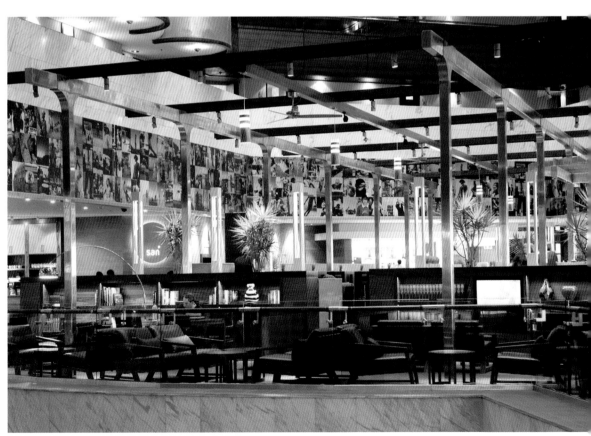

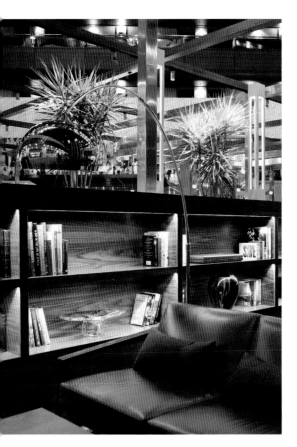

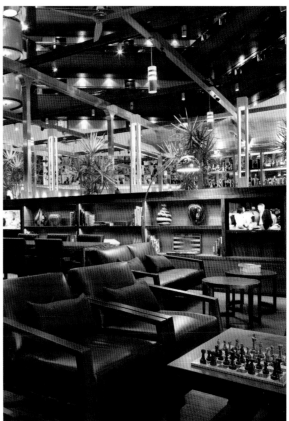

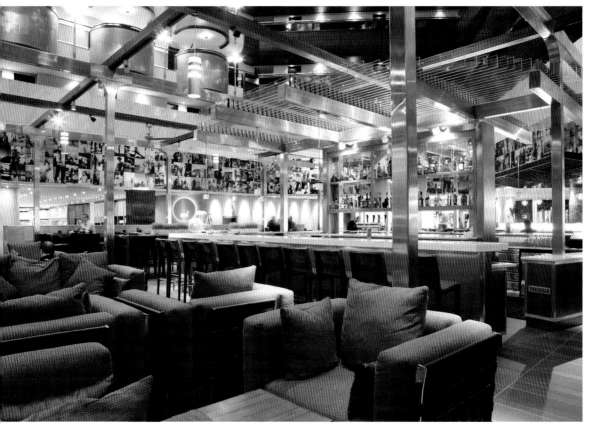

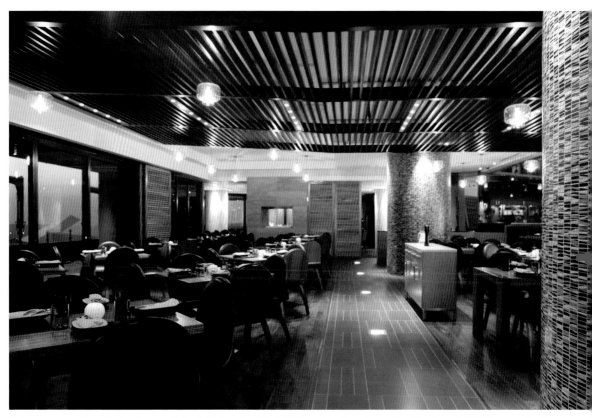

The bar serves as an informal business lounge and is located in the atrium of the hotel. The restaurant complex consists of San Bar and VIN MMX, a gourmet restaurant.

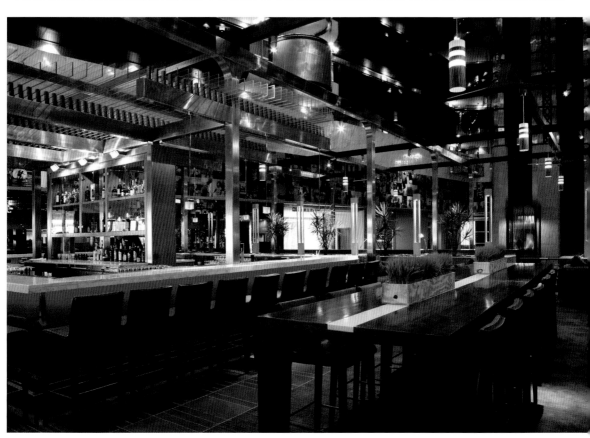

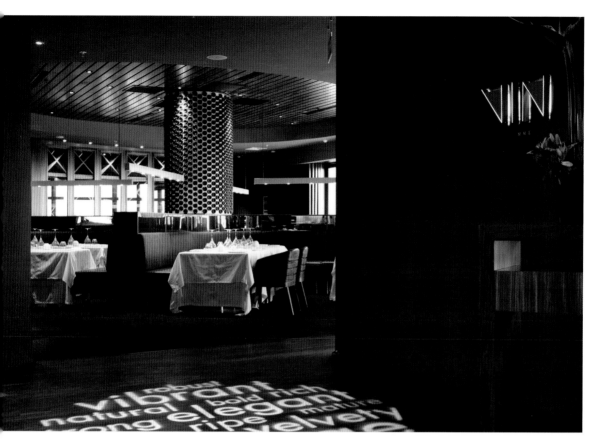

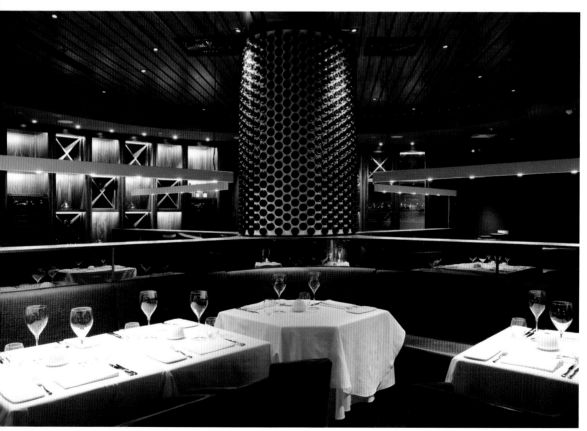

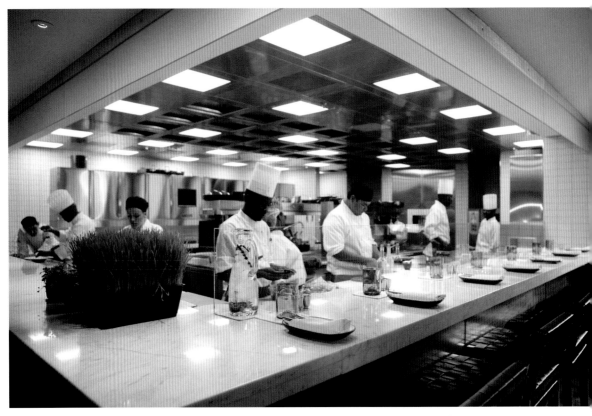

The design project, covering 15,000 m² (161,458 ft²), contains the colors of South Africa, in addition to natural materials and natural light.

1. Escalators
2. Elevatons
3. Retail shops
4. San Market
5. Business lounge
6. San Bar
7. San Restaurant
8. San Flex Dining
9. San Private Dining
10. San Exhibition kitchen
11. Vin restaurant
12. San View terrace
13. Vin terrace

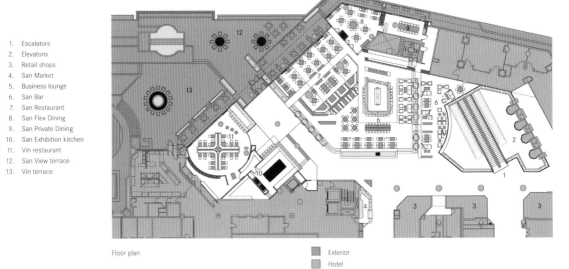

Floor plan

■ Exterior
■ Hotel

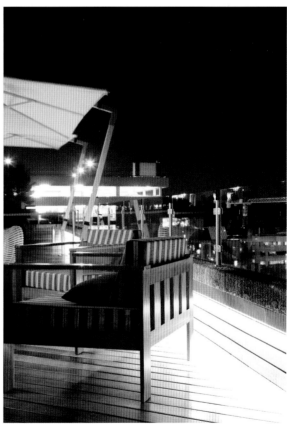

The Plant: Café Organic
San Francisco, CA, USA / 2009 / © Kelly Barri, Kris Tamburello, Melissa Werner

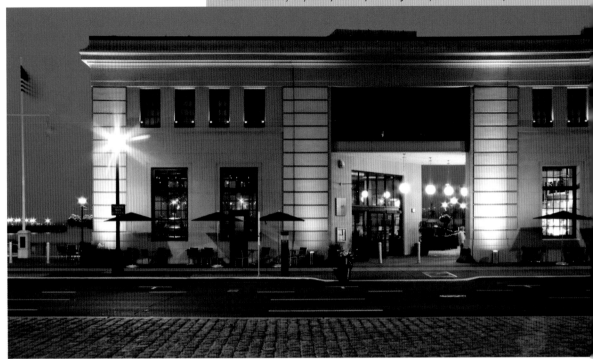

The establishment occupies two historic buildings overlooking the sea at Pier E, falling between what was once a rail crossing. The architecture studio has been modified to create the 112 restaurant spaces, a separate cafeteria, and a bar service.

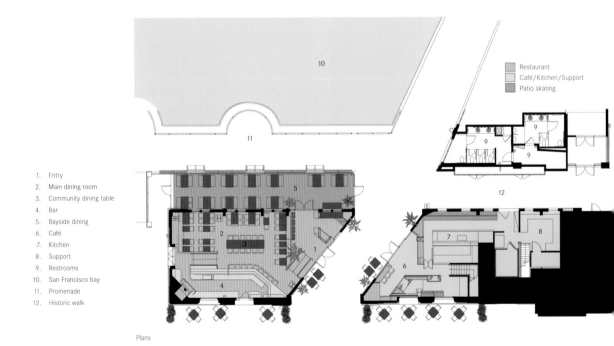

1. Entry
2. Main dining room
3. Community dining table
4. Bar
5. Bayside dining
6. Café
7. Kitchen
8. Support
9. Restrooms
10. San Francisco bay
11. Promenade
12. Historic walk

Restaurant
Café/Kitchen/Support
Patio skating

Plans

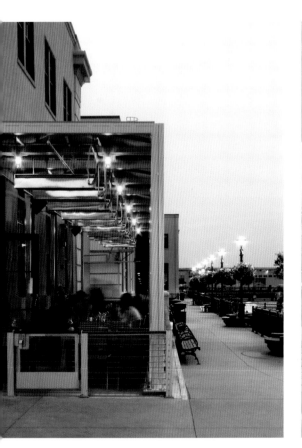
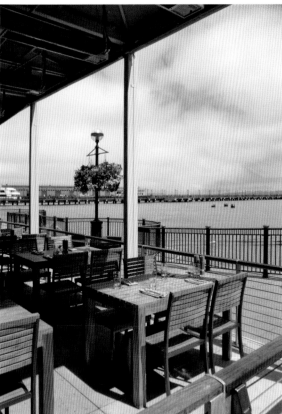
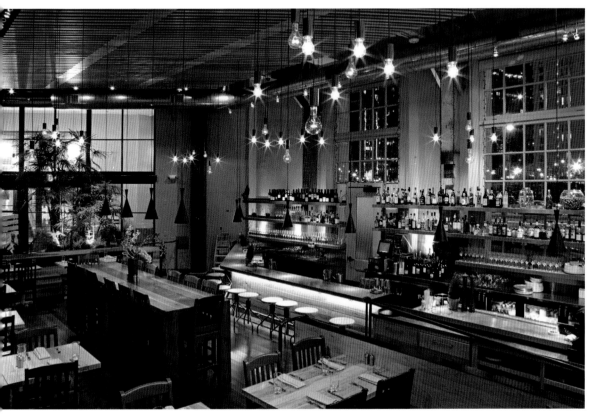

he restaurant is one of the few services in the city of San Francisco with a solar photovoltaic system roof, instead of electric power.

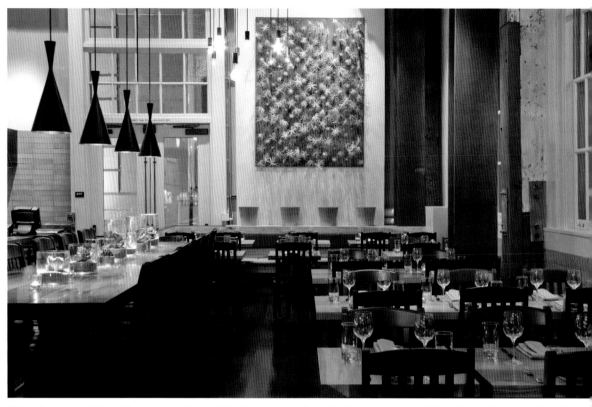

CCS Architecture uses bright and delicate interiors within the existing pier warehouses, using reclaimed wood, recycled content tiles, and an eclectic mixture of zinc, cold rolled steel, and stainless steel finishes.

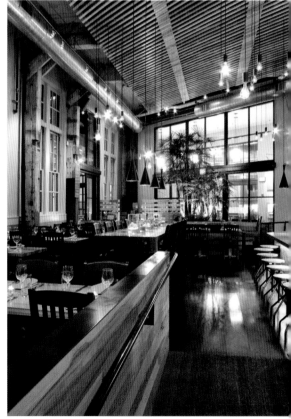

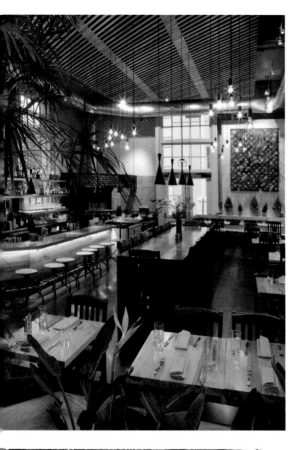

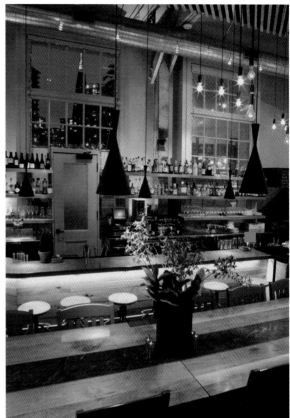

Corneille Uedingslohmann Architekten

Yves Corneille, Peter Uedingslohmann

Konrad-Adenauer-Ufer 83
50668 Cologne
Germany
Tel.: + 49 (0) 221 355 537 - 0
www.cue-architekten.de

Corneille Uedingslohmann Architekten specializes in architecture and retail design solutions. It has produced several successful award-winning projects, which have gained coverage in the national and international press. The studio mainly designs commercial spaces for the fashion and lifestyle sectors. In this area it devises the complete corporate design from project conception to merchandising. Thanks to its constant quest for renewal in architecture and construction, Corneille Uedingslohmann Architects has a presence in the latest commercial development plans for which it has become a consultancy, specializing in location.

Esprit Frankfurt
Frankfurt, Germany / 2010 / © Alexander Rümmele

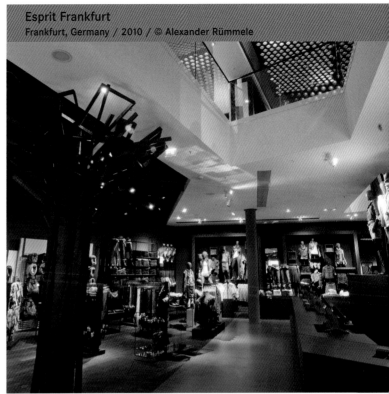

The store of the fashion brand Esprit is located in the well-known Zeil shopping center in Frankfurt. It occupies an area of 3,600 m² (38,750 ft²) over five floors. The storefront contains some 14,000 LED lights.

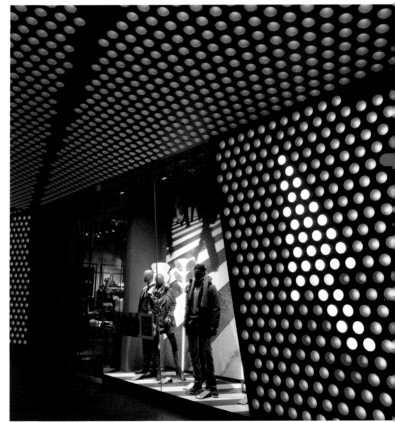

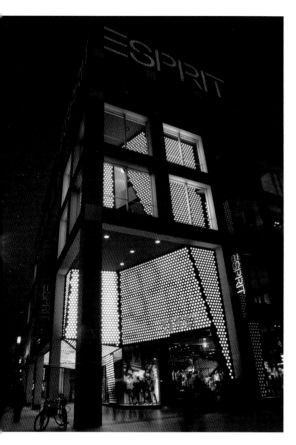

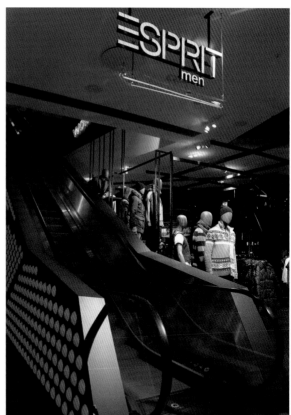

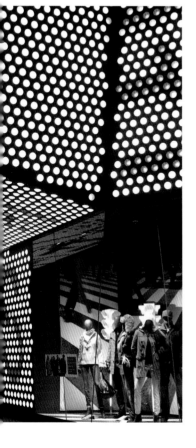

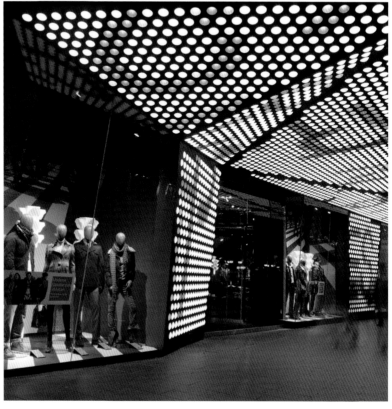

All the floors are interconnected with very broad landings to help shoppers gain their bearings vertically.

The store offers all the company's collections from clothing for women, men, and children, as well as accessories. Shoppers can go directly to the men's fashion department via a second entrance from the shopping center.

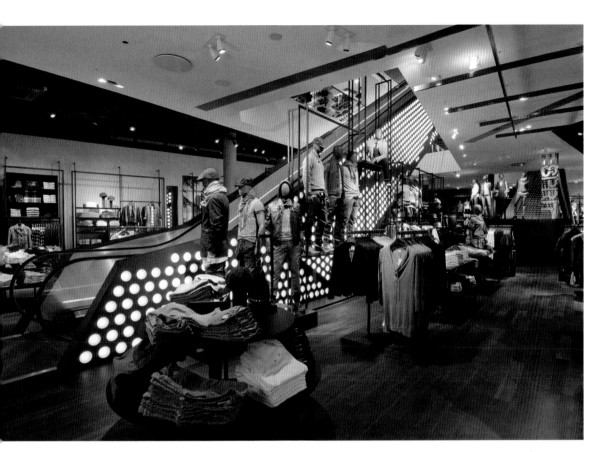

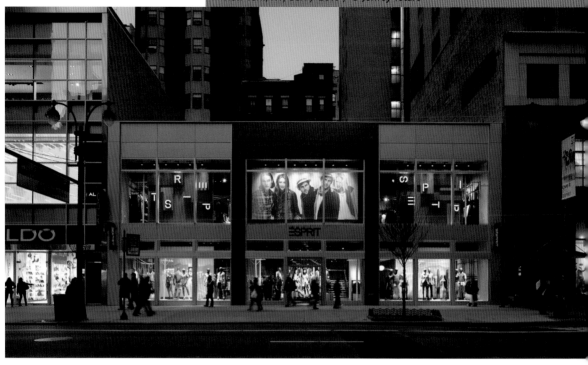

This store is located very near the Empire State Building in the center of Manhattan. Its 1,200m² (13,000ft²) are spread over three floors. With this design, the brand introduced a new concept of stores into the United States.

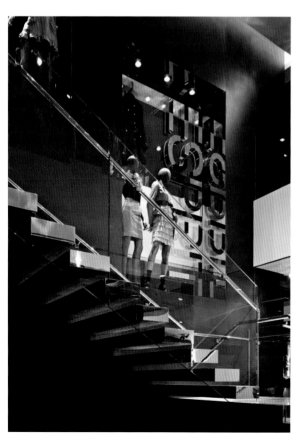

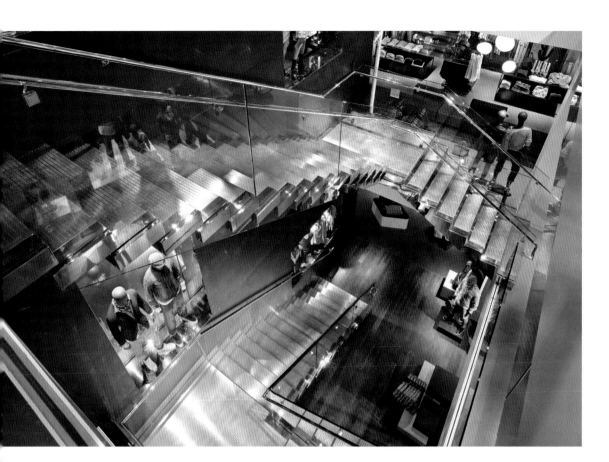

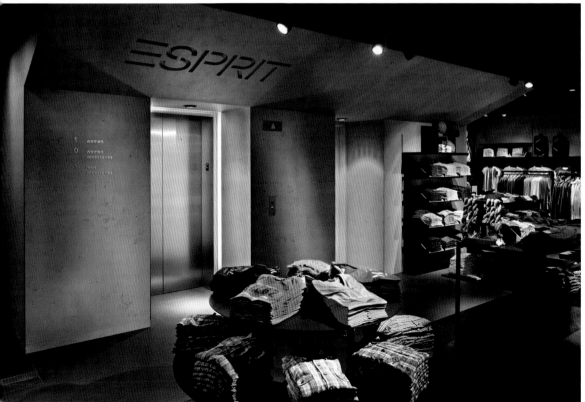

The central feature in the store is a staircase with a clear glass banister and steel stairs that create the illusion of floating, connecting the different levels.

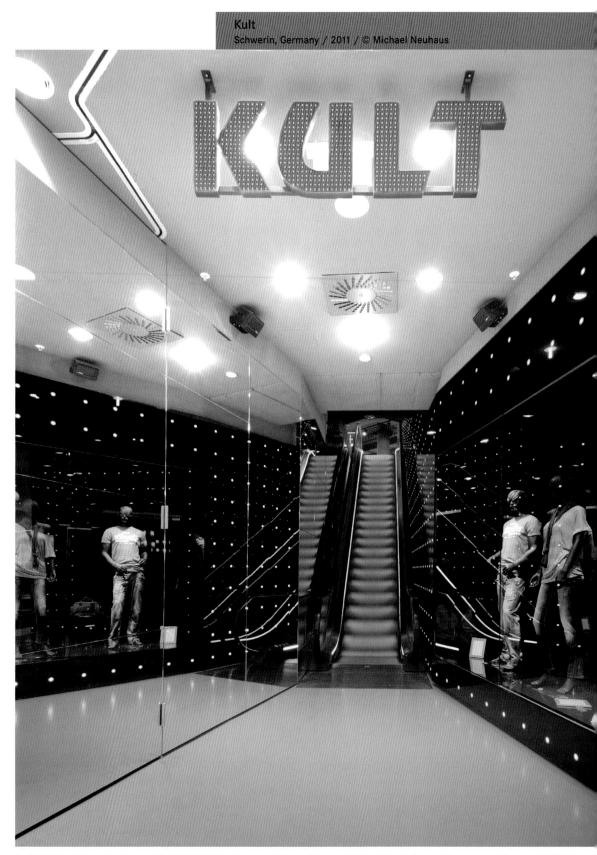

The Kult store has the same design concept in all of its thrity-five stores across Germany. They are all distributed on two floors which are accessed via a tunnel of LED lights.

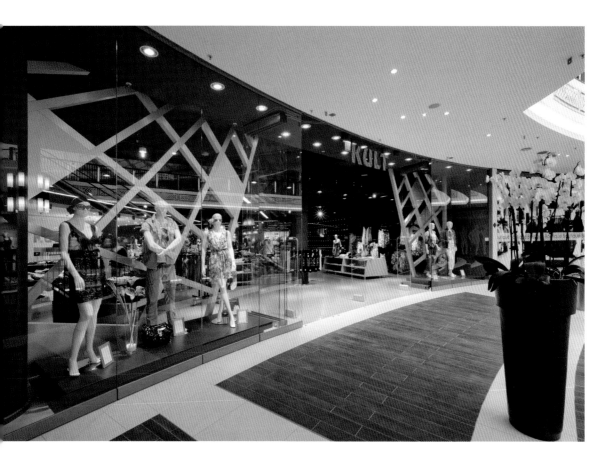

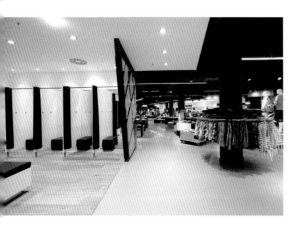

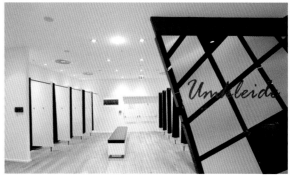

The store sells fashion products from different brands which are presented individually while respecting the universal aesthetics of the whole space.

Dalziel and Pow

David Dalziel

5-8 Hardwick Street
EC1R 4RG London
United Kingdom
Tel.: + 44 0 20 7837 7117
www.dalziel-pow.com

David Dalziel co-founded the London-based design consultancy in 1983. As creative director, David specializes in a wide range of designs, from environments to communications. He closely monitors the correct interpretation of what the client demands, from conceptualization to reality. Over the years, the Dalziel and Pow studio has built an excellent reputation in design with the combination of creativity and performance. The extensive knowledge base to develop the projects contributes to its consistent and successful outcome for the more adventurous customers. Mainly, its work is developed in the UK, but it is expanding internationally.

Aura
Riyadh, Saudi Arabia / 2011 / © Dalziel and Pow

The architectural firm was commissioned to create an identity for the brand and an ambience for the new store; in short, a new style for the Arabic company. They created a new logo in English and Arabic, in addition to communications within the store.

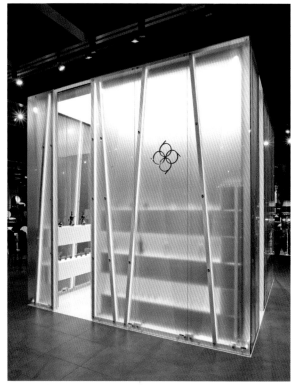

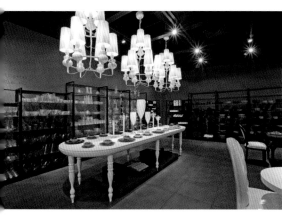

The icon represents the traditional products of the Middle East with a contemporary twist. The store environment is dark with lighting that emphasizes the product as if it were a jewel.

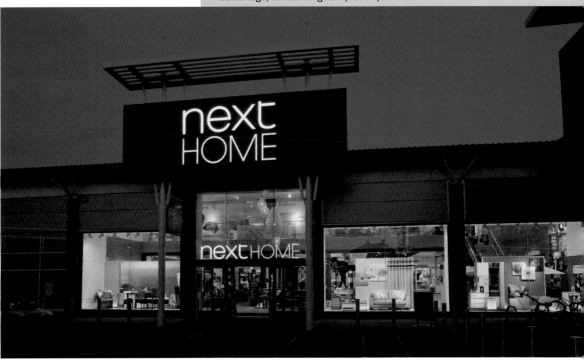

This is a sample of the new Next Home establishments. The recent opening introduces a number of new treatments to develop a more contemporary style through architecture For example, the window signage has changed from black signs to dark gray letters in 3D.

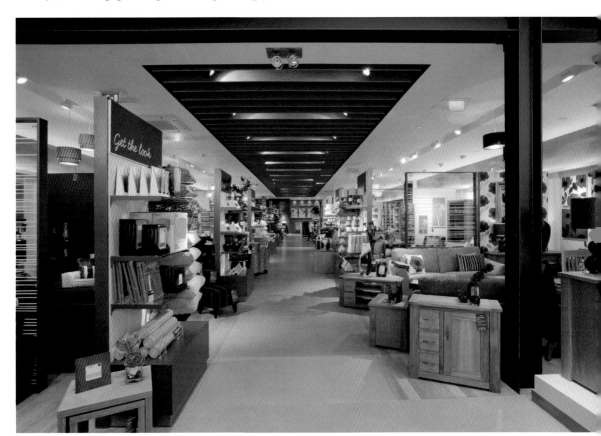

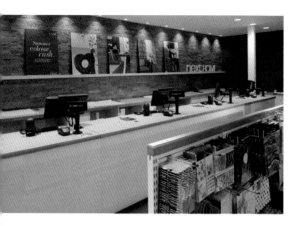

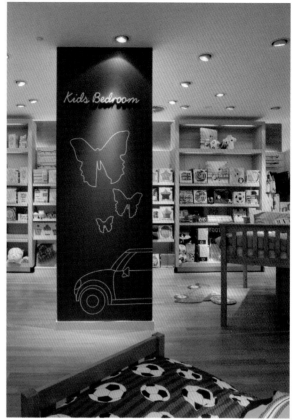

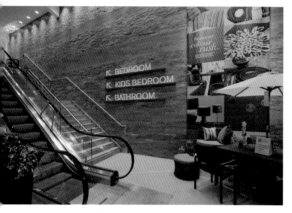

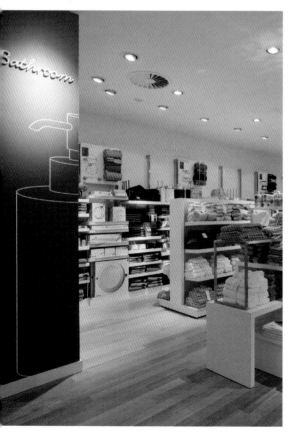

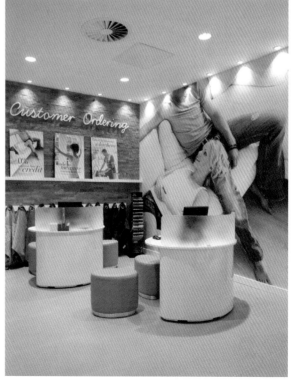

The use of natural materials has become an integral part of the plan. The quality of finishes and materials provide a simple language that is easily understood by the customer.

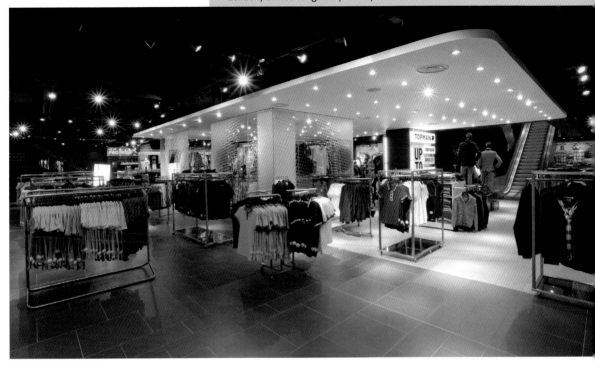

With the opening of the Topman store in Oxford Circus, the establishment has become a model for future openings in different countries. The new concept is based on the elements already designed for the Topshop store in New York.

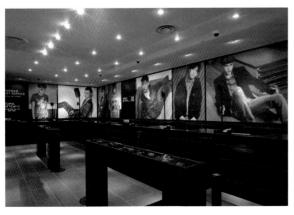

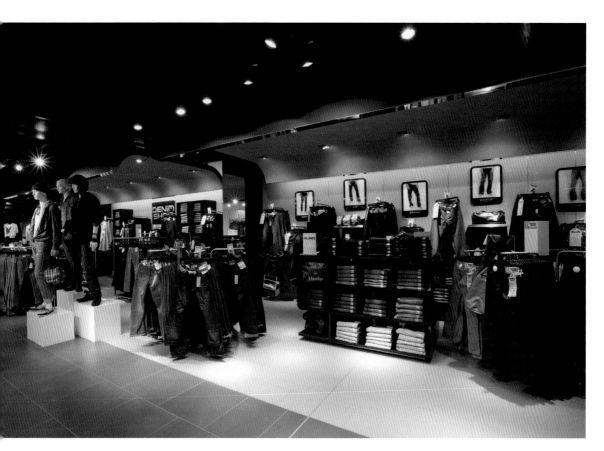

The area is predominantly black and white, and is divided into two levels: the first floor is intended for casual wear and the top floor for the brand's basics.

Dan Pearlman

© Marcus Fischer / Dan Pearlman

Marcus Fischer

Kiefholzstrasse 1-2
12435 Berlin
Germany
Tel.: + 49 0 30 53 000 560
Fax: + 49 0 30 53 000 588
www.danpearlman.com

The studio is an interdisciplinary creative agency in the areas of branding, entertainment, and development of strategies. It is distinguished by its comprehensive approach in twelve different fields: brand experiences, research, innovation, internal branding, trade shows, events, commercial space design, visual communication, public relations, hotel and catering trade, entertainment venues, and zoos. Its founder, Marcus Fischer, born in 1971, is dedicated to attracting potential clients at national and international fairs and stands. He graduated in 1999 at the HDK Berlin, where he founded the agency along with three partners. His customer portfolio includes companies like BMW, MINI, Atlkon, Roca, Museum of Arts and Crafts in Hamburg, Lufthansa, and MTV.

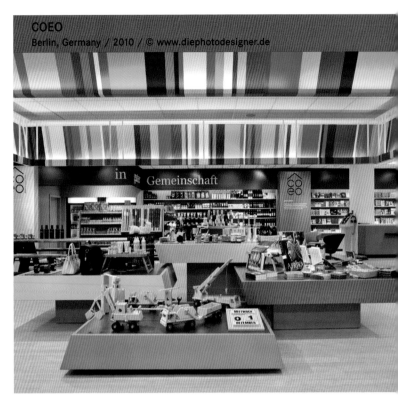

The House Of Good Deeds is a sustainable and socially responsible store concept designed for people who want to live well and do good. This new pilot project brings together the products of four different areas into one place: fair trade, workshops for disabled people, a library, and a cafeteria.

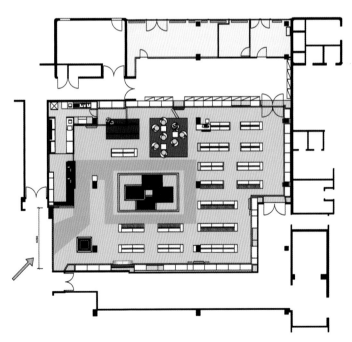

Floor plan

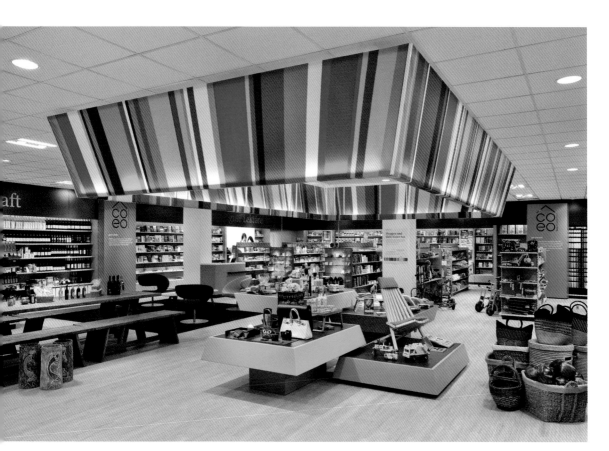

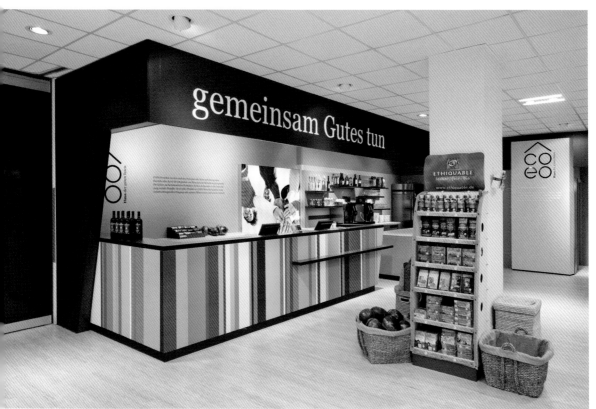

Far beyond the simple act of consuming, this store is trying to communicate the joy of doing something meaningful, a gesture for others that opens new horizons.

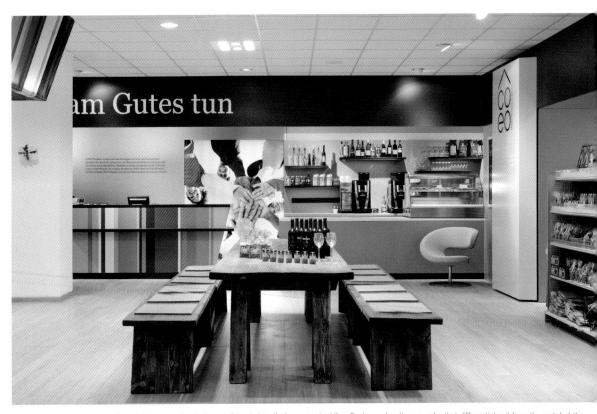

Despite the spatial division into four distinct areas, the design was intended to display a standard line. Each area has its own color that differentiates it from the rest, but the modern design and architectural concept unites them in one space.

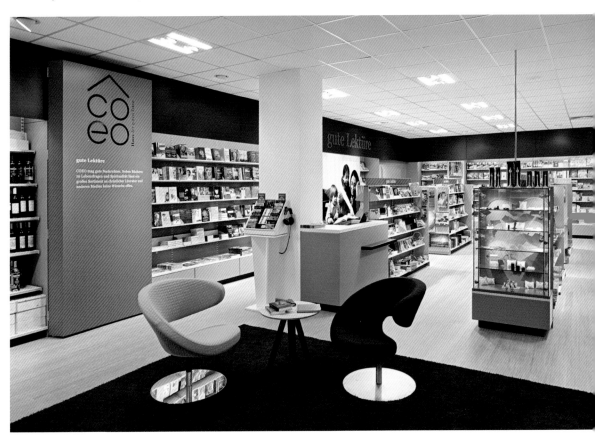

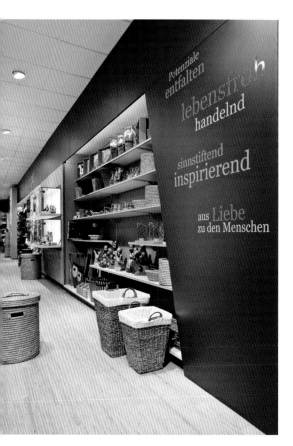

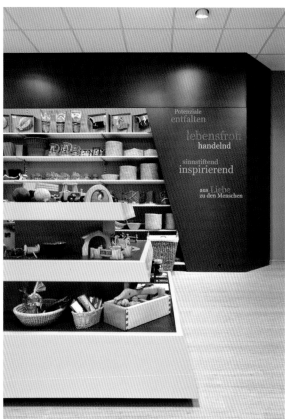

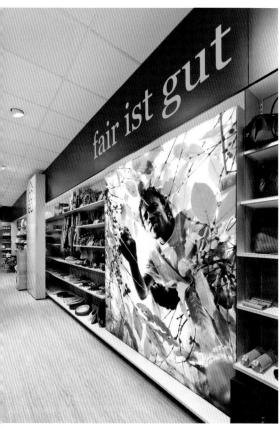

Dan Pearlman also developed the brand, logo, corporate design, and office space.

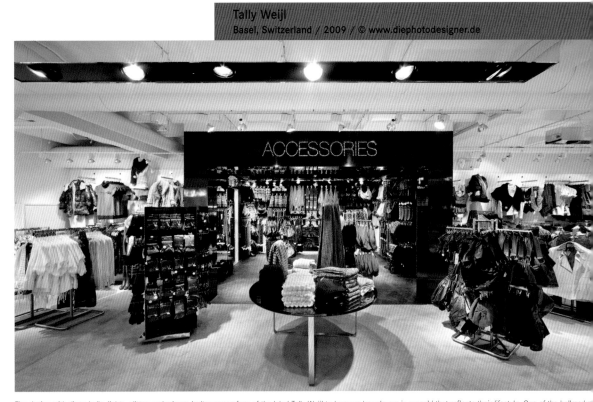

The design with disco balls, lights, glitter, and mirrors invites young fans of the label Tally Weijl to become key players in a world that reflects their lifestyle. One of the hallmarks of the brand, pink rabbits, has been integrated into the design of the store.

First floor plan and ground floor plan

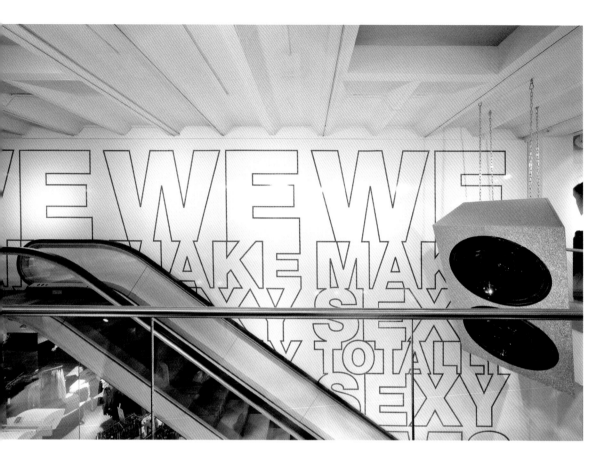

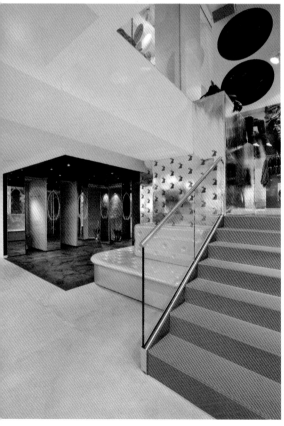

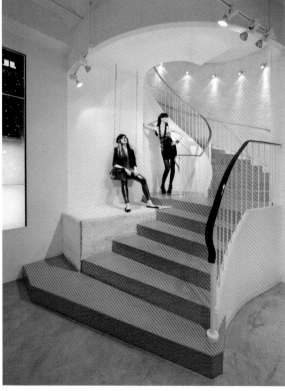

The theatrical conception of space, crowned with a large staircase accessing the second floor, has been designed by Dan Pearlman.

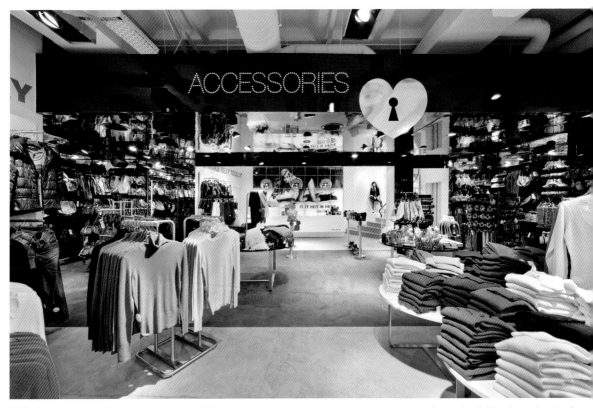

Lighting is very important to the theatrical stage designed by the interior design studio. Advertisements are inserted and the walls are painted bright colors to draw attention to the products, so the clothes stand out.

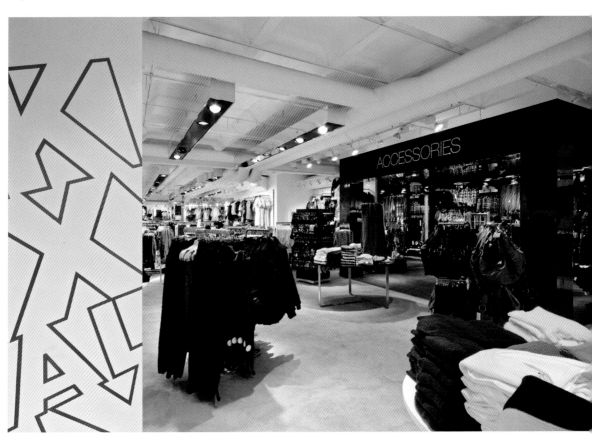

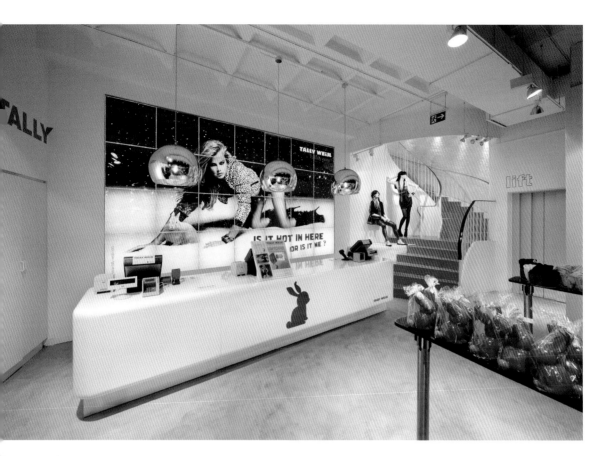

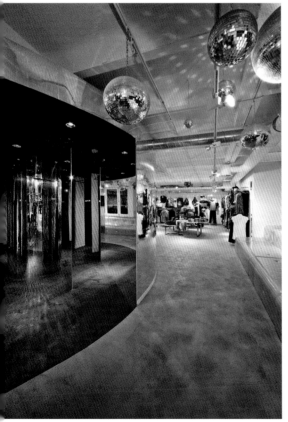

The area where the changing lounge is located invites clients to relax and to try on clothes in comfort. The French model of changing rooms from the eighteenth century was used.

design spirits co.

Yuhkichi Kawai

2-18-2-202 Ohara Setagaya
156-0041 Tokyo
Japan
Tel.: +81 3 3324 9901
www.design-spirits.com

Yuhkichi Kawai was born in Tokyo in 1967and is the chief designer and co-founder of design spirits co, a firm that was established in 2003. His first success was the Feast Village (2005) in Kuala Lumpur, for which he won the Silver Medal and Merit Award from the Malaysian Society of Interior Designers (MSID). The project was also recommended in the guides of the specialist magazine Wallpaper. It has also won numerous awards for his design of the restaurant Beijing No 9, including the award for the Best Store in Japan, and Great Indoor Award (Netherlands) in 2009. The same year, in Singapore, The Nautilus Project won the Japanese Society of Commercial Space Designers award (JCD). Also, the Niseko Lookout Café in Japan won the Restaurant & Bar Designs Award in 2011 (United Kingdom).

Beijing Noodle No.9
Caesars Palace, Las Vegas, NV, USA / 2008 / © Barry Johnson

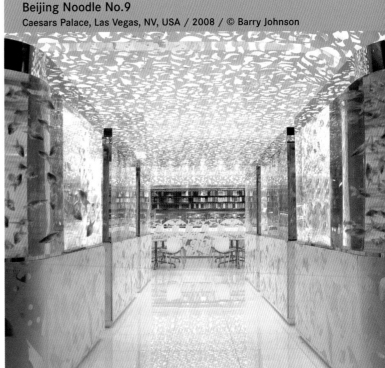

The restaurant is located next to the hotel's casino, which is naturally an area with a lot of noise and movement. To counteract this, and taking advantage of the fact that there are no support columns throughout the space, a peaceful, almost surreal, atmosphere has been created, utilizing a unique pattern on all surfaces.

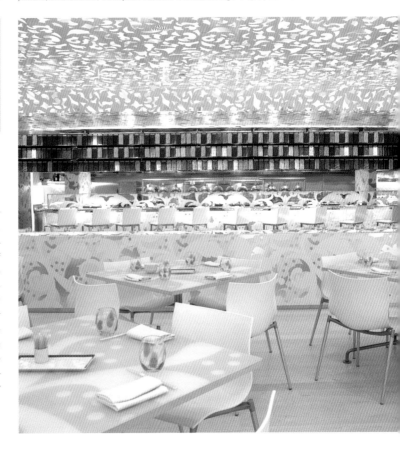

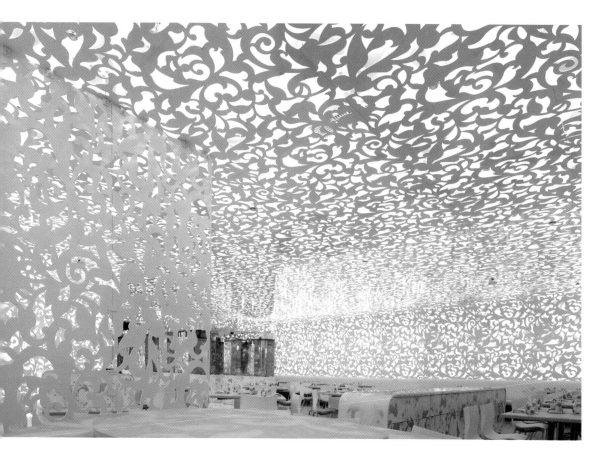

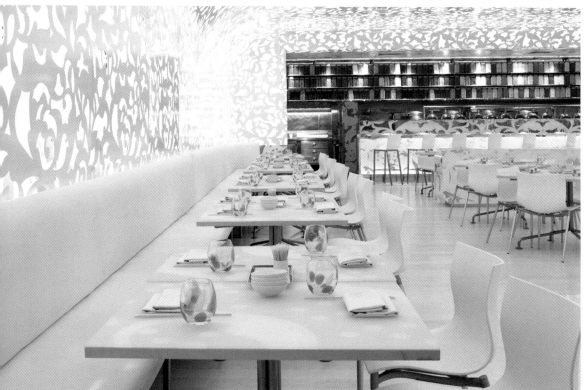

e double walls are continued on the ceiling and are composed of a panel with elegant steel arabesques in conjunction with another panel in a glossy finish. The intense hting filters through the drawings and is projected onto the table, creating a special atmosphere.

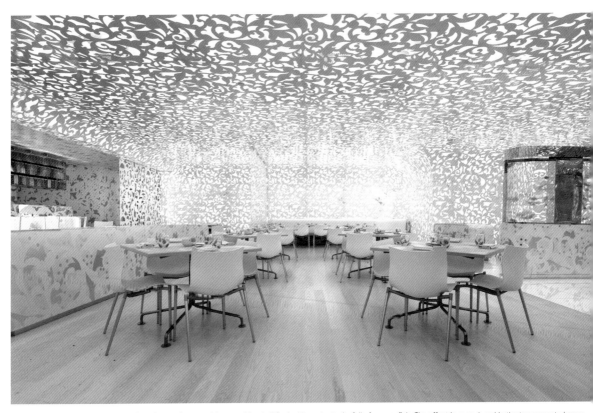

Once visitors enter through the front door, they are immersed in a sparkling hall flanked by water tanks full of orange fish. The effect is reproduced in the transparent glasses with spots of the same color.

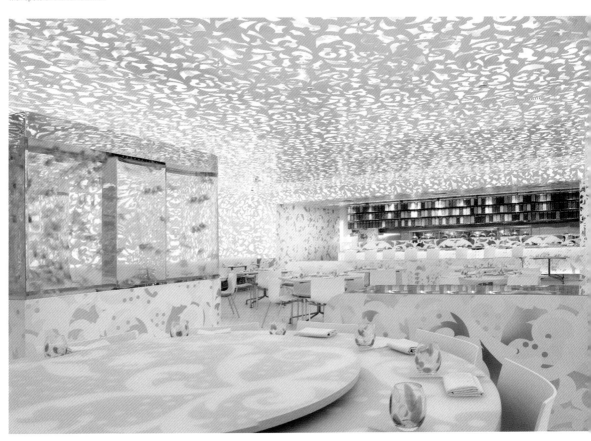

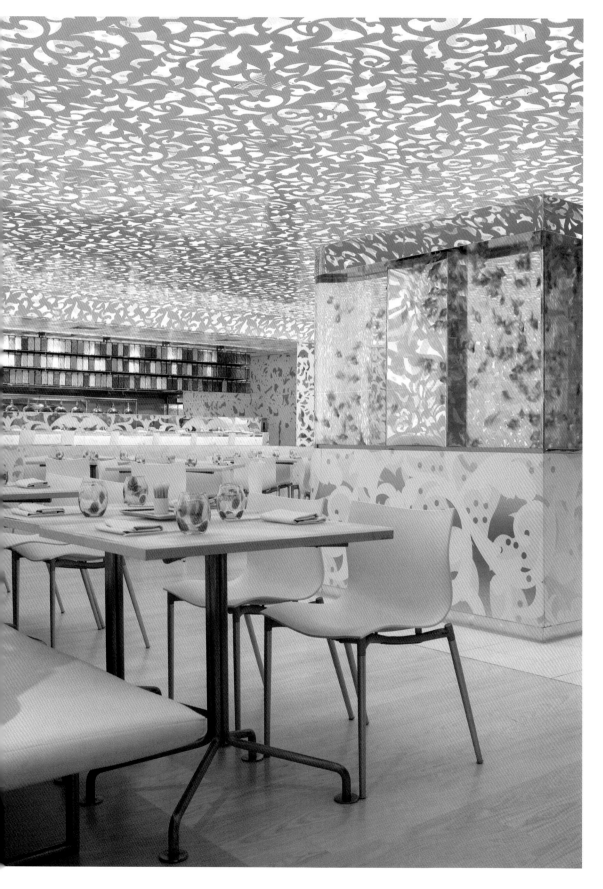

The Hutong Project
Kuala Lumpur, Malaysia / 2009 / © Toshihide Kajiwara

For the re-decoration of a food court located in the basement of a shopping mall, a street-like environment dominated by an invisible chaos with a touch of nostalgia has been emulated. Despite this, the space also has a futuristic look thanks to the exposed air ducts.

Floor plan

The designers anticipated that there would be changes due to the needs of the store owners, and for this reason they left the rooms open for flexibility.

Food stalls are located along an intricate layout, like a maze. This helps to create more intimate spaces for interaction between the storekeepers and their customers.

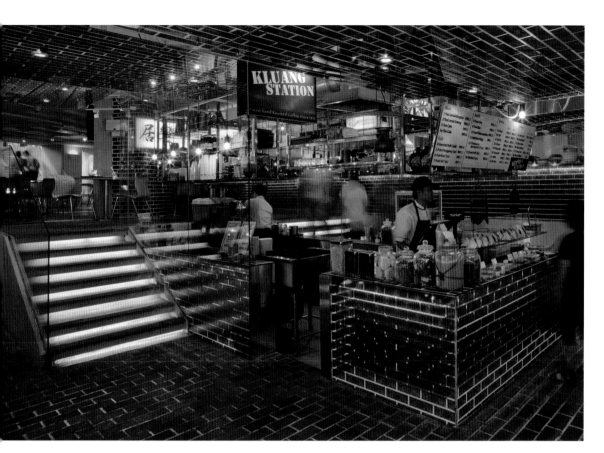

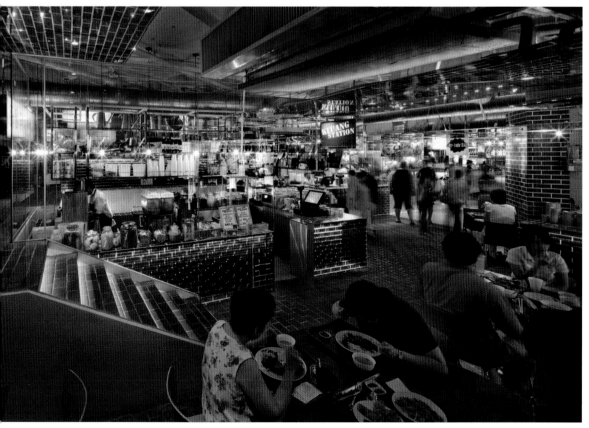

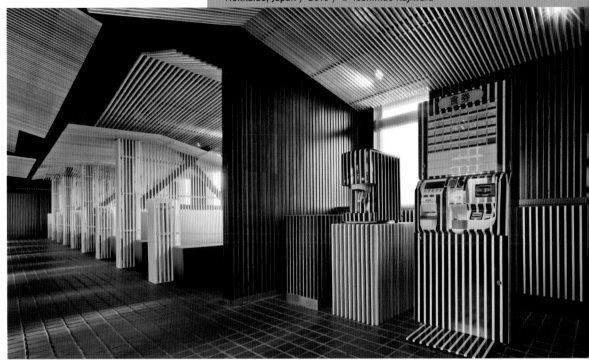

Niseko Look out Café
Hokkaido, Japan / 2010 / © Toshihide Kajiwara

This café for skiers, which opens only during the winter, was built almost entirely out of wood thirty years ago. For its refurbishment, a vertical wooden framework was used as the main material to represent the Japanese identity.

Floor plan

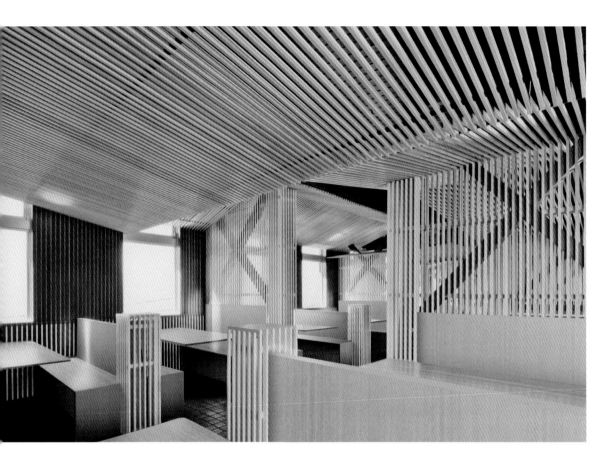

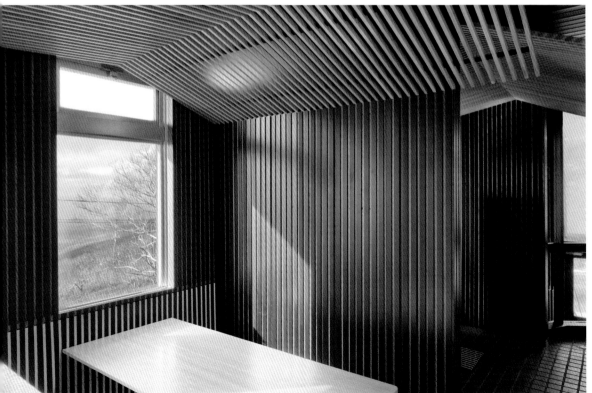

The lighting creates interesting effects thanks to the light sources that pass through the wooden framing. A feeling of warmth and security floods the environment where ceilings of different heights and sizes are found.

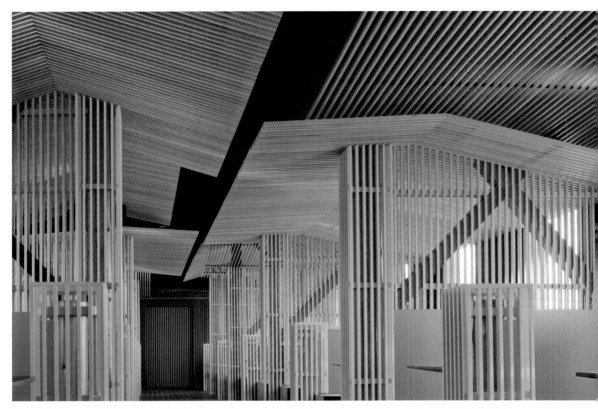

The wooden framings acquire different levels of robustness depending on usage. When they separate rooms they are semi-transparent and allow light to pass easily. At other times, they are embedded into the walls with contrasting designs.

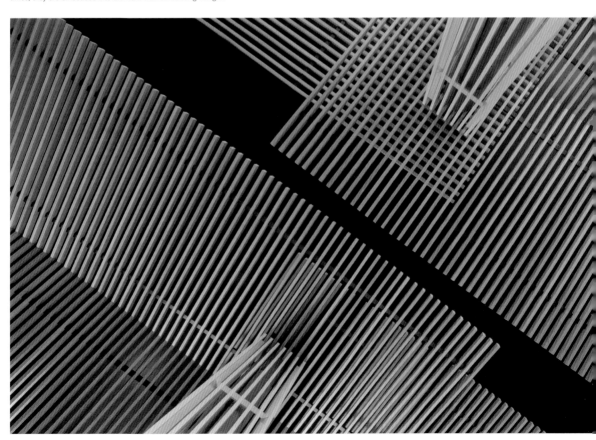

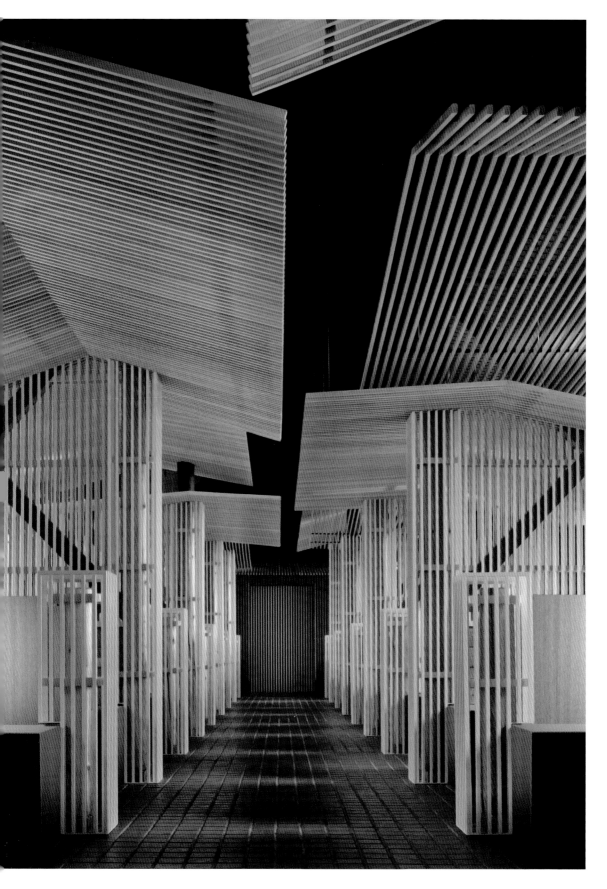

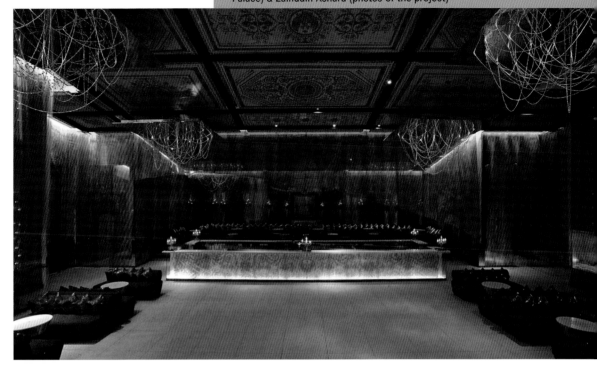

The club is dominated by a huge photograph showing the hall of a Russian palace. The image appears on the wallpaper and on organza cloth hanging in front so that the overlap creates a ghostly appearance.

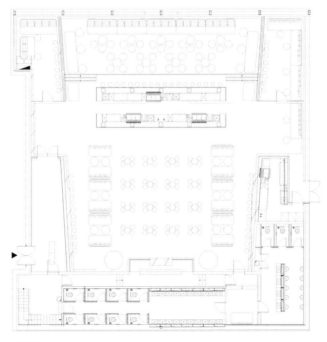

Floor plan

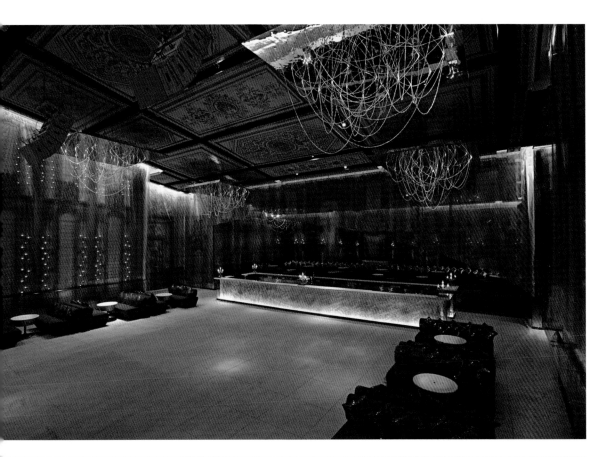

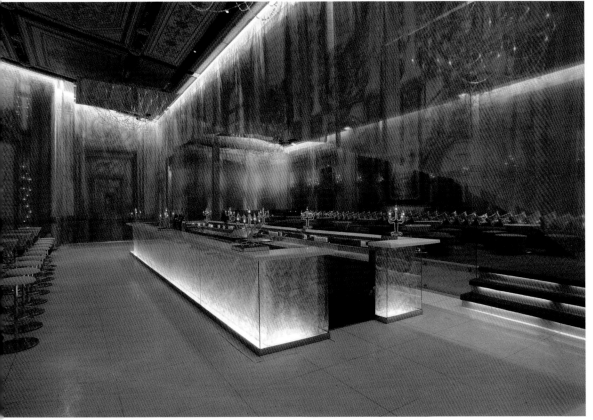

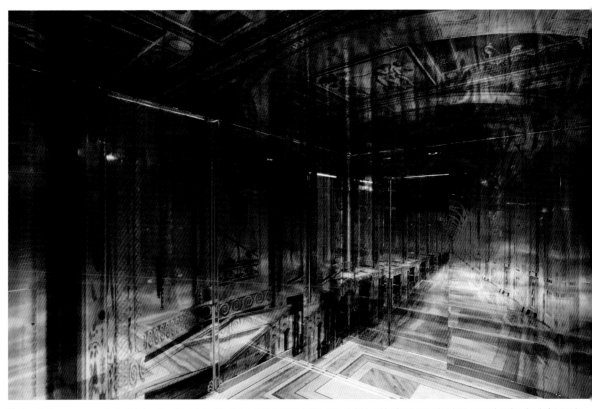

Contrary to the common aesthetic of clubs, often characterized by darker environments, in this case a bright and luminous space has been created so that the design can be seen and enjoyed in its entirety.

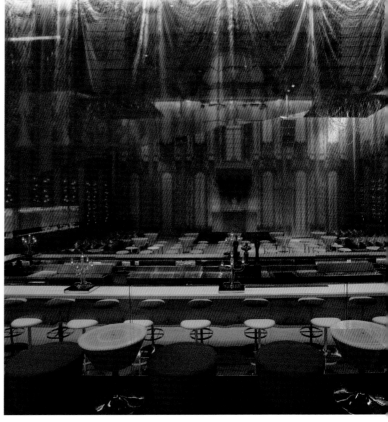

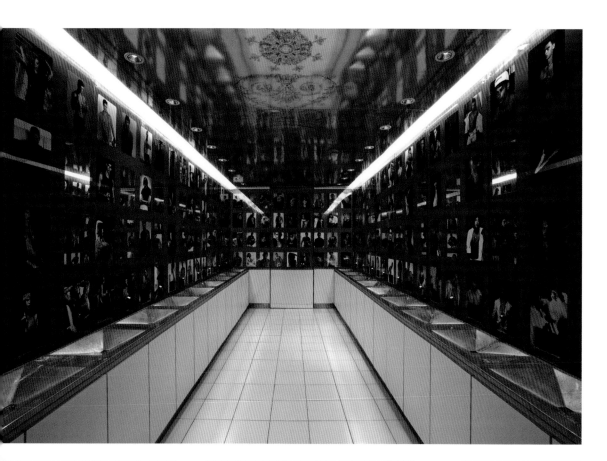

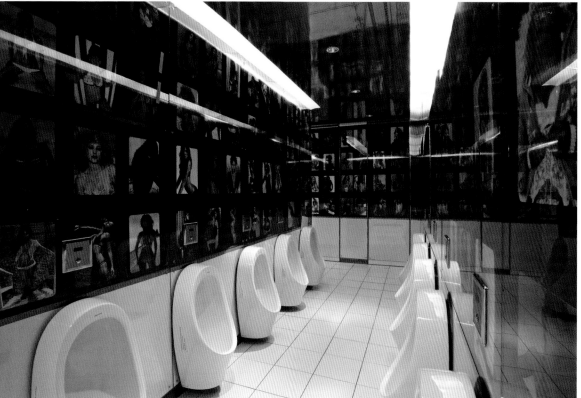

The images of the palace have been edited to fit the space it will occupy in the different areas of the club.

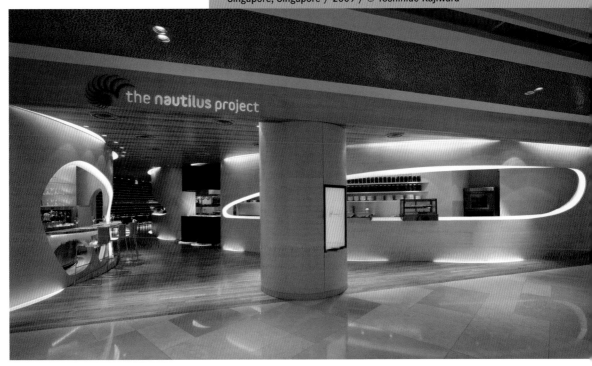

This restaurant is located on the fourth floor of a shopping mall and flanked by eateries. Instead of a façade, an entry hall has been designed that leads the customer to the heart of the establishment.

Floor plan

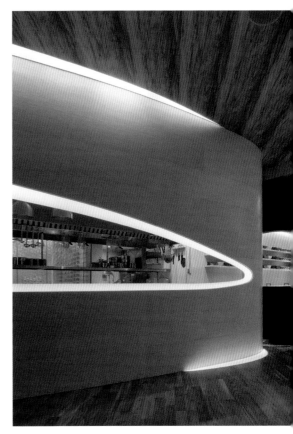

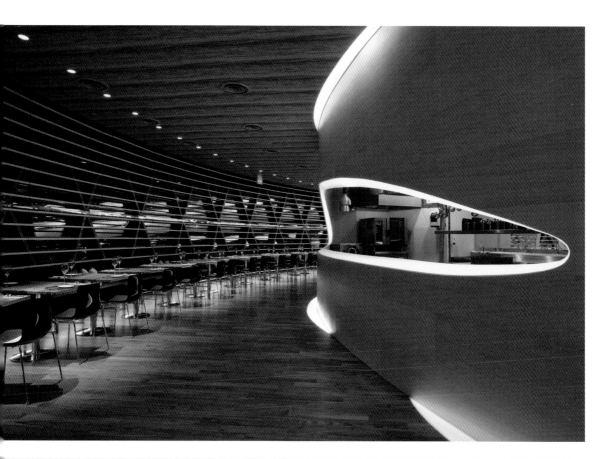

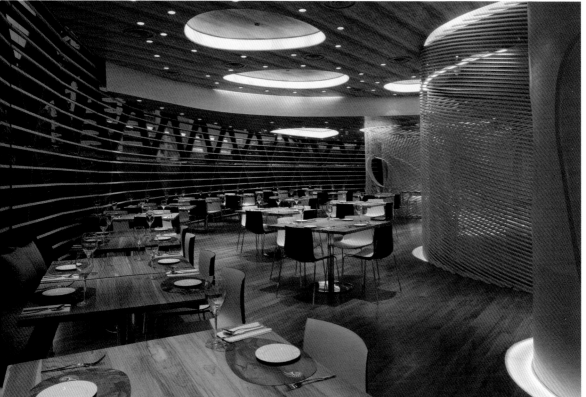

The space is divided using curved panels made of wooden frames so that the room resembles a rib cage.

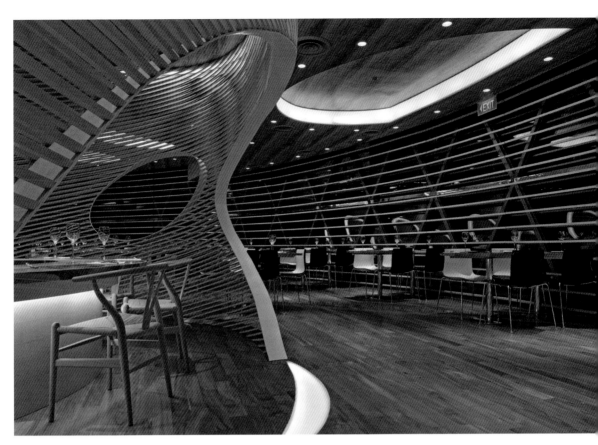

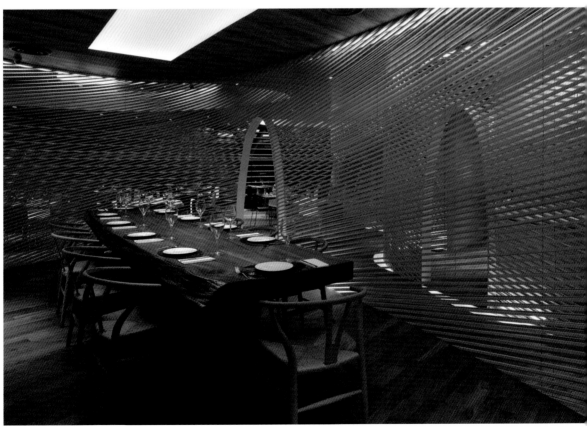

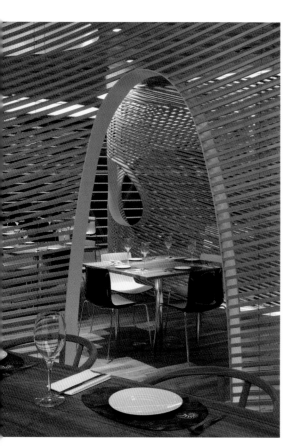

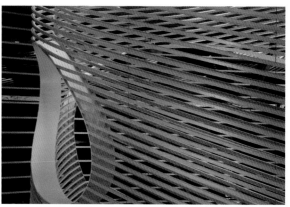

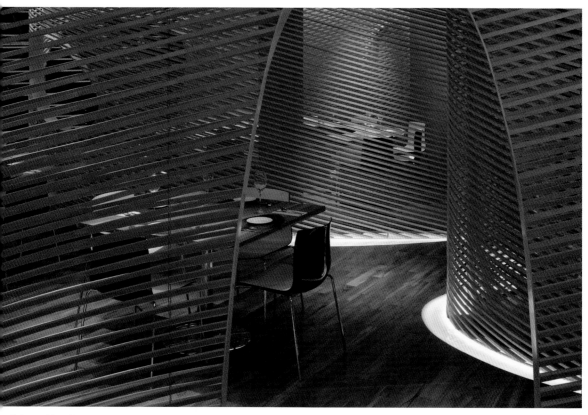

e kitchen and the toilets remain in semi-enclosed capsules hidden behind wooden panels.

Despang Architekten

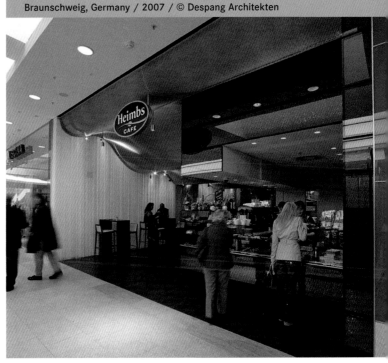

Café Heimbs
Braunschweig, Germany / 2007 / © Despang Architekten

Günther Despang, Martin
Despang, Cynthia Despang,
Isabel Schlüpmann

This is the first coffee shop designed by the German company. It is located in the new shopping center of the town where the firm was created. The architects' brief was to represent the company's principles, an authentic and pure image, with characteristics inherent to the coffee roasting process.

1040 North Olive Road
85721-0075 Tucson
Arizona
USA
Tel.: + 1 520 626 9350
Fax: +1 520 621 8700
www.despangarchitekten.de

Despang Architekten is a small-scale design practice in Germany. It was founded as a result of a family partnership between Martin and Günther Despang in 1990, and was officially established as an architectural firm in 2000. It also functions as an academic platform in Tucson, Arizona and recently joined the Isabel Schlüpmann and Cynthia Despang studio. As promoters of philosophical architecture, they believe in the impact of architecture on the mind and physical well-being and, ultimately, the potential for architects who work to improve peoples' lives. To achieve this goal, they create simple places and spaces with ecological aspects considered in the initial design.

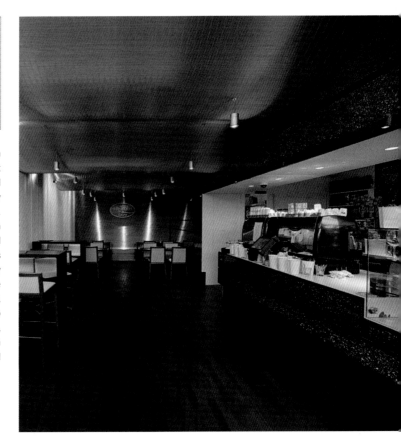

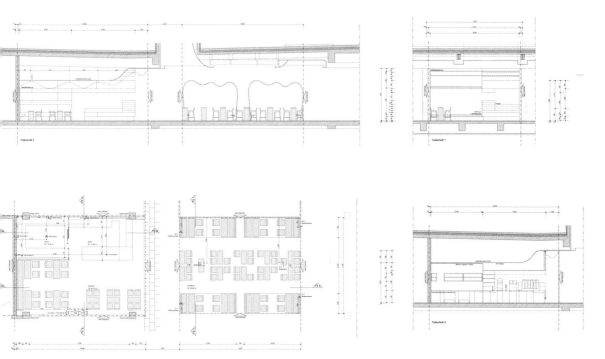

Plans and sections

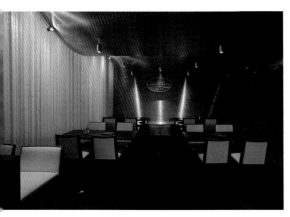

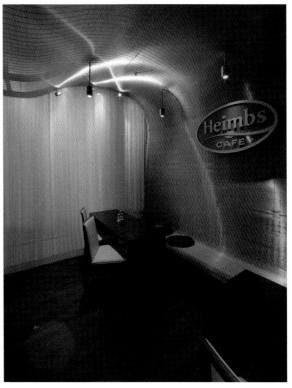

The center of the space is dominated by the central counter that shows the bean "in real time and real space." In the back of the store, the roof slopes down to form a bench.

Kreipe's Coffeeshop
Hannover, Germany / 2004 / © Despang Architekten

The Kreipe bakery and cafe, founded in 1873, wanted a new premise that would coincide with the change of generations, as well as attract a wider clientele. The design proposal oscillates between traditionalism and modernism. The entranceway was created in a narrow form which marks the beginning of a route to the main space.

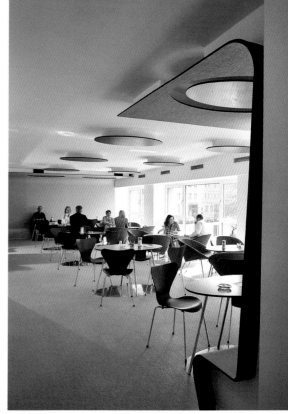

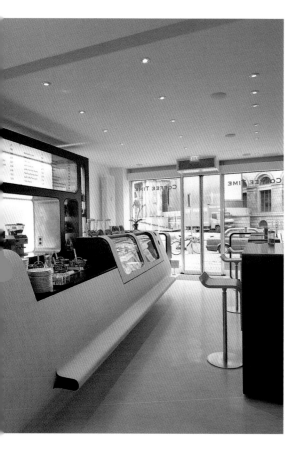

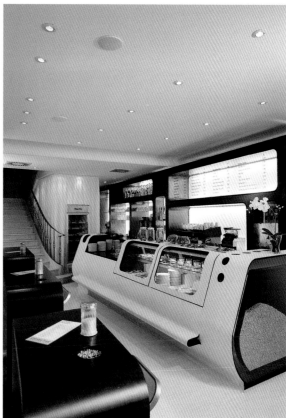

Rendering

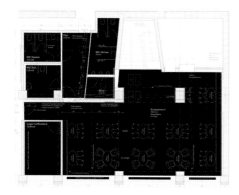

Floor plan

The facilities, the showcase-counter, as well as the chairs, tables, and other furnishings, help to create the illusion of depth and linearity sought by the architects.

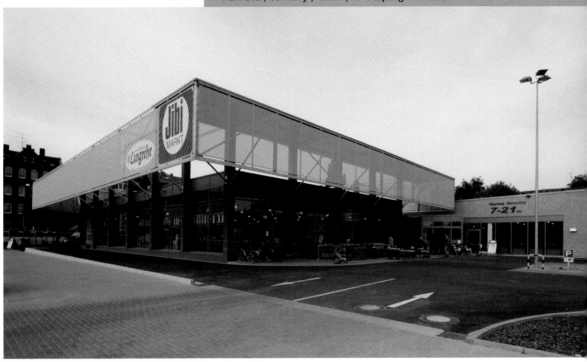

This project added a bioclimatic specialist food store to this district of Hannover. The building is located in the middle of a dense urban environment with limited parking, which encourages people to walk or ride a bicycle. The construction and maintenance work have been carried out following ecological criteria.

The center consists of two separate areas, one space for drinks and another for food. Key features are the green façade where ivy acts as a heat buffer, enhancing the microclimate and protecting walls against vandalism.

Elips Design

Elisa Pardini

Phoenix Yard
65 King's Cross
WC1X 9LW London
United Kingdom
Tel.: + 44 020 7239 4921
www.elipsdesign.com

The studio, founded in London in 2010 by Elisa Pardini, believes that environmental quality has a direct influence on the quality of life of people, whether at work, at home, or in the public sphere. Associated with this is the fact that architecture is generated based on people's material, spiritual needs, and a concern for the physical context, culture, and climate.

While the studio focuses on the construction of buildings, it also operates in areas beyond architecture, including semiotics, renewable energy, technology, and graphic and product design. Environmental consciousness is also a comprehensive part of its practice and its evolution to meet the challenges of the coming years.

Dri Dri St Martins Lane
London, United Kingdom / 2011 / © Carlo Carossio

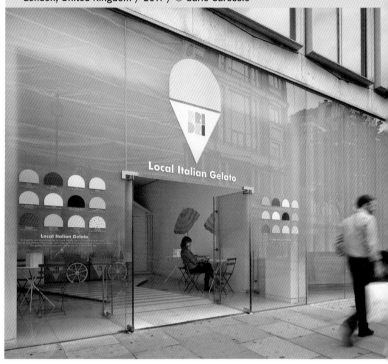

This seasonal ice cream parlor, located in the St Martin's Lane Hotel, is set in the style of an idyllic Italian beach with its traditional wooden platforms, colored huts, beach umbrellas, chairs, and tables.

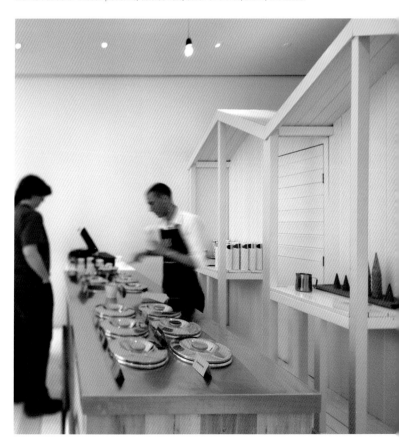

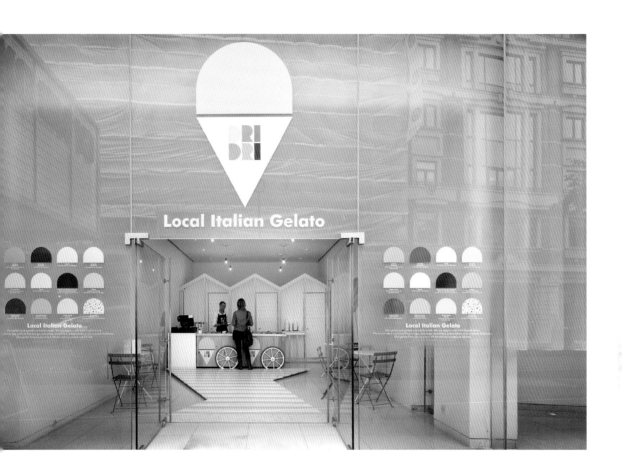

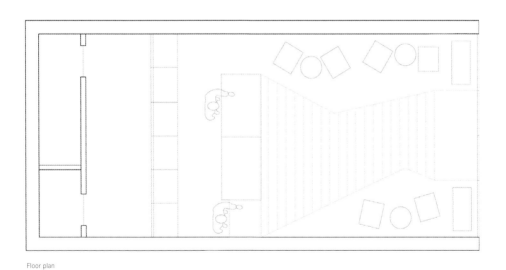

Floor plan

The beach huts are designed in a way that contributes to dividing the space while creating a storage site.

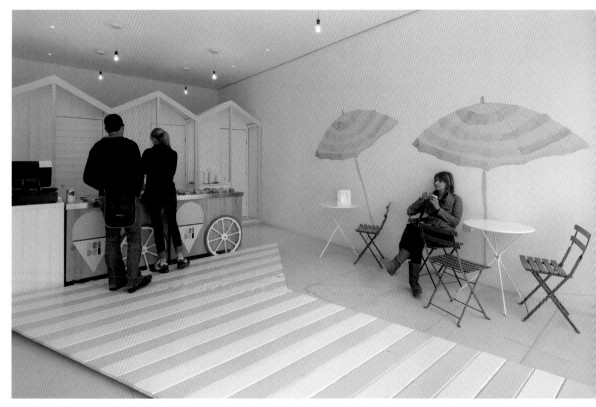

The design of the space transports guests to the Mediterranean from the heart of London. The typical outdoor tables and chairs are located in front of photos of life-sized umbrellas on the wall.

Elevations

Sketches

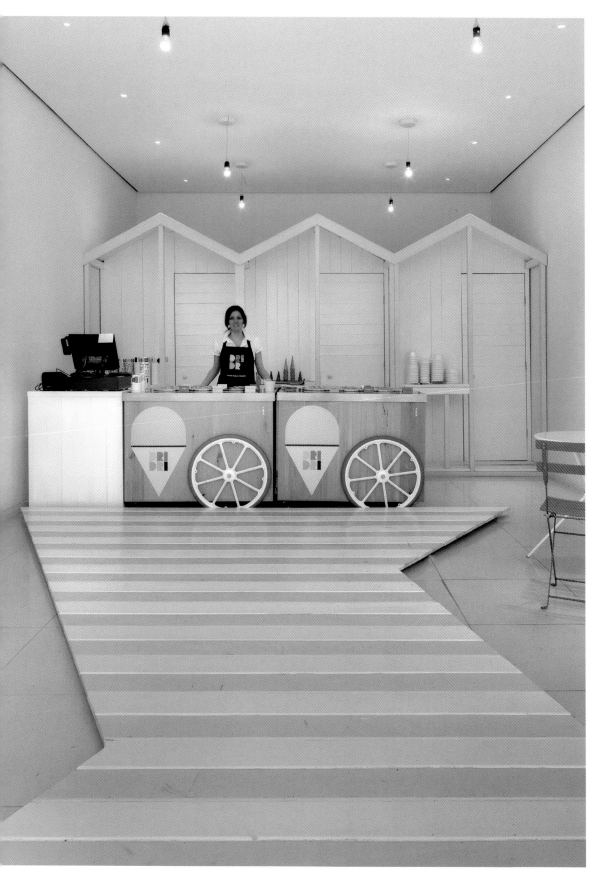

This multi-purpose building consists of a winery, a reception area, a hotel, a restaurant, common areas, and office spaces, and is presented as two twin volumes: one underground for the winery and another above the surface.

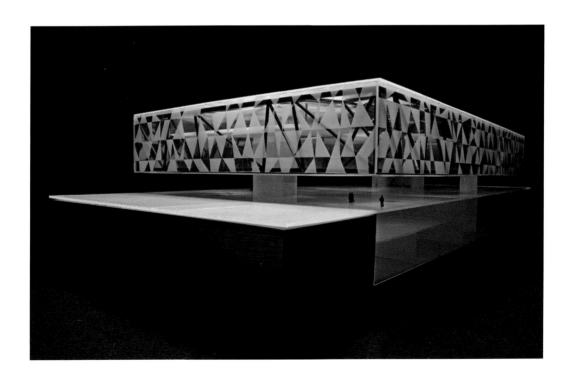

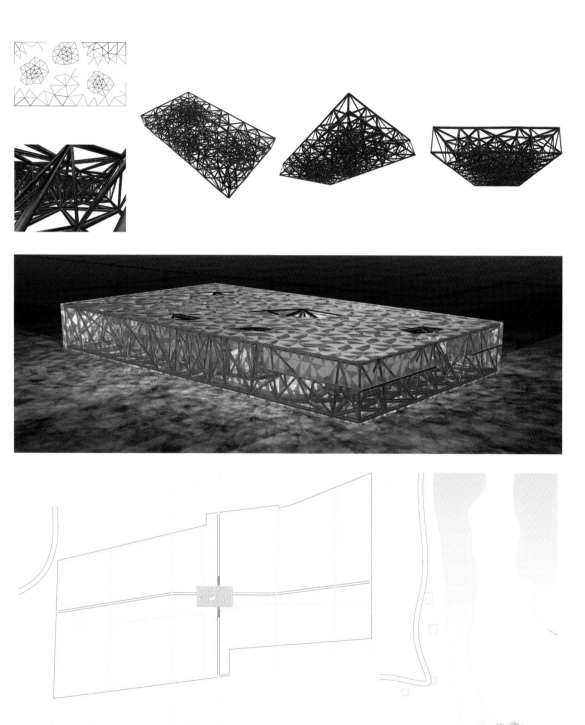

Renderings and diagrams

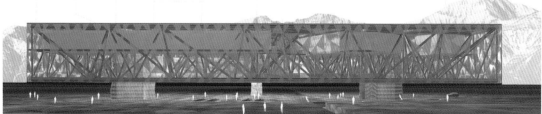

e skin of the building has a triangular framework with different degrees of transparency and solar panels to generate energy and evocative lighting effects. The monumentality the building seeks to emphasize the brand image.

Estudi Bonjoch

Estudi Bonjoch team

Carrer de Bonavista, 6 Int Pral 4a
08012 Barcelona
Spain
Tel.: + 34 93 415 00 07
Fax: +34 93 237 26 52
www.bonjoch.com

Ignasi Bonjoch Sesé was born in Barcelona in 1956 and graduated in interior design at the Escola Elisava de Barcelona in 1990. He then gained a Bachelor of Arts in Design at Southampton University. His career is marked by its multidisciplinary nature with projects of various types: graphic and scenic applications, cultural exhibitions, the design of ephemeral spaces, retail interior design, furnishing creation, etc. His works have a common denominator: they are characterized by a fascination for shadows, optical effects, and a quest to control spatial lighting in all its registers. Since 1990 he has worked as a lecturer in projects at the Escola Elisava and has been a guest lecturer at various international universities.

Andrés Sardá Showroom
Barcelona, Spain / 2008 / © Fernando Guerra

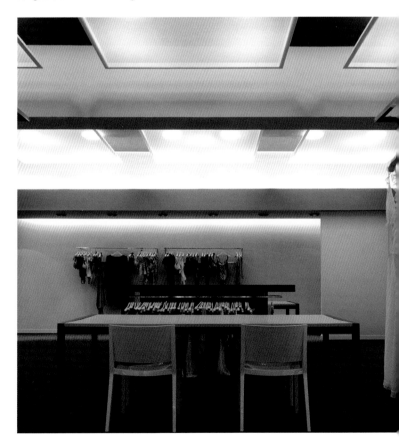

The aim of the architects in creating this clothing exhibit was not to conceal the industrial aspect of the building. They built a set of tables with a 2:1 proportion that allows the space to be organized with different table configurations to meet the differing needs of the business.

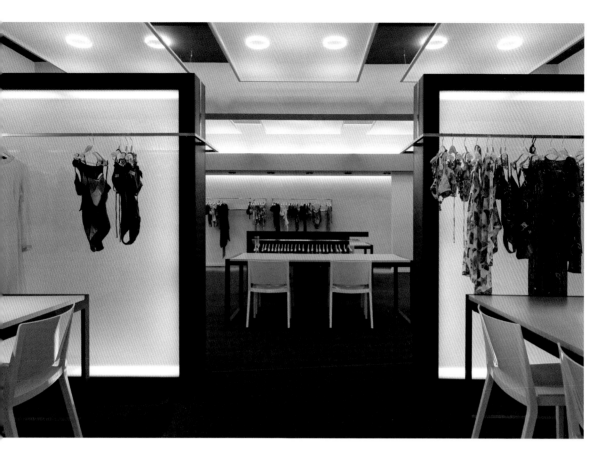

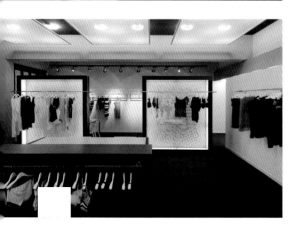

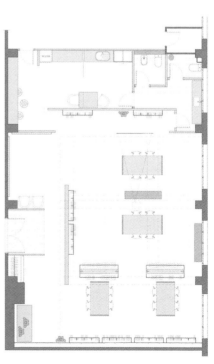

Floor plan

The ceilings have white fabric fitted in metal frames to diffuse the lighting. The lighting has been specially designed so as not to alter the colors of the garments.

Andrés Sardá Marbella
Marbella, Spain / 2008 / © Miguel de Guzmán

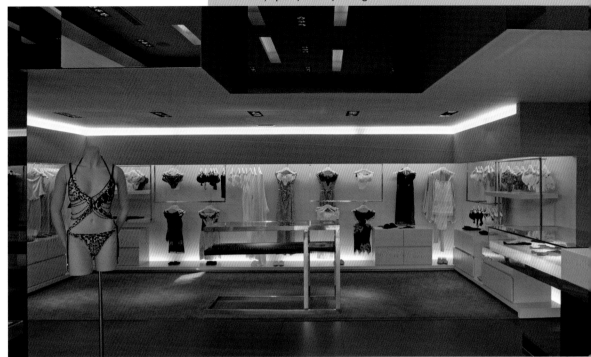

The Andrés Sardá store is located in the main shopping district in the Andalusian city of Marbella. It occupies an area of 110 m² (1184 ft²) and is organized on two levels in a corner. The ground floor houses all the product displays and the changing rooms. The upper floor contains a small office, warehouse, and VIP changing room.

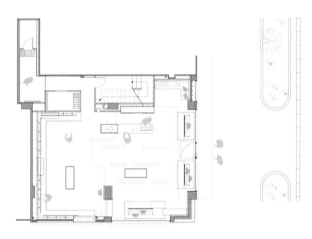

Floor plan

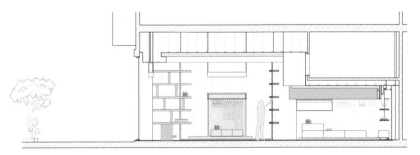

Section

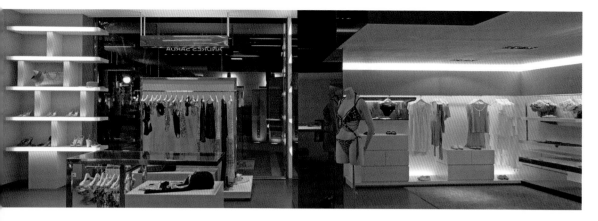

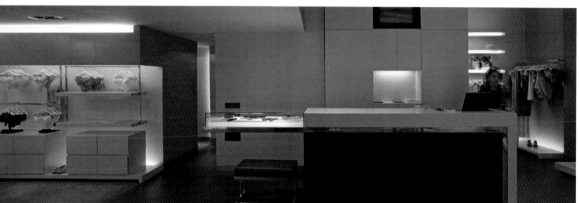

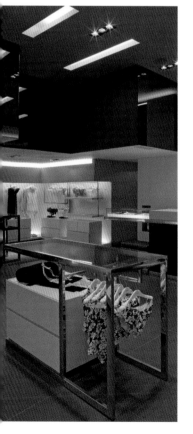

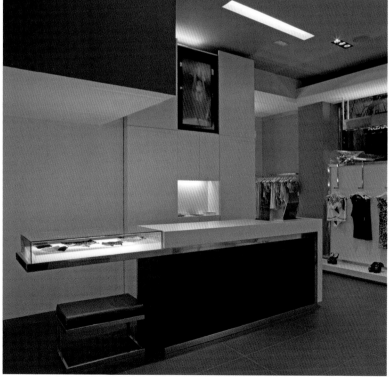

The central feature of the design scheme is the lighting and the combination of materials. The lighting is combined intelligently to enhance and enrich the overall perception of the products displayed. Ceramics, stainless steel, panels, mirrors, among other elements, also play a key role in the design.

Quitxen Doca Showroom
Capellades, Spain / 2009 / © Eloi Bonjoch

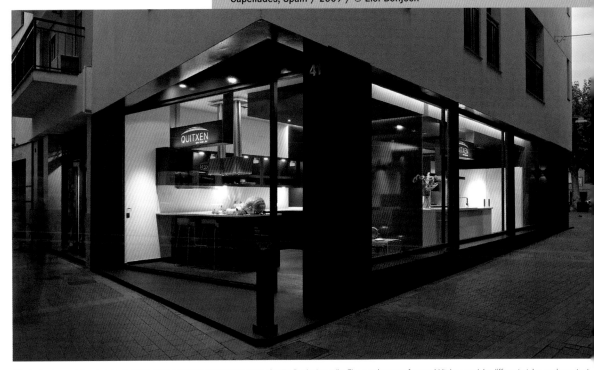

This design for a retail space devoted to a kitchen showroom was a challenge for the Bonjoch studio. The coexistence of several kitchen models, different styles, and constant changes of display models required a minimal, well-designed, and timeless intervention.

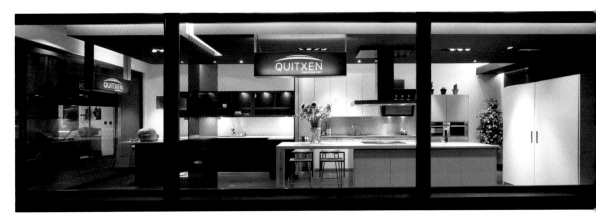

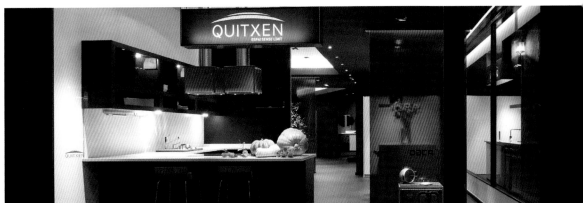

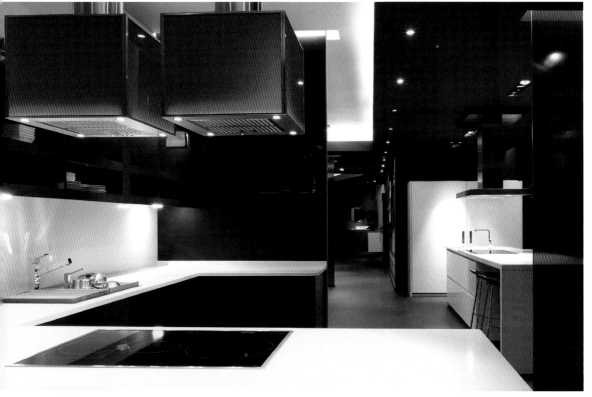

s there was a clear height, the architects opted to construct a false ceiling on two levels to house the air system and other installations. Vertical clear glass partitions were
sed to separate the kitchen spaces.

Fletcher Priest Architects

Michael Fletcher, Keith Priest

Devonshire Square
London, United Kingdom / 2012 / © Nick Clark, Chris Gascoigne

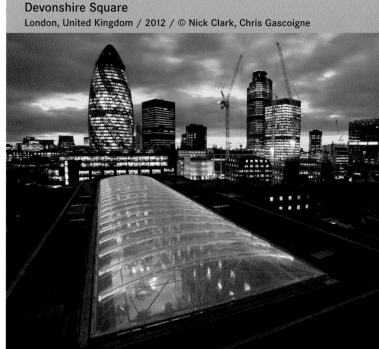

The building block which housed the warehouses of the former East India Company, has been remodeled and converted to offices, multipurpose spaces, shops, and restaurants. During the rehabilitation process, it has maintained the essence of the now protected eighteenth century building.

Middlesex House
34/42 Cleveland Street
W1T 4JE London
United Kingdom
Tel.: +44 (0)20 7034 2200
www.fletcherpriest.com

The Fletcher Priest studio was established in London in 1978. Years later, in 1992, the company opened an office in Cologne, Germany and in 2008 they opened another in Riga, Latvia, becoming one of the 100 largest architectural firms in the UK.

The firm's work includes urban design, architecture, and interior design, with clients such as St Anne's College Oxford, Royal Mail, UBS, Sony, IBM, and Vodafone. Their projects include the master plan of Stratford City in East London, an urban center of seventy-three hectares within the Village for athletes from the 2012 Olympics, and the new urban center of the city of Riga. The firm also has a strong line of design research by an internal team and close ties with universities and schools of architecture.

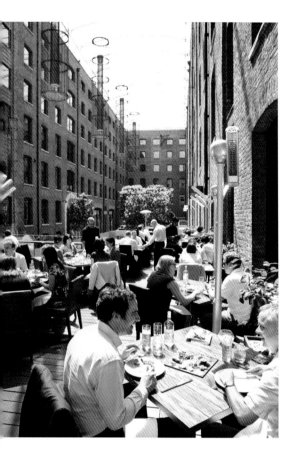

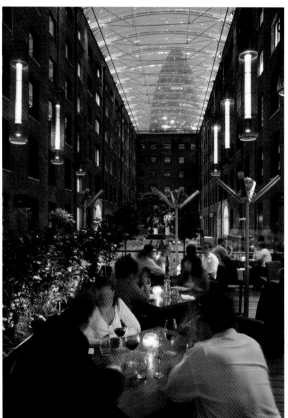

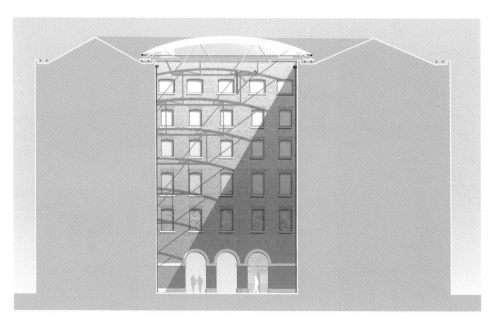

Elevation

The courtyard is home to a public space covered with a delicate steel and ETFE, a type of transparent, durable, and heat-resistant plastic.

Hackney PictureHouse
London, United Kingdom / 2011 / © Fletcher Priest

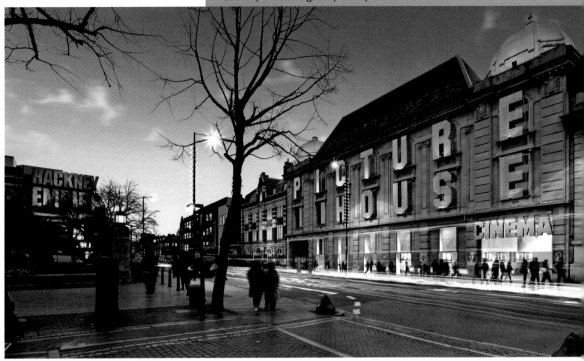

A historic building that overlooks the Hackney Town Hall Square has been remodeled to house four top quality movie houses from the independent distribution company City Screen, along with a cafeteria and community facilities.

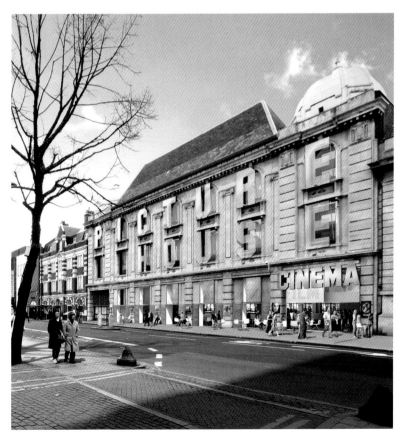

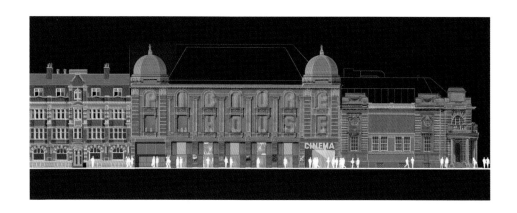

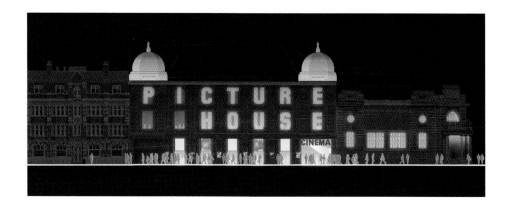

Renderings and sketch

palette of plain, bright colors and materials generates a new graphic identity.

Tyneside Cinema
Newcastle, United Kingdom / 2008 / © Sally Ann Norman

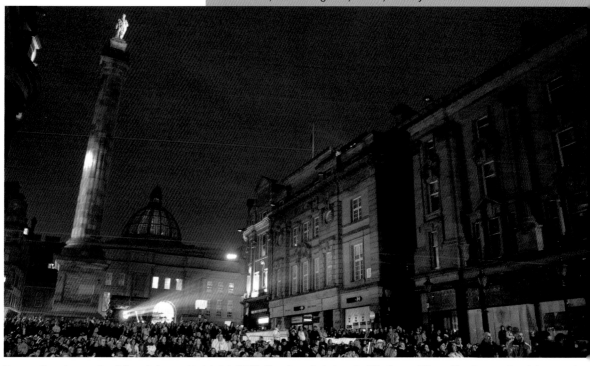

The renovation and preservation of this movie house—originally built in 1937 by Dixon Scott who is the uncle of film directors Ridley and Tony Scott—was intended to create the first e-cinema in the UK. The new space includes a hall to exhibit local digital production and to host educational activities.

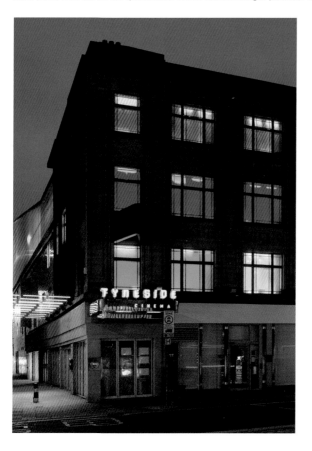

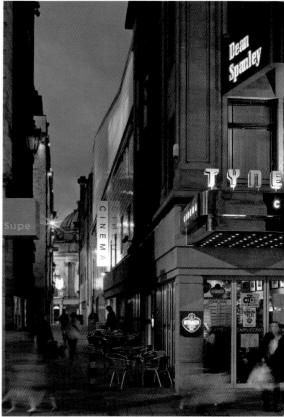

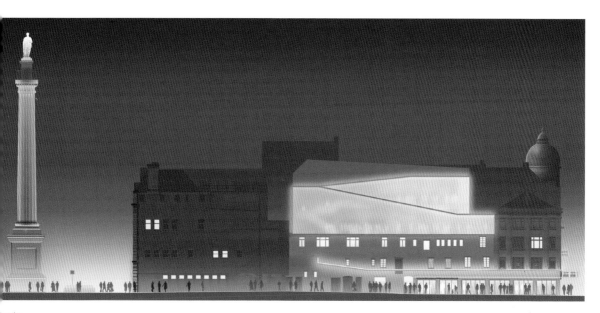

Elevation

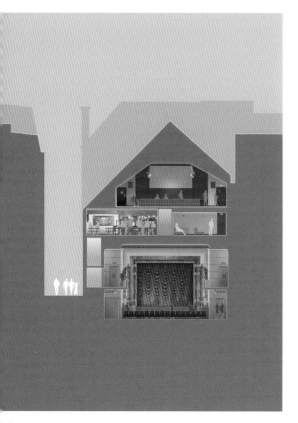
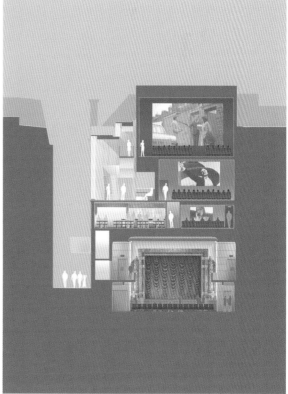

Sections

233

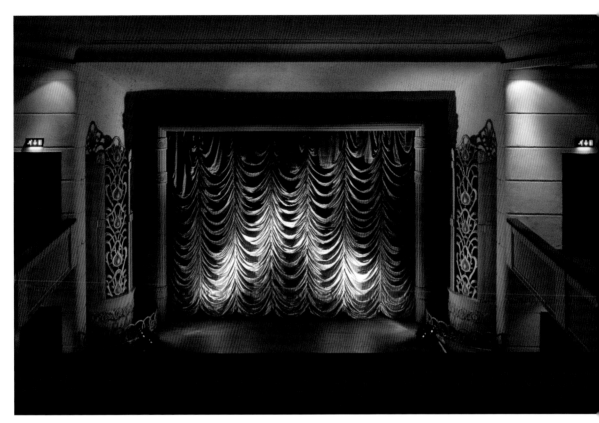

In addition to the remodeling of the central hall, two new rooms were built that expand the offering of the movie house: Electra and Roxy with 144 and 100 seats respectively.

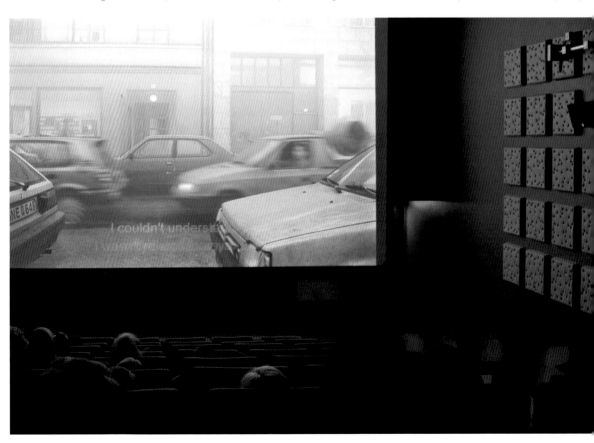

The original auditorium was completely renovated keeping the original features, but adding the installation of 200 new seats in the orchestra, plus sixty chairs and generously sized sofas in the amphitheater.

Fumita Design Office

Akihito Fumita

Masa House 3F, 11-21 Saragakucho,
Shibuya-ku
150-0033 Tokyo
Japan
Tel.: + 81 3 5875 0087
Fax: + 81 3 5875 0887
www.fumitadesign.com

Born in 1962 in Osaka, Akihito Fumito obtained a degree in Design in 1985 from the University of Art in his hometown. In the same year, he started to work in the RIC DESIGN studio. In 1995, he founded his own architecture and design studio, Fumito Design Office. Since then he has received numerous awards, such as the JCD Design Award 1997, the Good Design Award 2001, the Display Design Award 2003, and SDA Awards 2010. His creations include Natural Body, the Nissan Ginza Gallery, the Nissan stand for the Tokyo Motor Show, the basement of the Takashimaya department store in Osaka and many more. He has also worked in the field of private homes.

Anayi
Nishinomiya, Japan / 2008 / © Nacása & Partners

Akihito Fumita created an elegant and simple space for the new Anayi store. He used few materials as a way to emphasize the dramatic use of lighting.

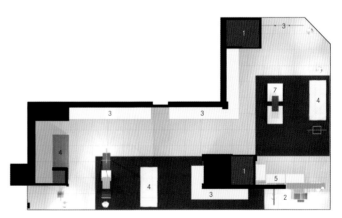

Floor plan

1. Fitting rooms
2. Show Windows
3. Clothes rack
4. Display table
5. Shelving
6. Cash desk
7. Bench

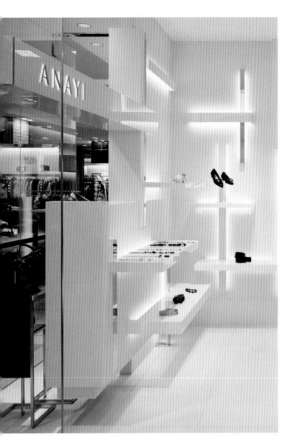

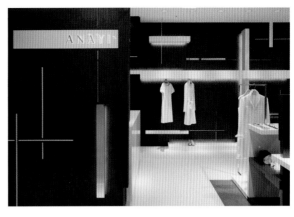

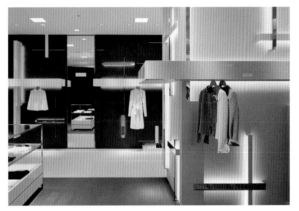

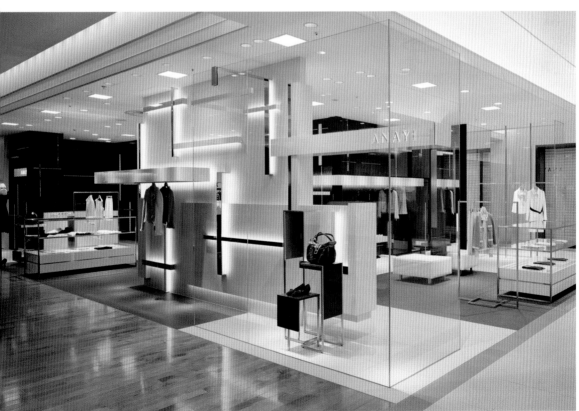

The floor, walls, ceiling, and windows are characterized by their longitudinal and transverse layout, which emphasizes the rationality of space.

Core Jewels

Tokyo, Japan / 2010 / © Nacása & Partners

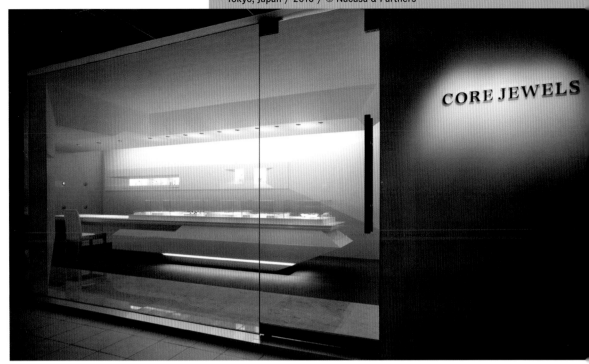

The designer wanted to reflect the usual cutting and grinding process that jewels go through in the interior of the jewelry store. To achieve this effect, he created a pure and clean space where the geometric forms resemble the facets that are made in jewelry.

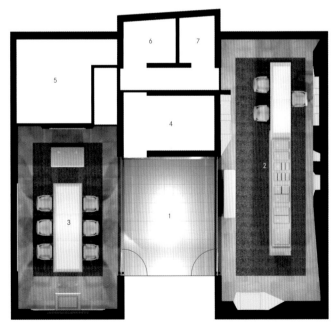

1. Entrance hall
2. Shop space
3. VIP room
4. Stairway
5. Office
6. Toilet
7. Kitchen

Floor plan

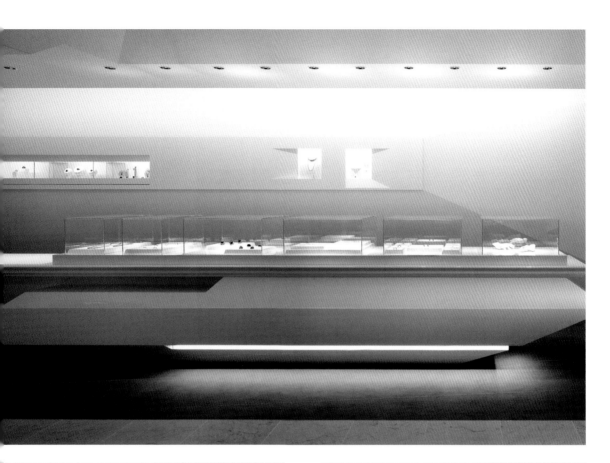

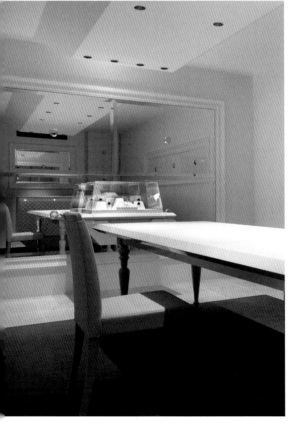

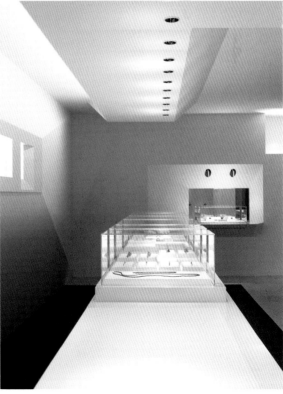

In addition to an elegant and sober style, the designer has added an industrial touch to the interior of the boutique.

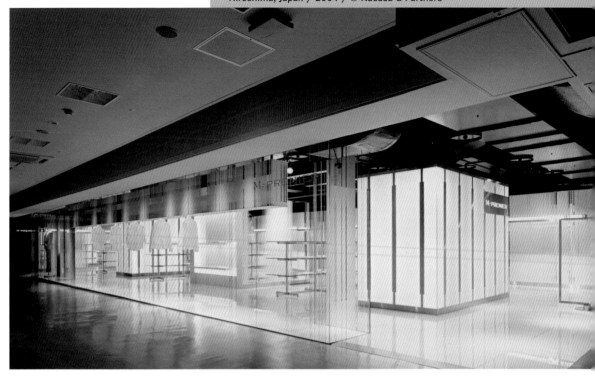

This store for M-Premier is the result of a creative process to renew the brand identity. With a minimalist solution, this new space gives the clothing company a fresh look.

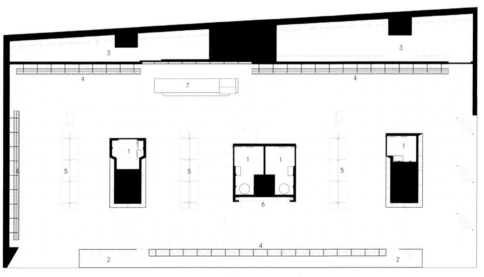

1. Fitting rooms
2. Show windows
3. Backyard
4. Clothes rack
5. Display table
6. Shelving
7. Cash desk

Floor plan

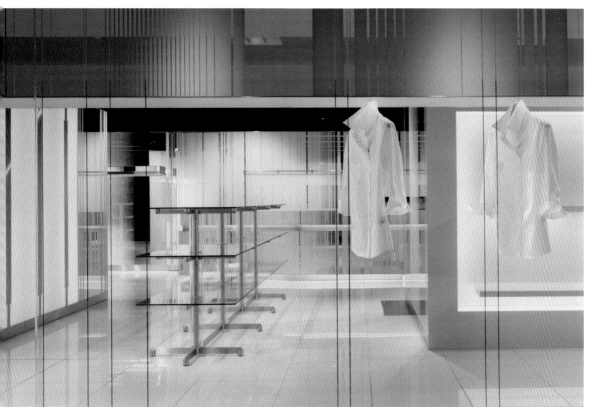

Mirrors, screens, and glass panels follow the same pattern of random stripes so that all of the elements are interconnected.

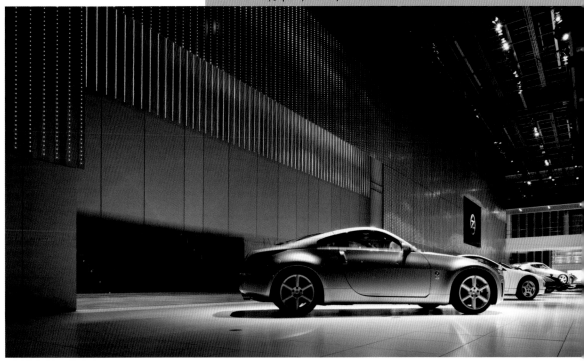

The customer's requirements for the creation of these offices and display units for a range of cars included a showroom, a shop, a café, a museum, and a rest area. The galler
was designed to display interactive information, and the showroom was designed to enhance the product.

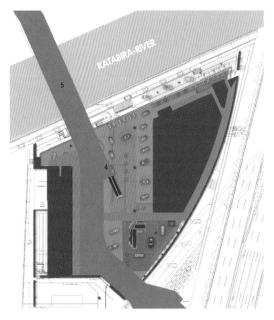
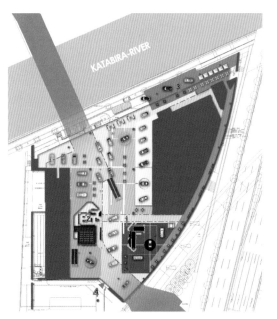

First floor plan and ground floor plan

1. Reception counter
2. Goods shop
3. Café
4. Entrance
5. Bridge

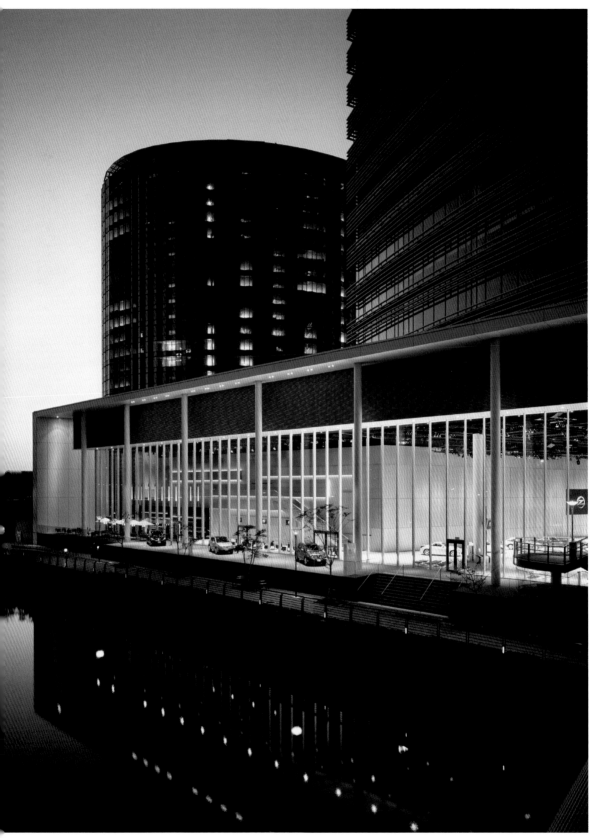

The architecture of the building was developed primarily to offer the product in a privileged location facing the sea. In this way, the cars, aided by dramatic lighting, look good from any perspective.

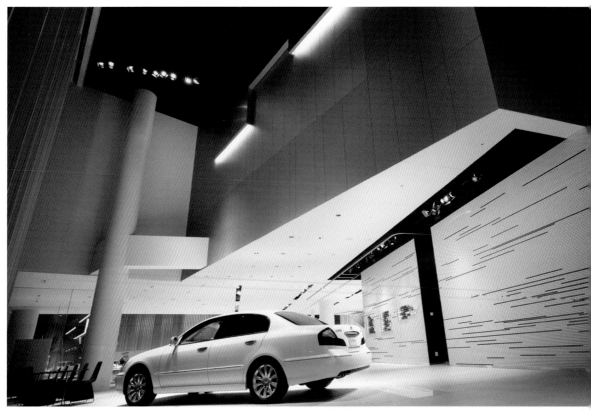

A large area constructed from small pieces that form layers has been created in the interior.

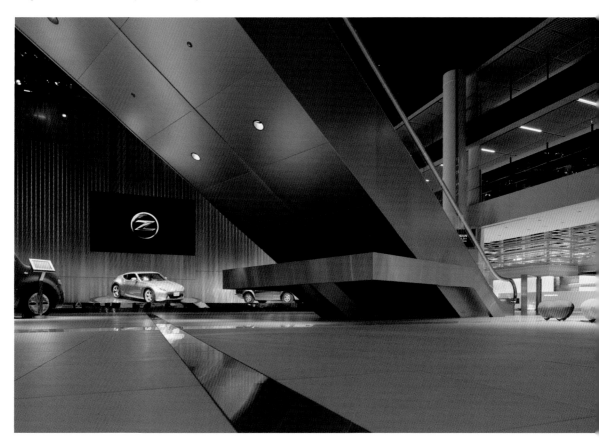

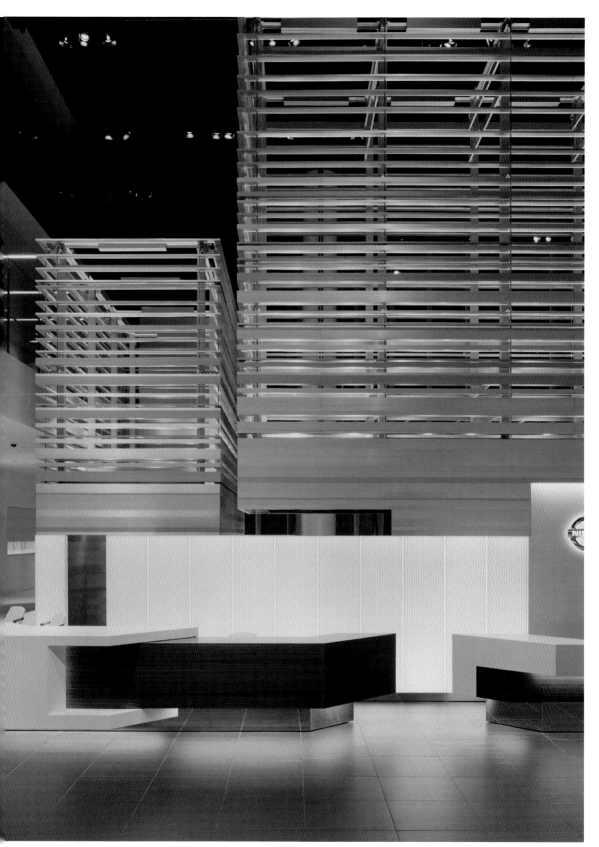

...pacious geometric spaces, minimalist décor, and shades of gray are the most important elements of this project. The architect was inspired by "furniture music" by the French ...mposer Erik Satie.

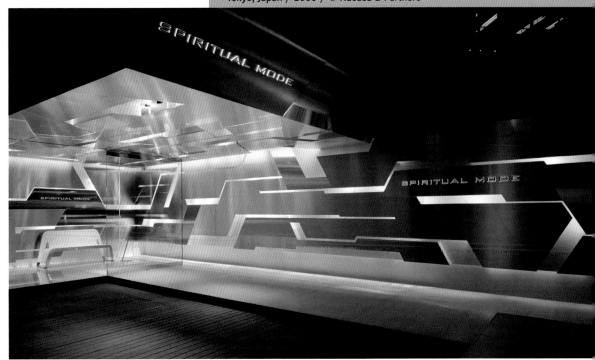

Spiritual Mode, a division of Wako specializing in bathroom fittings for homes, wanted an original design for its store. The decorative motifs on the walls and ceiling are mutually reflected to create a large kaleidoscope.

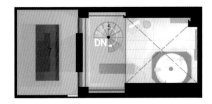

1. Entrance
2. Reception counter
3. Shower booth
4. Unit bath
5. Stairway
6. Service counter
7. Office

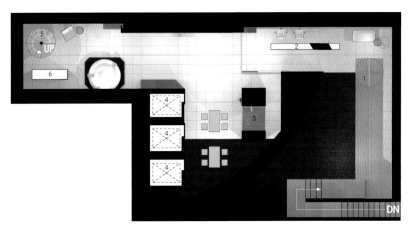

First floor plan and ground floor plan

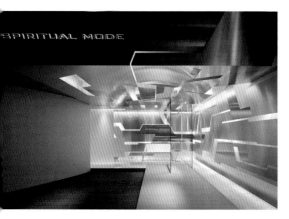

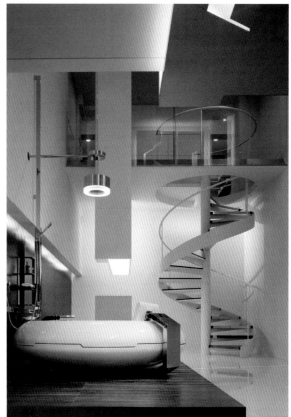

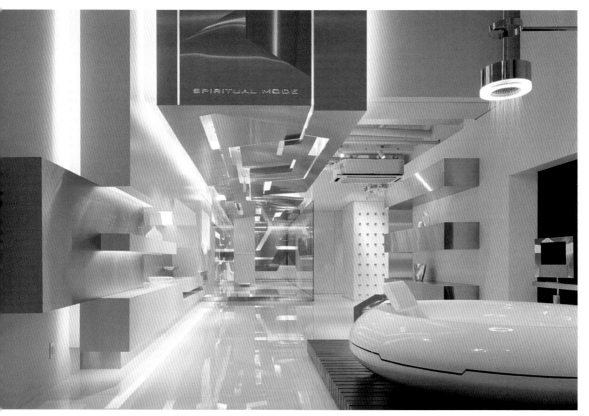

the new flagship store, steel and light were used to create a new composition of a hexagonal-shaped logo.

GCA Arquitectes Associats

J. Castañé, Ll. Escamís,
J. Hernando, J. Juanpere, A. Puig,
J. Riu, F. de Paz

Carrer de Valencia, 289 baixos
08009 Barcelona
Spain
Tel.: +34 93 476 18 00
www.gcaarq.com

GCA was founded in 1986 by Josep Juanpere and Antonio Puig. Later Josep Riu, Jesús Hernando, Jordi Castañé, and Francisco de Paz joined the team. Today, the studio has a team of sixty professionals, with its headquarters in Barcelona. In 2010, GCA opened a permanent office in Shanghai to develop international projects located in Asia. Its team is made up of multidisciplinary professionals in architecture, interior design, engineering, graphic design, landscaping, documentation, photography, management, and administration. GCA designs and develops architecture, town planning, and interior design, with projects ranging from office buildings, hotels, and houses, to commercial spaces and equipment.

Restaurante Tienda Cornelia & Co
Barcelona, Spain / 2010 / © Cornelia & Co

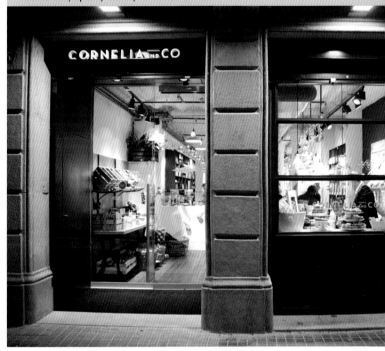

Two spacious areas connected to the street lead towards a large central part. Shelves for displaying and purchasing are placed around this passage in addition to the bar, benches, chairs, and tables that allow clients to drink, eat, and talk. The product display stems from the idea of a warehouse.

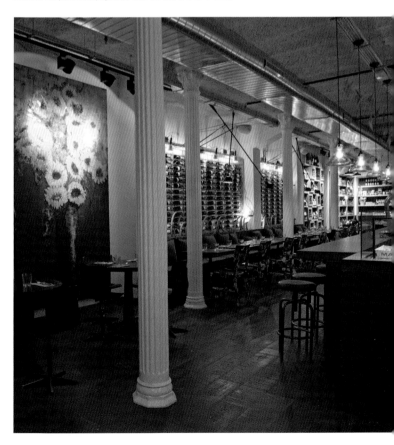

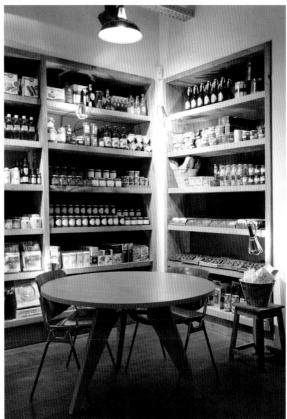

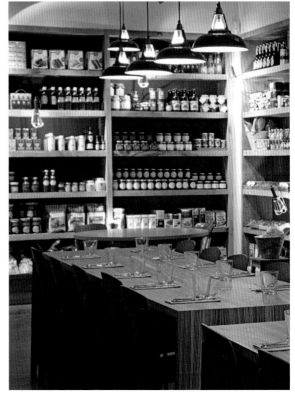

The dominant colors are white and black, allowing the product and the people to take the leading role within the space. Also, the materials are presented in a natural way.

Pastelería Oriol Balaguer Barcelona
Barcelona, Spain / 2005 / © Jordi Miralles

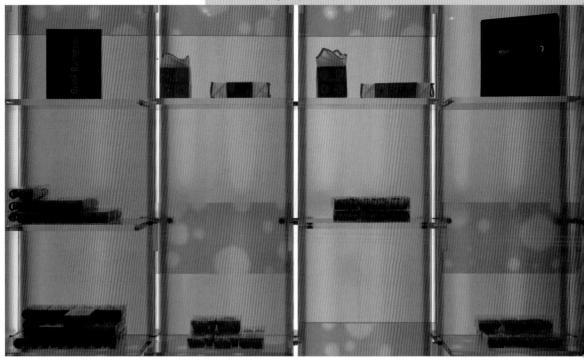

The lack of counters in the design of the bakery allows customer to move with complete freedom around the interior of the establishment. The space is designed as a mirrored, silkscreened box that offers an alternative perception where images and colors are mixed.

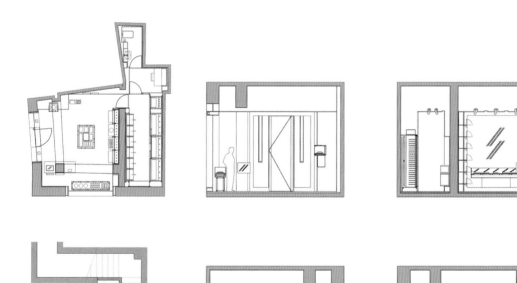

Plans and elevations

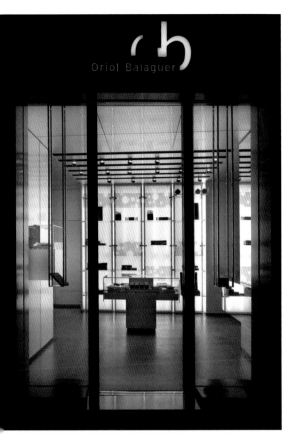
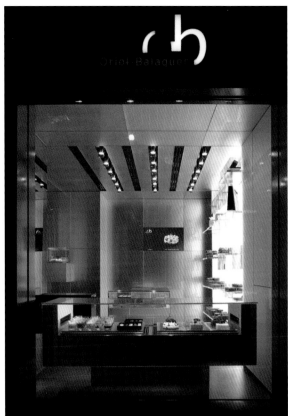
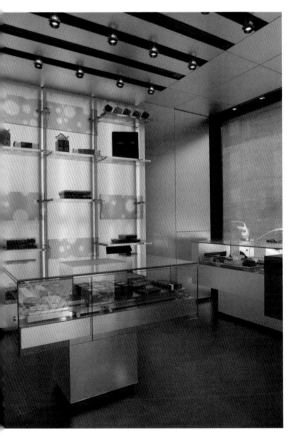
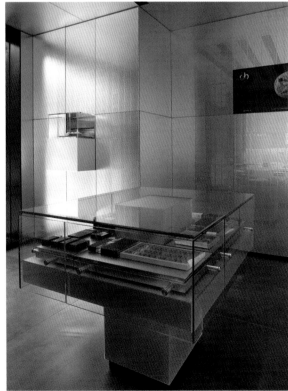

The façade is defined by a black, iron frame that creates a strong distinction between the interior and exterior.

Pastelería Oriol Balaguer Madrid
Madrid, Spain / 2005 / © Jordi Miralles

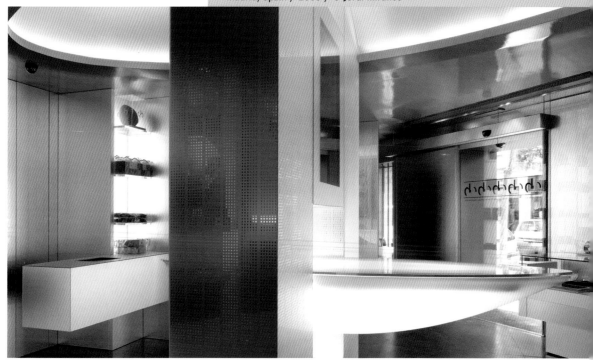

The new store for Oriol Balaguer remained true to the avant-garde style that characterizes the Catalan designer. In the center of the space, around the two existing pillars, the defining element of the entire store has been created: a methacrylate table internally illuminated that can be used as a lamp.

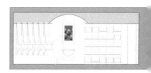

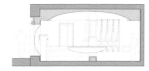

Plans, sections and elevations

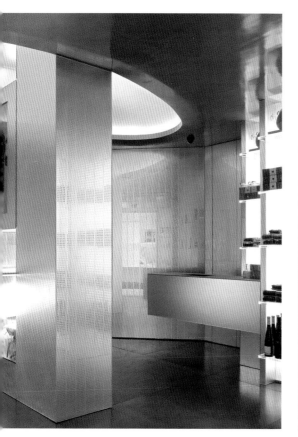

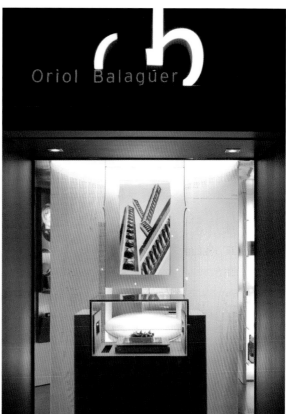

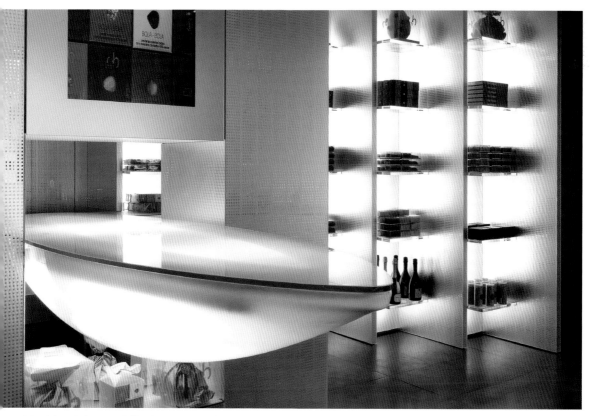

one of the windows the "concept cake" has been created, consisting of the monthly display of the new cake collection as if it were a jewel.

Giorgio Borruso Design

Giorgio Borruso

333 Washington Blvd #352
90292 Marina Del Rey
California
USA
Tel.: +1 310-821-9224
www.borrusodesign.com

Giorgio Borruso Design has a multi-disciplin-
ary approach to the fields of architecture,
interior design, and product design. His work
on projects, collections, and brand identity
for retail firms has always been influential in
these fields.

Under the leadership of the founding archi-
tect Giorgio Borruso, the creative work of
the studio is characterized by its sculptural,
streamlined, and organic nature, which is the
product of an unusual blend of materials.

Based in Los Angeles, the firm has received
more than a hundred international awards.
Many of its projects are part of permanent
collections at the Chicago Athenaeum Muse-
um of Architecture and Design, and the Red
Dot Museum in Germany.

Carlo Pazolini
Milan, Italy / 2011 / © Alberto Ferrero

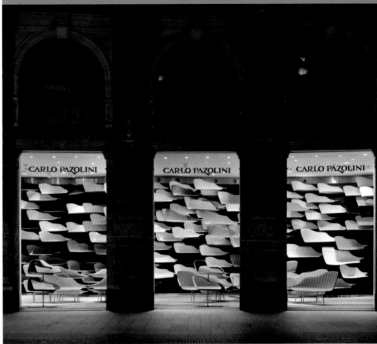

This 386 m² (4,154 ft²) store was the first that the brand of shoes and accessories opened in Western Europe,
redefining its store concept. When creating the main shapes in this space, the Giorgio Borruso studio was inspired
by the anatomy of the human foot.

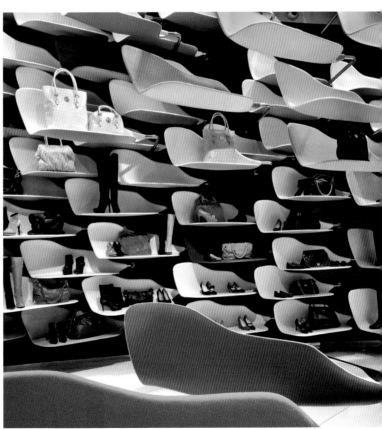

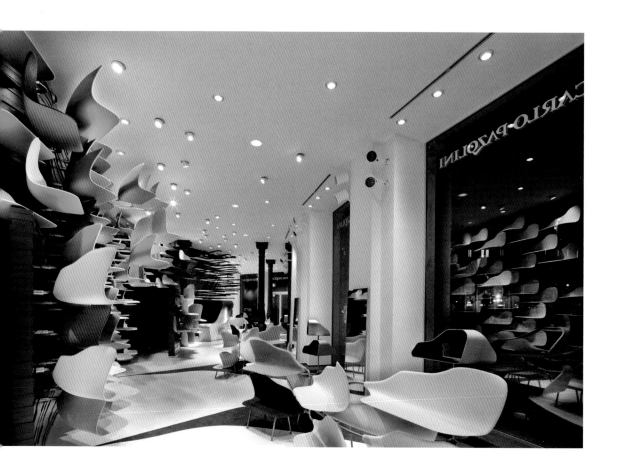

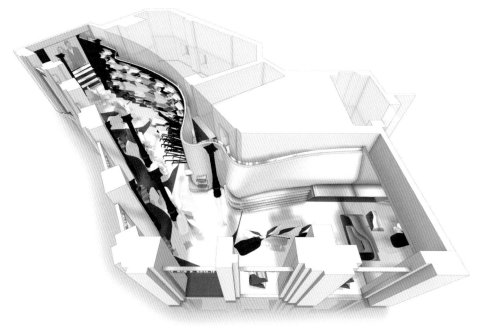

Axonometric

The undulating front wall holds a cellular shelving system made from rounded components of different colors and stands out from the outside area, contrasting with the esthetics of the stately buildings in Piazza Cordusio in the center of Milan.

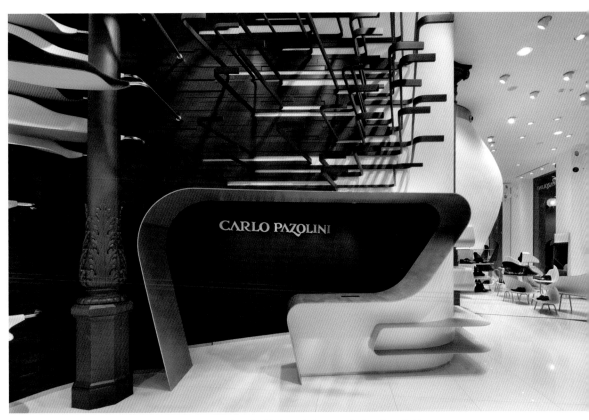

In stark contrast to the clean white surface near the tills, the central area has black metal tubes protruding from the wall strips.

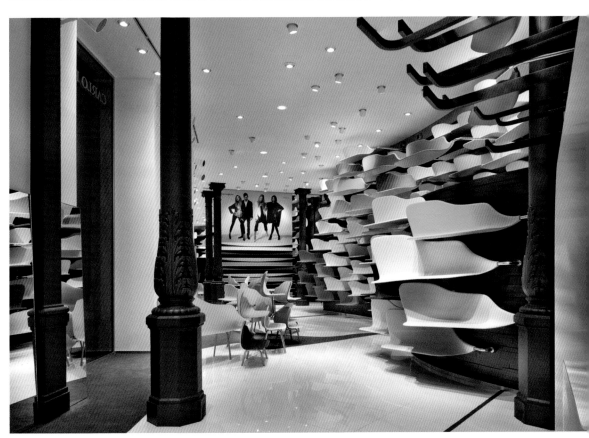

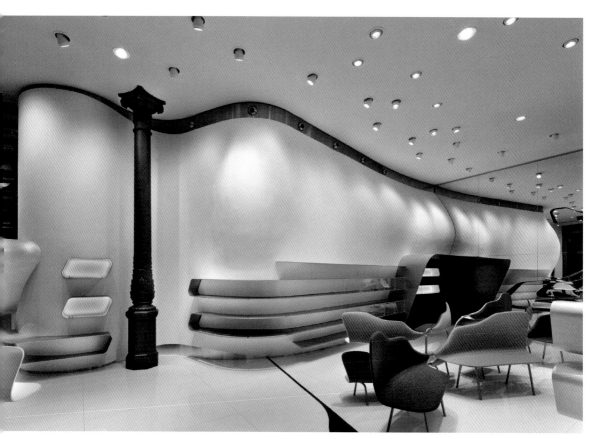

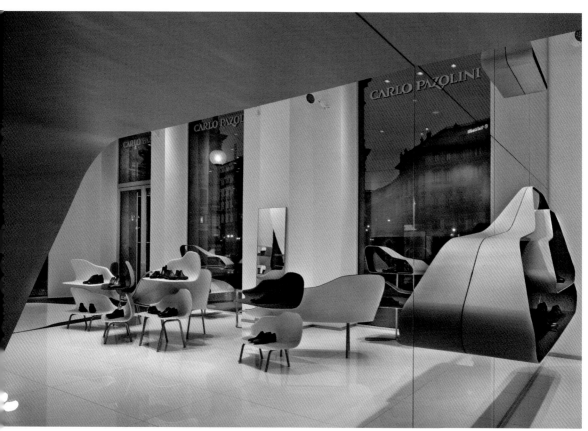

This project is a conceptual continuation of two previous showrooms in Miami and Los Angeles owned by the same brand. The aim was to create a space to display kitchens without directly simulating a domestic space.

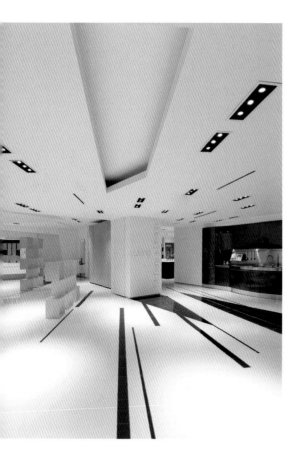

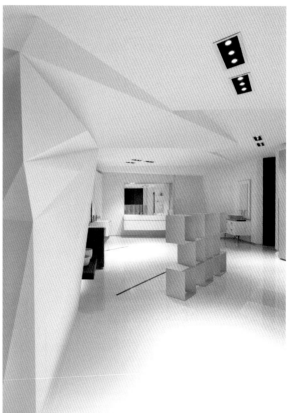

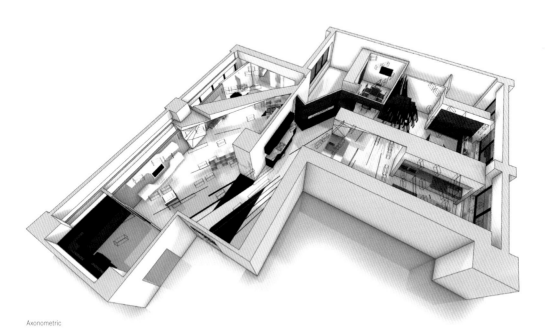

Axonometric

...art of the wall is covered with a special chalkboard finish to allow customers to leave messages, opening up a channel for communication.

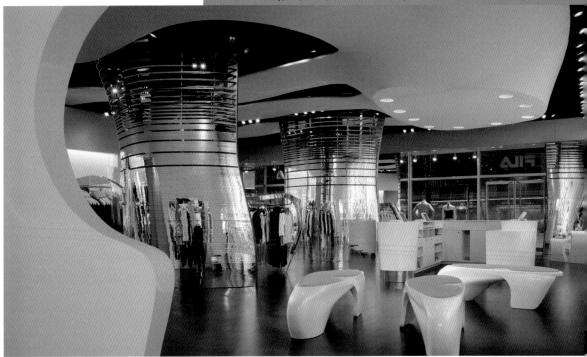

The sense of movement is the most important element in this store, which sells sports clothes and accessories. The store is presented as a fusion of natural materials, sophisticated silhouettes, and unexpected shapes. The furnishings evoke muscles in tension or in poses ready for physical activity.

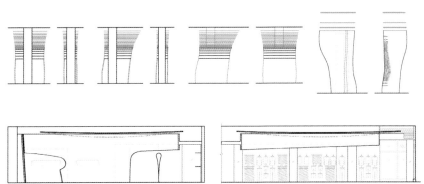

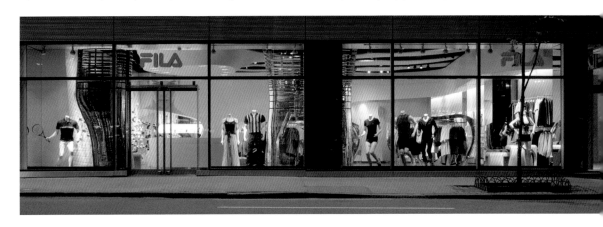

Elevations and sections

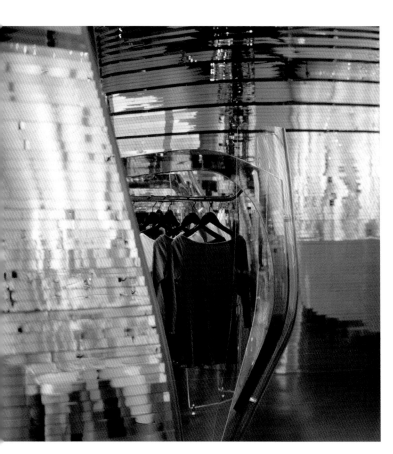

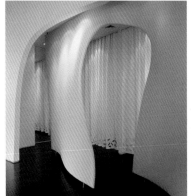

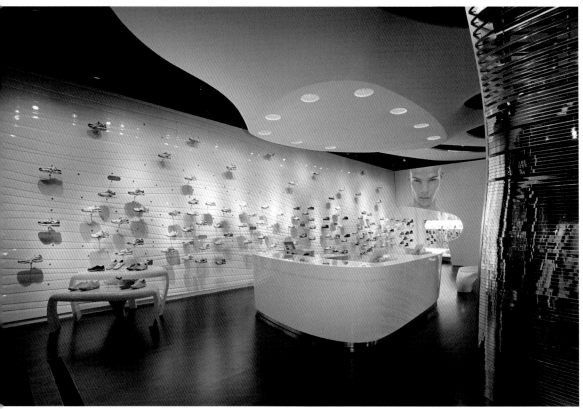

Two metal-covered ellipsoidal forms run around the inside of the store, wrapping around the existing columns to reflect the surrounding environment.

Graft

© Graft

**Gregor Hoheisel,
Lars Krückeberg, Wolfram Putz,
Thomas Willemeit**

Heidestraße 50
10557 Berlin
Germany
Tel.: +49 (0)30 306 45 10 30
www.graftlab.com

Graft was founded in 1998 in Los Angeles, California by Lars Kruckeberg, Wolfram Putz, and Thomas Willemeit. Since then, they have opened offices in Berlin in 2001 and China in 2003 with Gregor Hoheisel as a partner in the Asian market. With architecture as the core activity, Graft has a strong interest in crossing boundaries between disciplines. This is reflected in the studio's expansion into areas such as exhibition design, product design, art installations, academic projects, and events in Germany, China, Russia, Georgia, United Arab Emirates, the United States, and Mexico. Their projects cover a wide range of buildings dedicated to art, education, housing, businesses, and institutions. Graft has won several awards in Europe and the United States.

Erics Paris Salon - Beijing Kerry Center
Beijing, China / 2007 / © Yang Di

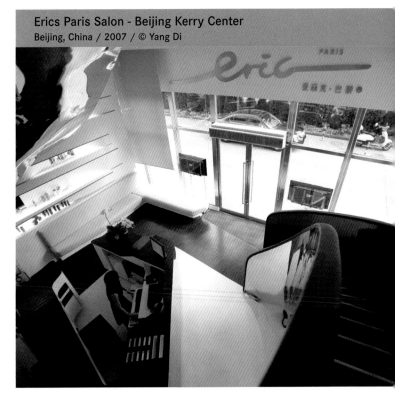

The refurbishment of this salon was responding to the need to connect the first floor containing the entrance, a store, and reception, with the second floor, where the salon space would be installed. To do this, a flowing staircase was designed linking the two spaces, creating a vertical runway.

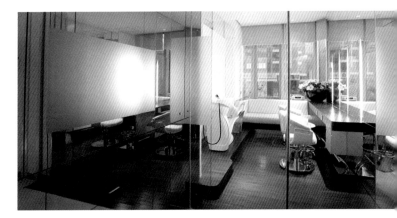

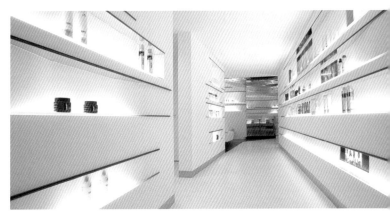

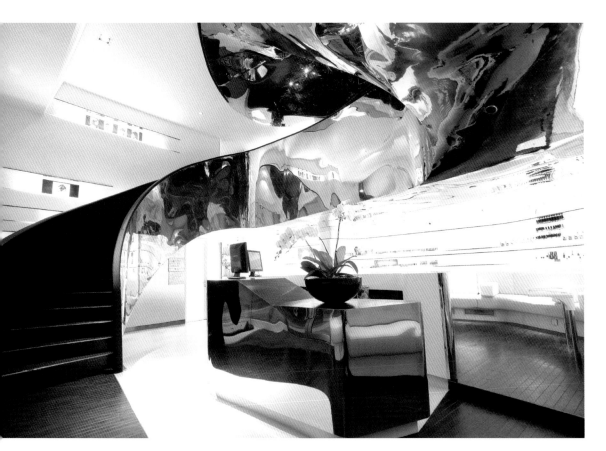

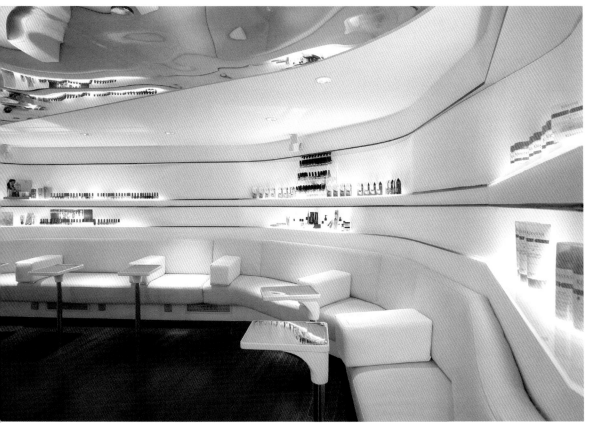

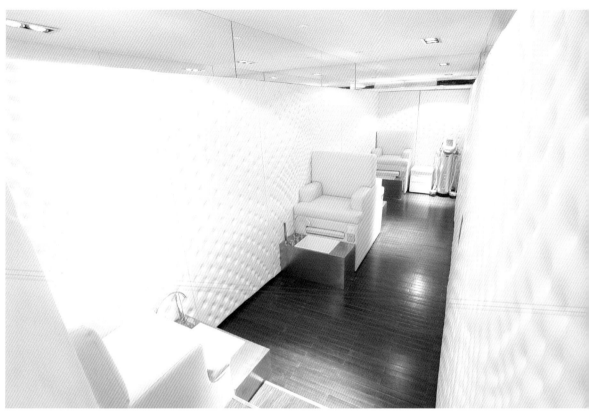

The pedicure and manicure areas are presented as galleries, while other areas have been concealed with walls lined in leather.

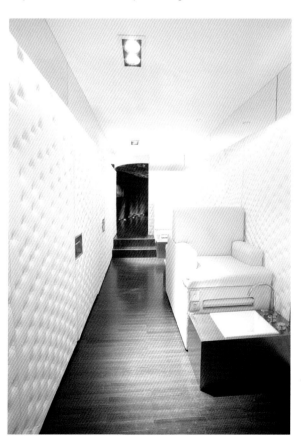

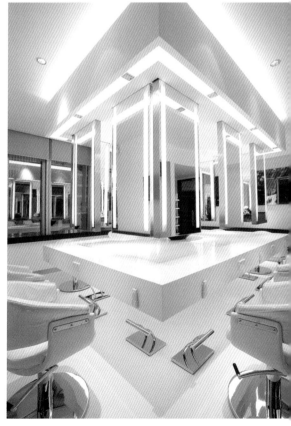

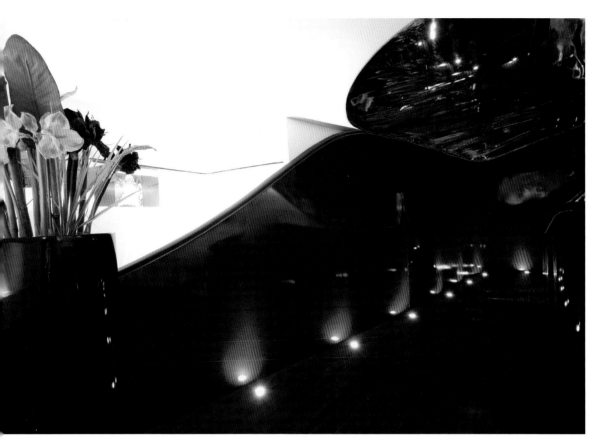

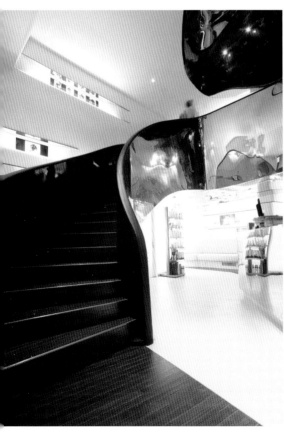

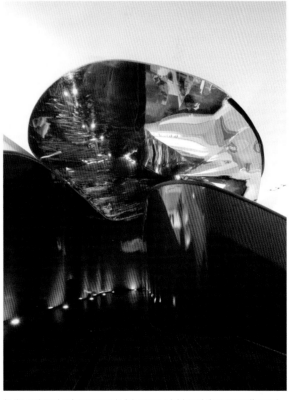

As the sculptural staircase ascends, it becomes a bright and sinuous metallic panel, until it morphs into a corridor that reopens on the second floor.

Ginko Bacchus Restaurant

Chengdu, China / 2009 / © Golf Tattler: Lai Xuzhu, Oak Taylor Smith

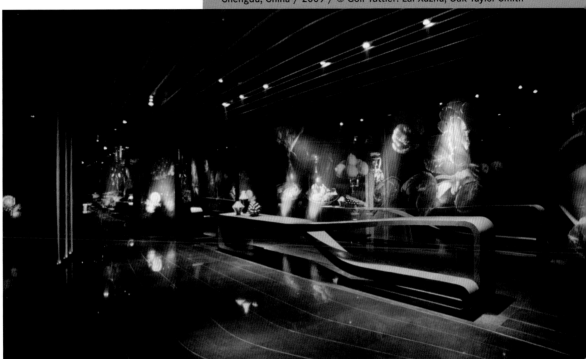

The starting point is a space that flows into a completely black 1,200 m² (12,916 ft²) area and ends in eight private dining rooms, each with a color code and an individual theme according to the food and different representations of the god Bacchus.

The undulating wood ceiling and drawings that form strips of stainless steel on the floor help to create a sense of flow in space. Tinted mirrors and reflective surfaces are also used to create a surreal atmosphere.

The food takes center stage and therefore it is a recurring decorative motif. High resolution images of simple products such as meat, vegetables, and fruits cover the surfaces.

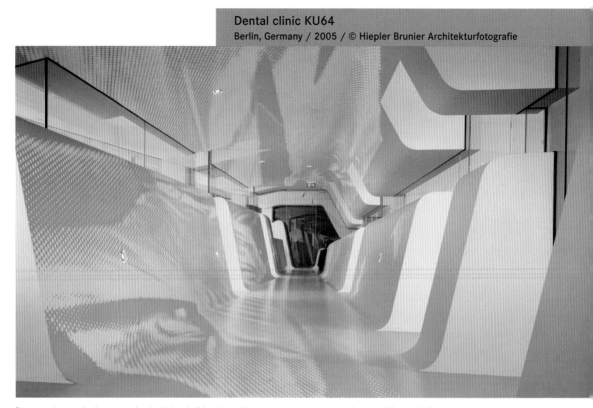

To counter the negative image associated with dental clinics, the architects created a space where patients could forget their fears and see it as a spa, designing a place where people might go for beauty or prevention treatments. The space is conceived as a landscape with dunes.

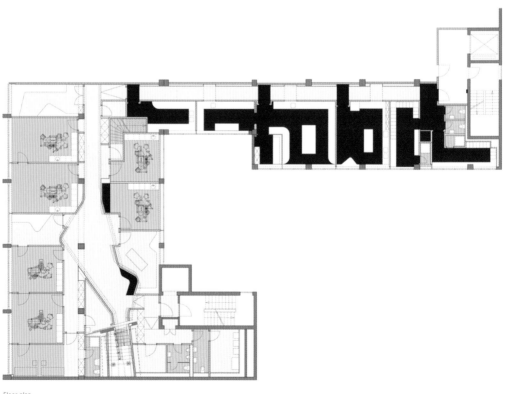

Floor plan

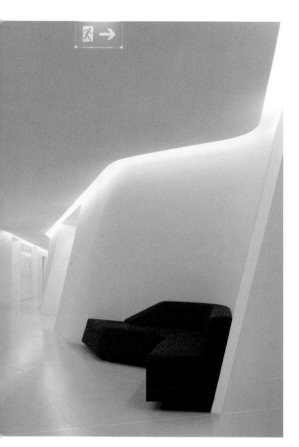

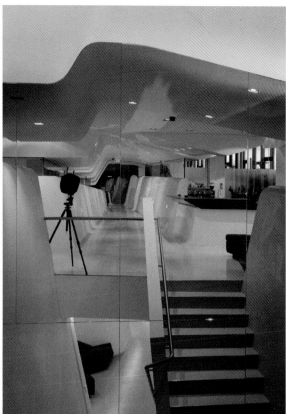

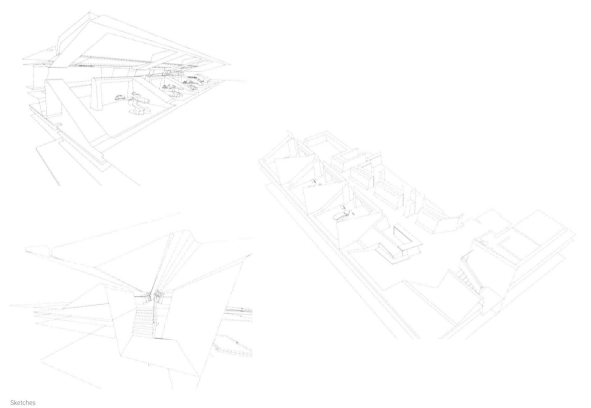

Sketches

The waiting room consists of a lounge which continues the concept of dunes, with integrated seating situated around a hanging fireplace.

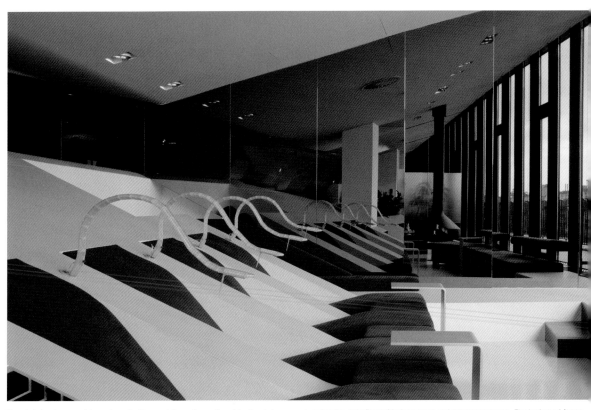

The clinic is a large sculpture where the floor and the walls continue into the staircase, connecting the main floor with the terrace and treatment spaces. The horizontal forms are transformed into walls, creating a center aisle.

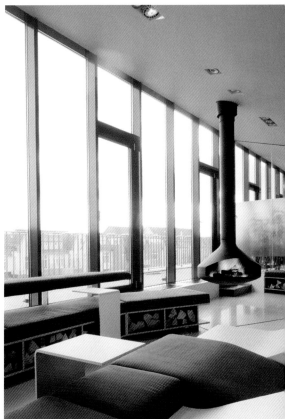

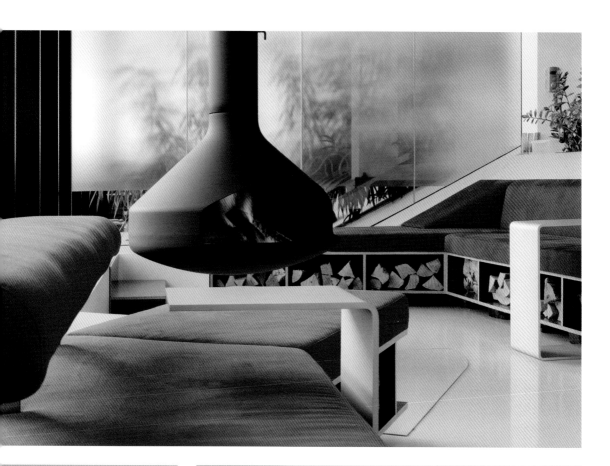

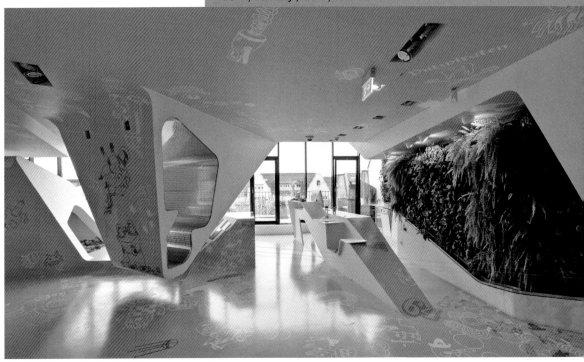

This extension of the adult clinic houses the treatment area for children and orthodontics for the general public. The concept of dunes that inspired the design of the main clinic is also extended to this space with the addition of a vertical garden.

 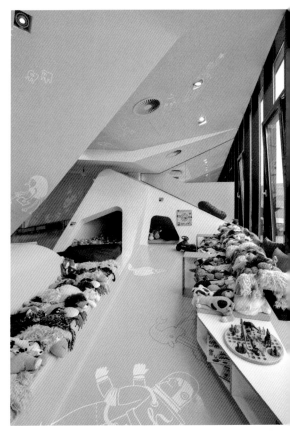

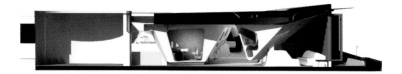

Sections

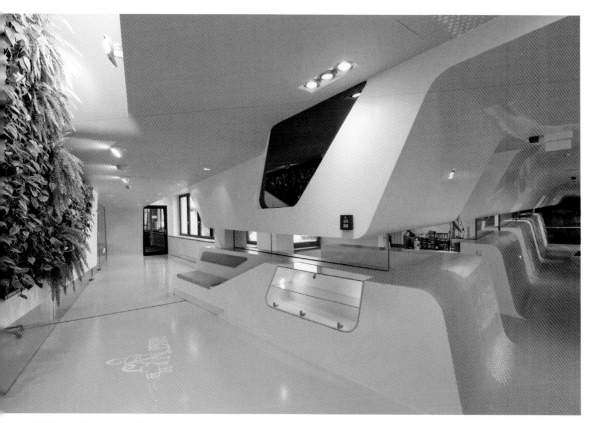

In some cases, the dune has been inverted to create play areas or private spaces.

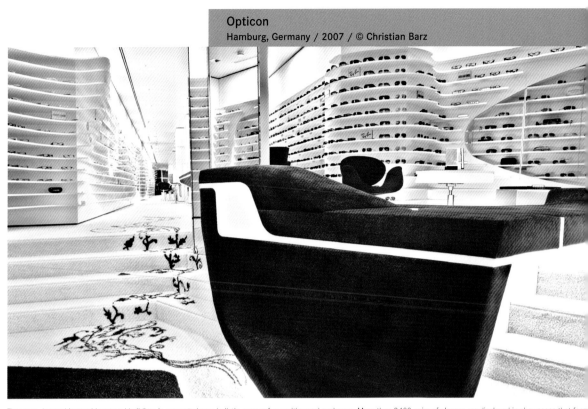

Opticon
Hamburg, Germany / 2007 / © Christian Barz

The store, located in an old restored building, is presented as a holistic space of exposition and exchange. More than 2,100 pairs of glasses are displayed in showcases that form an integral part of the design.

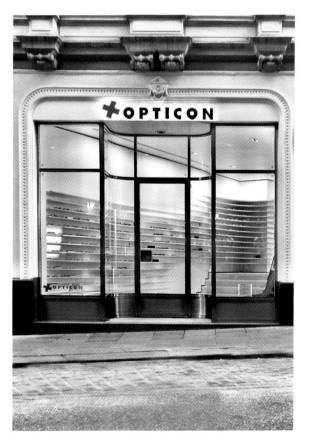

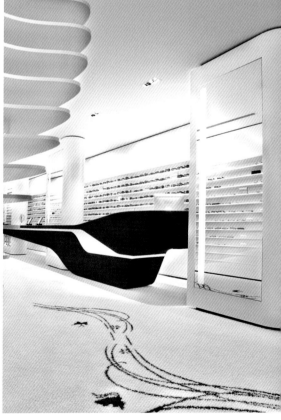

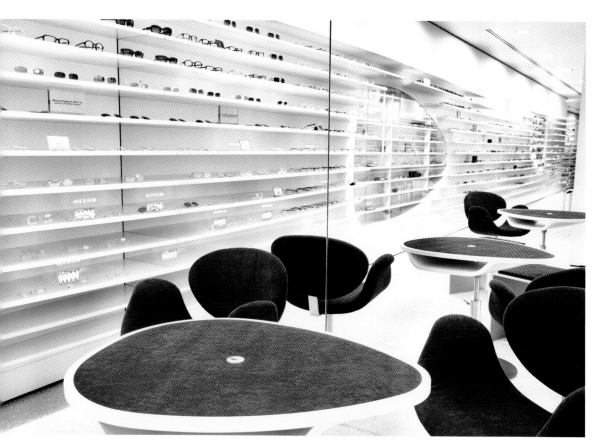

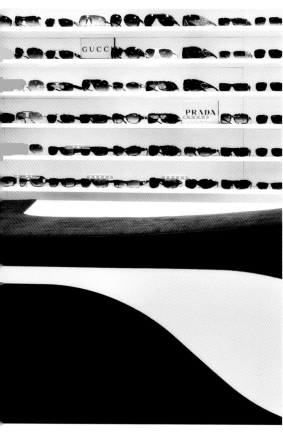

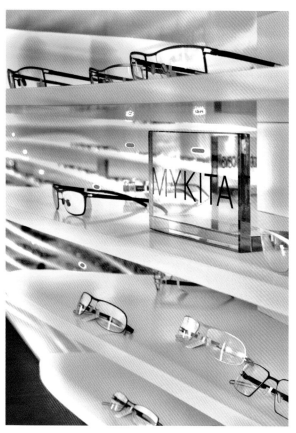

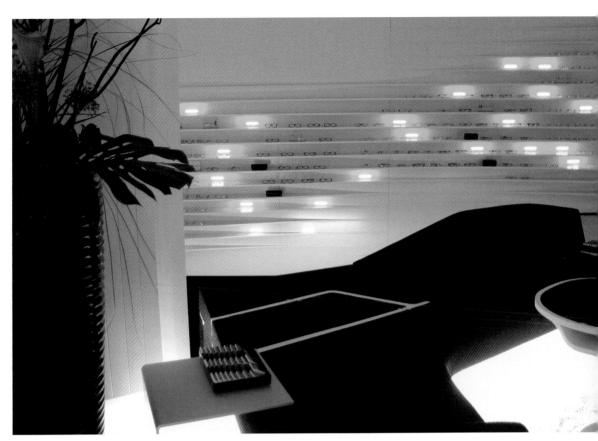

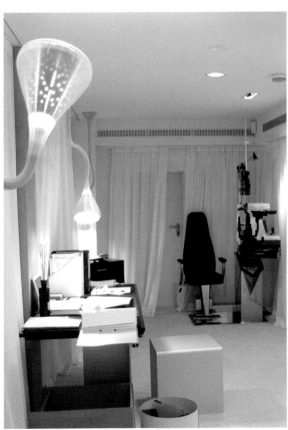

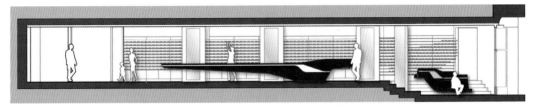

Section

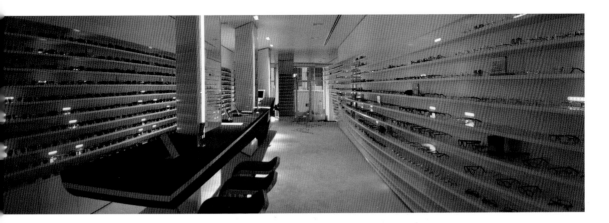

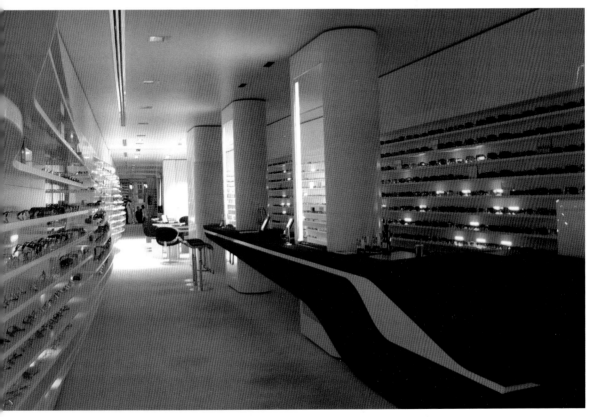

he curved walls widen and narrow the space and create versatile areas for shopping but also for events. Special lighting accentuates the curves.

Gudmundur Jonsson
Architecture office

Gudmundur Jonsson

Hegdehaugsveien 24
0352 Oslo
Norway
Tel.: +47 23 20 23 50
www.gudmundurjonsson.no

Gudmundur Jonsson Architecture was foun-
ded in 1987 after winning the contest for the
Icelandic Scandinavian Concert Hall. The stu-
dio addresses a broad spectrum of projects
in the field of architecture, interior design,
exhibitions, urban planning, and design. The
studio's most prominent projects in Norway
include the Hardangervidda National Park
Centre, Norveg Coast-Cultural Centre, and
the Norwegian Fjord Centre Geiranger, along
with the Weidemann-Gallery. Internationally,
it boasts Iceland's embassy in Washington,
Attached House in Malmö, Sweden, and the
library in Akureyri, Iceland, among others.

Norveg Coast-Cultural Center
Rørvik, Norway / 2004 / © Thomas Mayer/Erco Leuchten

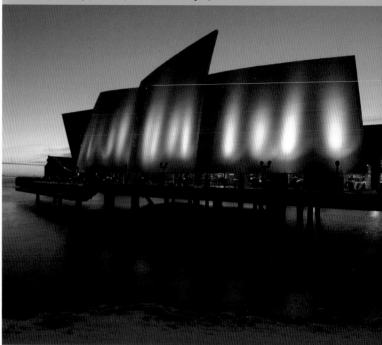

This cultural center is located in an area with a rich tradition of fishing and shipbuilding, all of which have served as
inspiration for the central idea of the design. The building was constructed following the image of three sails leaning
against a modern vessel, as a way to unite the past and present.

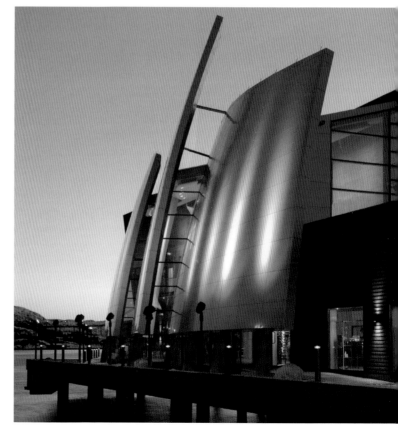

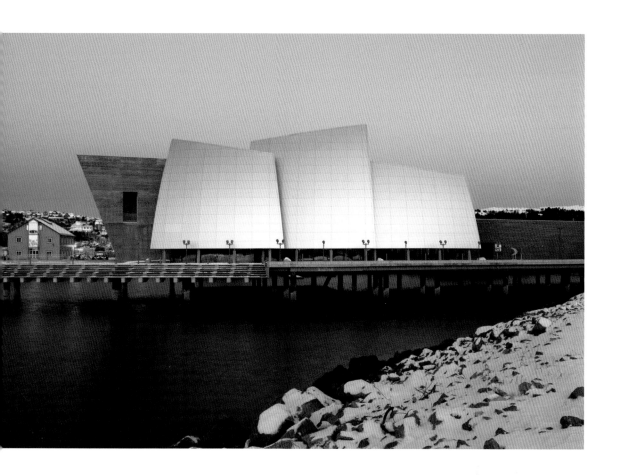

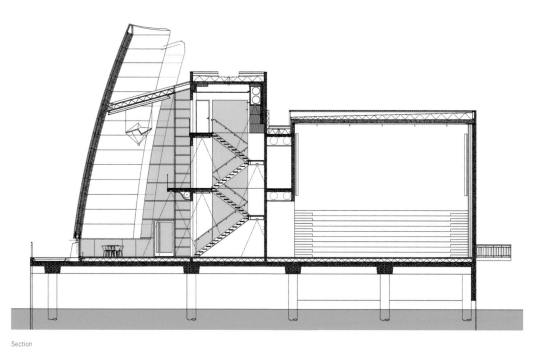

Section

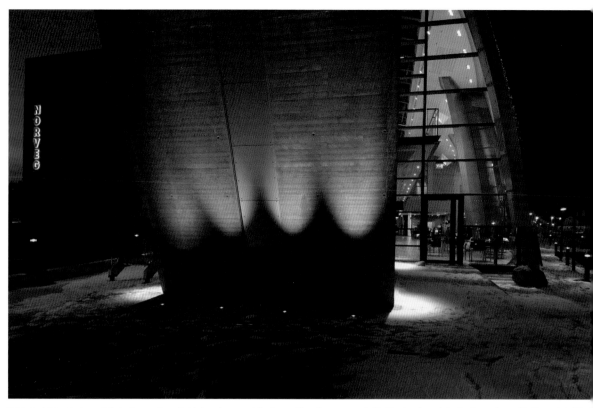

Because of the center's proximity to the sea, the materials have been carefully chosen. The sails are covered with Alucobond panels to give them a longer life. The main building is concrete, cast by horizontal formwork boards to allude to the ship.

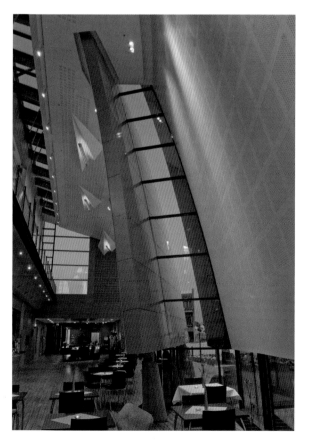

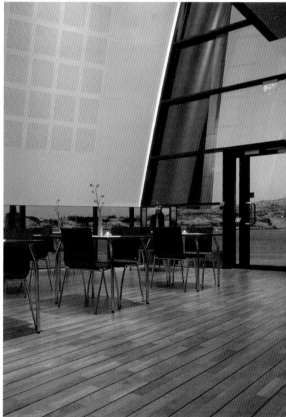

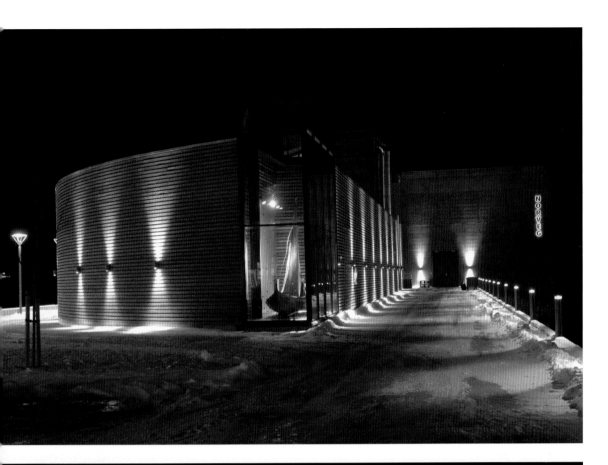

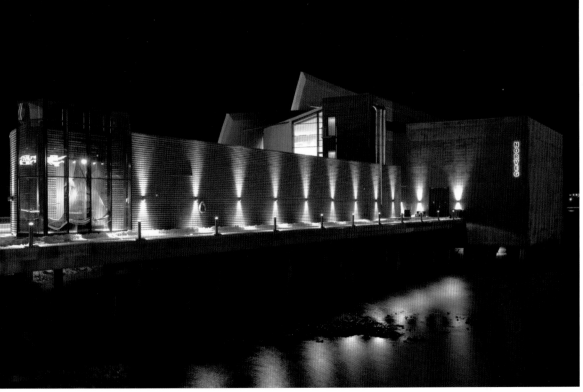

he building is 1730 m² (18,620 ft²) and is comprised of a central building and the sails that cover the lobby, restaurant, and temporary exhibition hall. A structure, which ymbolizes the shore where the ship is docked, contains an auditorium.

The Ibsen Museum
Oslo, Norway / 2006 / © Jiri Havran

In the redesign of the interior of the museum, the architect wanted to create a fascinating and untraditional exhibition space that interprets the essence of Ibsen's literary work, a space that would be a representation of history right next to the apartment where the writer lived.

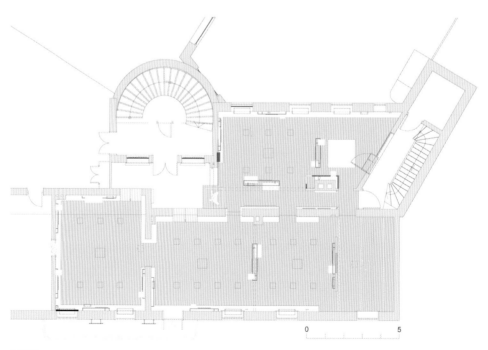

0 5

Floor plan

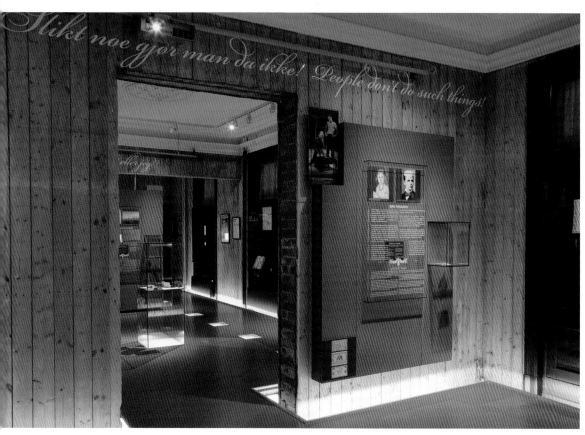

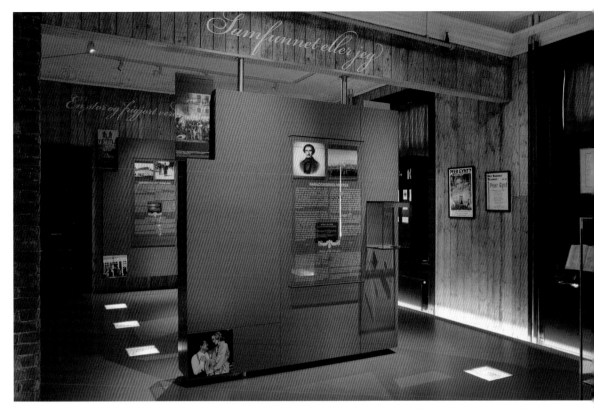

The deep red that is the natural color of the theater, dominates the whole space that is divided into "stops" or "stations." These points refer to a matter of Ibsen's authorship and displays objects of the writer related to the topic.

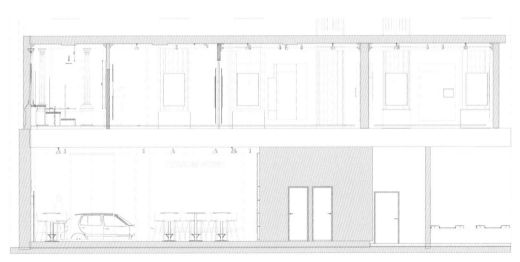

Section

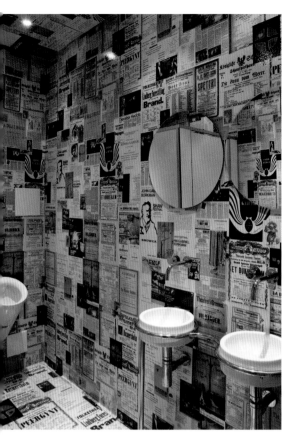

The bathroom is papered with old posters for theater festivals and premieres of works.

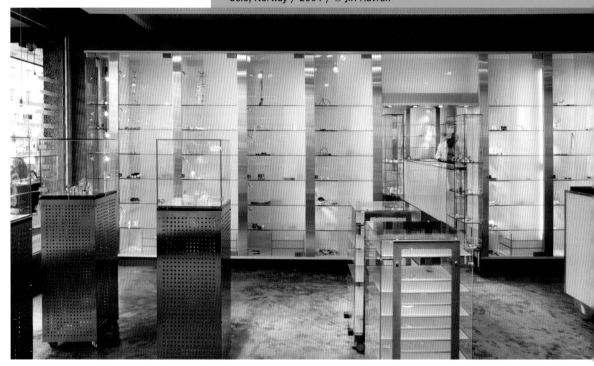

The expansion of the store responded to the need for more space for the exhibition of objects. This involved working the depth of space more so than the shop window towards the exterior. Windows that occupy all the peripheral walls were fitted, creating an increased sense of spaciousness.

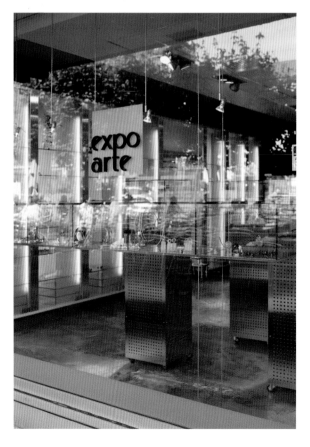

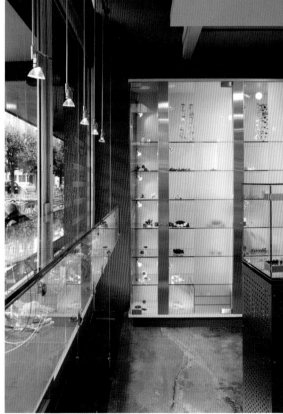

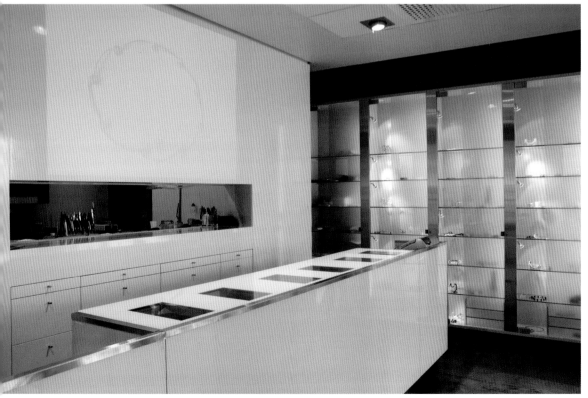

e main wall is white and shiny and serves as a projection screen for a multimedia show which reveals the latest jewelry designs available in-store. It is presented to the most portant jewelers in Europe.

Guillermo Blanco

Guillermo Blanco

© Pablo Pérez Mínguez

Begonia, 54
28900 Madrid
Spain
Tel.: + 34 655 92 17 30
Tel.: + 44 0 784 936 59 29
www.guillermoblanco.com

Although he was born in La Paz, Bolivia in 1958, Guillermo Blanco spent his childhood in London, where he studied and lived until the late sixties. He then moved to Madrid, where he graduated in Design and Decoration from the School of Decorative Arts and began working in the company Centro Decoración as a decorator, an occupation which he juggled with fashion design and the publication of publicity newspapers such as *Made in Ibiza Madrid* and *Ibiza Magazine*. In the eighties and nineties, he designed emblematic bars in Madrid and collaborated on hit movies. In the late nineties, he decided to devote himself exclusively to the field of high-end decoration. He works on decoration projects for private homes and yachts, as well as for stores, hotels, and restaurants.

Amarcord
Madrid, Spain / 2004 / © Yolanda Rodríguez

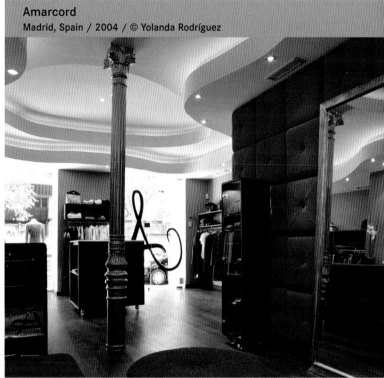

Actress Penélope Cruz wanted to open a store and commissioned Guillermo Blanco for the project. The guidelines given were the use of the colors strawberry and chocolate. Given the client's profession and the business' name, a famous Fellini movie, the designer created a very theatrical world—a pink space with dark wooden floors to make the clothes stand out.

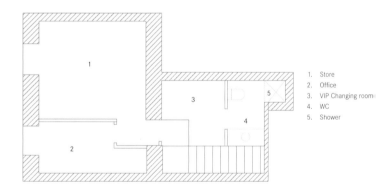

1. Store
2. Office
3. VIP Changing room
4. WC
5. Shower

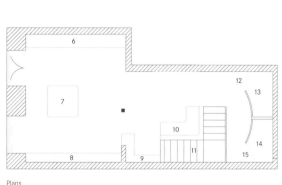

6. Window display 1
7. Showcase
8. Window display 2
9. Counter
10. Sofa
11. Stairs
12. Curtain 1
13. Changing room 1
14. Changing room 2
15. Curtain 2

Plans

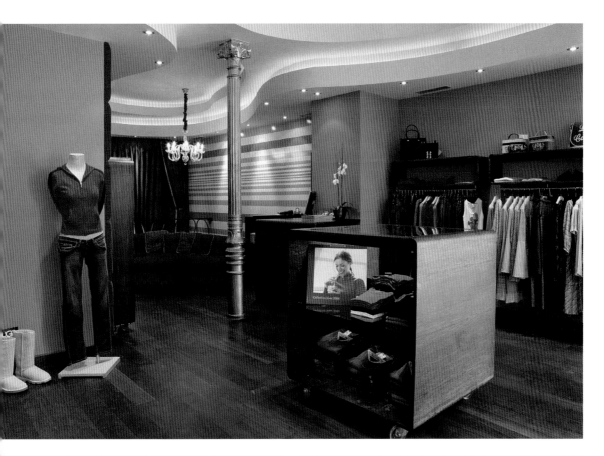

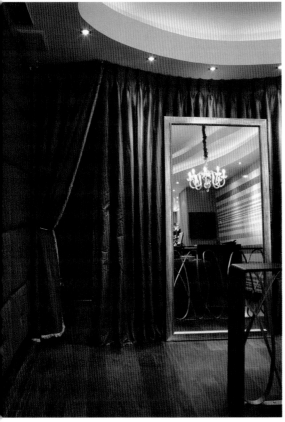

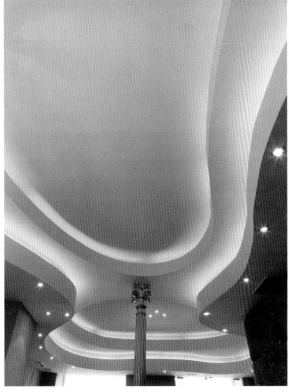

The curved lines of the ceiling, emphasized by the indirect colored lighting, are prominent features. The fitting rooms are reminiscent of theater boxes and curtains.

Spa Nixe Palace
Palma de Mallorca, Spain / 2006 / © Tito Bosch

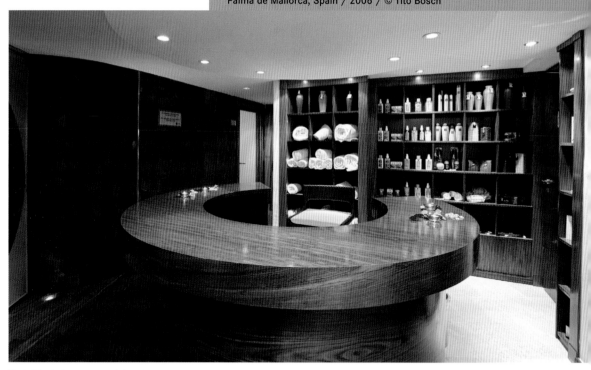

The Bolivian designer was commissioned to adapt the Hotel Nixe Palace and convert it into a luxury five star hotel. The bedrooms, gym, restaurant, banquet rooms, reception area, and spa were all redesigned.

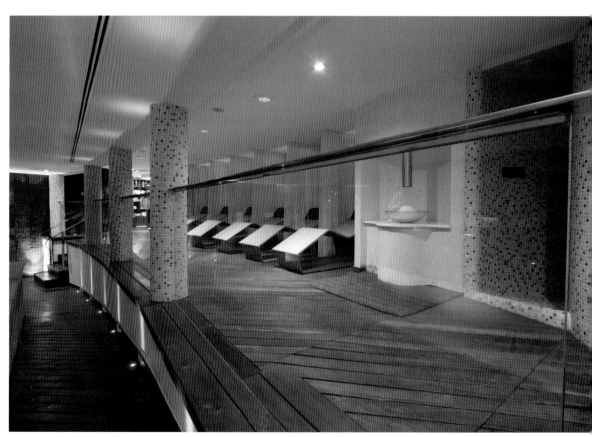

e rooms where the spa and relaxation treatments are carried out are distinctly Mediterranean. The light is diffused to create a relaxed atmosphere.

The spa was refurbished to create a clean space with sinuous forms. Different materials like travertine and glass mosaic were combined to encourage the rest of the users.

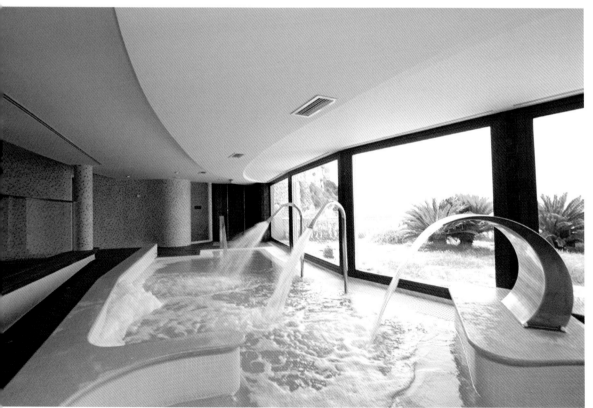

The pool area merges with the water treatment area through the use of palm trees and sand.

In 1992, the first store was opened in the center of Bilbao, which became one of the city's trendiest bars and a classic hot spot of Bilbao nightlife. After fifteen years of success, Guillermo Blanco was asked once again to design the new Kamin.

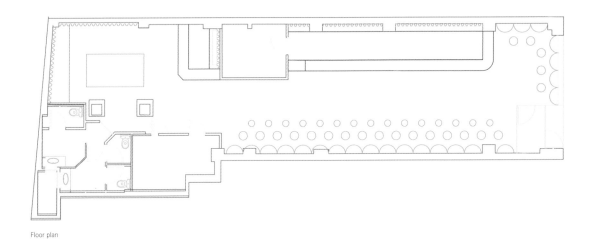

Floor plan

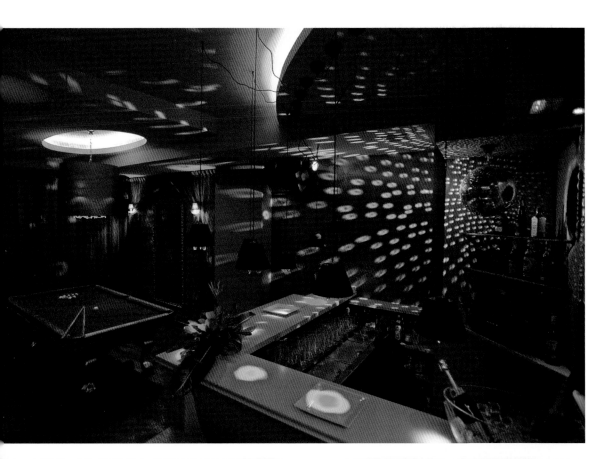

With a slight neo-Baroque style, the silver tones of the walls, ceilings, decoration, and upholstery stand out. The lighting adapts to the different times of the café and bar.

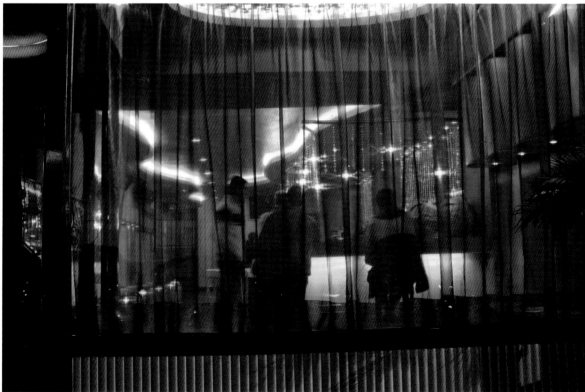

Lamps, sculpted glass curtains, and gold leaf on the pool table create a continuous contrast between the classical and the baroque. These details give a palatial touch to the linear structure.

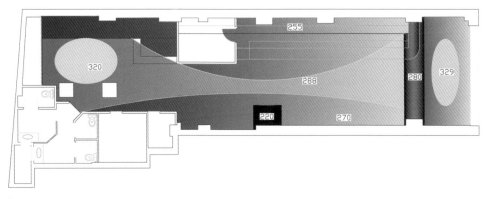

Floor plan

evation

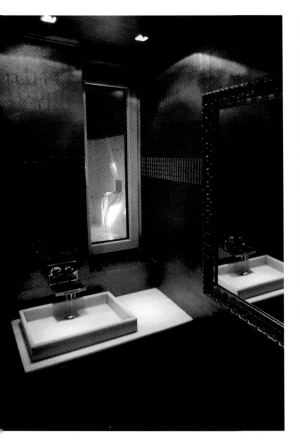

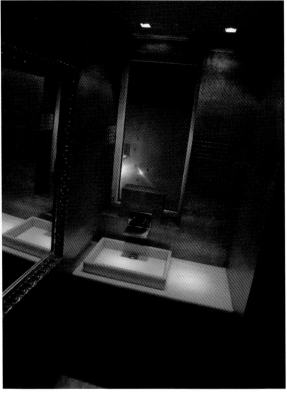

The floors are paved with graphite to create a neutral space between the grays and silvers of the rest of the décor.

HWKN

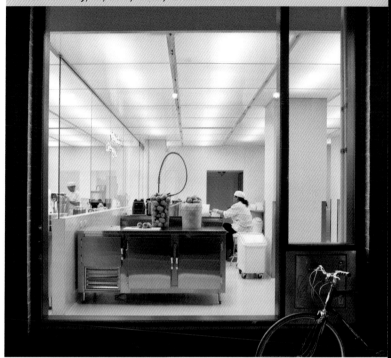

Il laboratorio del gelato Cooler
New York City, NY, USA / 2010 / © Michael Moran

© Andrew Loxley

Marc Kushner, Matthias Hollwich

For this project, which includes a retail space and processing area, a laboratory-style space was designed to work as a very bright and luminous backdrop against which colorful ice cream flavors can stand out.

200 Varick Street; Suite 507B
10014 New York
New York
United States
Tel.: +1 212 625 2320
www.hwkn.com

HWKN is a group of architects, designers, experts in social media, and inventors based in New York, working in the fields of architecture, urbanism, branding, digital media, and development.

The architecture of this studio, led by Matthias Hollwich and Marc Kushner, arises from an optimistic design approach incorporating all facets of contemporary culture to enrich and re-invent the profession.

In its projects, architects, producers and developers act as incubators. The group co-founded Architizer, one of the most important social media sites devoted to architecture. They also created BOOM, a community project in the U.S., and, more recently, they designed twelve of the tallest buildings in New Jersey, to be finalized in 2015.

The staff makes the ice cream in a space slightly elevated above the level of the public as a way to highlight their skills. The experience of buying an ice cream cone from Laboratorio del gelato Cooler is like leaning on the counter of an old pharmacy.

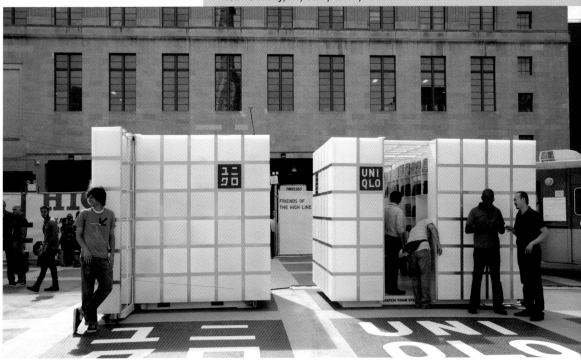

These cubes, which contain a temporary Uniqlo store, are located on "The Lot" at the end of the second phase of The High Line greenway on the west side of New York City. The structures have bright façades with simple shelves against which the colorfulness of the youth clothing brand stands out.

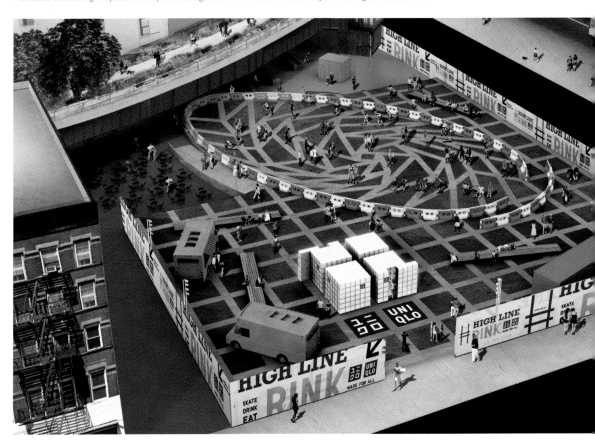

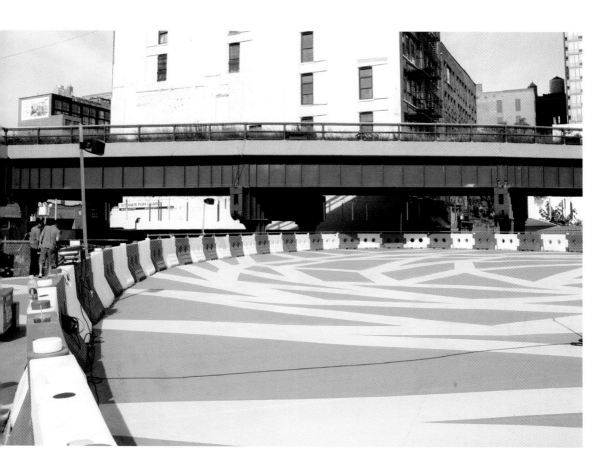

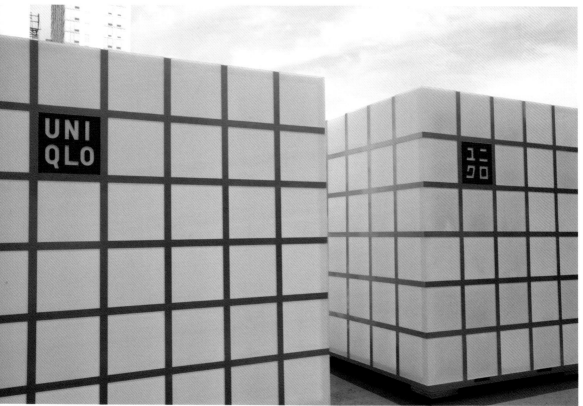

The drawing on the floor of the skating rink, which was also designed by HWKN, is a square grid on which the cubes sit perfectly.

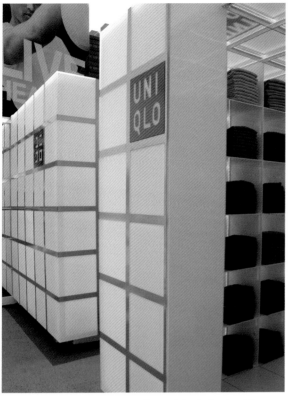

One part of the structure slides and opens like a vault door inviting the public to enter. At night, the cubes glow in the dark.

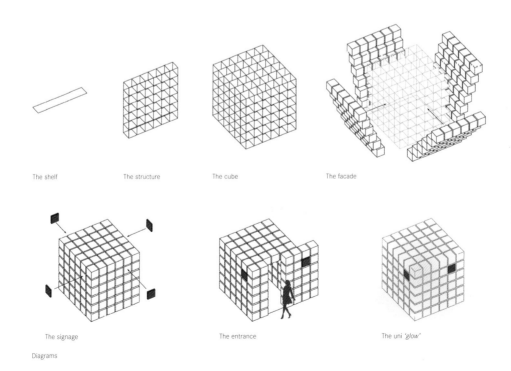

The shelf The structure The cube The facade

The signage The entrance The uni *'glow'*

Diagrams

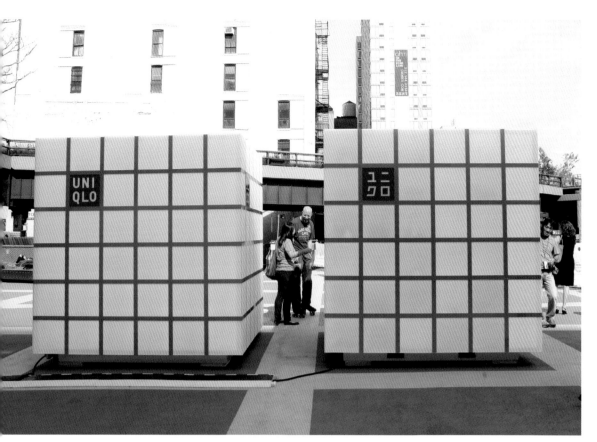

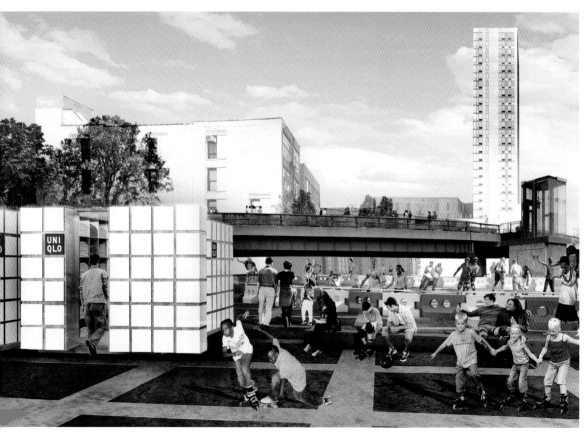

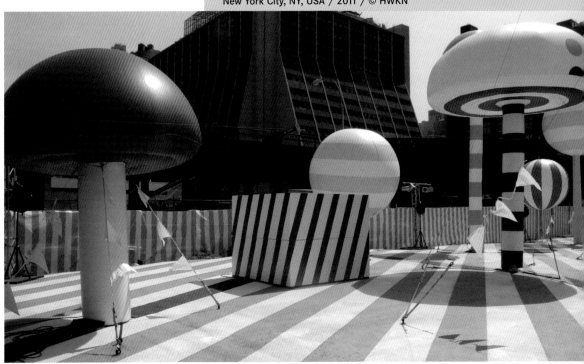

Boxer is a temporary store selling miscellaneous items in Rainbow City, a month-long art installation presented by AOL and created by FriendsWithYou, to celebrate the opening of the second phase of the New York High Line.

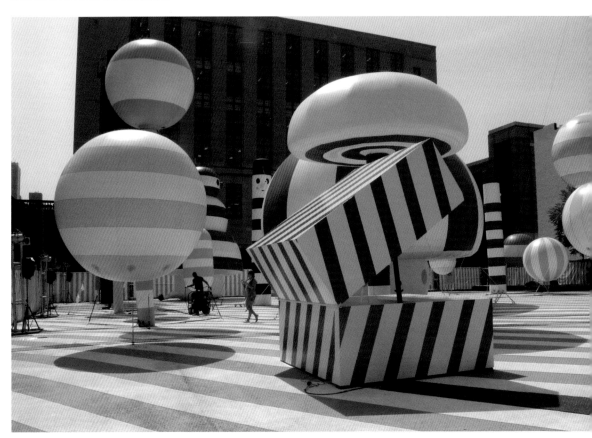

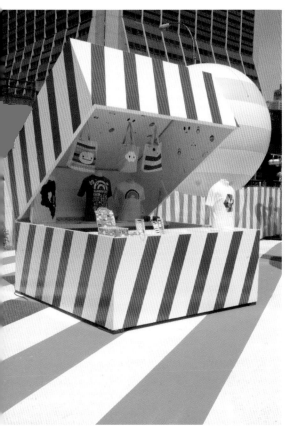

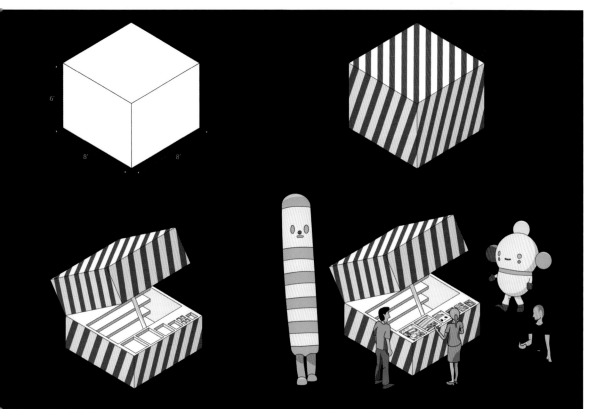

The box opens in the middle and the top part is raised revealing a counter and shelves.

Mini Roof NYC
New York City, NY, USA / 2008 / © Michael Moran

This temporary project was commissioned by BMW in the context of the campaign for its Mini Cooper and the desire for a creative use of space. The roof of a Manhattan building was used on which a stage for various activities was created, combining the natural with the artificial.

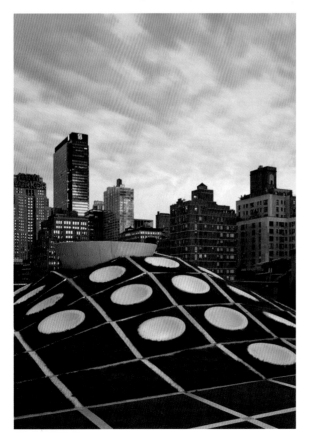

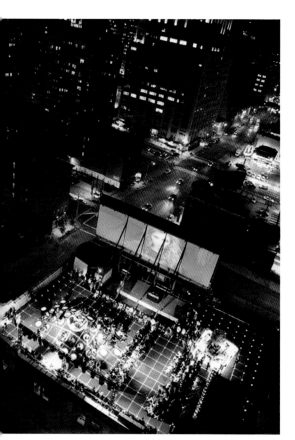

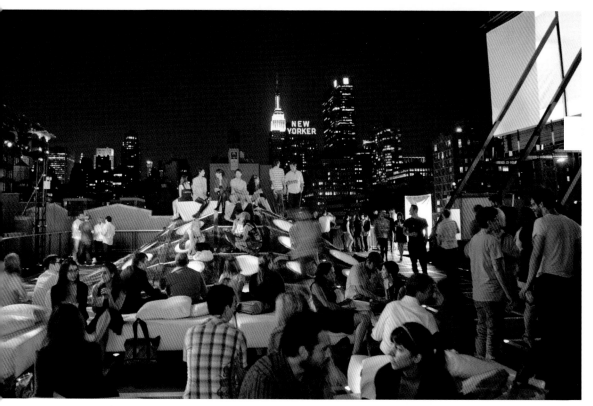

The grassy hill culminates in a structure that can be used as seating or a stage. Along with this structure a lighting tower and a panoramic bar overlooking the Hudson River was built.

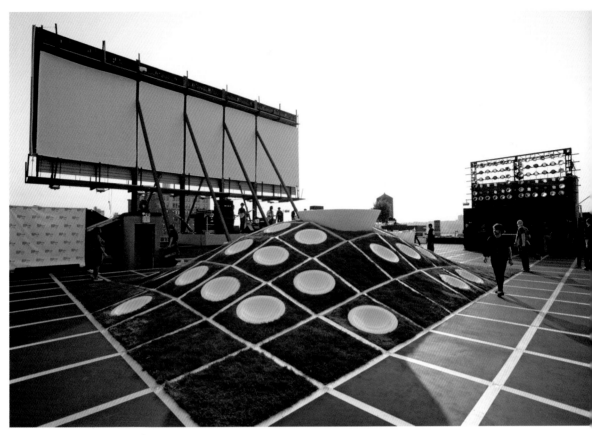

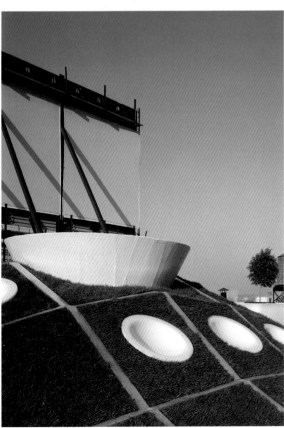

uring the ten day event, the floor was fitted with a LED carpet turning the surface into a programmable billboard.

Jean-Pierre Lott Architecte

Jean-Pierre Lott

31 rue Coquillière
75001 Paris
France
Tel.: +01 44 88 94 95
www.jplott.fr

Born in 1962, Jean-Pierre Lott graduated in 1988 from the University of Belleville in Paris. In 1999, the architect founded his own studio, which is devoted almost exclusively to public procurement. He is considered an architect that is highly representative of the new generation of specialists who define architecture with all that is most important: form, matter, spectacle, accessibility, and environmental respect in certain monumental beauty. The architecture studio has specialized in the construction of public buildings such as schools, kindergartens, universities, multimedia centers, police stations, and fire stations, among others.

Médiathèque Hugo Pratt
Cournon d'Auvergne, France / 2009 / © Jean Pierre Lott Architecte

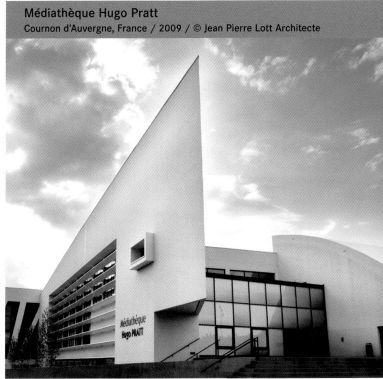

The land where the multimedia center was built, led the architecture studio to create two levels for the open public space. The double height lobby and conservatory gave unity to the project and established a simple relationship between the remaining parts.

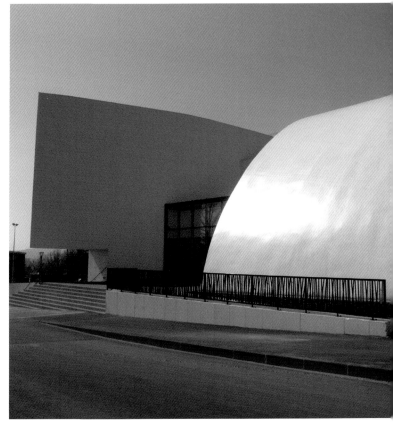

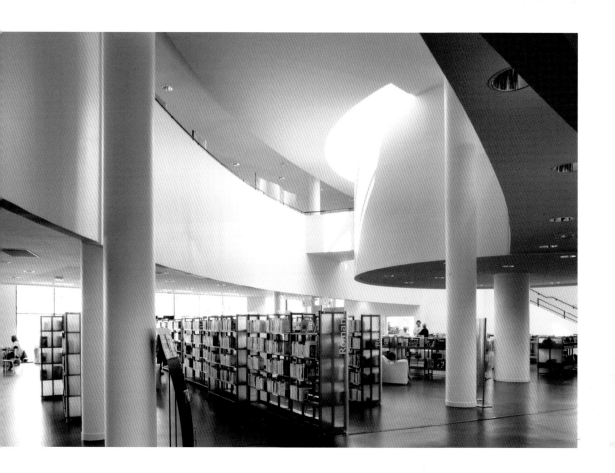

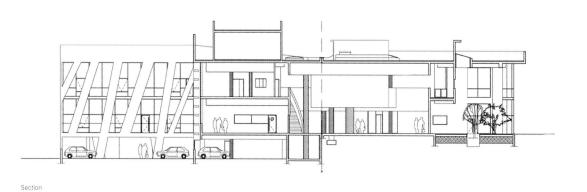

Section

The main hall has become the focal point and links every part of the library, besides being the starting point for other spaces. All reading rooms face the gardens, and an underground garage was built to keep the space around the entrance clear.

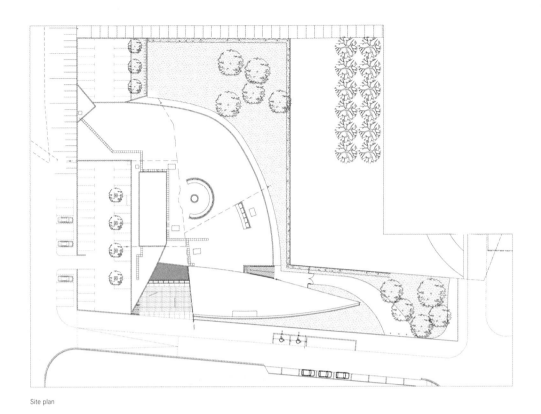

Site plan

The building's architectural style is contemporary and has become an influential image to the institution. The reception is located on the first floor and is accessible from the plaza located at the entrance. The remaining spaces are divided by the youth sector, which occupies a large part of this floor.

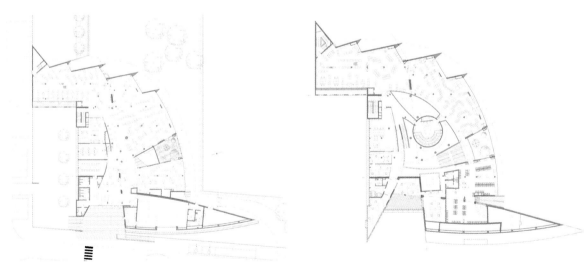

Plans

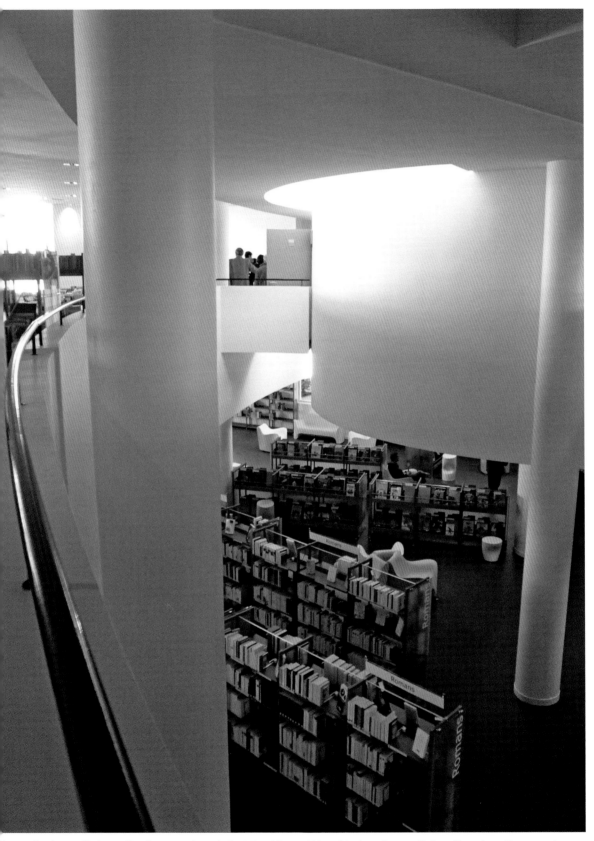

The upper floor is accessible from a wide staircase or an elevator leading to the adult area, which consists of a reading area with views of the garden, a video room, and administration offices.

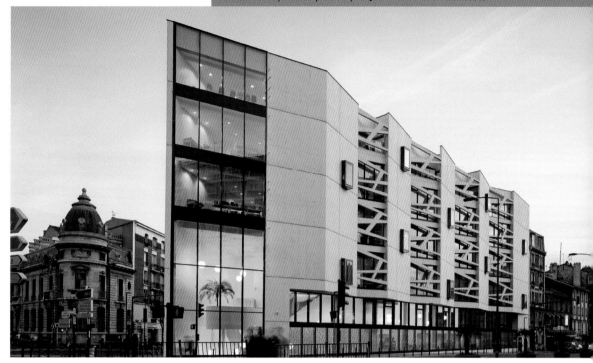

In the city archives, near the town hall, a multimedia center has been created. Due to its special location, the building has attracted considerable popular interest. The orientation of the plot conditioned the main façades to be exposed to the East and West. The project also required a specific work in search of light.

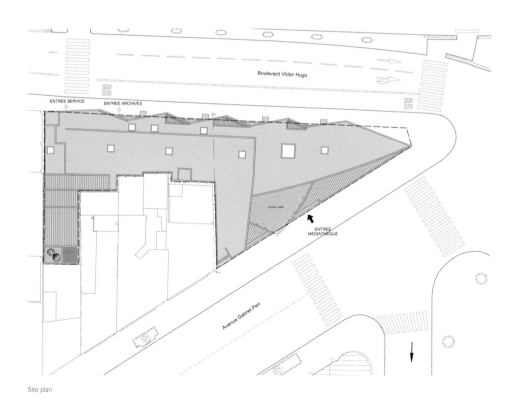

Site plan

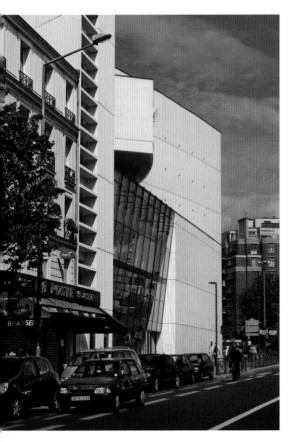

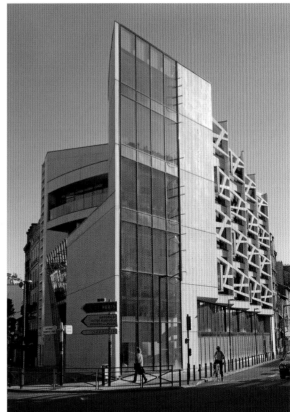

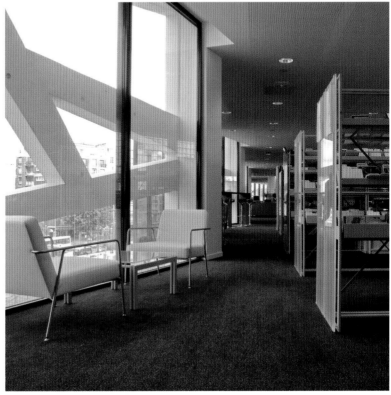

The building consists of four levels and two underground floors. They are home to the auditorium, the press and work areas, entrance hall, library, store, and archives.

KLAB Architecture

Konstantinos Labrinopoulos

© KLAB Architecture

2 Achaiou str. Kolonaki
106-75 Athens
Greece
Tel.: + 30 210 3211155
www.klab.gr

Konstantinos Labrinopoulos, born in 1970 in Athens, graduated in architecture from the National Technical University of Athens in 1994. He then continued his studies in the United States where he obtained a Master's Degree in Advanced Architectural Design at the Southern California Institute of Architecture in Los Angeles in 1996. After working as a freelancer from 1998 to 2001, he created KLMF in partnership with the architect Miltos Farmakis. In 2007, when the partnership came to an end, the company was renamed KLAB (kinetic lab of architecture). Today, the studio is a highly qualified international group of architects with the motivation to seek out opportunities for unique creations and urban integration.

Androkinos Hotel
Mikonos, Greece / 2010 / © KLAB Architecture

The architectural studio was commissioned to redesign this old hotel to transform it into a sculpted interpretation Mykonos town. It is a modern version of the vernacular architecture of the Cycladic islands—the spiral staircase ar ramps lead down to the pool, creating a theatrical scene.

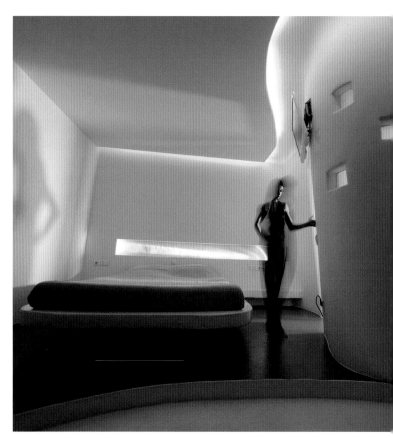

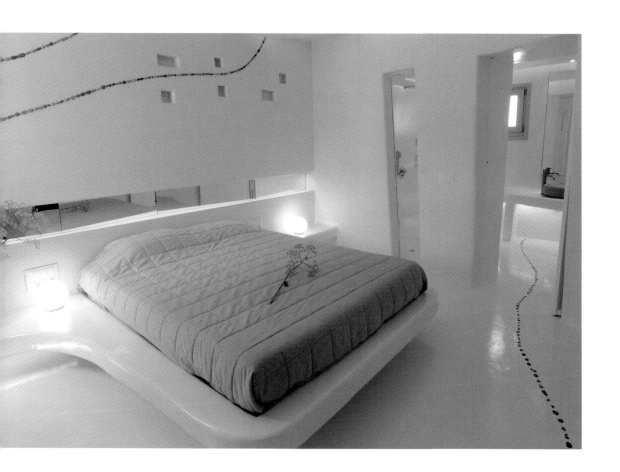

Rendering

The bedrooms are designed as harmonious private rooms with continuity to the external spaces.

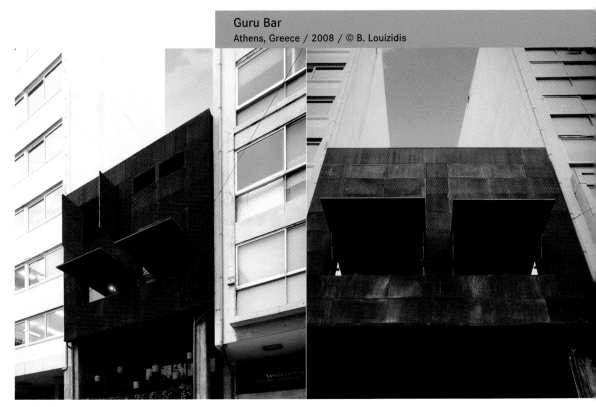

Guru Bar
Athens, Greece / 2008 / © B. Louizidis

Located in the Psiri district of the Greek capital, the bar has become one of the most fashionable bars and restaurants in the city, particularly for those involved in the arts. The renovation created additional floor space, a new façade, and it reconstructed the upper floor.

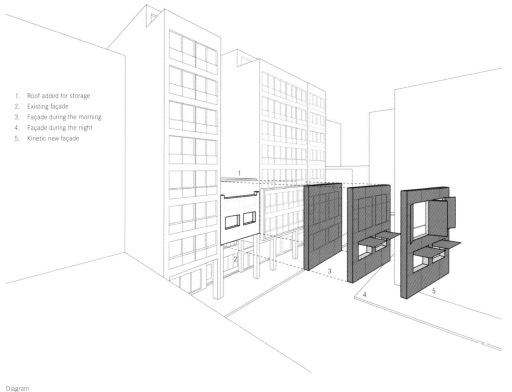

1. Roof added for storage
2. Existing façade
3. Façade during the morning
4. Façade during the night
5. Kinetic new façade

Diagram

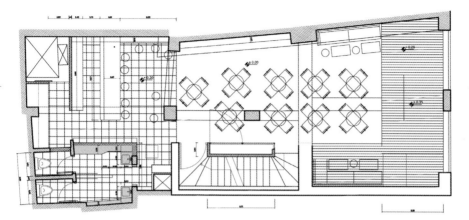

Floor plan

Working on a tight budget, the designers created an oxidised steel skin which is closed during the day and can open at night.

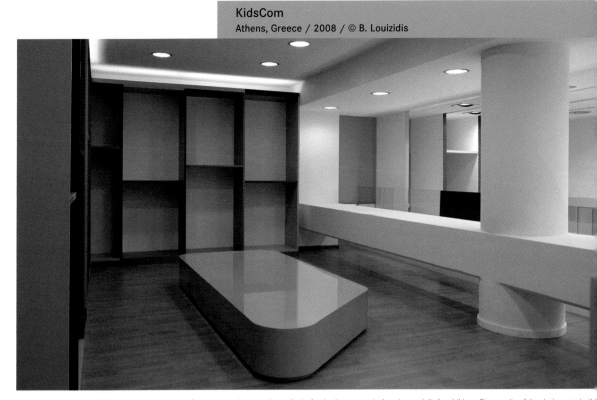

The project given to the KLAB architects was to transform an everyday store into a lively, fascinating space designed especially for children. The novelty of the design was in the creation of a space that avoids the typical clichés for children.

Mezzanine plan

Ground floor plan

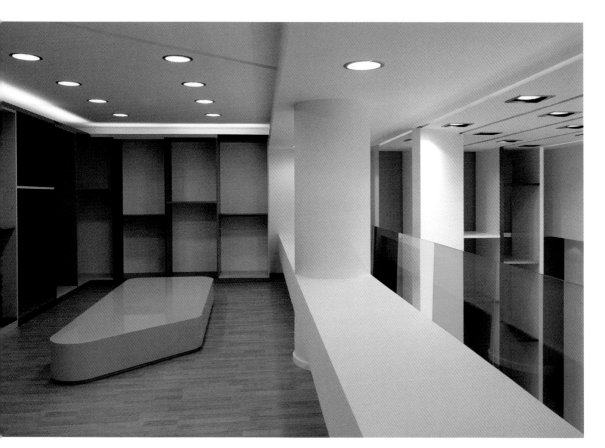

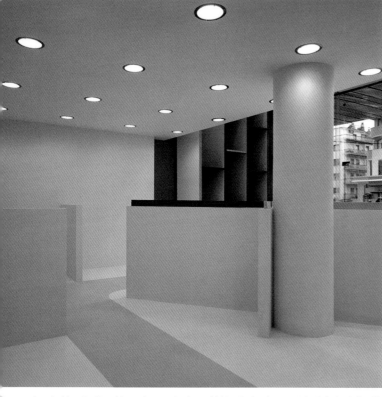

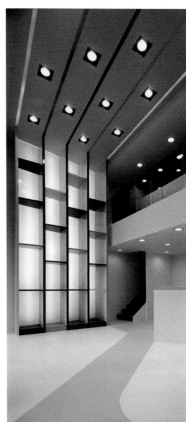

The space is a playful exploration of lines, planes, and volumes. Light and color play a central role in the design. The edges are curved to soften impacts from accidental bumps.

Koukaki Pharmacy
Athens, Greece / 2010 / © KLAB Architecture

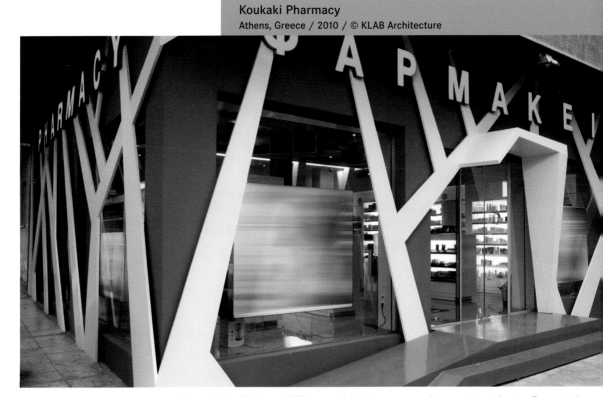

In Koukaki, one of the oldest districts in Athens, close to the Acropolis Museum, KLAB was commissioned to create a new pharmacy and cosmetics store. The property is located on the ground floor of an apartment building.

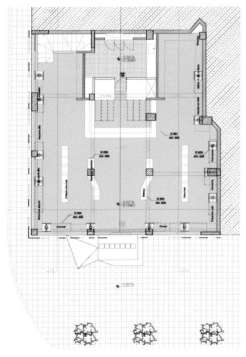

Ground floor plan

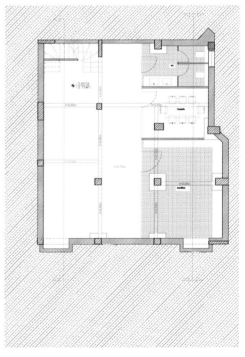

Basement floor plan

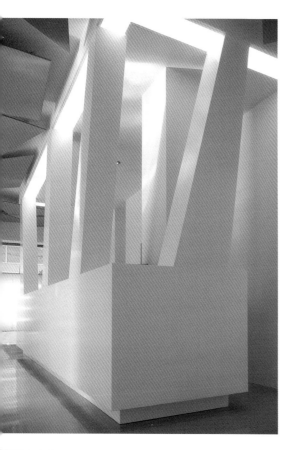

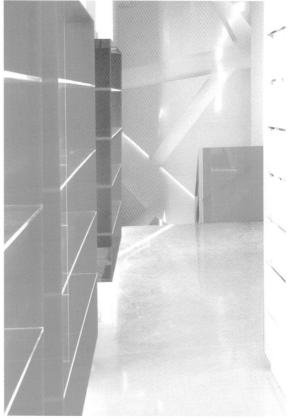

The leitmotiv is nature living side by side with technological innovation to create pharmaceuticals and cosmetics.

The aim of the architects was to create a striking façade that would stand out from the rest of the buildings in the district. Inside, emphasis was given to the ceiling and column built from exposed concrete, representing a forest. The reception area is the nerve center of the store.

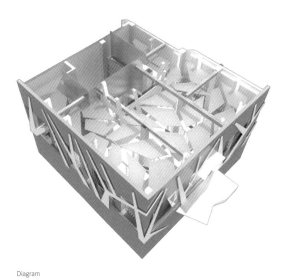

Diagram

Roof plan

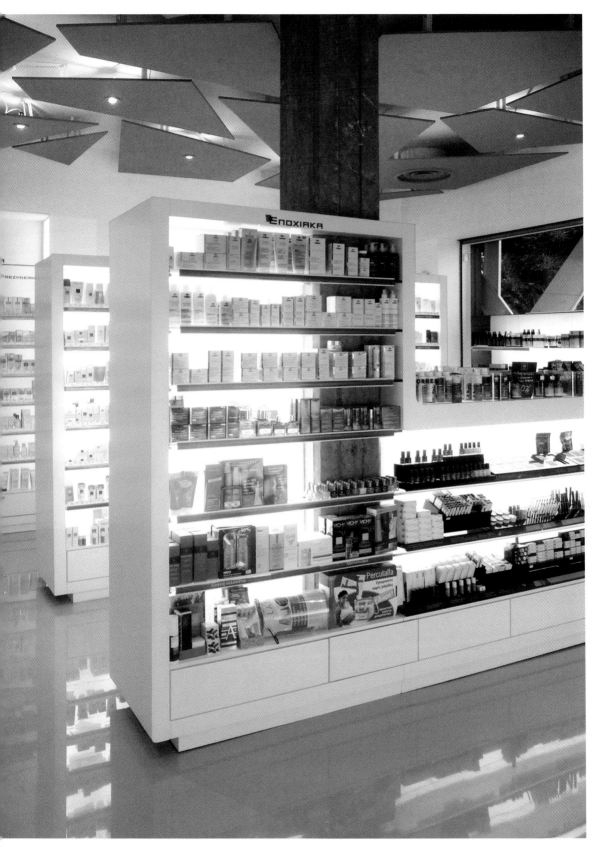

Plexiglass and painted white shelves were designed by KLAB to create a unique atmosphere. A metal staircase leads to the ground floor where there is a laboratory area to create the formulas, as well as offices. The lighting is designed to create ever-changing plant forms.

Placebo Pharmacy
Athens, Greece / 2010 / © P. Kokkinias

The octagonal shape of an existing structure was refurbished into a cylinder to house a 600 m² (6,450 ft²) pharmacy. This rounded shape is designed to create a spiral that aim to enter into a dialogue with the fast-moving Vouliagmenis Avenue, the adjacent urban transit way.

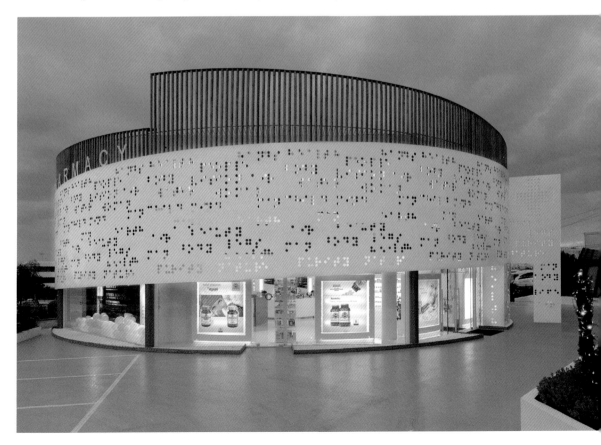

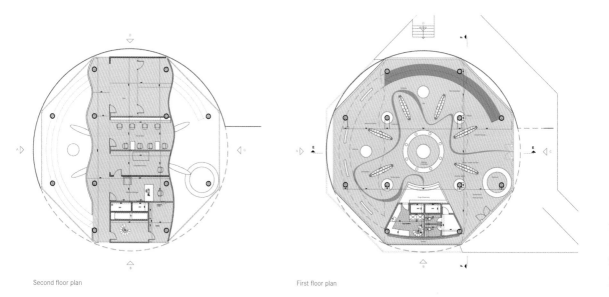

Second floor plan

First floor plan

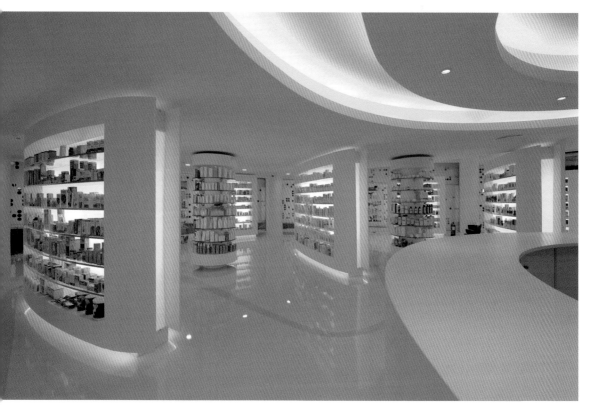

The pharmacy is located on two floors: the ground floor is used for the main store and the first floor is used as offices and a meeting area. Special attention was made to the counter and drawers, which act as focal points, drawing the eye to the central area of the store.

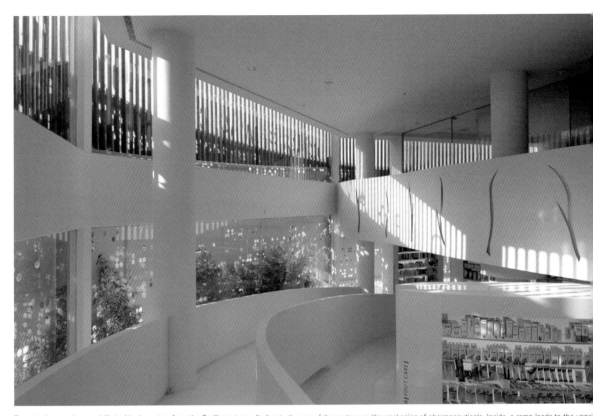

The exterior panels were drilled with characters from the Braille system, alluding to the use of the system on the packaging of pharmaceuticals. Inside, a ramp leads to the upper level and extends the dynamism of the exterior spiral into the interior space.

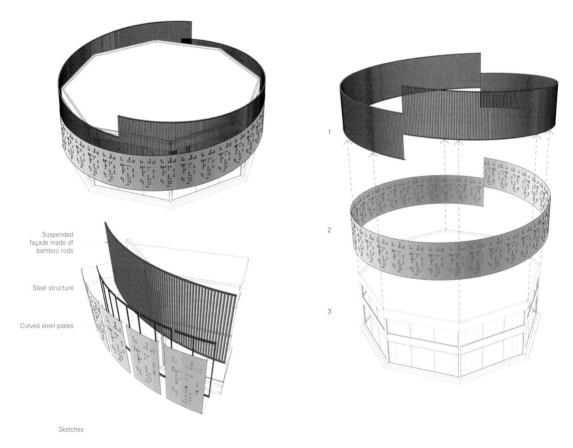

Suspended façade made of bamboo rods

Steel structure

Curved steel plates

1

2

3

Sketches

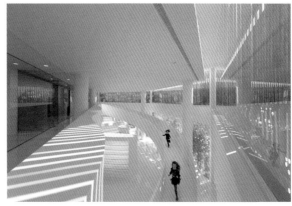

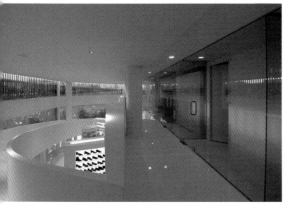

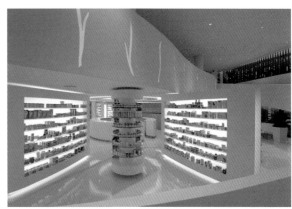

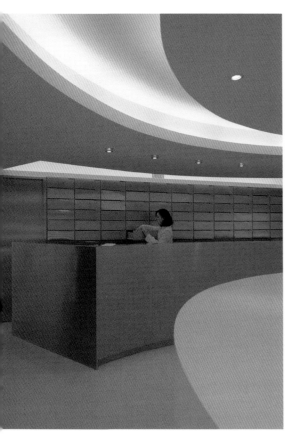

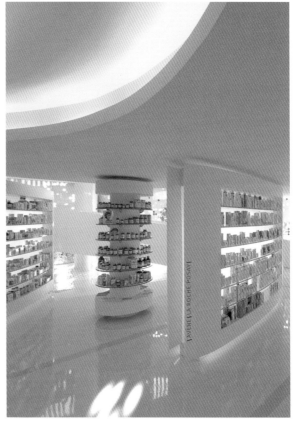

LOVE architecture

Bernhard Schönherr, Mark
Jenewein, Herwig Kleinhapl

Hans Sachsgasse 8/2
8010 Graz
Austria
Tel.: +43 316 81 01 06
www.love-home.com

The architecture and town planning studio
LOVE was founded in 1997 by Mark Jenewein,
Kleinhapl Herwig, and Bernhard Schönherr.
LOVE is committed to developing intelligent
and innovative solutions. It has projects in
Austria, Japan (Webasto's Headquarter), Unit-
ed States, South Korea (Silver World master
plan) and Germany (Baufeld 10, HafenCity).
The studio has won competitions such as the
Masterplan Silver World, the Alpenstrasse
Shopping Center, the Grand Holiday Hotel
complex, the Baufeld 10, HafenCity, and the
Gerngross Shopping Center. It has also been
awarded several times and invited to take part
in international competitions. In 2003, the
same partners created the label Brandfield,
dedicated to developing branding concepts,
marketing, and identity strategies.

The new Gerngross
Vienna, Austria / 2010 / © Bruno Klomfar, Jasmin Schuller

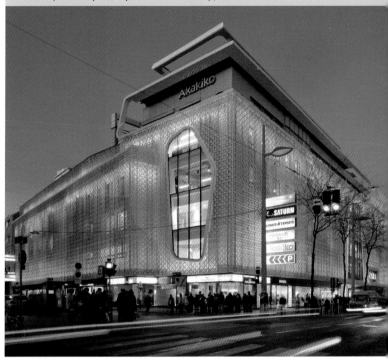

In this shopping mall, the architects worked on the distribution of the space, which was chaotic and confusing
before the remodeling. The atrium and its network of stairs has become the main reference point of the building.

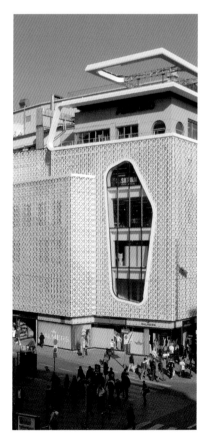

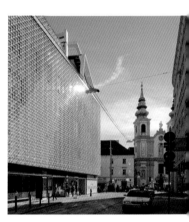

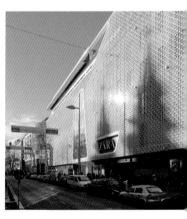

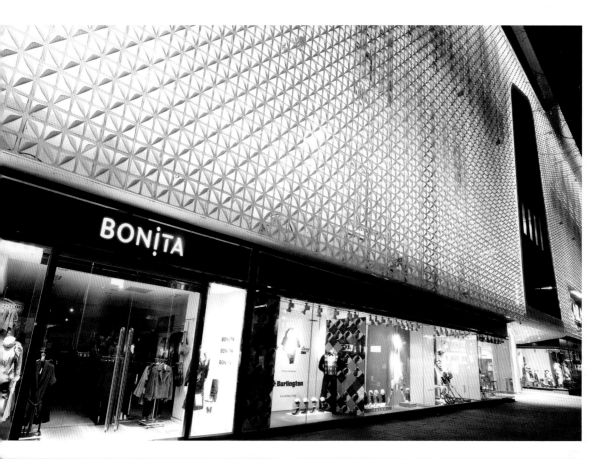

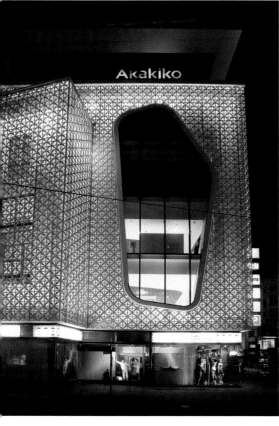

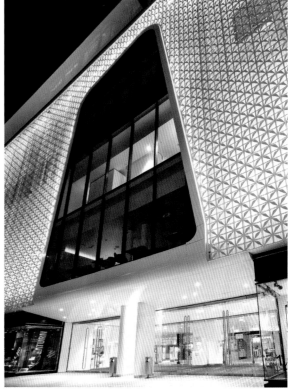

The façade is covered with an ornamental exterior that at night stands out thanks to its lighting.

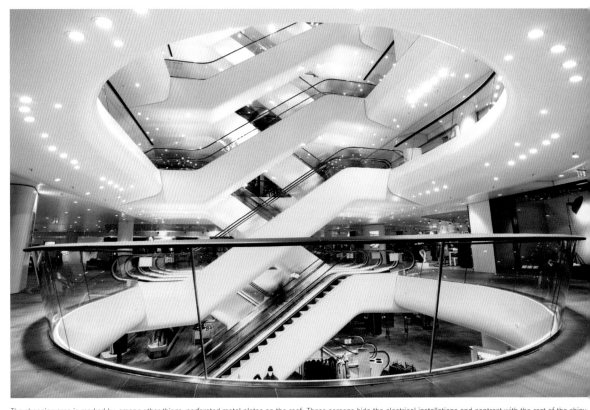

The shopping area is marked by, among other things, perforated metal plates on the roof. These screens hide the electrical installations and contrast with the rest of the shiny, reflective surface of the roof.

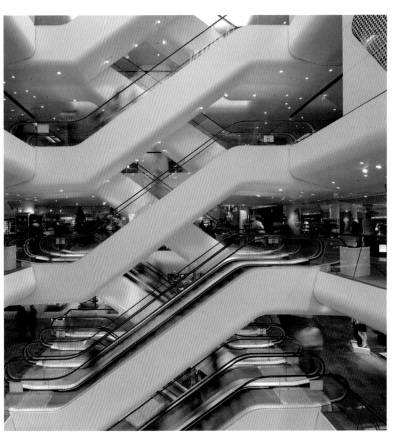

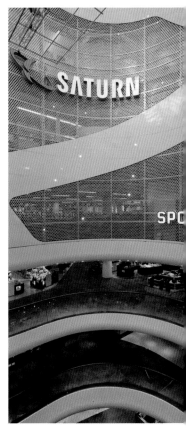

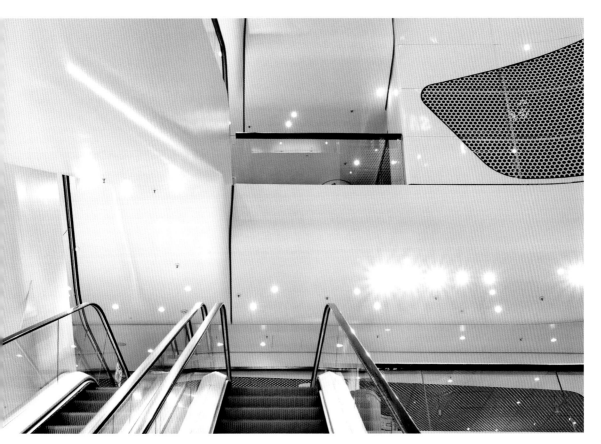

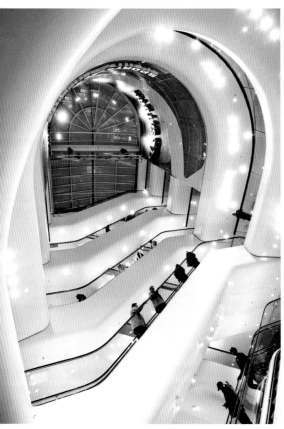

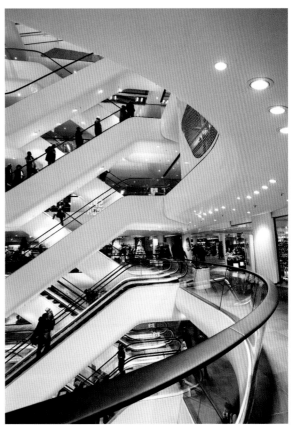

Bar Kottulinsky
Graz, Austria / 2009 / © Jasmin Schuller

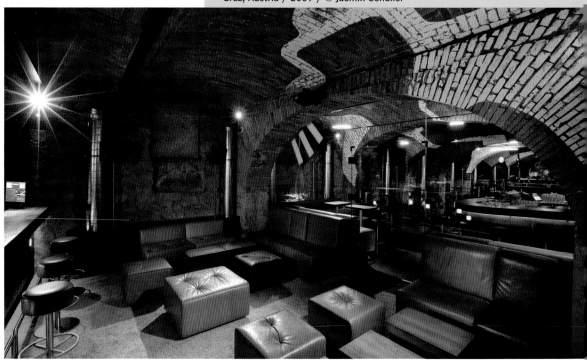

This bar is located in the space set aside for the Kottulinsky Palace wine cellar, a building dating back to 1853 and the end of Gründerzeit, when the city was founded, and so it is protected by strict regulations. The space occupies 350 m² (3767 ft²), crossed by transversal arches.

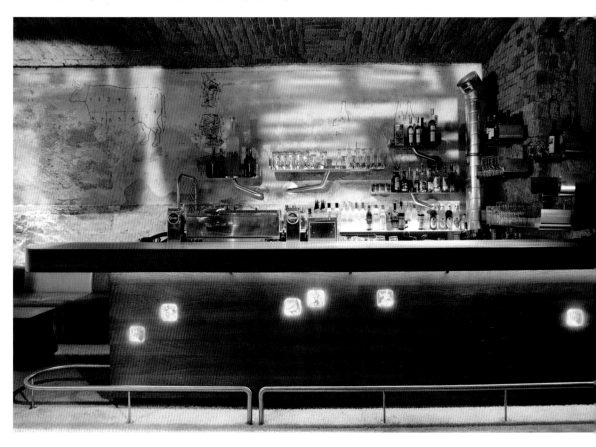

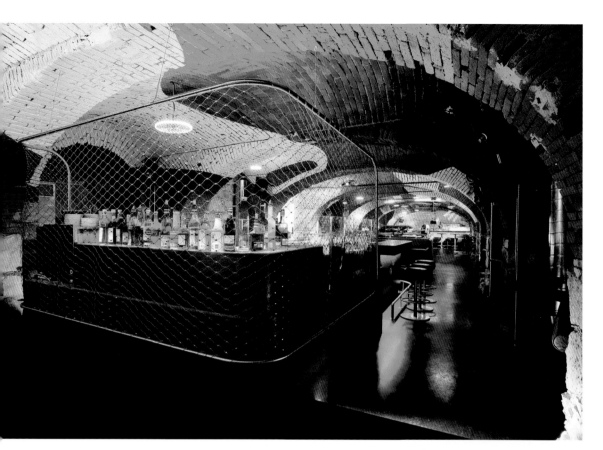

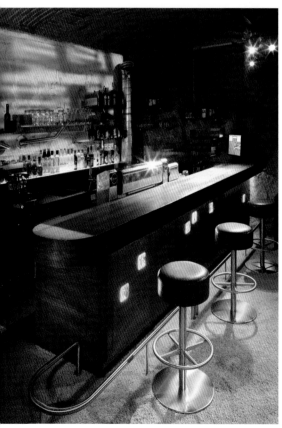

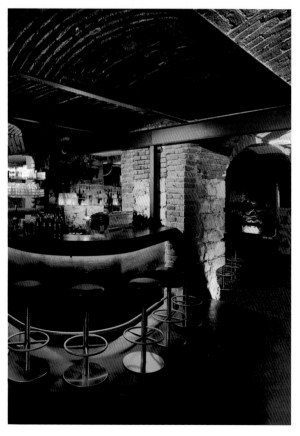

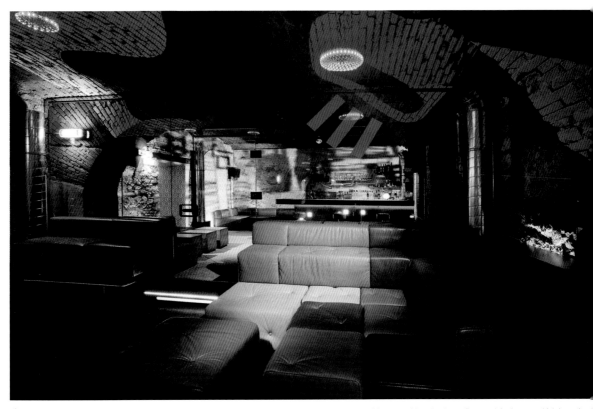

The bar has three areas which are climatically and acoustically insulated with glass walls: the warm-up zone with a central bar, the dance floor, and the lounge, which is equipped with versatile furniture that is adaptable to any circumstance.

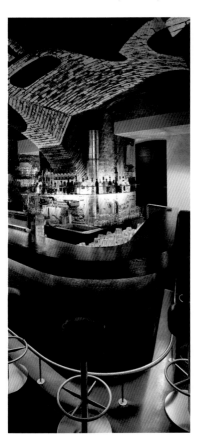

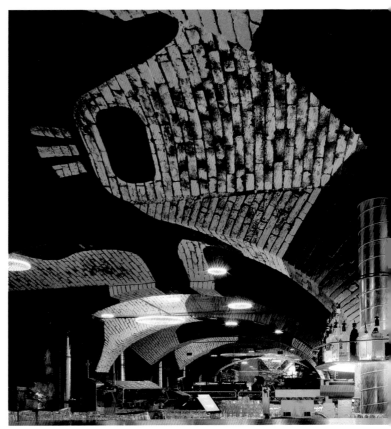

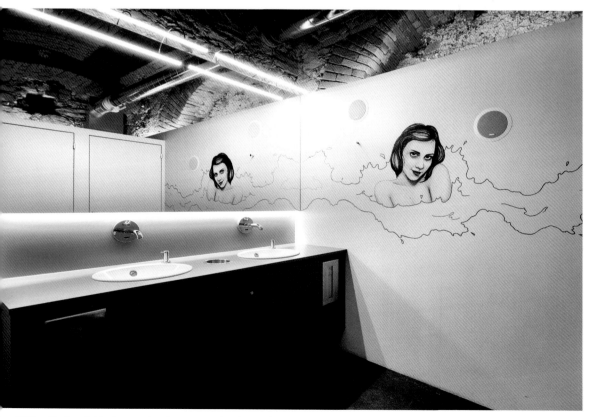

The artist Nana Mandl created two large murals at the entrance to the toilets and bar area.

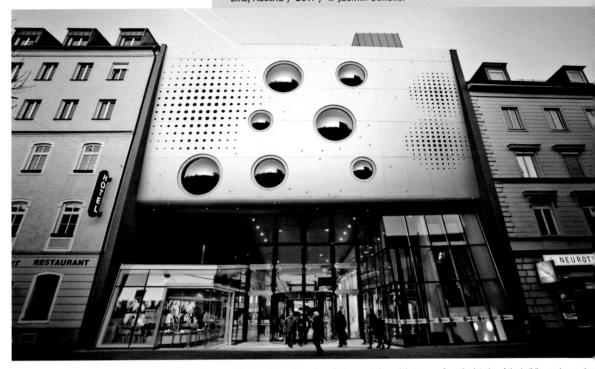

In order to create a distinctive presence on the street, the façade of the shopping mall consists of a large metal panel that comes from the interior of the building and runs alor the front wall. The façade has large round holes that contain the spotlights and evoke a starry sky.

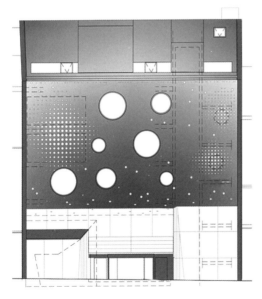

Elevations

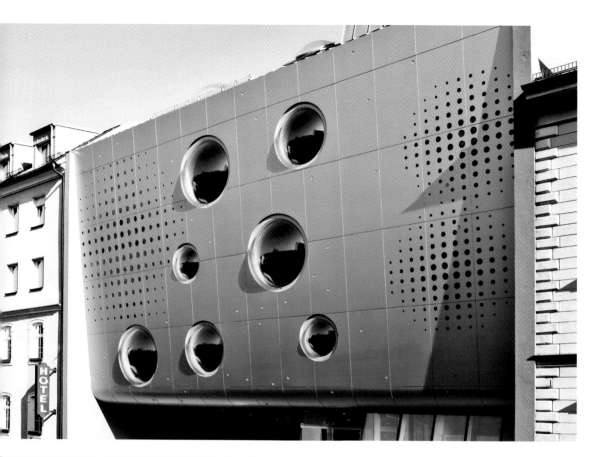

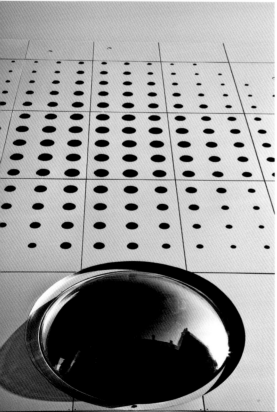

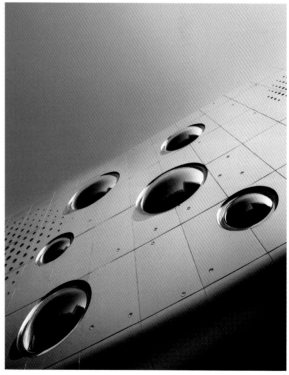

The entrance to the building has been designed as a cone that opens onto the street like a funnel and creates a feeling of spaciousness on the sidewalk. On one side, a panoramic lift connects the five floors of underground parking with the other floors.

Martí Guixé

© Imagekontainer /Knölke

Martí Guixé

Lapin Kulta Solar Kitchen Restaurant Helsinki, Finland
Temporary installation August 2011 / © Imagekontainer /Knölke

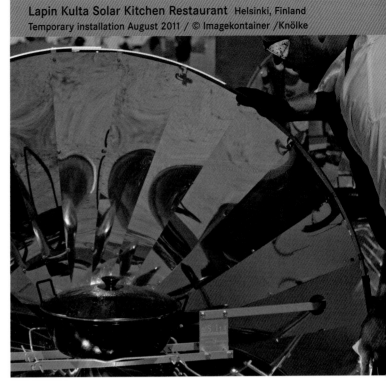

This temporary project conducted in collaboration with famed chef Antto Melasniemi with support from the Finnish brewery Lapin Kulta, attempted to redefine the perception of the kitchen, the act of cooking, and food in relation to nature.

Entença, 1, bajo
08015 Barcelona
Spain
Tel.: +34 933 251 951
www.guixe.com

The Catalan industrial designer who studied in Barcelona and Milan is characterized by formulating a new way to understand the culture of objects. Guixé began exhibiting his work in 1997 with the introduction of design in spaces dedicated to food and the presentation of performances. His unconventional point of view creates both simple and brilliant ideas, steeped in a curious seriousness. His international clients include Camper, Alessi, Vitra, and Droogs Design. His work appears in books devoted entirely to the designer and has been exhibited at MoMa (New York), MUDACES (Lausanne), MACBA (Barcelona), and the Pompidou Center (Paris). He won the Ciutat de Barcelona award in 1999 and the National Design Award from the Generalitat de Catalunya in 2007. He has offices in Barcelona and Berlin.

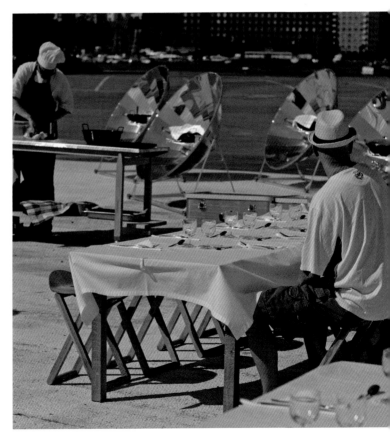

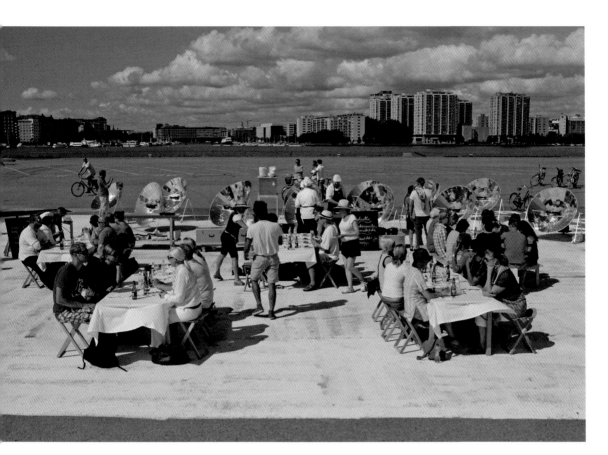

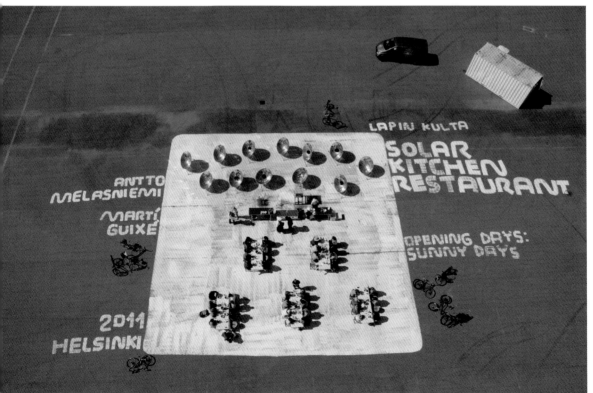

The restaurant, which can be found in different locations, consists of a space with tables and twelve parabolic cookers, defined by white paint on the floor. The daily menu depends on the amount of sun each day.

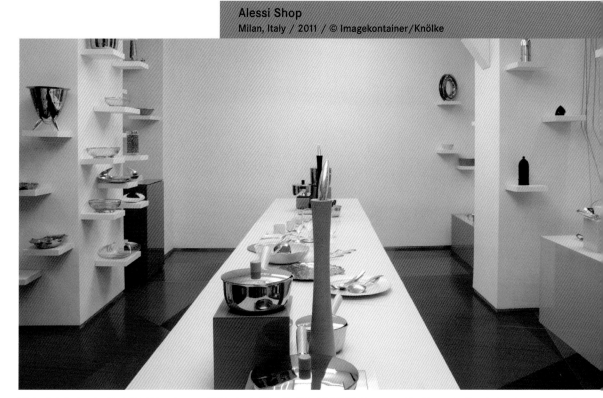

This iconic Italian brand celebrated its 90th anniversary with this store in Milan. The 170 m² (1,829 ft²) of space consists of four parts: shop window, store, museum and "wunderkammer," or the cabinet of curiosities.

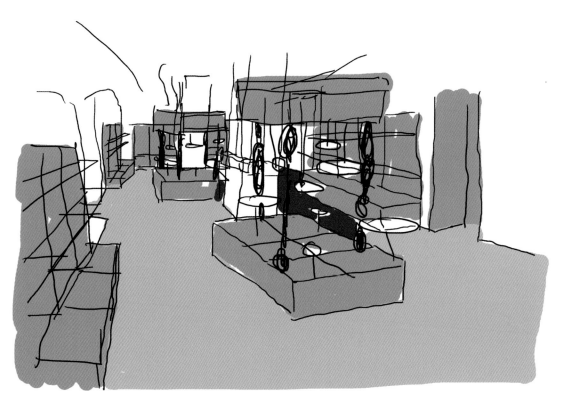

Sketch

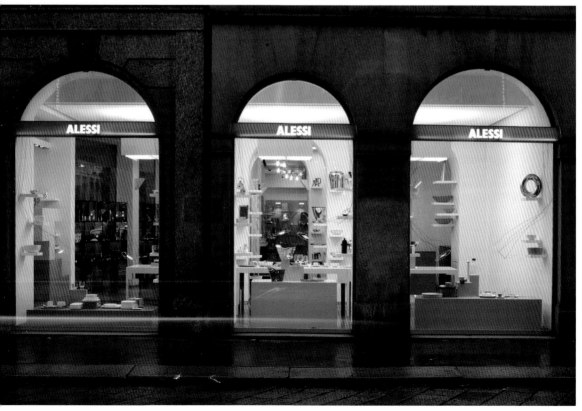

he walls are painted the corporate red and white colors of Alessi and each space is identified with the spelling that characterizes Martí Guixé.

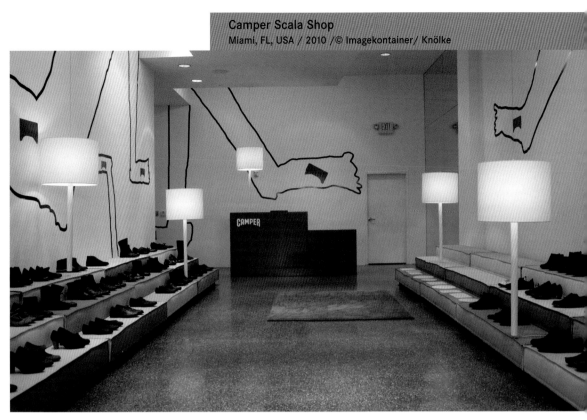

The design concept for this Camper store plays with different levels of a display stand, an idea taken from the sofa designed by Guixé that is called "Scala."

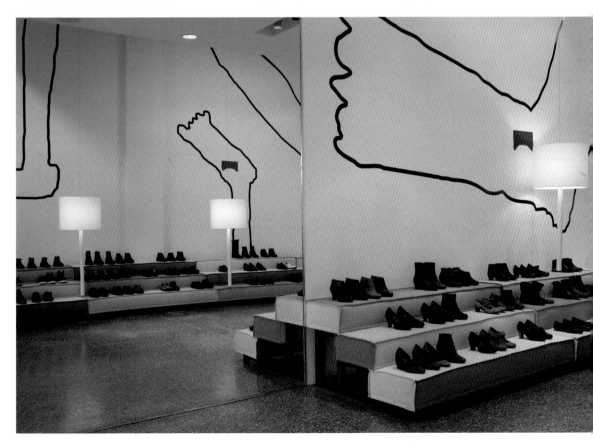

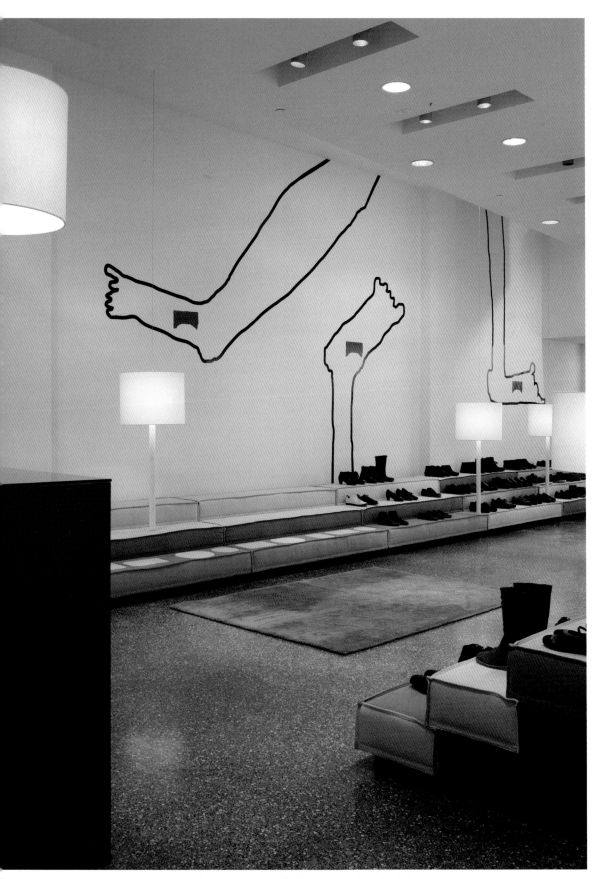

The unmistakable graphics of the designer is displayed with feet drawn all over the walls of the store and reinforced by the brand's corporate colors.

Matali Crasset

Benjamon Chelly

Matali Crasset

26, rue du Buisson Saint-Louis
75010 Paris
France
Tel.: + 33 1 42 4099 89
www.matalicrasset.com

Matali Crasset is an industrial designer who has ventured into the fields of architecture and interior design through commercial spaces. Having worked with Denis Santachiara in Italy and with Philippe Starck in France, she set up her own studio in 2000. Through her expert, yet naive eye, she questions the obviousness of established codes. Far from being simple improvements to existing concepts, her proposals develop typologies structured around principles such as modularity and interactive networks. Always seeking to explore new territories, Matali Crasset works in a wide variety of worlds, from craft to electronic music, and from textiles to fair trade, as well as in furniture design, architecture, graphics, and collaborations with artists, councils, and communes.

La Cantine de la Ménagerie de Verre
Paris, France / 2009 / © Patrick Gries

The canteen of La Ménagerie de Verre arts center was conceived as a space to relax, where people could wait and have a s nack before or after each show. Given the serenity conveyed by the site, the designer chose birch plywood as the predominant material.

...he tables and chairs were inspired by trestles, one of the most basic structures in ...rnishings. Thus, they can be easily moved to clear the space, if needed.

Nouvel Odéon

Paris, France / 2009 / © Jérôme Spriet

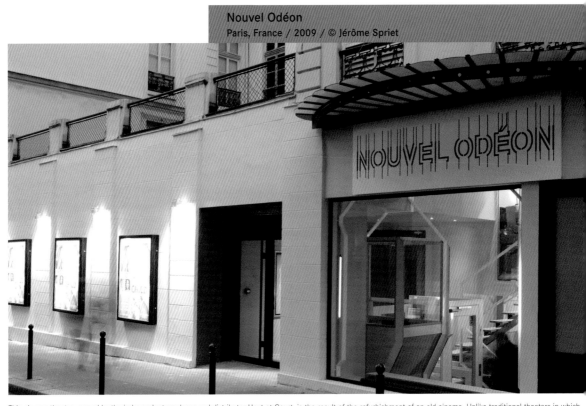

This cinema theater, owned by the independent producer and distributor Haut et Court, is the result of the refurbishment of an old cinema. Unlike traditional theaters in which darkness and impermeability predominate, here a large window sets up a dialogue with the street.

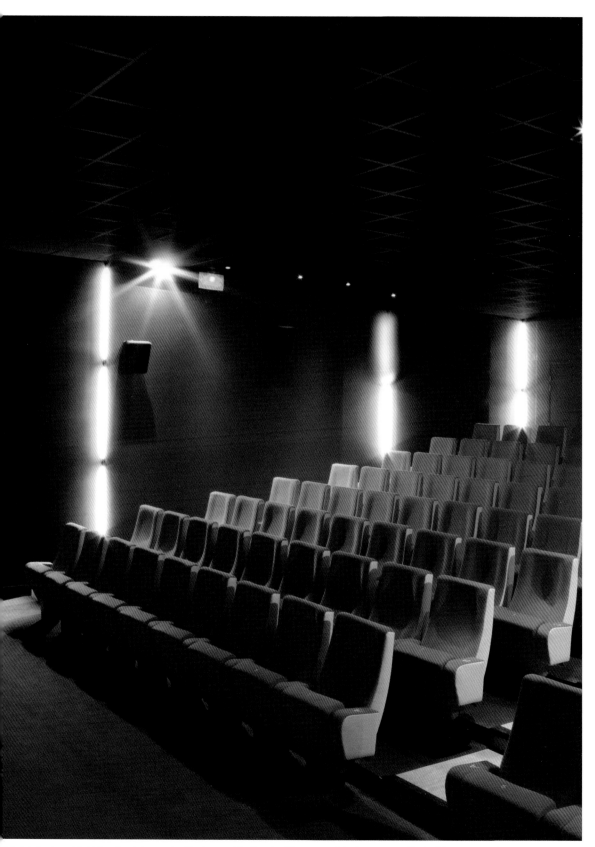

e foyer is the element that brings the whole space together, because it is where the different parts of the theater are combined as if it were a three-dimensional puzzle. The
ense colors are combined and sweetened through the use of light wood in most of the furniture.

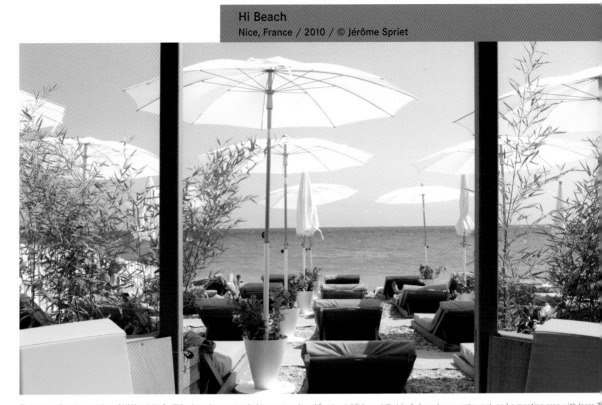

Five years after the opening of Hi Hotel, its facilities have been extended to create a beachfront establishment that includes a bar, a restaurant, and a meeting area with large T screens, books, magazines, and computers, and an area for yoga and massage.

...e facilities include bedrooms lined with wood and built-in tables and seating, while others have beds allowing guests to rest facing the sea, but sheltered from the sun.

Following the first successful hotel in Nice, Matali Crasset has once more collaborated with Patrick Elouarghi and Philippe Chatelet in the creation of a Hi Life establishment with forty-two cabin-style rooms for travelers wanting to have an original experience for a reasonable price.

354

esigned with sustainable materials, the spaces and furnishings of the rooms are flexible: the bed becomes a sofa during the day and allows guests to enjoy a more ample room.

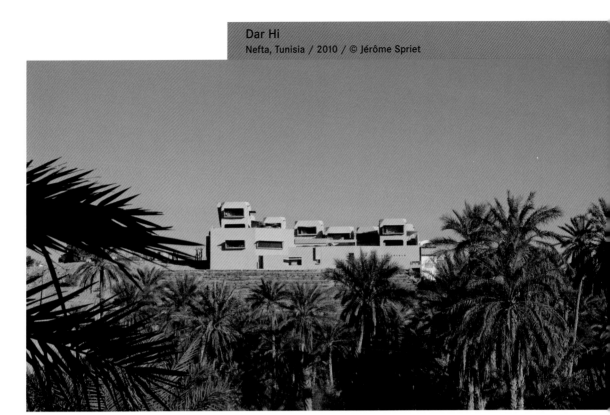

This ecological center with hot springs in the Tunisian desert shares the concept of the Hi Life hotels and was inspired by the troglodyte dwellings of the Berber population. The facilities—spread throughout eight towers containing the bedrooms —seek to escape from excessive luxury.

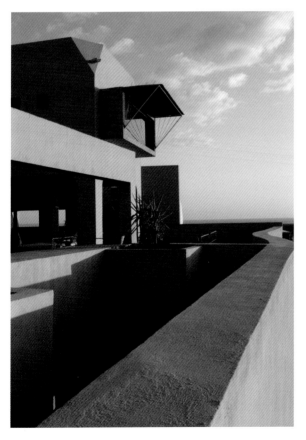

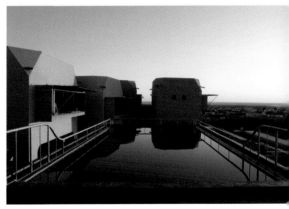

The hotel has been designed to preserve harmony with the Nefta landscape. Known as the "Pearl of the Djerid," Nefta is famous for its hot springs and for its magnificent oasis. Films such as Star Wars and The English Patient, among others, have been shot in this privileged location.

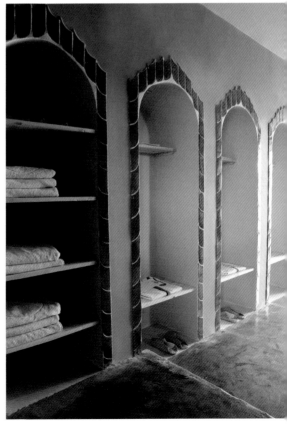

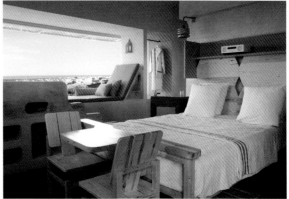

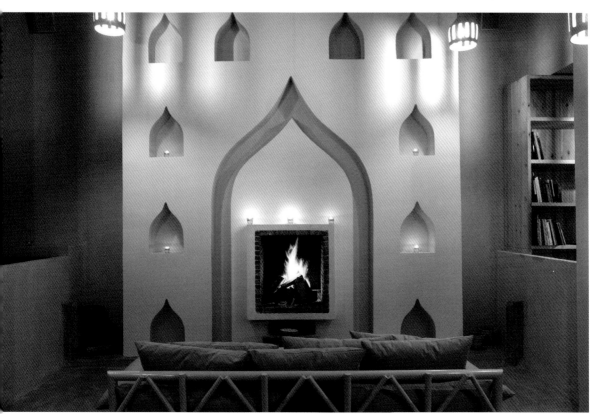

The spa has its own bazaar where a selection of typical products and aromas, as well as books and kitchen utensils can be purchased.

Maurice Mentjens Design

Maurice Mentjens

Martinusstraat 20
6123 BS Holtum
The Netherlands
Tel.: +31 (0)46 481 14 05
www.mauricementjens.com

Maurice Mentjens works mainly in the area of interiors and furnishings. His creations are geared toward the retail sector, hostelry, restaurants, offices, and museums. The practice has a fondness for projects that are small-scale yet interesting and gives priority to quality and creativity in its designs and implementations. The firm has been awarded the Dutch Design Award three times and, in 2007, received the Design Award of the Federal Republic of Germany. Its portfolio of customers includes the Bonnefantenmuseum Maastricht, the Frans Hals Museum in Haarlem, Post Panic in Amsterdam, the DSM offices in Heerlen, and Amsterdam's Schiphol airport.

Airport Park
Schiphol Airport, Amsterdam, Netherlands / 2011 / © Arjen Schmitz

A space designed as if it were a park in the waiting area at Schiphol Airport is a perfect place in which to rest and relax. The area is home to a café/restaurant, stores, an Internet area, and the KLM lounge.

The oak timber flooring with green-colored areas contains elevated platforms of artificial turf distributed in an apparently random manner. These become an "island" for picnics with potted plants and trees, drawing travelers' attention to the outside garden terrace area.

In order to reinforce the concept of the outdoors, virtual sensor-activated butterflies were placed in certain areas. These are complemented by other features simulating real life such as animal and park-life sounds, and the smell of grass.

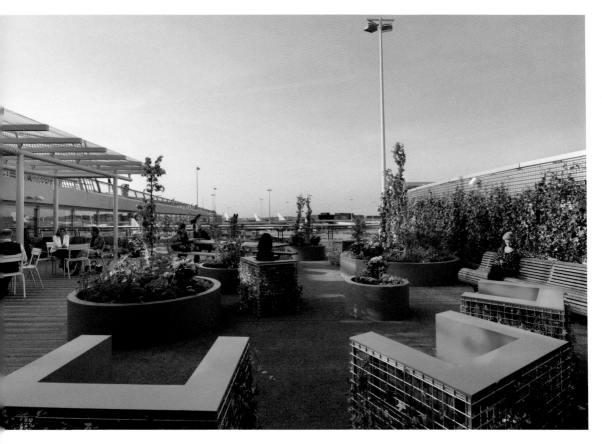

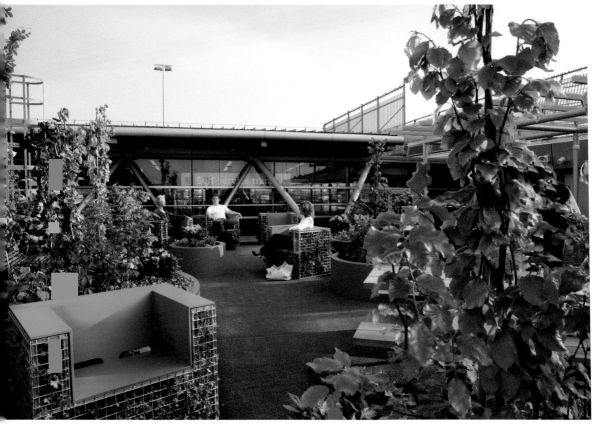

Kymyka
Maastricht, Netherlands / 2009 / © Arjen Schmitz

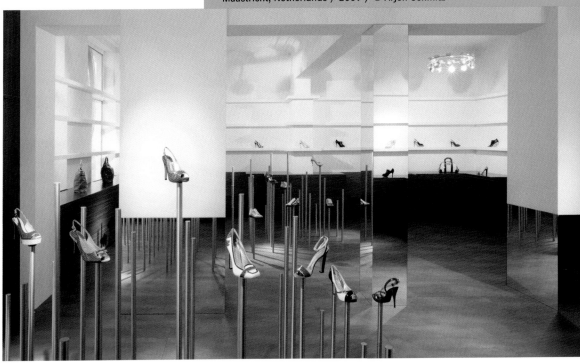

The footwear are displayed in this store as if they were objects of art. These shoes, designed by well-known, exclusive fashion brands, are placed as if they were butterflies resting on stainless steel bars.

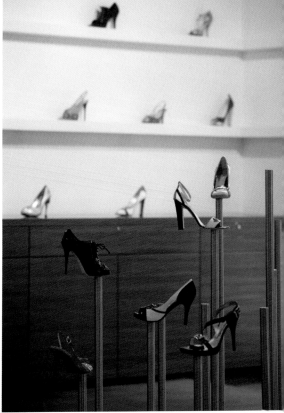

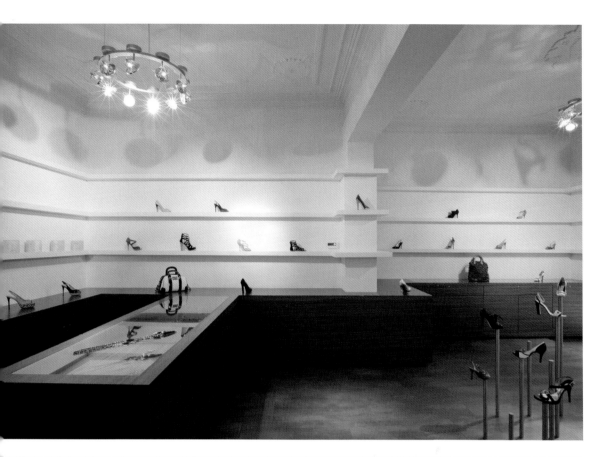

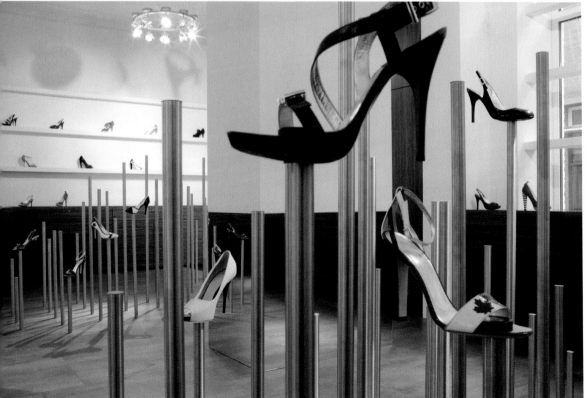

The magical atmosphere is enhanced by the mirrors covering the columns in the central space and the lower sections of some walls that seem to float.

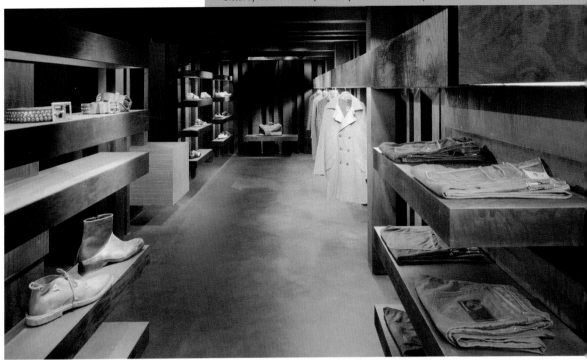

The extension of this clothing store, which sells prestigious fashion brands, is composed of three small spaces: a garden with a transparent roof, a completely white space representing innocence, and another predominantly black space representing paradise lost.

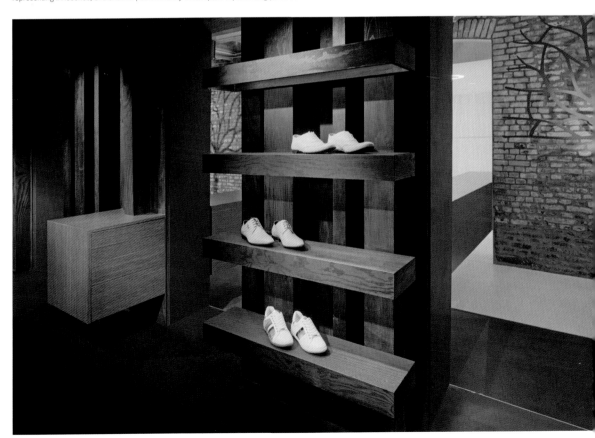

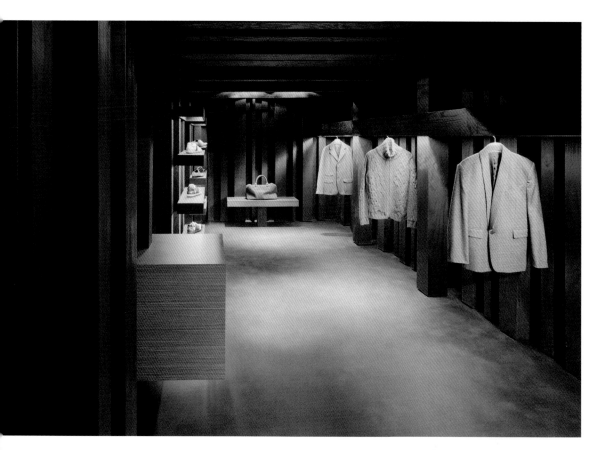

...mmed steel trees recreate the atmosphere of the Garden of Eden. This courtyard between two buildings has been covered with a transparent roof and functions as a ...ansition space between the male and female zones in the store.

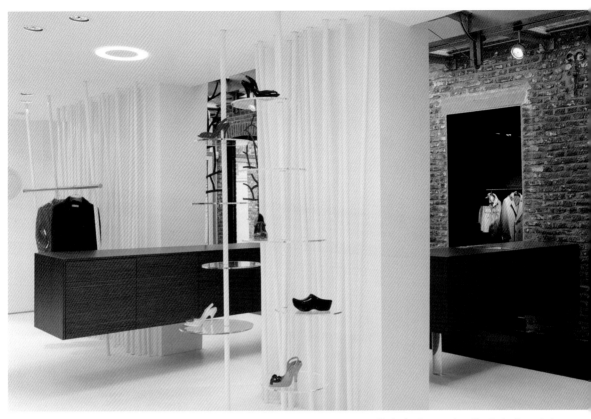

Pure, virginal white dominates the space containing the collections of women's clothing. Halogen lamps, located in circular shapes on the ceiling, imply a heavenly air.

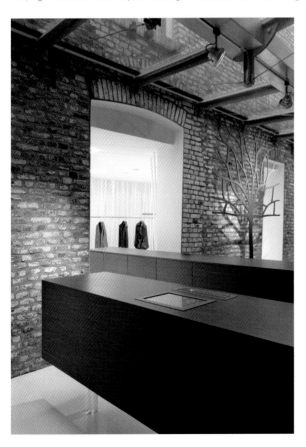

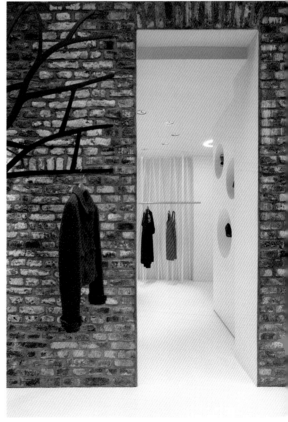

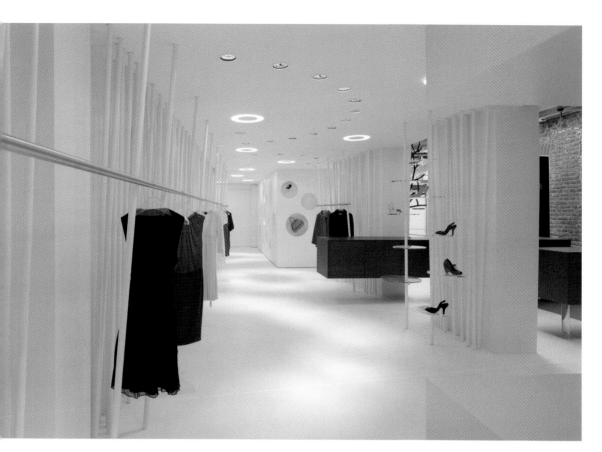

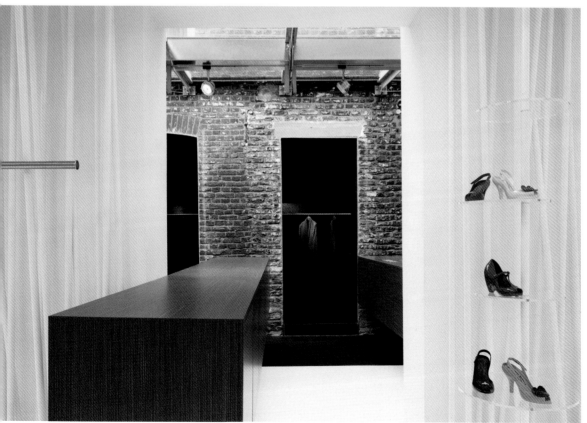

Pascal Arquitectos

Carlos Pascal, Gerard Pascal

Atalaltunco 99
Col. Lomas de Tecamachalco
53970 Mexico D. F.
Mexico
Tel.: + 52 55 52 94 23 71
Fax: + 52 55 52 94 85 13
www.pascalarquitectos.com

Pascal Arquitectos, with headquarters in Mexico City and founded in 1979, is unique as it differentiates itself from unitary discourses that are applicable to any project. These architects avoid strict rules, language, and default materials. For the studio, each creation is the result of unique conditions and the resources made available from the social environment or location. Their commitment is simultaneous with the client, the customer, the environment, and the city. They are also characterized by experimentation with new materials and technologies. The office consists of a multifunctional group performing all types of work: residential, corporate, hospitality, religious, etc. They cover everything including architecture, interior design, furniture, lighting, and landscape design.

Guria
Mexico D.F., Mexico / 2005 / © Jaime Navarro

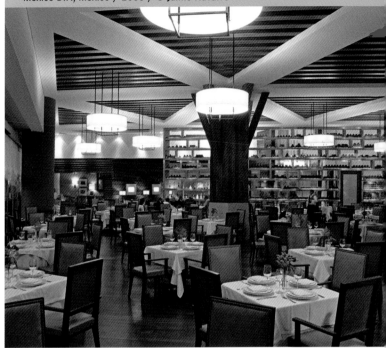

The design of the restaurant Guria comes from a contemporary interpretation of the Basque houses. This concept was required by the restaurant owners, who sought continuity with the successful formula of the original premises.

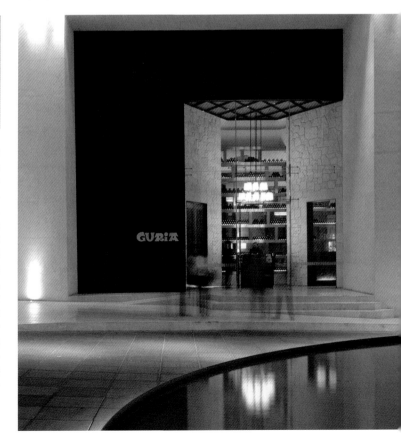

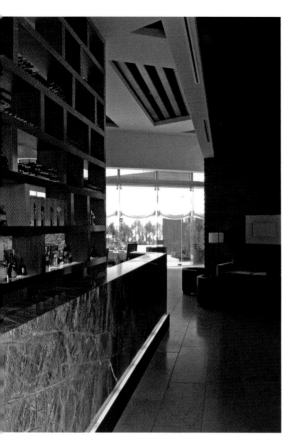

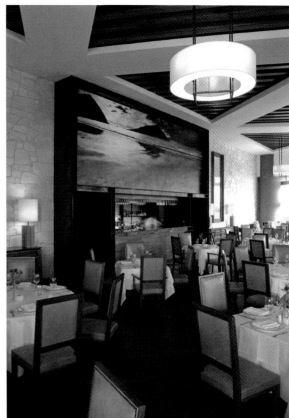

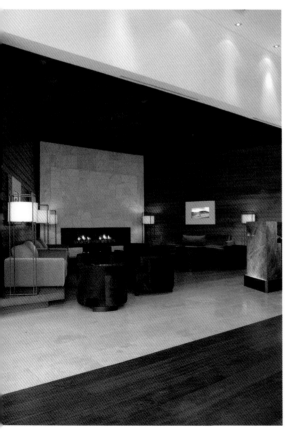

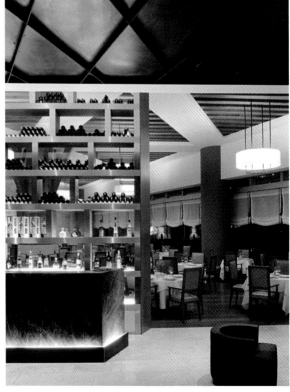

There is a green marble bar, a stone fireplace, mahogany wall cladding, floor lamps, and video screens displaying decorative pictures.

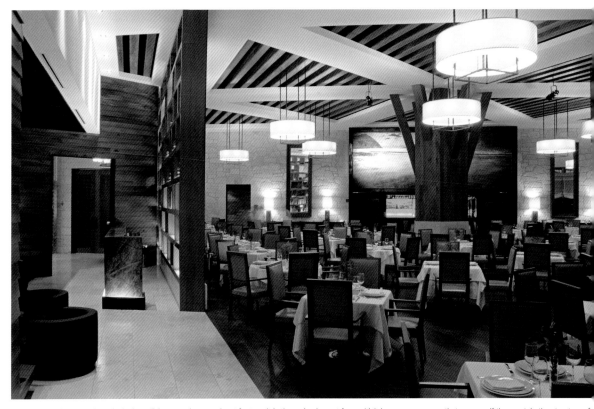

The central mahogany column in the large living room is a prominent feature. It is the main element from which large arms emerge that seem as if they sustain the structure of the restaurant. The stone walls frame the picture painted by Fernando Aceves Humana, representing the sunset at the La Concha beach in San Sebastian, Spain.

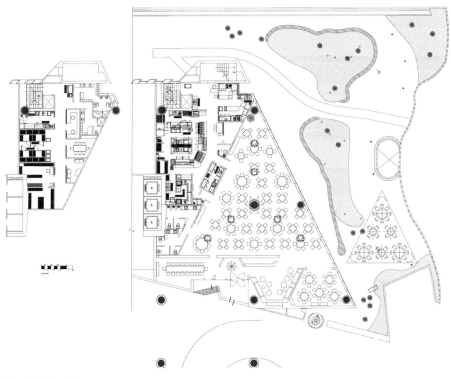

Upper level and lower level

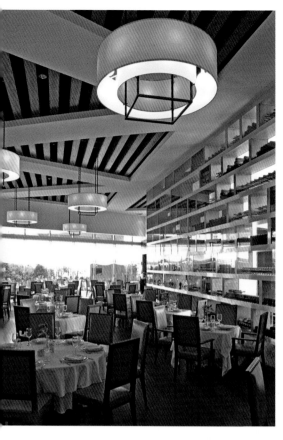

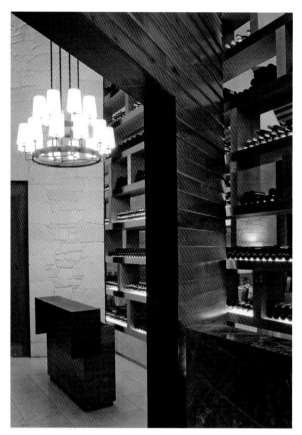

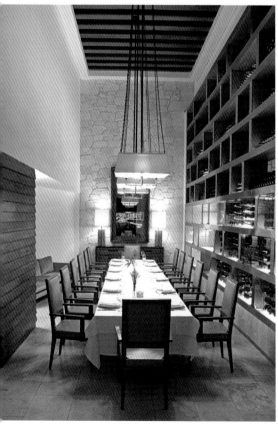

Natural materials, mahogany wood, iron, and exotic marbles, create a warm atmosphere that recalls the uniqueness of Basque architecture.

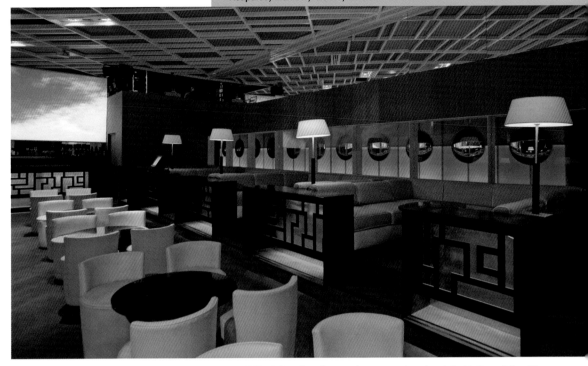

The bar is located in the La Isla Boulevard de las Naciones shopping mall. The design reflects the entertainment atmosphere characterized by the exaltation of the senses through architecture, people, music, and images. The space simulates the interior of a ship clad with timber.

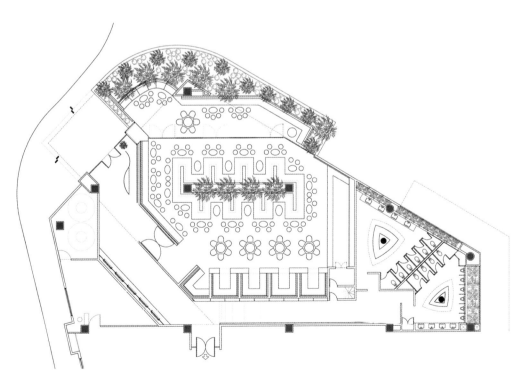

Floor plan

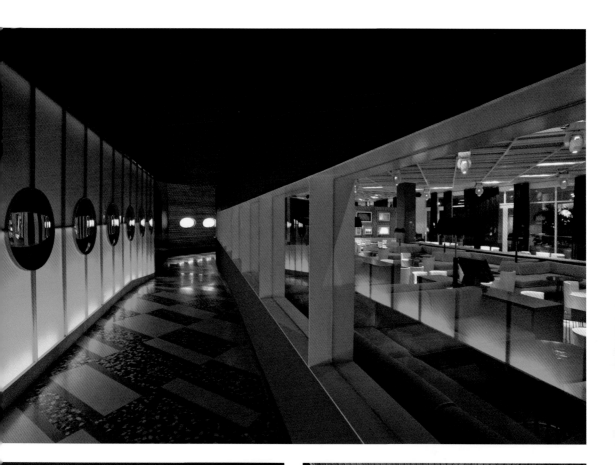

Five high-definition screens were installed in the lobby and framed by window-like ovals that project images of the sky with clouds, or the ocean floor.

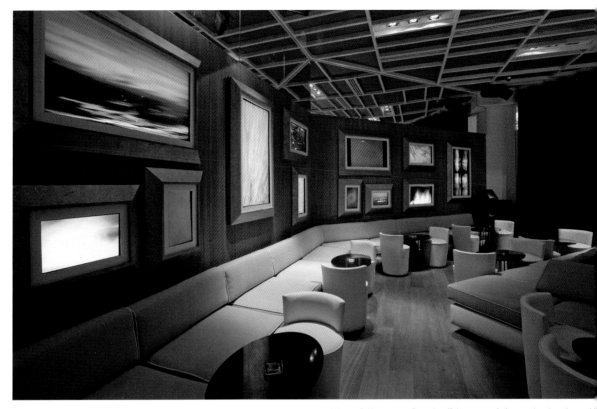

The lounge is home to different sitting areas with sofas for relaxing. At one end, there are several high definition screens framed as if they were paintings, and at the other end a 15 m (49 ft) long bar, behind which there is a screen that projects videos in high resolution.

Elevation

Elevation

Longitudinal section

Section 1-1'

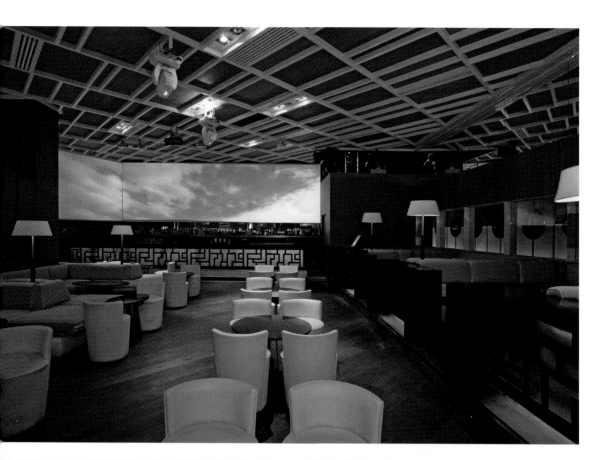

The bathrooms are designed as meeting spaces and lined with glass. The ladies' room is red with a white flag and a central palm tree, while the men's room is done in black and blue glass.

Nisha Bar Lounge Las Palmas
México D.F., México / 2007 / © Sófocles Hernández, Jaime Navarro

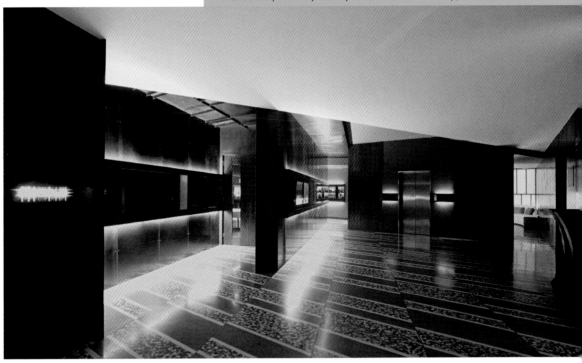

The project consists of a lounge, a restaurant, and a bar that are connected by a reception lobby. The reception area stands out for the predominance of dark tones, as it is covered in black metal sheets and terrazzo floor. However, the lounge, which you can see below, is clad with wood and surrounded by windows with views.

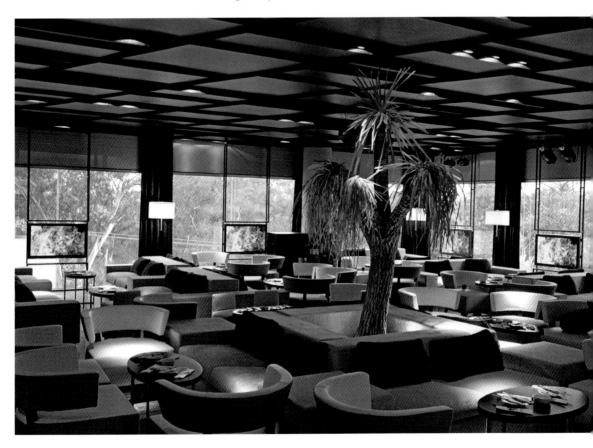

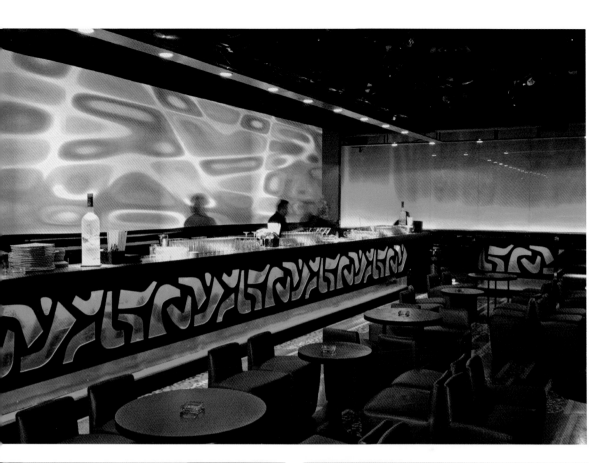

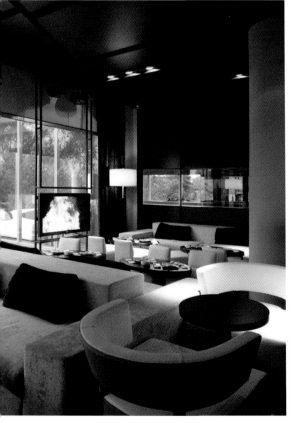

The hall is illuminated by psychedelic images that emerge from eight plasma screens.

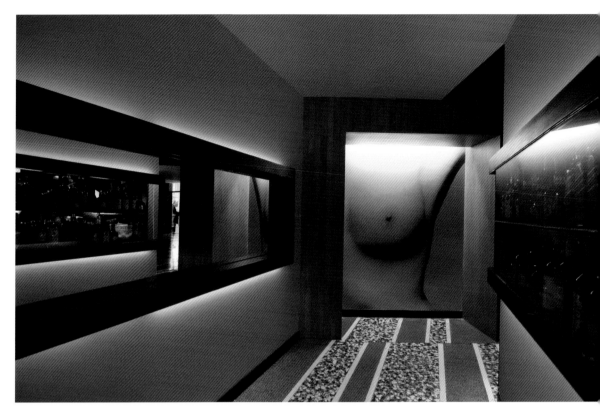

The restaurant and bar are completely surrounded by glass that changes color according to the music and videos that are shown. The use of color in all areas arouses visual excitement in the viewer, which is enhanced by the acoustic and visual stimulations.

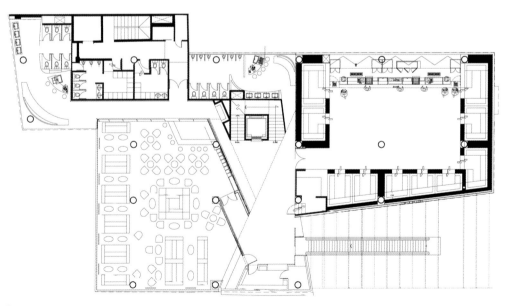

Floor plan

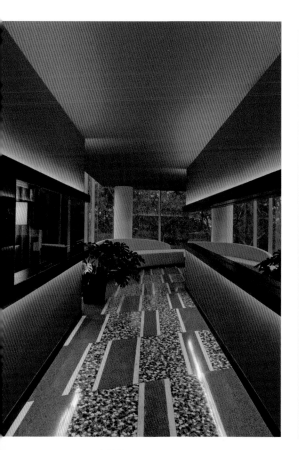

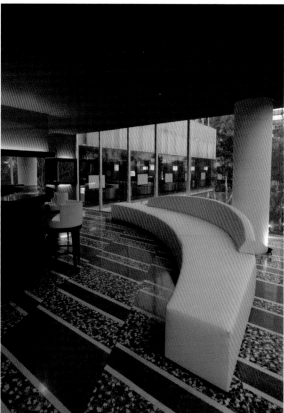

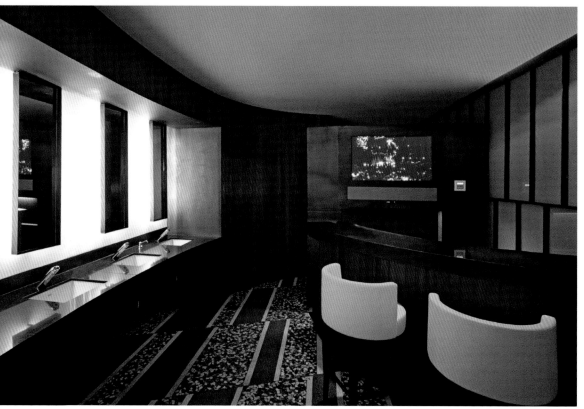

The bathrooms have been designed so that they form part of the recreational spaces. To achieve this effect bar tops and lounge chairs have been installed.

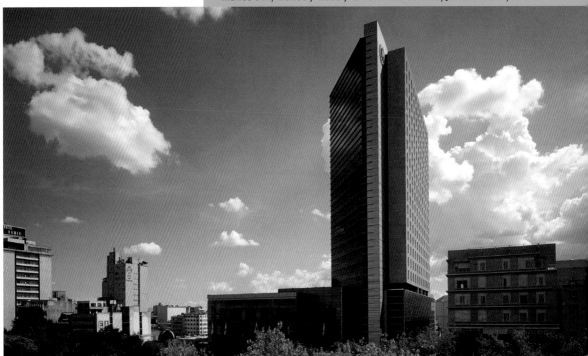

Cutting-edge design technologies were used for the creation of this new building. The hotel is aimed at business people—hence its appearance as an office tower. Inside there are convention areas, showrooms, cafés, restaurants, and a spa.

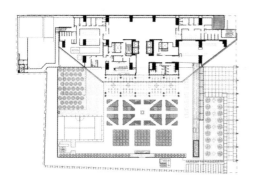

Roof garden plan

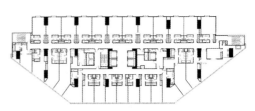

Rooms plan

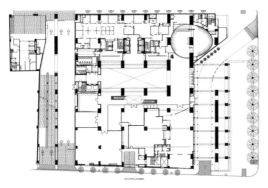

Lobby plan

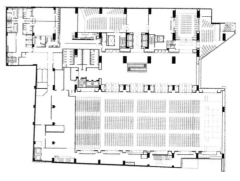

Lounge plan

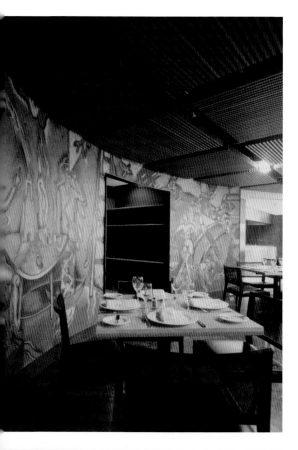

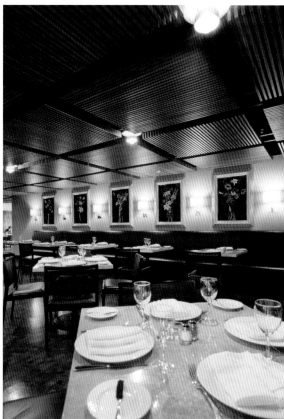

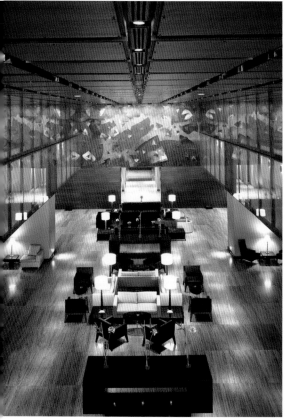

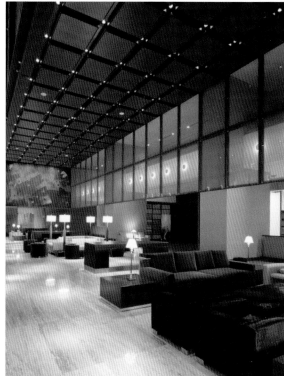

The carefully selected materials are perfectly integrated into the building and the environment because of their aesthetic function and usefulness, in addition to their textures, colors, and shapes.

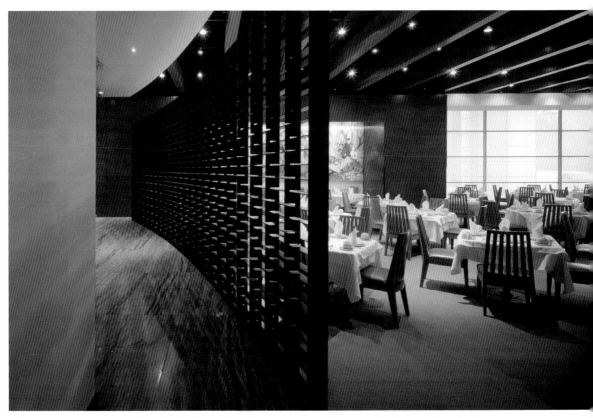

Soffits, marble, wood, granite, furniture, lamps, fabrics, floor coverings, and carpets are typical of a modern and luxurious hotel, but require little maintenance.

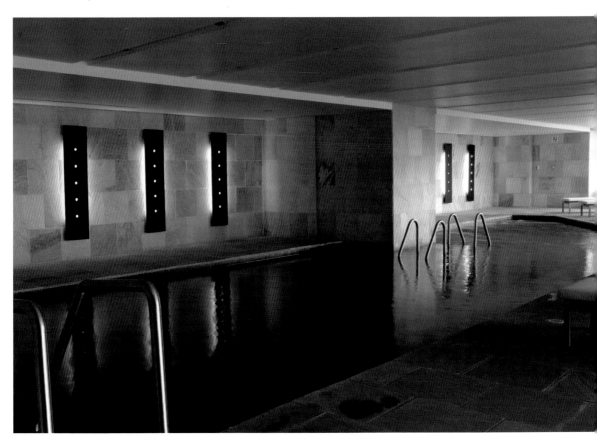

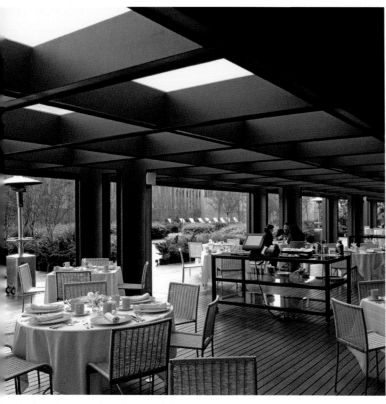

pen, landscaped spaces are located on the roof of the building, as is a cafeteria where you can enjoy moments of
st and relaxation.

Plajer & Franz Studio

Werner Franz, Alexander Plajer

Erkelenzdamm 59-61
10999 Berlin
Germany
Tel.: + 49 030 616558 0
Fax: + 49 030 616558 19
www.plajer-franz.de

Plajer & Franz Studio is an international and interdisciplinary team of forty-five architects, interior designers, and graphic designers based in Berlin. All stages of creating a project, from the concept of the design, its deployment and supervision, are carried out by the studio. The founding architects, Alejandro Plajer and Franz Werner, had their first international experience in New York, at the office of Richard Meier and Tsao & McKown, where they worked for two years with projects in the United States and the Middle and Far East. In 1996 they returned to Germany to establish their own company.

Today, Plajer & Franz Studio has an international reputation for excelling in innovation, quality down to the last detail, great planning skills, and a unique sense of style.

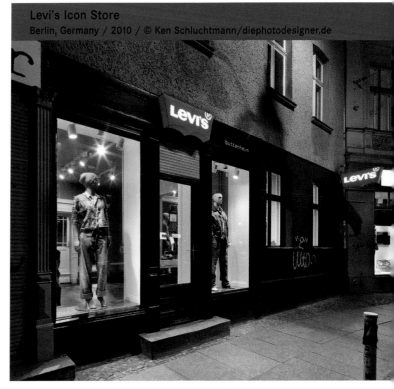

Levi's Icon Store
Berlin, Germany / 2010 / © Ken Schluchtmann/diephotodesigner.de

The Levi's store is an icon in the German capital. The challenge of the new store commissioned to the architecture studio was to redesign the existing store in just five weeks, before Berlin Fashion Week. The studio introduced the concept of a small store to stick to a very tight budget.

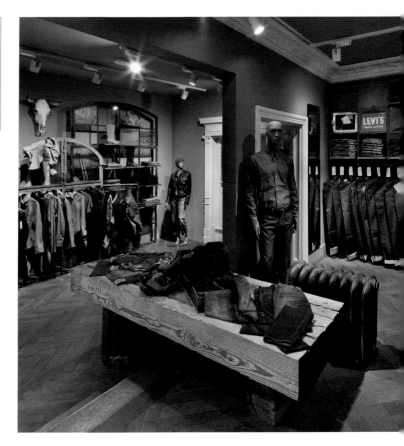

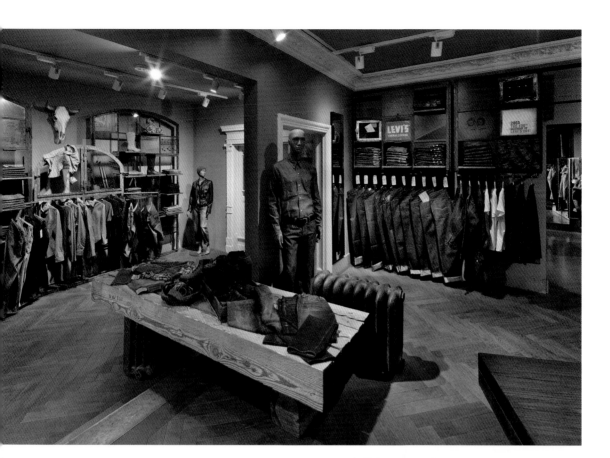

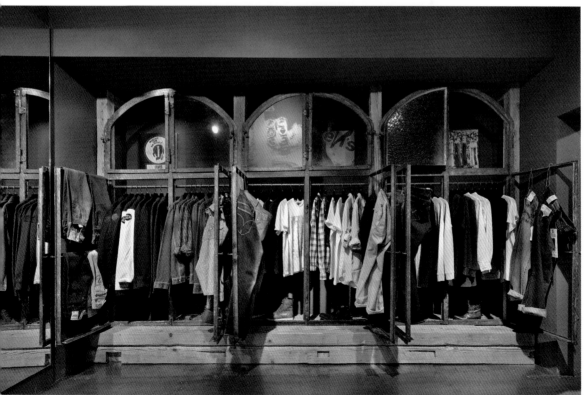

The store design was meant to create a feeling of being in an old loft style apartment, typical of the industrial age. The window structures were used as shelves and the window bars as rails to hang the pants.

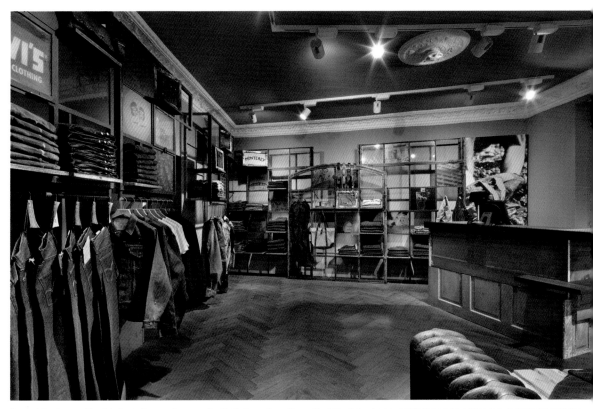

Some of the glass used is original and other panels are acrylic with Berlinese decorative motifs. Old radiators have been fitted to provide a basis for a presentation table that forms the center of the store and allows for an unusual way to display the products.

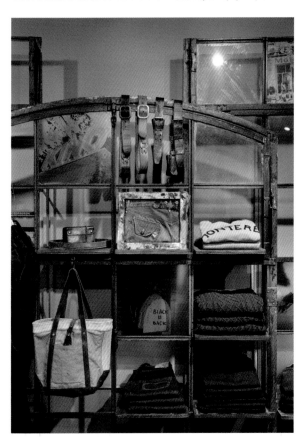

Located close to the Pompidou Center in Paris, the Puma store is situated in the Sebastopol Boulevard and was reopened after a complete redesign in April 2011. The idea of a new concept developed by the studio and management of the Puma brand was to bring joy and color to the commercial environment.

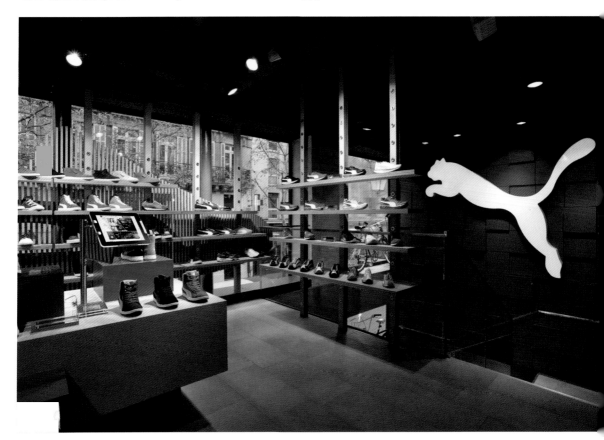

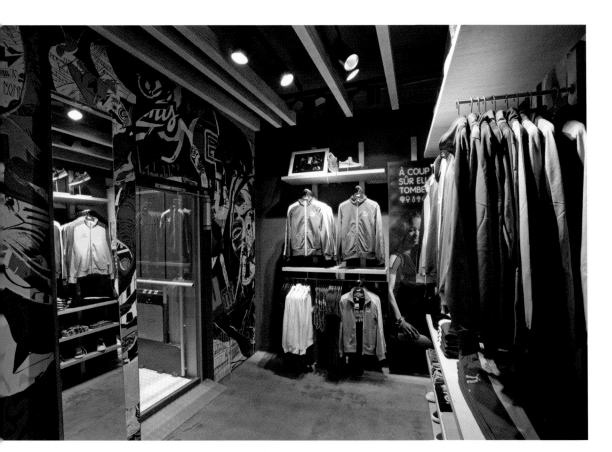

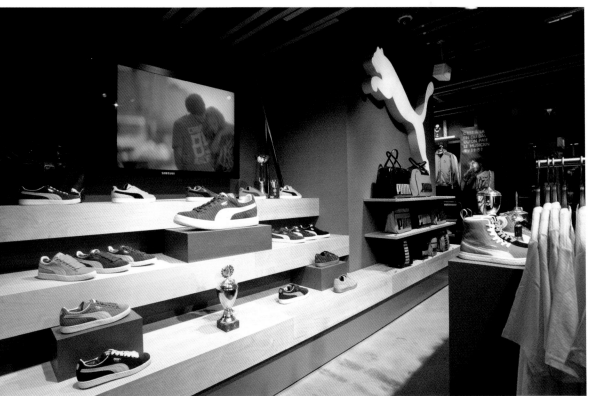

The design is characterized primarily for being sustainable and innovative, in line with the vision of the four keys of the Puma brand: fair, honest, creative, and positive. The new store features a mix of ecological concept and high technology.

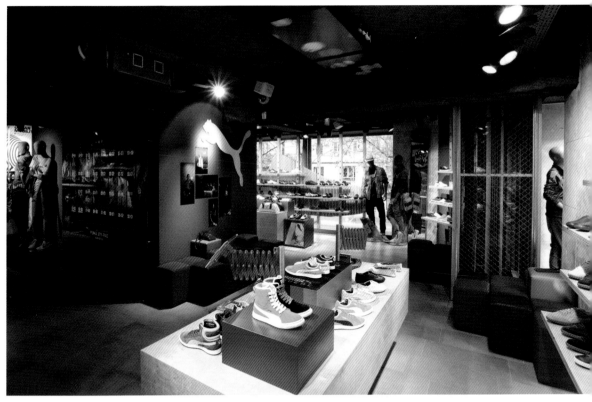

The store covers two floors and 200 m² (2,152 ft²) of retail space, packed with a wide range of stylish footwear, clothing, and accessories. The design of the store improves shoppers' visualization of the performance of the sneakers and lifestyle articles, which is encouraged through the usage of multi-color lighting.

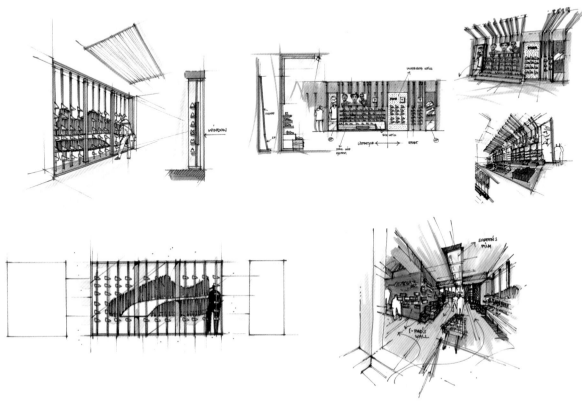

Sketches

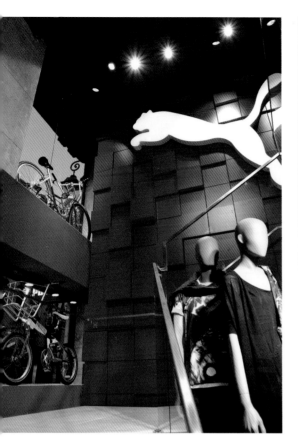
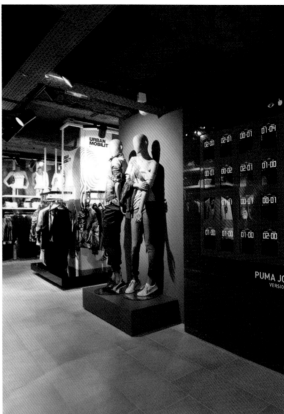
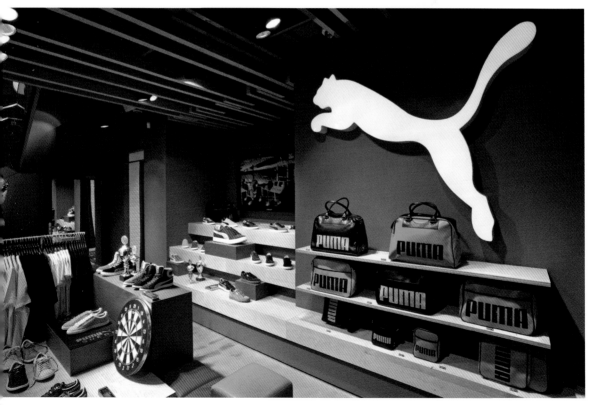

...he idea of cheerful colors, the Puma icon on the majority of the walls of the establishment, and the installation of video screens that show videoclips allow interaction with the ...lient. The designers also used organic materials, such as treated wood, low emission paint, and energy efficient lighting.

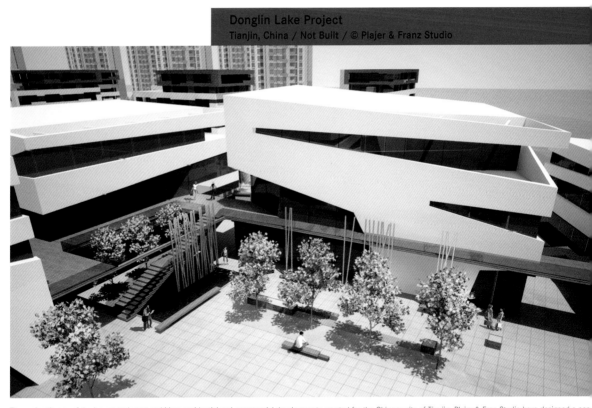

The project is one of the largest and most ambitious residential and commercial developments created for the Chinese city of Tianjin. Plajer & Fran Studio have designed a par of the new district of the city for Vanke, which defines the task of development.

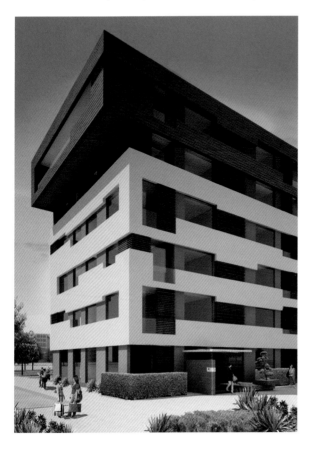

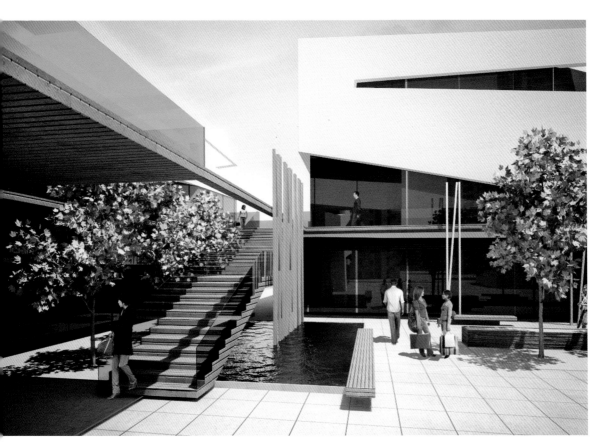

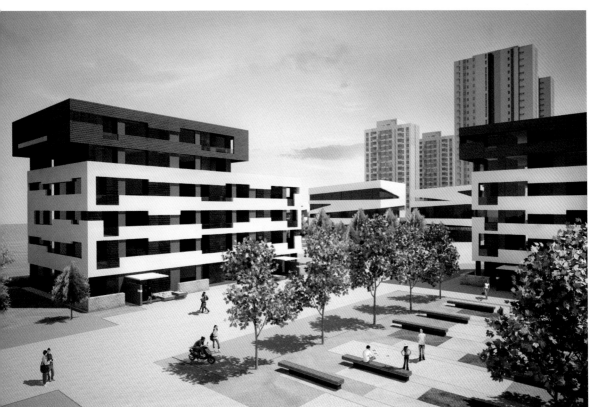

Pedestrian stone paths leading to the commercial areas have been created. The project creates green areas and suitable spaces for social interaction.

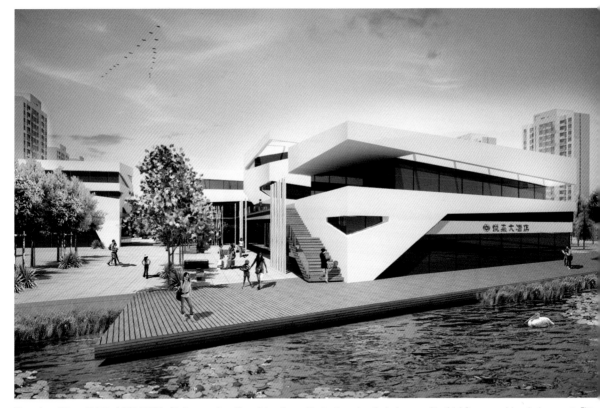

The project will have 25,000 m² (269,097 ft²) of built area and provide an interesting architectural complex of mixed uses: residential, loft, commercial, and urban spaces. The concept calls for the intelligent distribution of spaces on either side of a main street which distributes the new urban plan.

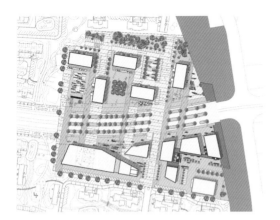

Site plan

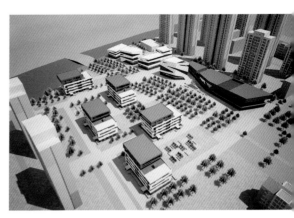

Rendering

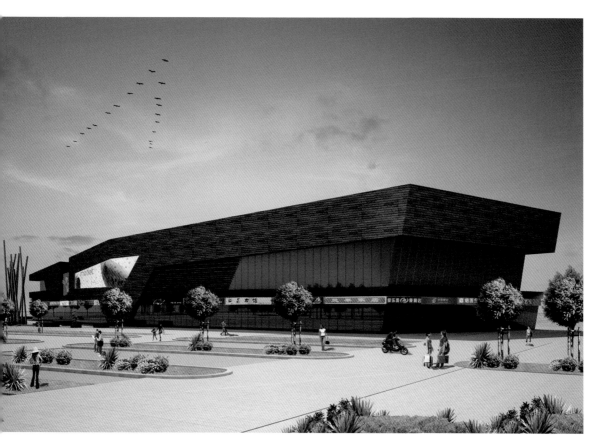

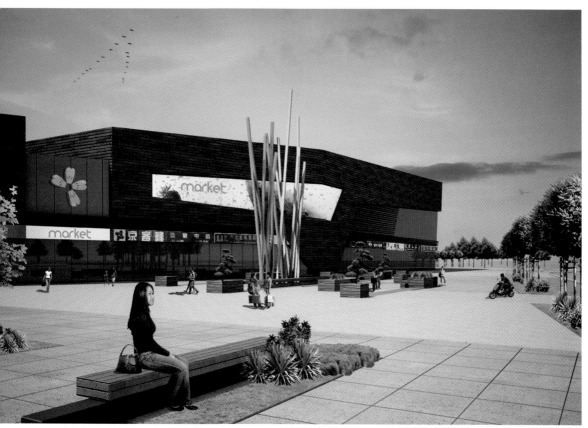

Plaren

Vítor de Sousa, Paulo de Sousa

Rua do Mosteiro, 1907
4425-140 Águas-Santas
Portugal
Tel.: + 35 1938 418 221
Fax: + 35 1229 714 207
www.plaren.com

In 2003, the brothers Vítor de Sousa and Paulo Sousa founded a new architectural studio in Oporto. They gave this cutting-edge challenge, architecturally speaking, the name of Plaren. The studio undertakes all kinds of architectural planning and has carried out numerous projects of different types: residential, offices, warehouses, etc. In recent years, it has specialized in interior refurbishments, particularly for stores and pharmacies. Plaren has also participated in various tenders for several international organizations. The team's philosophy is to "innovate together," and they work closely with customers to ensure total satisfaction with the end product. The studio also provides consulting and advisory services, as well as project design and management services.

Mania Das Plantas
Maia, Portugal / 2008 / © Plaren

The idea of this project was to create a new concept in garden centers, which are often confusing spaces. The customers wanted a comfortable space where users could receive special care while drinking a coffee, reading a book, or receiving advice.

Floor plan

To fulfill the desire of creating a fashion brand while working within a low budget, the architects opted for the use of bright colors, such as red, which is the corporate color.

Oticas Minho
Braga, Portugal / 2011 / © Plaren

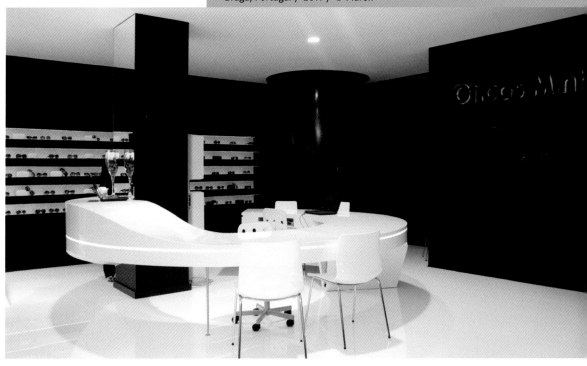

The customers asked the architects to design a new "suit" for the store located in one of the main streets of Braga. Their aim was to attract new customers and maintain high quality service. The architects designed a black box with white accents. The key element is a large white counter.

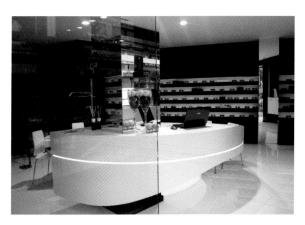
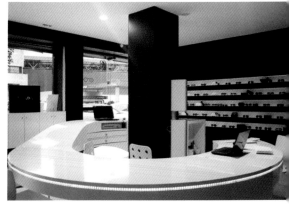
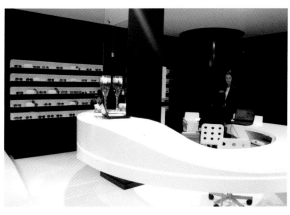
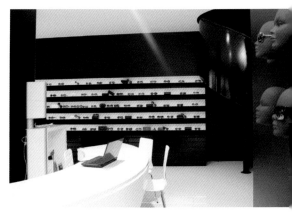

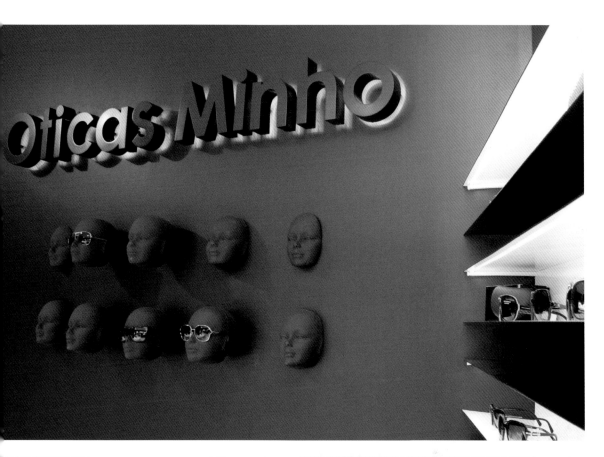

The contrast between black and white allows the visual focus of the products to reach potential customers passing along the street, making the products more easily recognizable.

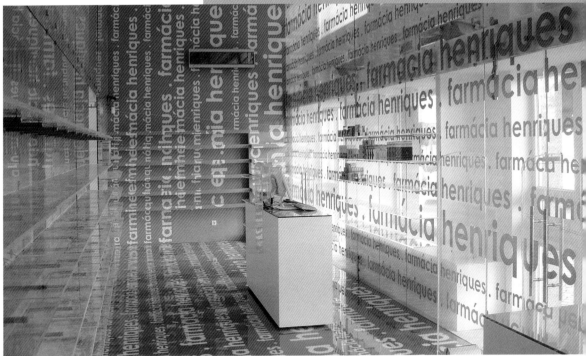

Pharmacy Henriques
Oporto, Portugal / 2007 / © Plaren

The customer requested the pharmacy to be completely redone with only three restrictions: maintaining the main structure of the building, completing the works in a short period of time, and keeping the shop open during the refurbishment process. The architects devised an innovative, powerful design, split into two areas with different identities.

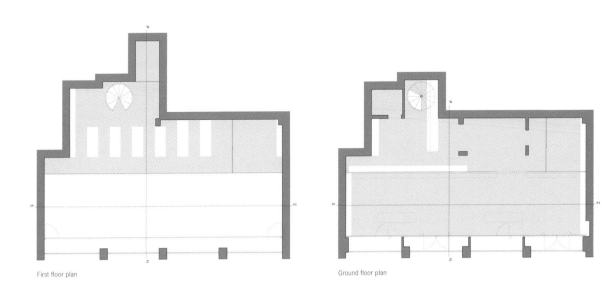

First floor plan

Ground floor plan

The key feature of the project is a printed glazed screen that allows the customer to visualize the pharmacist, as well as a white space for the private area.

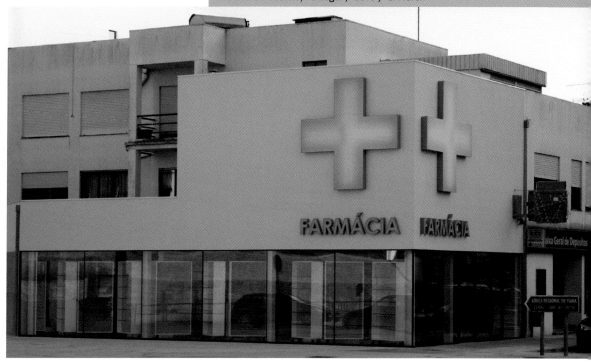

The customer commissioned a renovation of the building that would attract users and would make it stand out from the other stores. The building consists of two levels. The ground floor is the only public space and the first floor is devoted to private events, a laboratory, and offices.

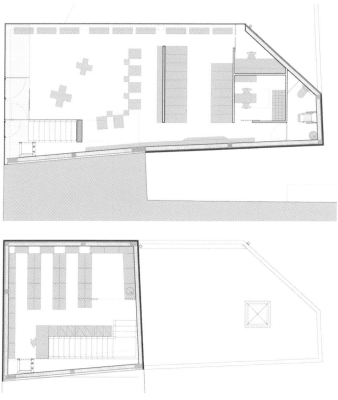

Ground floor plan and first floor plan

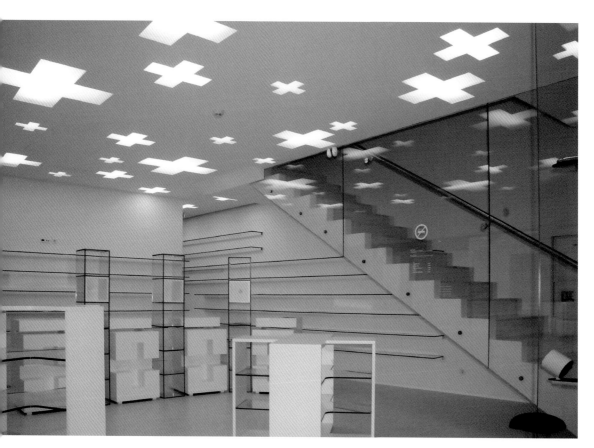

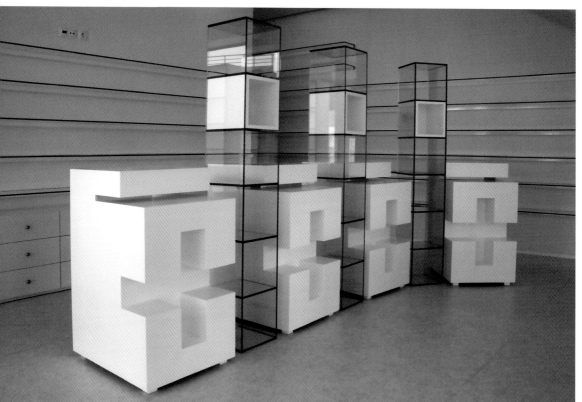

Both the counter and the ceiling were designed using the international symbol of the pharmacy: the cross. The lighting is important in the design, creating a timeless atmosphere.

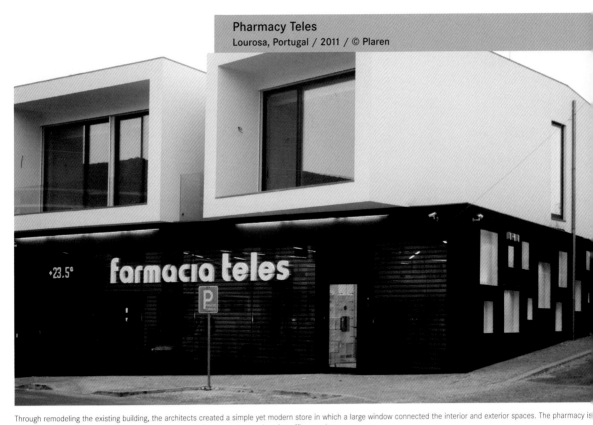

Pharmacy Teles
Lourosa, Portugal / 2011 / © Plaren

Through remodeling the existing building, the architects created a simple yet modern store in which a large window connected the interior and exterior spaces. The pharmacy is a showcase with a transparent space, including some half-concealed areas housing offices and storage areas.

Elevations

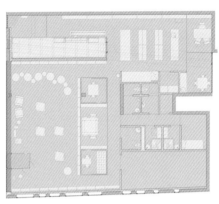

Floor plan

Simple, commonplace materials were used, such as glass and rock in the walls, PVC on the ground, and LEDs for lighting.

REACT Architects

Natasha Deliyianni, Yiorgos Spiridonos

Samou 7 A
14569 Anixi
Greece
Tel: + 30 210 806 1277
Fax: + 30 210 806 1282
www.re-act.gr

Natasha Deliyianni and Yiorgos Spiridonos are the founding members of the architecture and design firm, REACT Architects. In 1997, they decided to set up their own architectural studio that aimed at a theoretical approach to architecture through a research orientated process. They specialize in all types of projects such as small offices, private residences, exhibitions and stores, libraries, hotels, cultural centers, etc. The interior design is an important part of their work. They apply a very particular design scheme combining archetypes from Greek architecture with design ideas that meet twenty-first century needs.

Cyclist Shop
Athens, Greece / 2010 / © REACT Architects

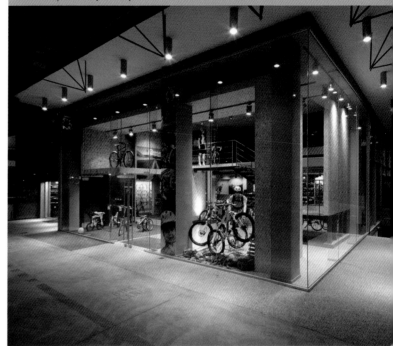

The second store of the company cyclist.gr was designed for and constructed in the area opposite to the central station of the Athens Metro. The design concept revolves around the way of life and lifestyle of bicycle lovers. The store has two levels: the ground floor of 400 m² (4,300 ft²) and a 150 m² (1,614 ft²) attic.

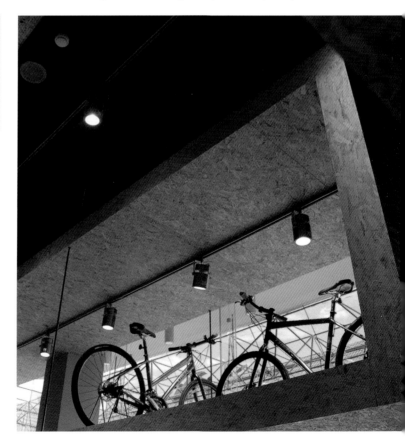

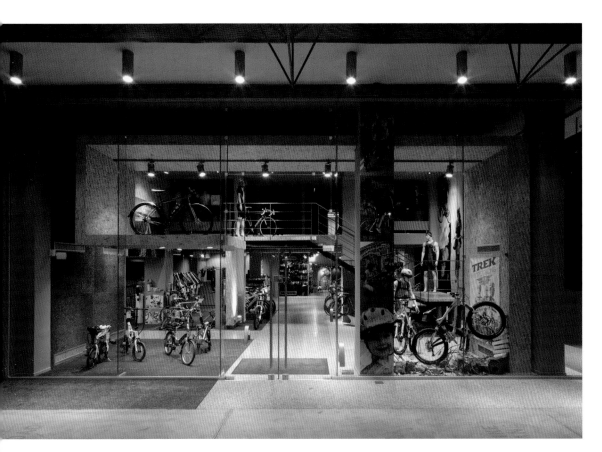

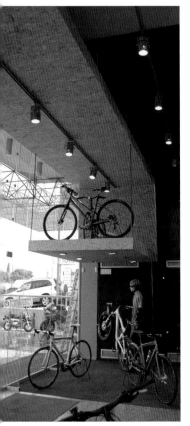

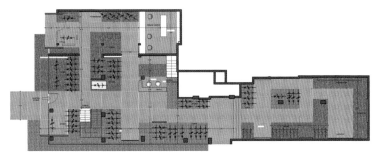

Ground floor plan

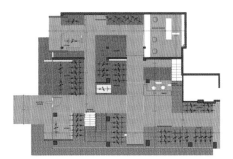

Mezzannine plan

Visible from the outside and just behind the entrance, elements have been suspended where basic products from the store are displayed. From this area, the route that the customer must follow up to the mezzanine—the clothing and footwear department—is marked.

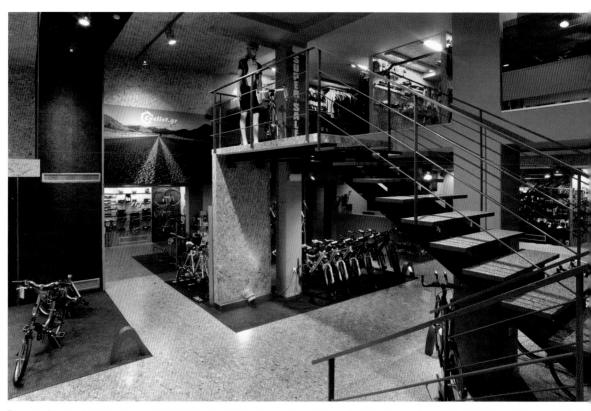

The ground floor contains the main exhibition space, with four themed categories: city bikes, mountain bikes, road bikes, and kids' bikes. The second floor contains bicycle part the repair shop, and photos for cycling fans.

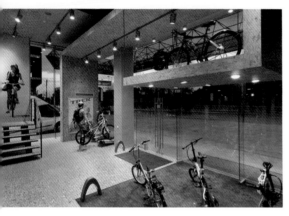

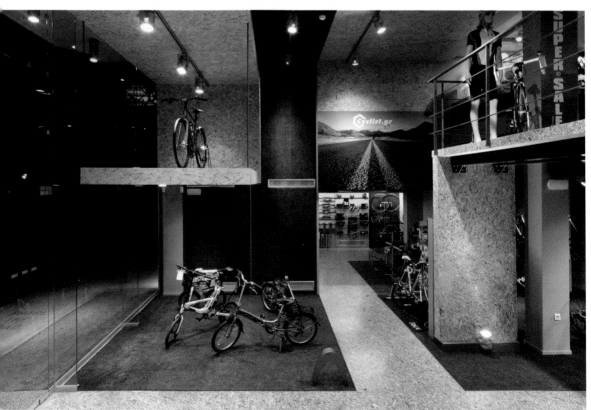

The combination of surfaces of different layered materials creates an intense depth that tempts shoppers to enter.

Future Health
Athens, Greece / 2009 / © REACT Architects

This building houses the offices and customer care center for couples interested in harvesting stem cells. To create the design, the architects were inspired by the shapes and colors in the company logo. The space had to convey a feeling of calm and relaxation.

Rendering

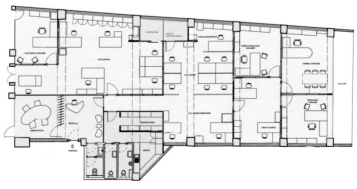

Floor plan

The materials used were translucent colored glass, and words were printed on the walls. The space contains Vitra furnishings as well as furnishings designed by the architects.

Rockwell Group

David Rockwell

5 Union Square West
10003 New York
New York
USA
Tel.: + 1 212 463 0334
www.rockwellgroup.com

Founded in 1984 by David Rockwell and based in New York and Madrid, the firm covers a wide range of architectural types: hotels, hospitals, cultural and educational centers, products, and set designs. Their development of a narrative and unique strategy for each client is fundamental for their approach of a successful design. The perfect synergy of craftsmanship, technology, and design is reflected in environments that combine handmade objects, high-end video technology, special effects, customized accessories, and furnishings. David Rockwell graduated in Architecture from Syracuse University and the Architectural Association in London. Ever since he was young, he has been interested in theater and set design, formative influences that have had a strong impact on his practice.

Mauboussin
New York City, NY, USA / 2008 / © Baber Miebach

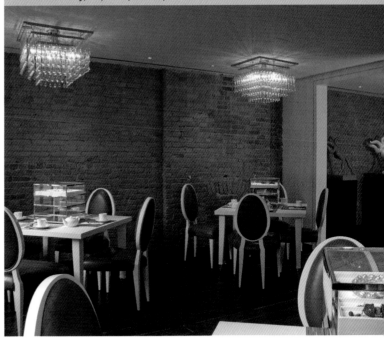

Rockwell Group created an experimental setting in which visitors can discover the jewels of fashion in an imaginative way. With the aim of evoking an emotional connection between the client and the jewelers, the designers showcase the beautiful pieces with surreal and unexpected design details. The space consists of four floors housing the jewelry store, a bridal room, a tasting room, and a loft.

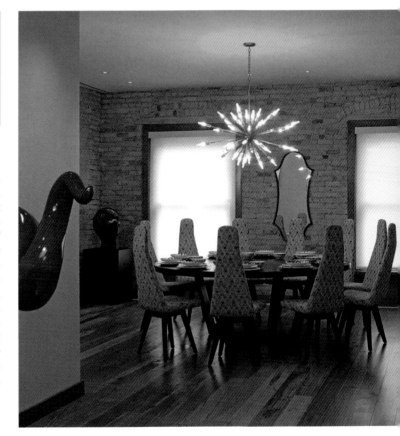

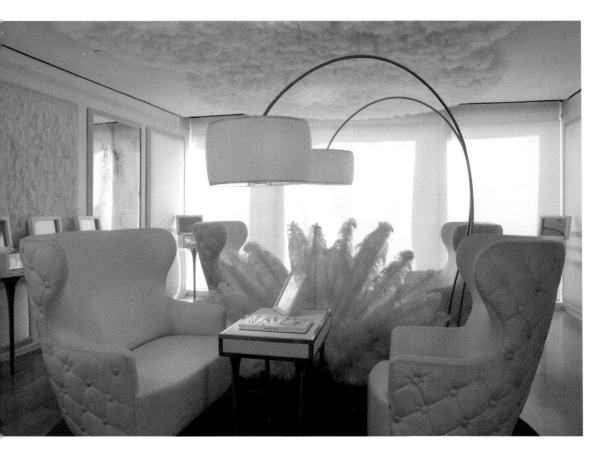

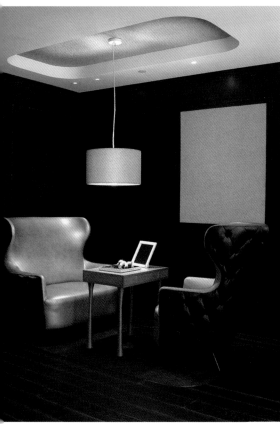

Before entering the store, customers are faced with a beautifully illuminated glass case. The façade was designed to illustrate the magic of color and the geometry of the jewelry.

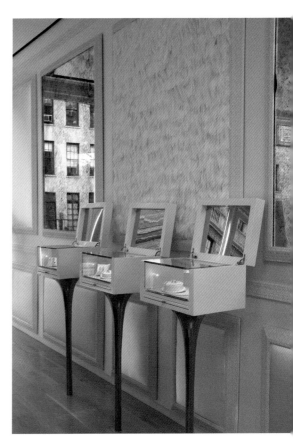

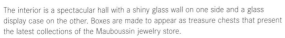
The interior is a spectacular hall with a shiny glass wall on one side and a glass display case on the other. Boxes are made to appear as treasure chests that present the latest collections of the Mauboussin jewelry store.

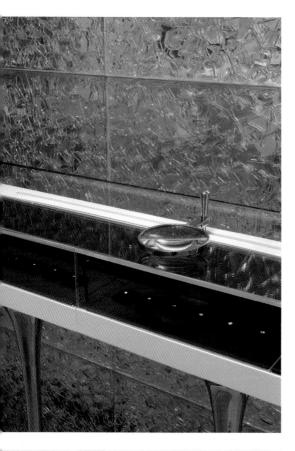

On the first floor there is a dark, dreamlike space that acts as a spectacular backdrop for the jewelry.

Crystals and CityCenter
New York City, NY, USA / 2009 / © MGM Mirage

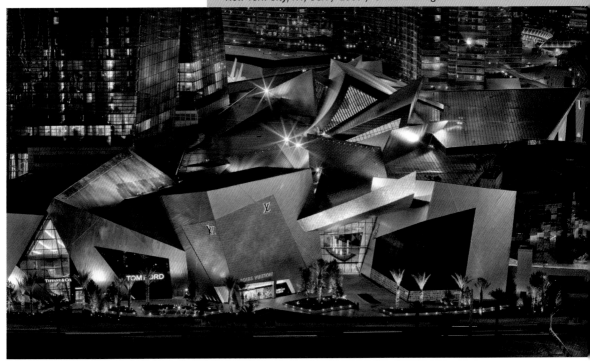

The Crystals building is the link that connects the hotels, resorts, and homes that make up the innovative metropolis called CityCenter. The designers were in charge of the interior design and came together with the architects who collaborated on this project: Daniel Libeskind, César Pelli, Rafael Viñoly, Normal Foster, and Helmut Jahn.

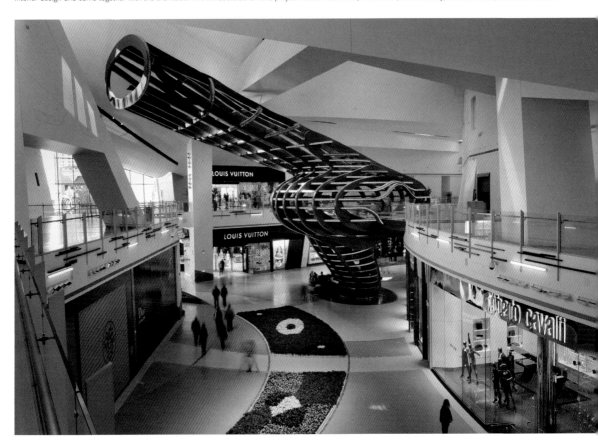

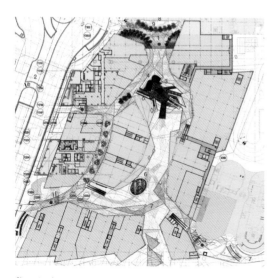
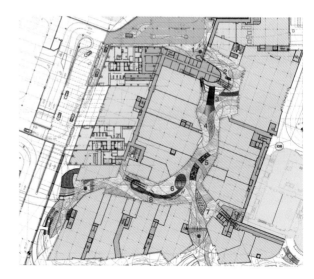

City center plans

The architects designed the project as a central urban park that would function as a social setting, with stores and restaurants. The architectural complex consists of three levels and the materials used were selected on the basis of sustainability and recycling.

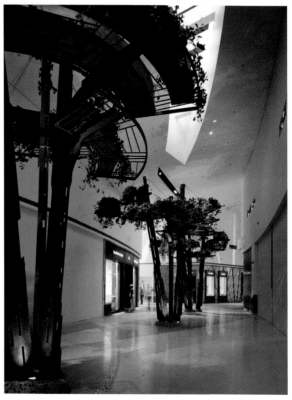

Highlights include a magnificent wooden staircase constructed of treated bamboo and a huge sculpture inspired by a modern tree house.

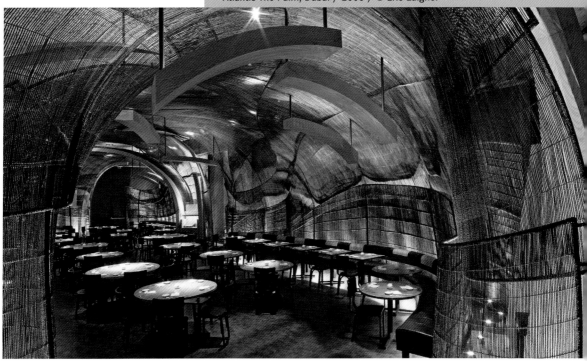

This project is the first Nobu restaurant located in the Middle East, the result of many years of collaboration between Rockwell Group and Nobu. The restaurant is located in Palm Jumeirah, the famous artificial island shaped like a palm tree in the middle of the Persian Gulf

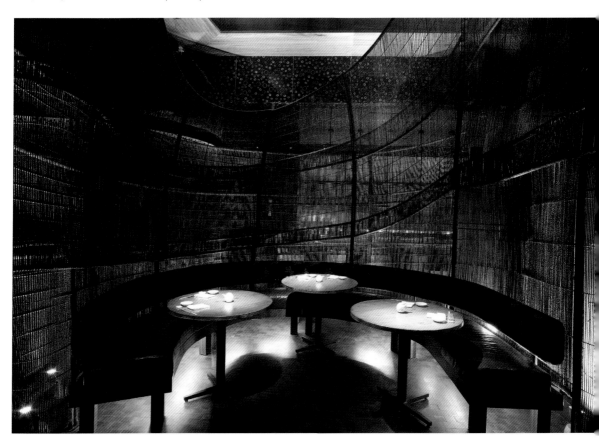

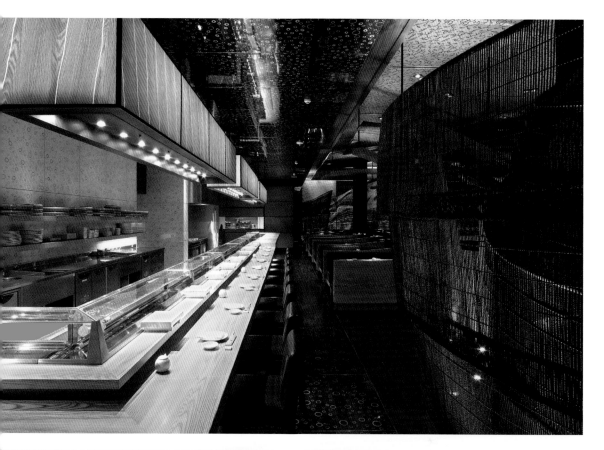

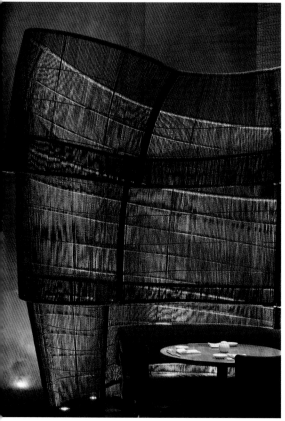

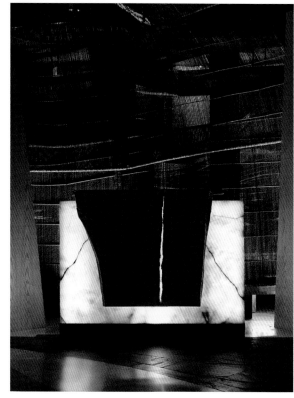

The textures and materials were chosen specifically to reflect the roots of Nobu in rural Japan and the context of Dubai overlooking the sea.

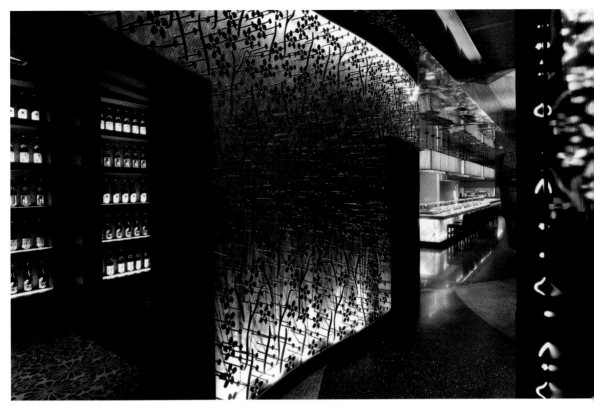

Nobu Dubai is an improvement on all of the concepts that the Rockwell Group has developed for Nobu in cities like New York, Melbourne, Moscow, and Hong Kong: the emphasis is on craftsmanship, natural materials, and narrative.

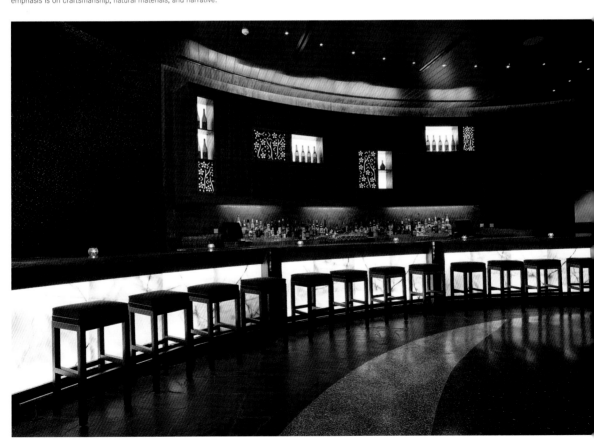

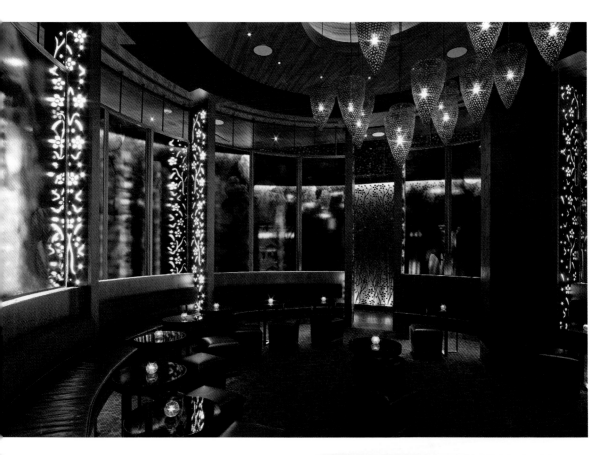

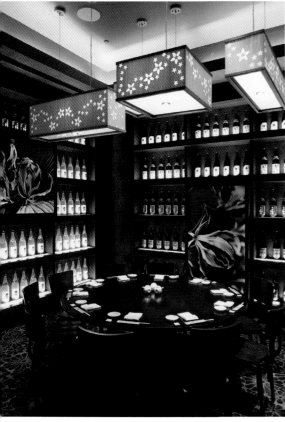

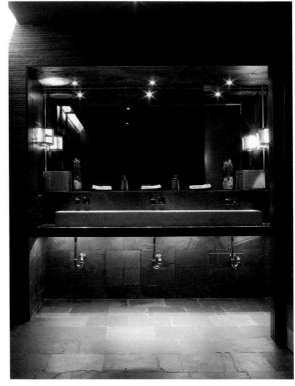

The columns of hand-cast iron flowers and leaves represent aspects of traditional, vernacular architecture in the Middle East, as do the large fabric panels that are reminiscent of waves of the sea.

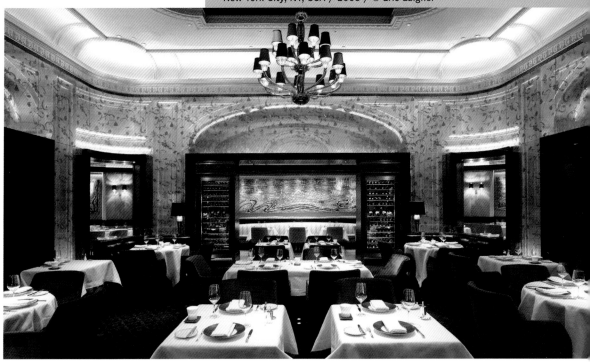

The goal of the designers was to create an environment as rich and complex as a wine tasting. This complexity is expressed through the creation of special materials, the original use of the color palette, the presentation of wines, and the integration of design and technology.

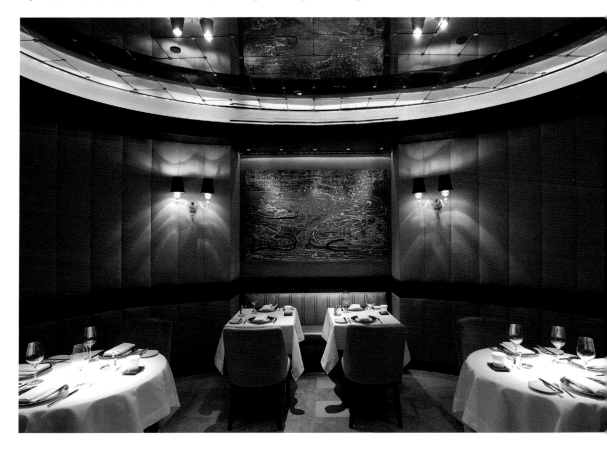

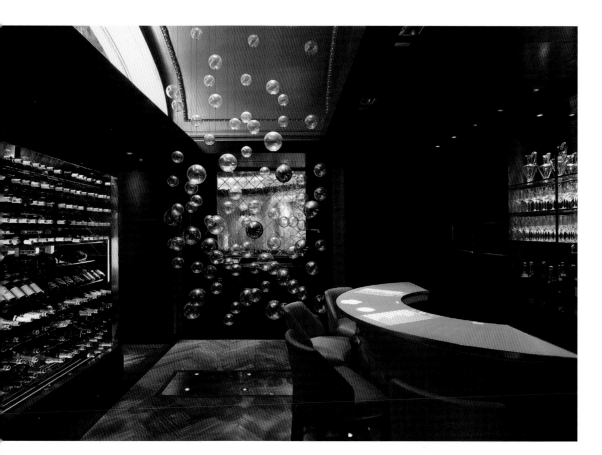

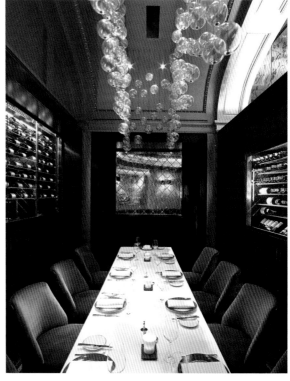

The bar is comprised of golden tones with a bronze-topped bar, framed by bottles of wine on shelves, along with tasting glasses and a special collection of antique wine bottles.

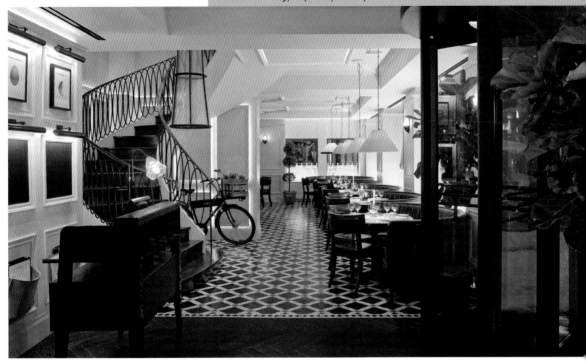

Rockwell Group was commissioned to design a restaurant for the Benjamin Hotel in Manhattan. The chic cafes of Paris, London, and New York served as inspiration to create an establishment with three distinct areas. It also took into account the rehabilitation of the building in 1927.

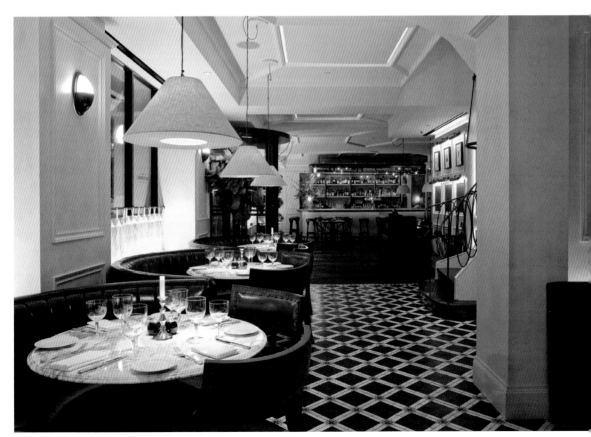

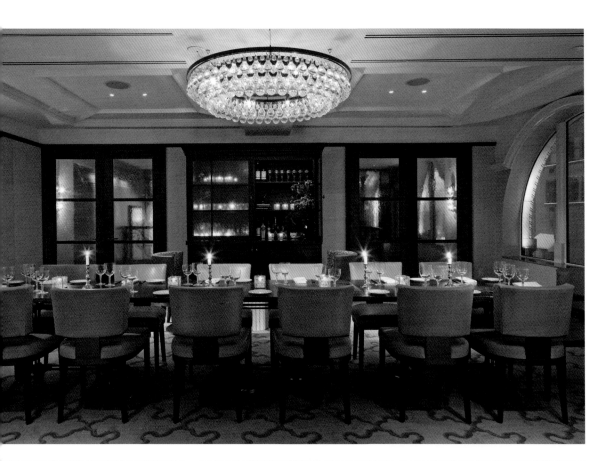

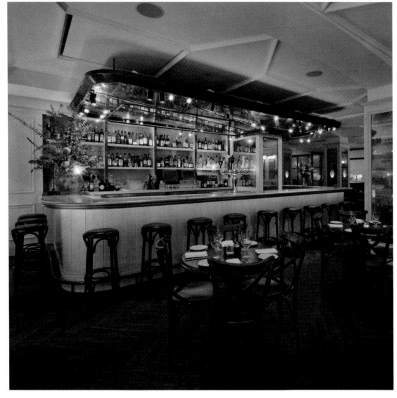

A blue-green leather has been used to upholster stools and chairs; the shade has become the leitmotif of the restaurant.

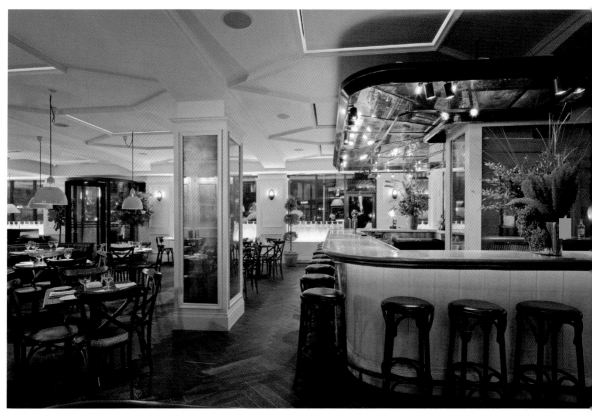

The lounge-bar is characterized by oak flooring, classic bar stools, and a modern light fixture, but with design based on the revival style of the restaurant.

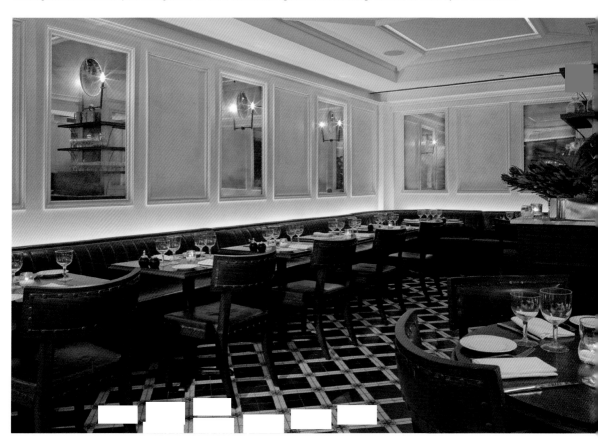

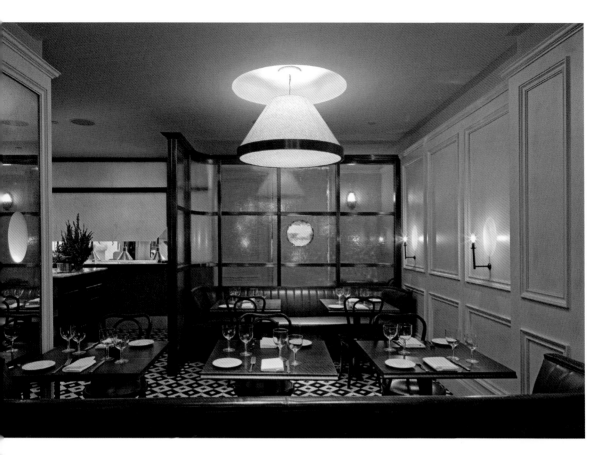

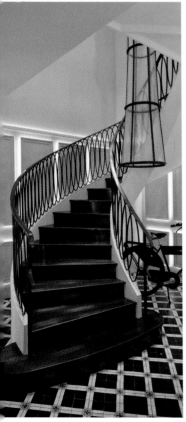

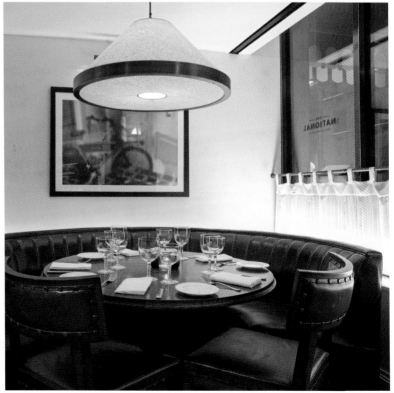

A bronze spiral staircase leads guests to the restaurant on the second floor where the private dining rooms and a library are located.

SF Jones Architects

Stephen Francis Jones

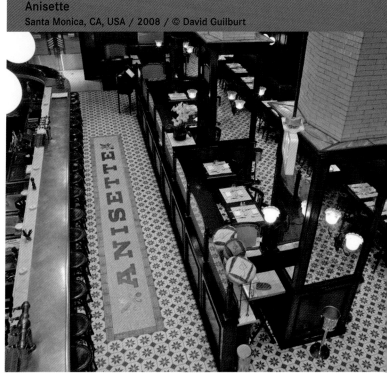

Anisette
Santa Monica, CA, USA / 2008 / © David Guilburt

This project, which resembles a Parisian cafe but is located in the heart of Santa Monica, was designed for an art deco style building dating back to 1929. The chef Alain Giraud wanted to bring the classic taste of French cuisine to the area, which is reflected in an elegant and vintage décor.

4218 Glencoe Avenue
90292 Marina del Rey
California
USA
Tel.: + 1 310 822 3822
Fax: + 1 310 306 4441
www.sfjones.com

This architectural studio specializes in designing exclusive restaurants. From its latest rustic luxury restaurant, Manhattan Beach Post, to the classic high-end style of Kumo Sushi, Stephen Francis Jones has created extraordinary ambiences dedicated to gastronomy and entertainment. He has vast experience and a rich vision that has been expressed in different types of projects—the restaurants, lounges, bars, hotels, and spas that he has designed in the United States and around the world are a testament to this. After studying architecture at the University of Florida, Jones graduated from UCLA and began his career in Boston, working with Jung/Brannen Associates. Later he went to Tuscany, Italy to perfect his skills and study the architecture of the region. He returned to Los Angeles and began working at Wolfgang Puck Food Company, which he left in 1996 to establish his own firm.

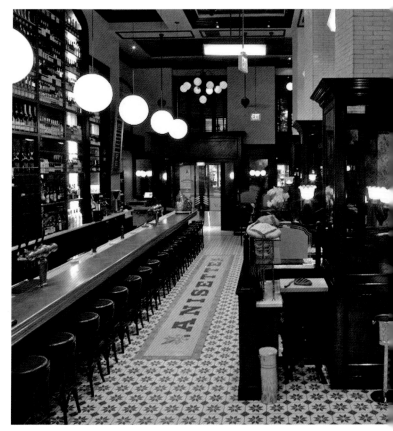

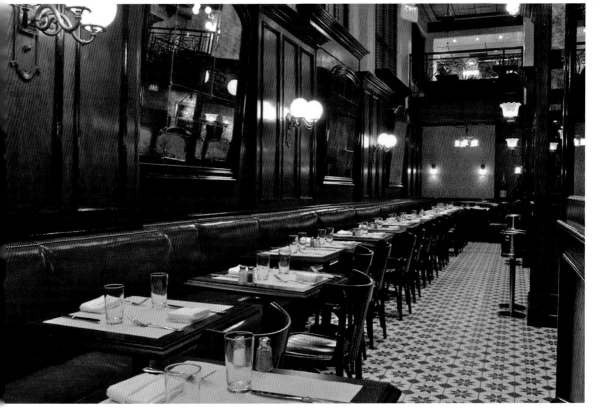

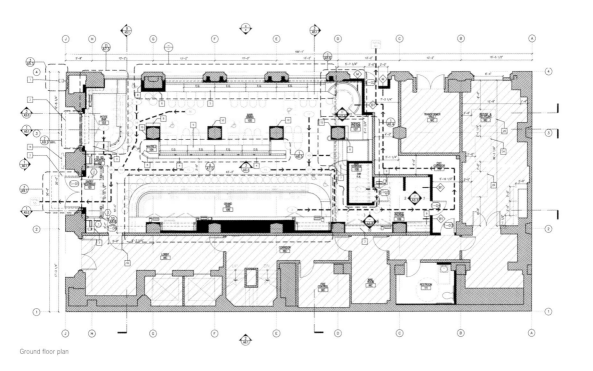

Ground floor plan

alls, shelves, and furniture in oak make the wine bottles imported from France stand out.

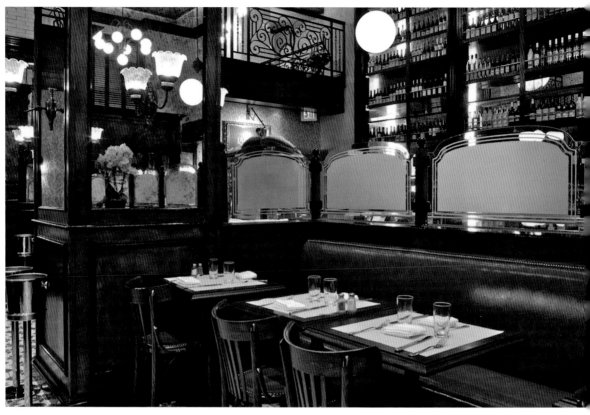

Red leather has been used for the upholstery. The art deco-style mosaic tile floor strategically contrasts with the elegant frosted glass partitions.

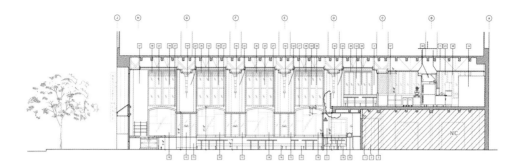

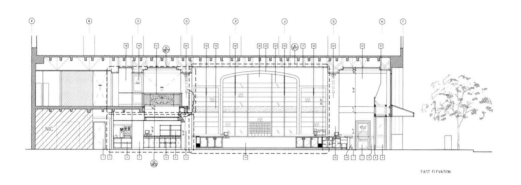

FAST ELEVATION

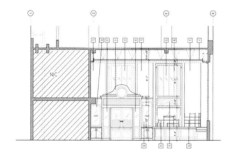

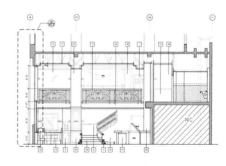

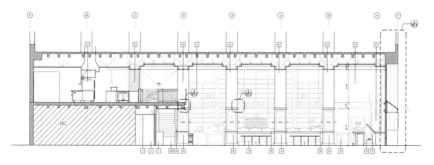

Sections

e high pillars support a building that was formerly the headquarters of an old bank. This space operates as a café and exclusive wine bar.

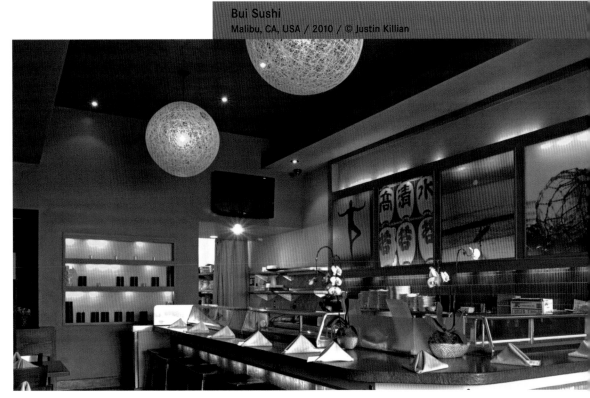

Opened in July 2010, Sushi Bui is a remodeling of an old establishment. The owner wanted to expand his business with a nightclub. The most interesting aspect of this intervention is the use of textures that give the premises the chic look it needed.

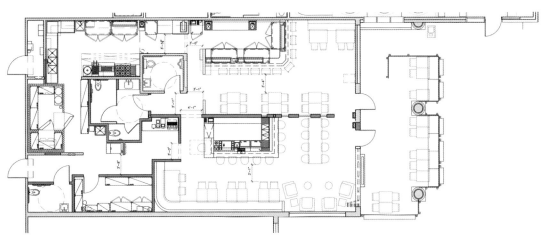

Floor plan

Special features of the classic palm wood allow the light of the restaurant bar to shine during daylight hours.

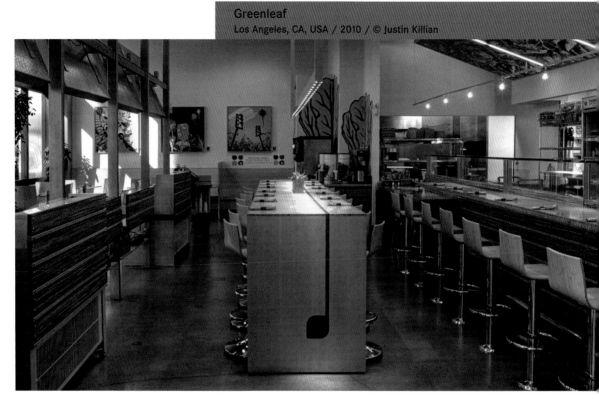

The owner of the establishment, Jonathan Rollo, wanted a clean, contemporary design to provide a unique and fun atmosphere for those wishing to eat lunch at his restaurant. The designers built an open counter on which clientele can easily see the menu.

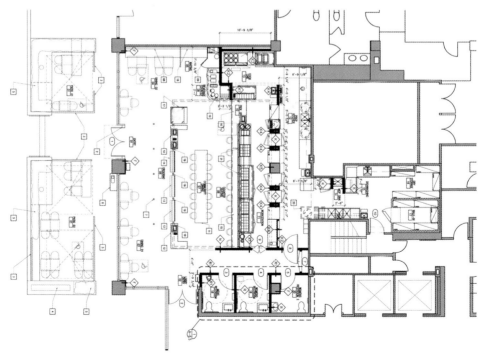

Mezzannine plan and ground floor plan

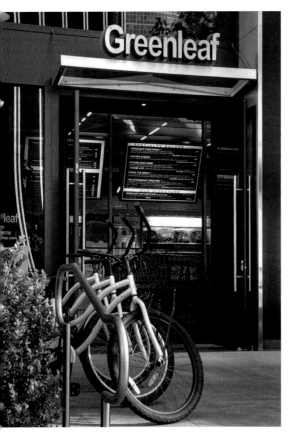

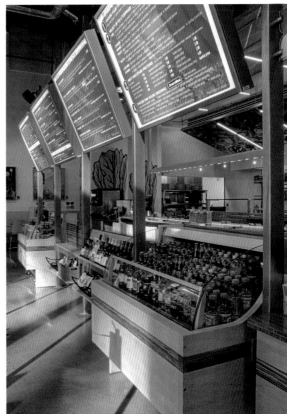

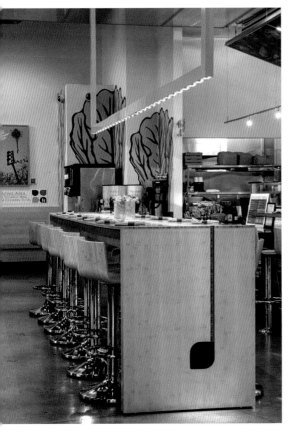

Light plays an important role in the design. The lighting system on the communal tables and seating highlights the bamboo furniture. Lettuce leaf motifs decorate the walls, advertising the healthfulness of the food.

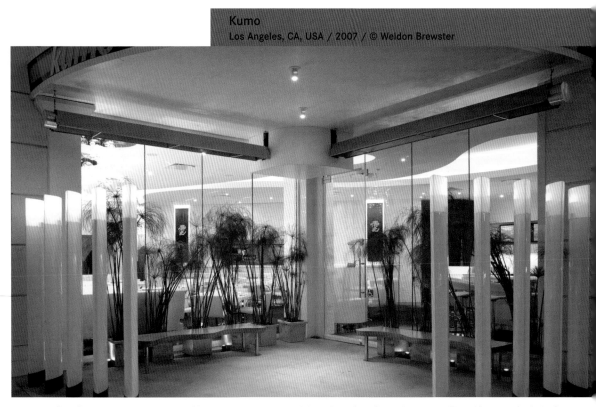

Kumo means "cloud" in Japanese and this concept led SF Jones to create a pure and pristine white ambience for a sushi restaurant. The architects drew inspiration from renowned Japanese artists and architects, such as Isamu Noguchi.

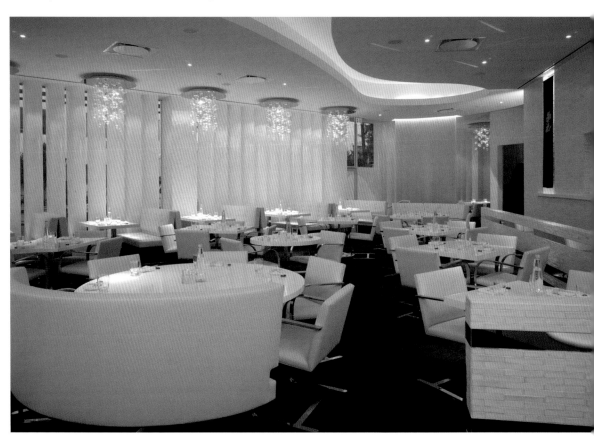

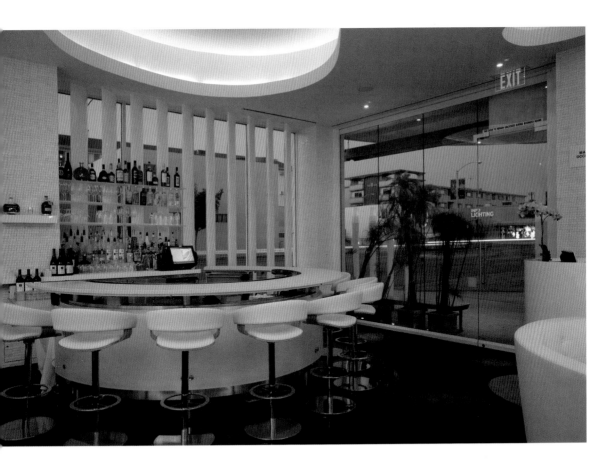

The architects have created an elegant, achromatic, modern, and refined space, much like the cuisine of chef Hiro Fuijita.

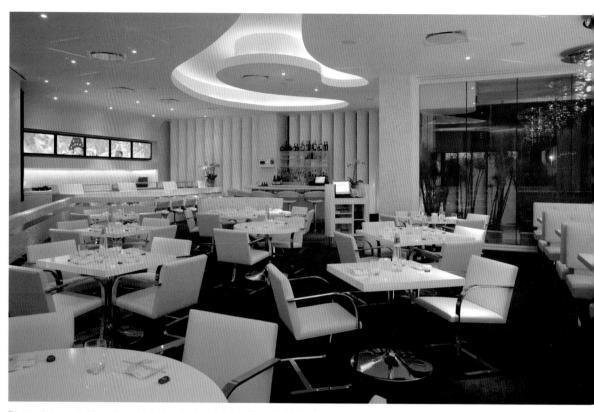

The smooth curvature of the ceiling and walls allows for the installation of dramatic lighting. A row of plasma screens with a cyclic animation called City Glow has been arranged designed by the artist Chiho Aoshima, whose painting style is derived from combining traditional Japanese painting with pop, anime, and manga.

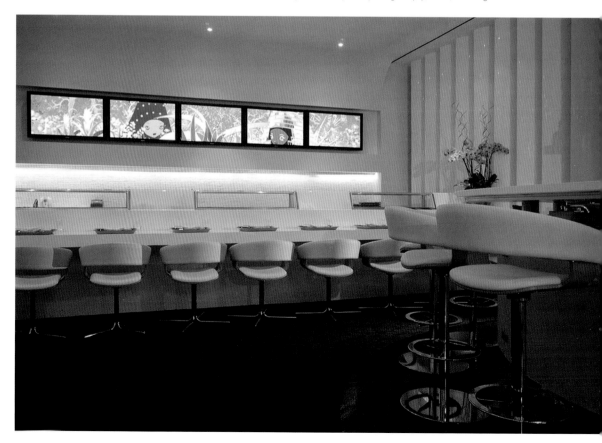

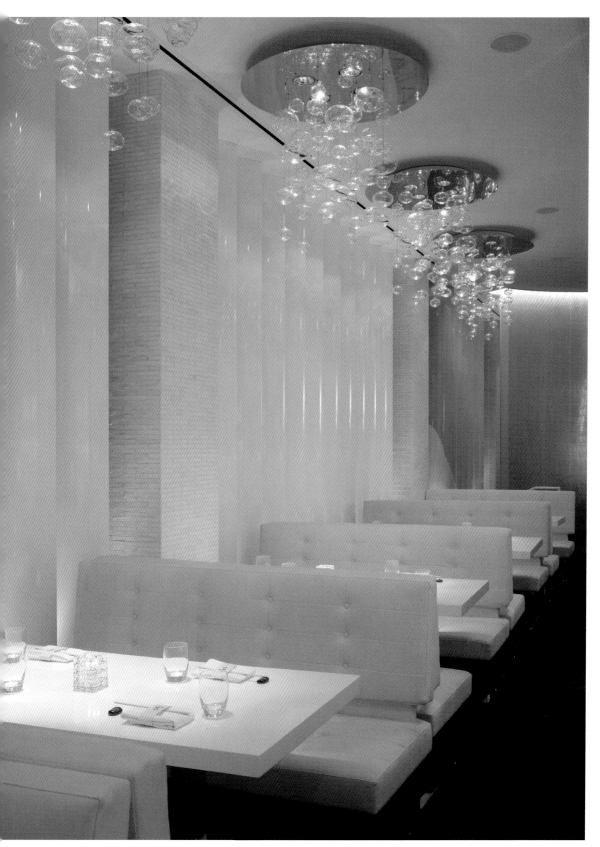

small private dining room has been installed with a cascade of large, bright, glass sphere hanging lamps. The décor evokes large drops of rain that descend from the clouds.

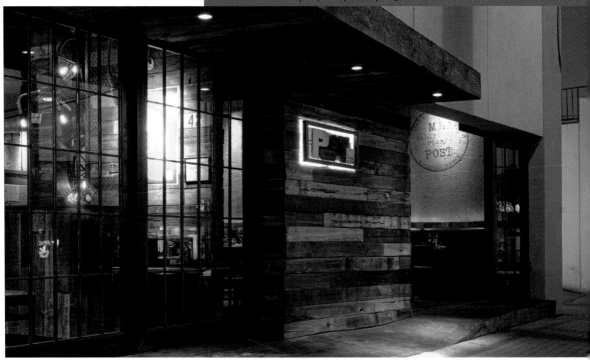

The luxury restaurant chain M.B.Post asked the architects to create a "sentimental space." In response to this challenge, the director of the firm decided to bring defining pieces from Manhattan Beach to capture the essence of this American town.

Floor plan

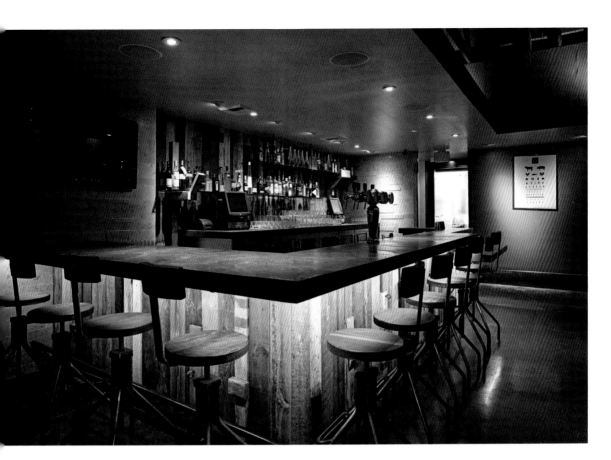

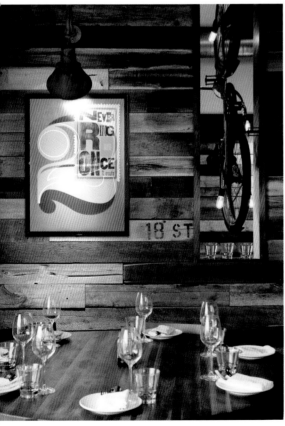

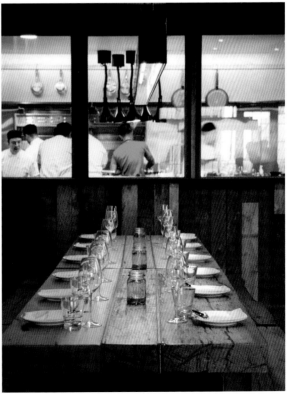

The incorporation of historical and cultural references such as volleyball poles, lifeguard stands, and reclaimed wood from a barn are the leitmotif of this restaurant.

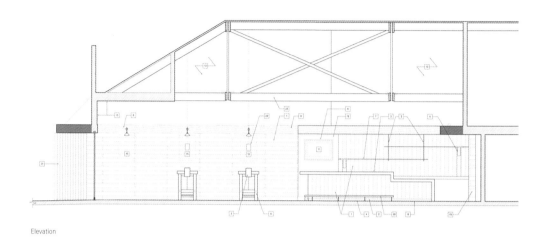

Elevation

Special reference is made to the original post office in Manhattan Beach through the use of rustic walnut carpentry. Rusty steel doors and floor paving further help to make the clients feel at home.

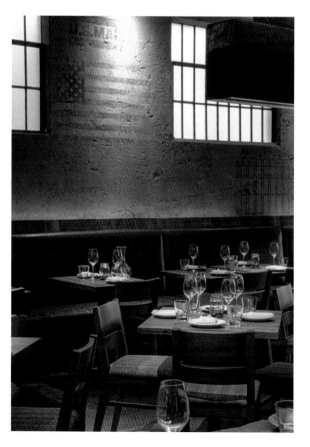

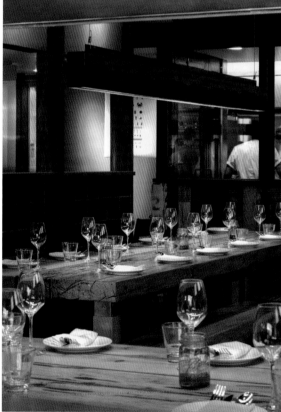

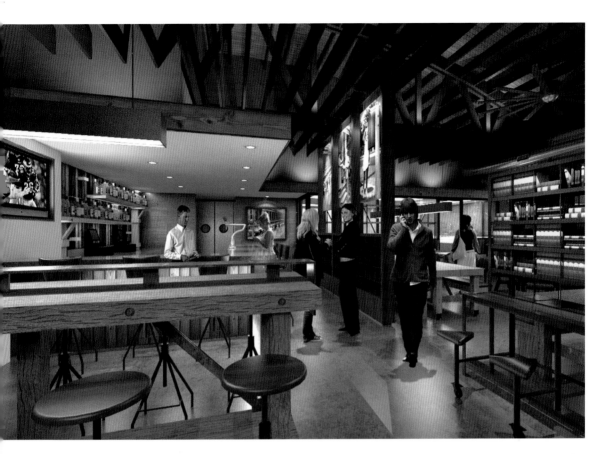

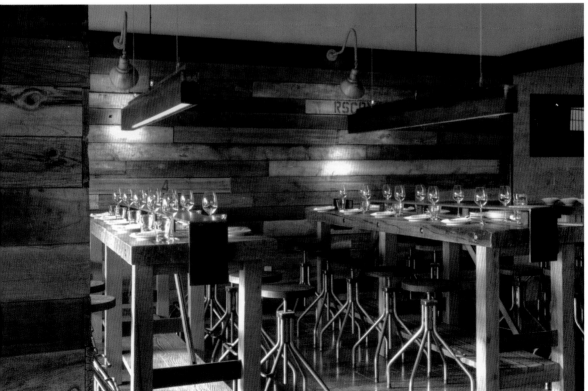

The 309 m² (3326 ft²) are distributed on one floor and in different spaces depending on the number of diners. The architects decided that the kitchen should be open to make the restaurant more familiar for its guests.

Shichieh Lu/CJ Studio

Shichieh Lu

6F # 54 Lane 260
Kwang-fu South Road
Taipei
Taiwan
Tel.: + 886 2 27738366
Fax: + 886 2 27738365
www.shi-chieh-lu.com

Born in Taipei in 1965 Lu Shichieh graduated in Architecture from the Architectural Association in London in 1993. In 1995, he set up the office CJ Studio. He has taught at the Universities of Shih Chien, Min-Chang and Tung-Hai. In 2003, he created his own brand. CJ Studio defines architecture and design as social acts, not only as art. Each design project is an experience where the owners and users have to join this venture to seek and create a new system. He believes that through analyzing, integrating, rediscovering, and the existing conditions (the environment, function, owner, historical background, etc.), the order and geometry that exist in the real world can be found and the past can be connected with the future.

Pamper Heiress
Taipei, Taiwan / 2008 / © Marc Gerritsen

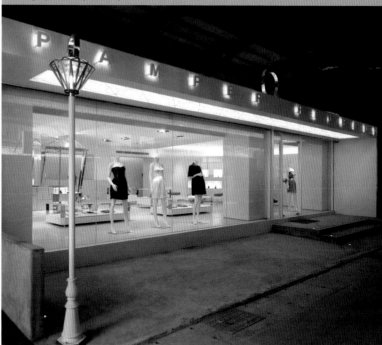

The brand Pamper Heiress adopted the theme "the house of diamonds" for this project. Inspired by clothing and jewelry displayed in the store, the designers created a bright and glossy ambience. The showcases were designed to mimic the light reflections in multiple angles, as if they were diamonds.

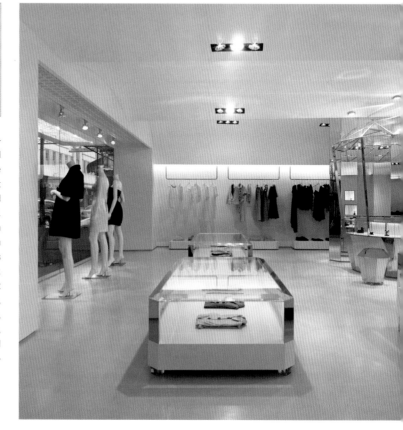

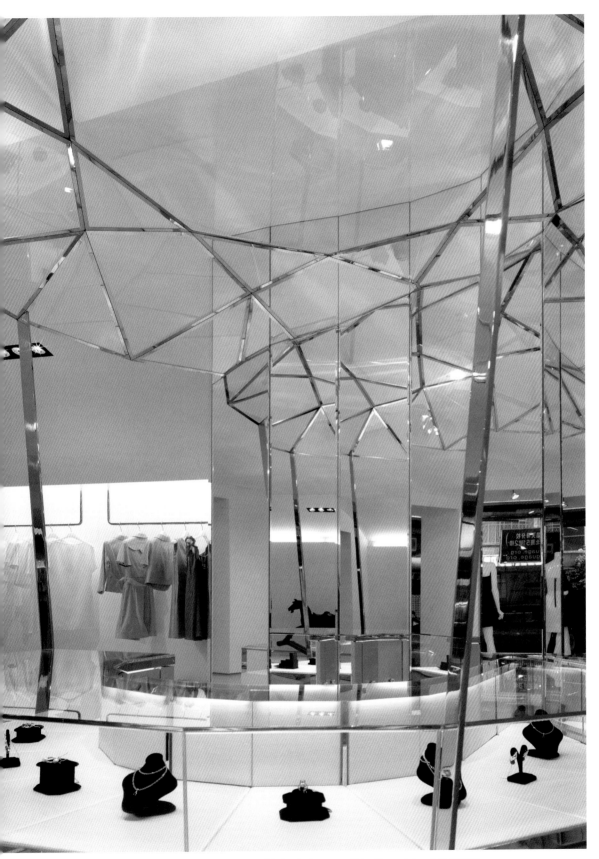

The ceiling was decorated with sinuous lines that respond to the angular shapes of the jewelry showcases, which achieves a balance in all elements.

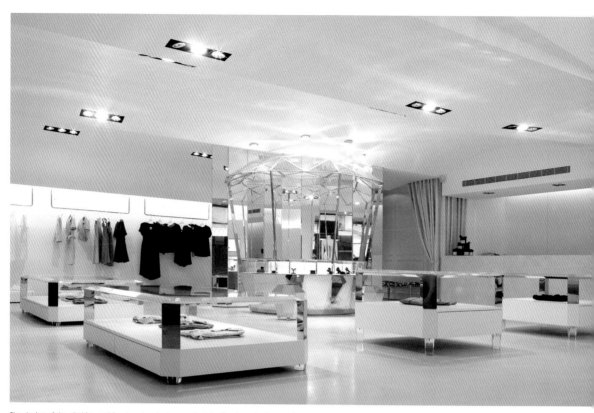

The design of the clothing and jewelry store is clean and minimalist, from the large objects to the smallest details. The entire space is sophisticated and luxurious, reflecting the philosophy of the brand.

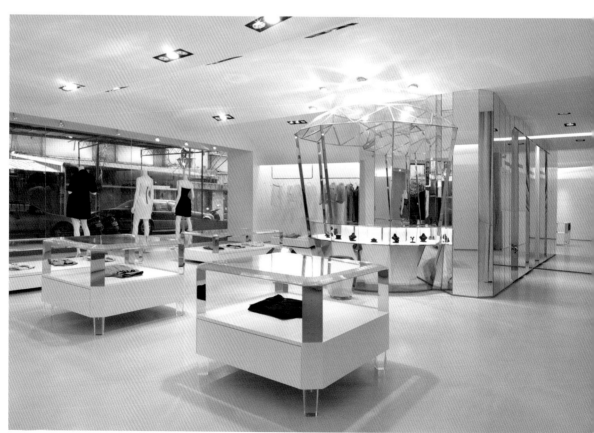

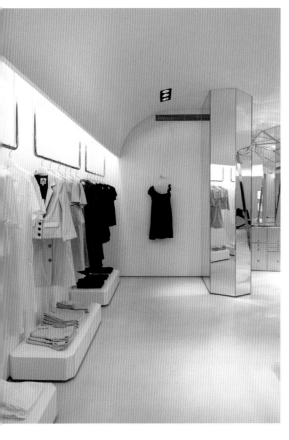

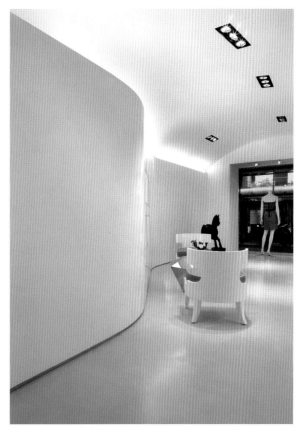

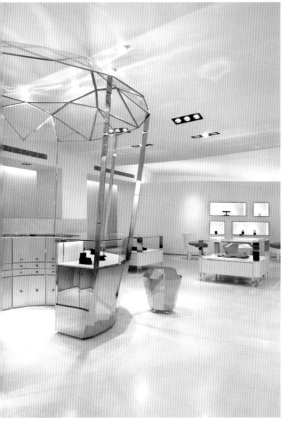

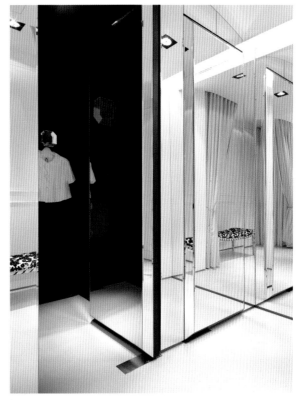

Diamonds are present throughout the store and the shape of a diamond ring was even used as a model for the hangers in the fitting rooms.

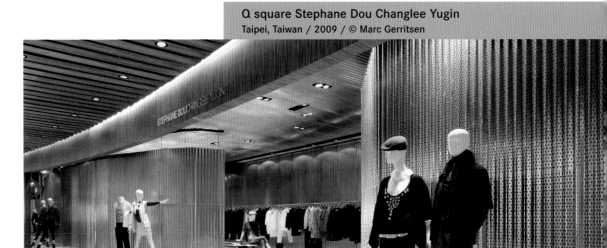

The opening of a new Stephane Dou and Changlee Yugin boutique was a creative challenge that consisted of developing the brand image and adapting it to a commercial environment. The unique location of the premises, right across from the public hallway, forced the designers to design a store-within-a-store model.

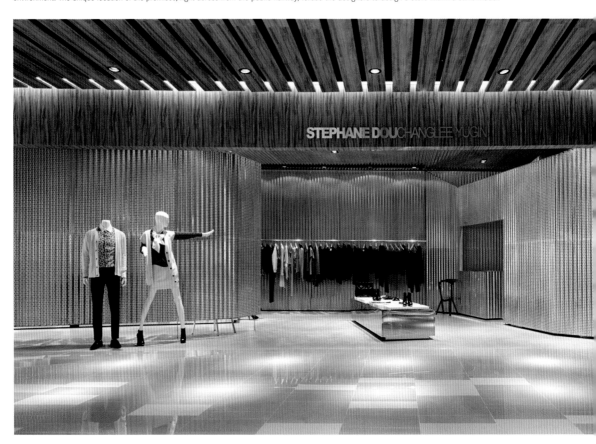

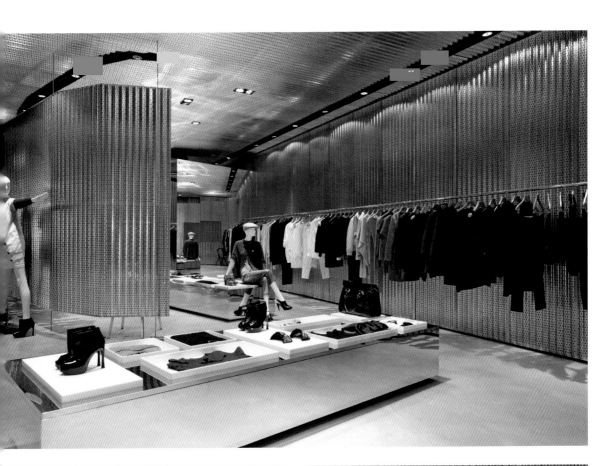

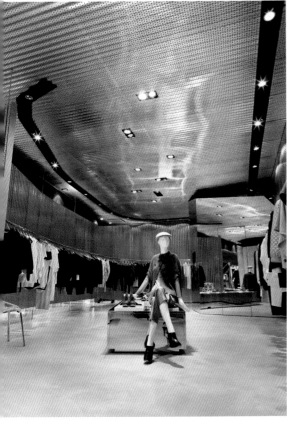

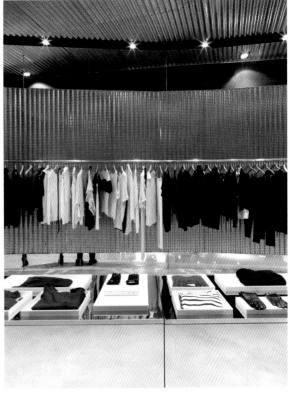

The original structure of the boutique consists of corrugated sheets often used at construction sites to define the space.

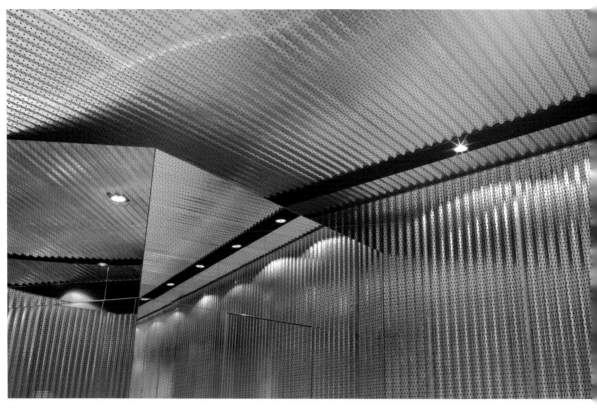

The designers sought a wraparound design that encourages a carefree shopping experience. This was achieved with the use of metals and glass panels to produce ripples and reflections, creating a simple and soft atmosphere.

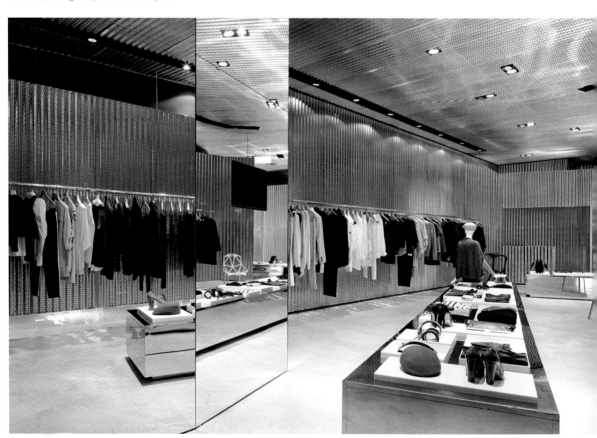

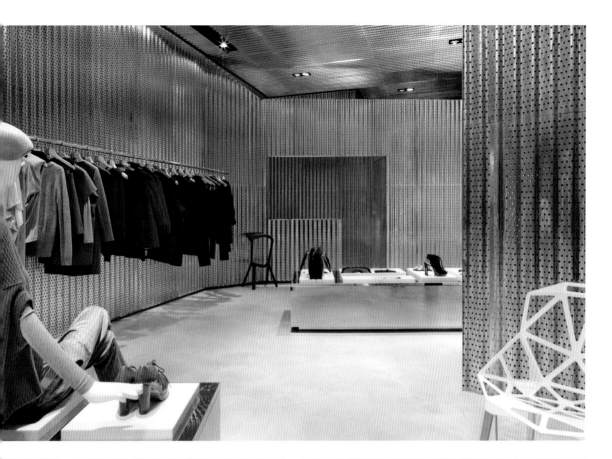

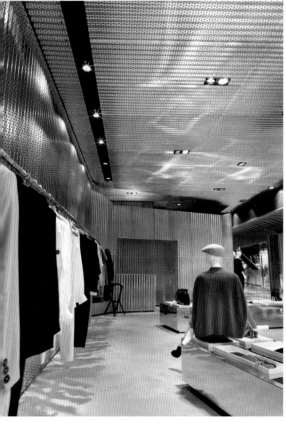

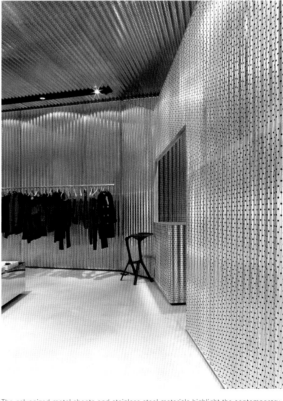

The galvanized metal sheets and stainless steel materials highlight the contemporary and avant-garde spirit of the brand.

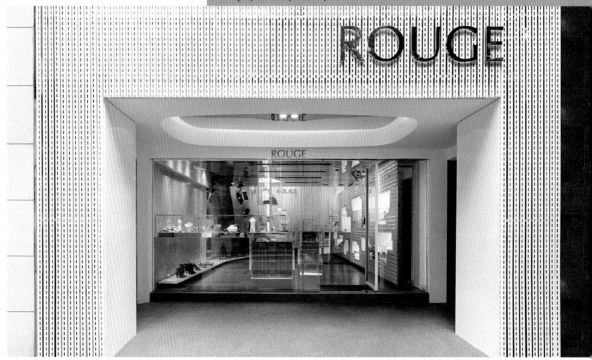

The owners of the accessories store Rouge wanted an impressive premise that would reflect the new line and quality of the boutique, which brings together more than twenty famous brands from around the world. To achieve this goal, the interior designer created a space with classic and modern lines.

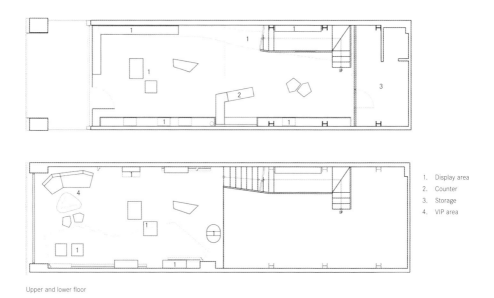

1. Display area
2. Counter
3. Storage
4. VIP area

Upper and lower floor

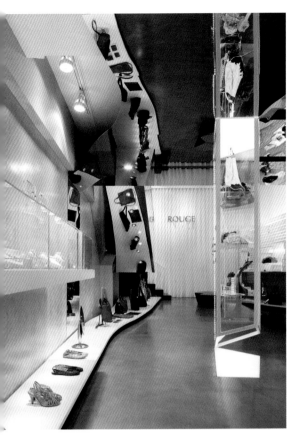

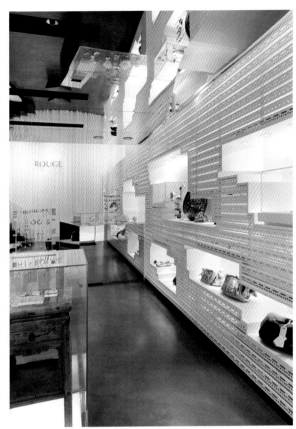

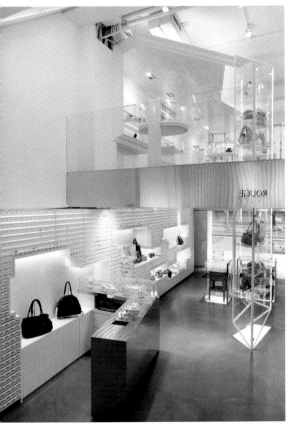

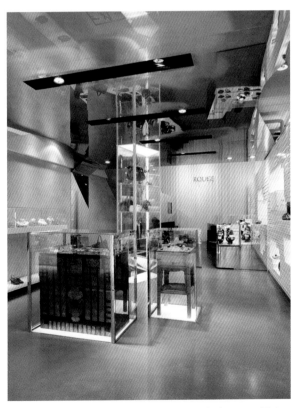

In the center of the exhibition space, a large glass structure has been created that rises from the floor on the first floor and reaches the second floor.

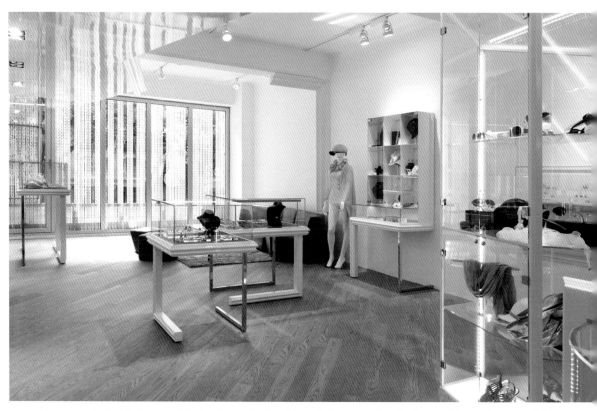

Perforated metal profiles are the main elements, and they have been used on the exterior and in the main elevation of the first floor. This material, of common industrial use, offers an unusual beauty to this space.

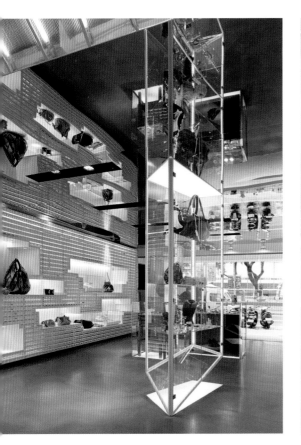
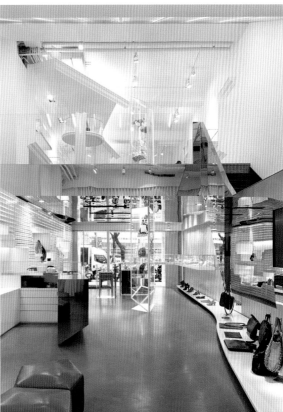
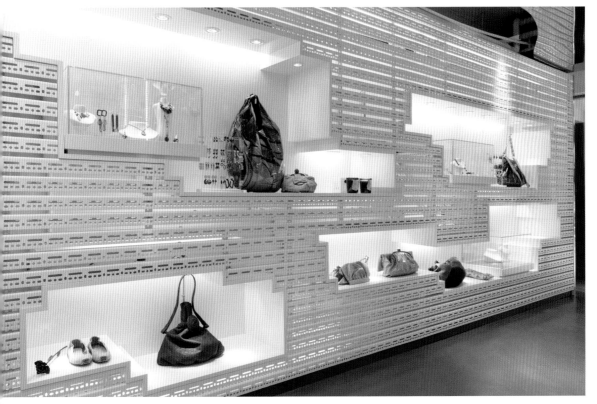

The third floor has a VIP room whose design offers a comfortable and stylish area for clients. The steel profiles, glass elements, and hand-cast cement are the main interior design materials used.

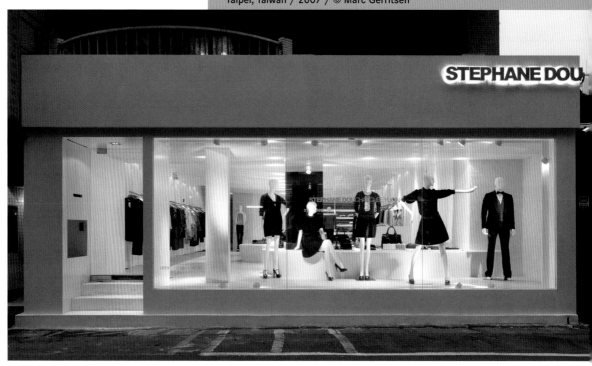

A one-story building serves as a modern showcase for the collections of these fashion designers. White walls and exposed metal painted the same color make the clothing visible from the exterior, converting it into the centerpiece.

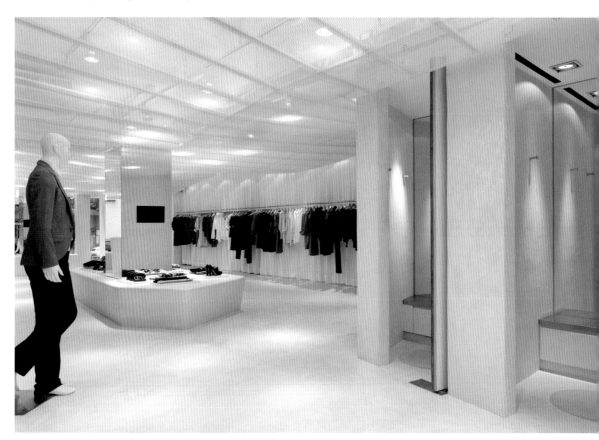

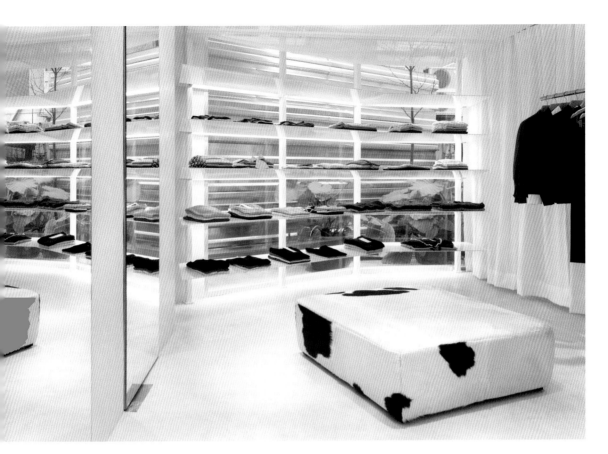

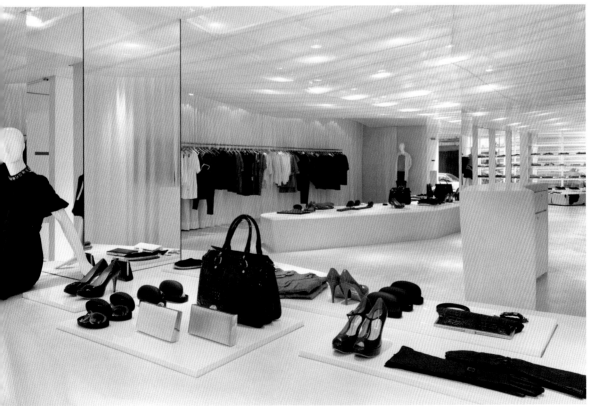

The theatrical lighting was installed so that it functions as a guide for visitors. Its geometric arrangement forms flowing lines and angular curves.

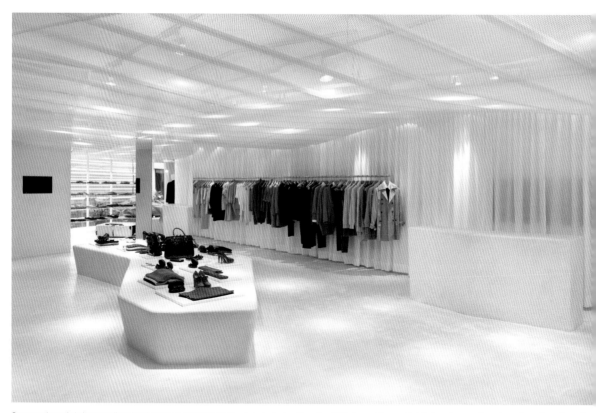

Corrugated metal shelves are aligned horizontally to showcase the luxury accessories. More than 300 pieces of laser cut cloth hang from perforated metal panels on the ceiling. These, along with lighting and hanging screens, create a technological style.

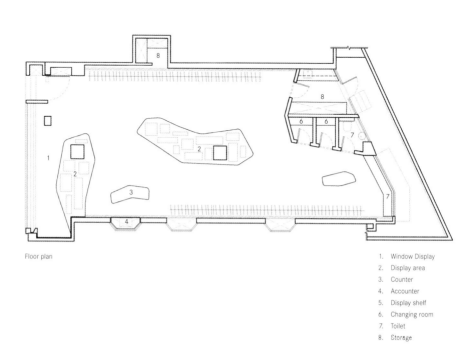

Floor plan

1. Window Display
2. Display area
3. Counter
4. Accounter
5. Display shelf
6. Changing room
7. Toilet
8. Storage

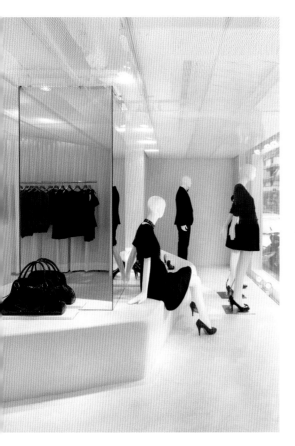

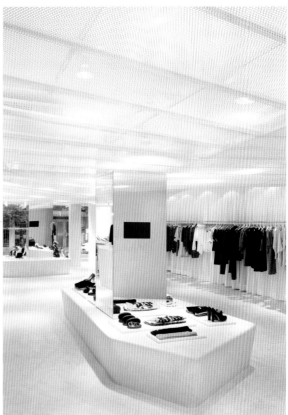

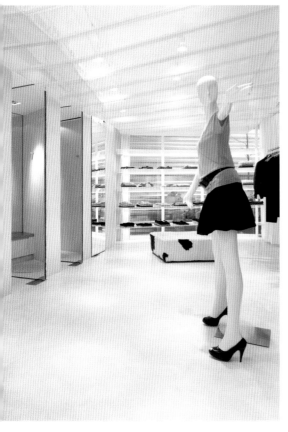

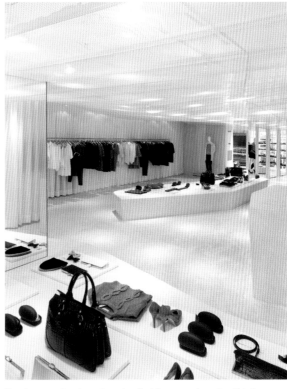

The mirrors are placed on columns to reflect the accessories and multiply the spaces. The hardness of the marble floors and display cabinets are softened by the lightness of the fabrics and the windows.

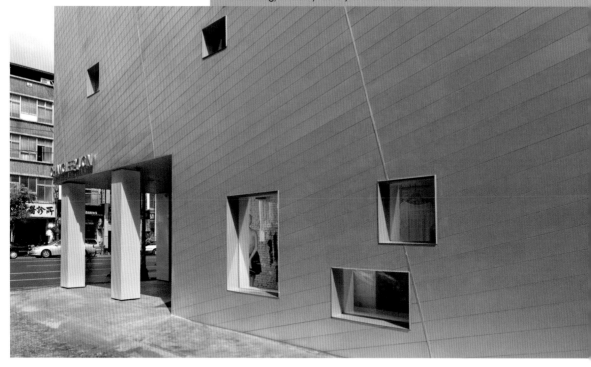

StephaneDou ChangleeYugin Bia
Kaohsiung, Taiwan / 2010 / © Marc Gerritsen

This project was created for the first Stephane Dou and Changlee Yugin store in Kaohsiung. Galvanized steel is the main material used in the design, which features on the façade as folded cloth. This gray area is a sneak-preview of the avant-garde interior of the boutique.

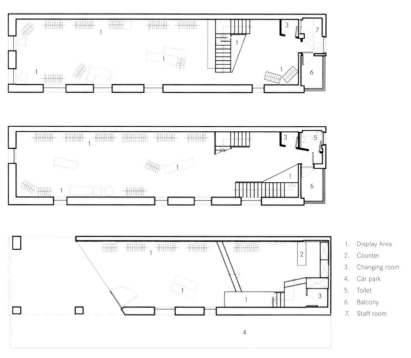

1. Display Area
2. Counter
3. Changing room
4. Car park
5. Toilet
6. Balcony
7. Staff room

Second floor plan, first floor plan and ground floor plan

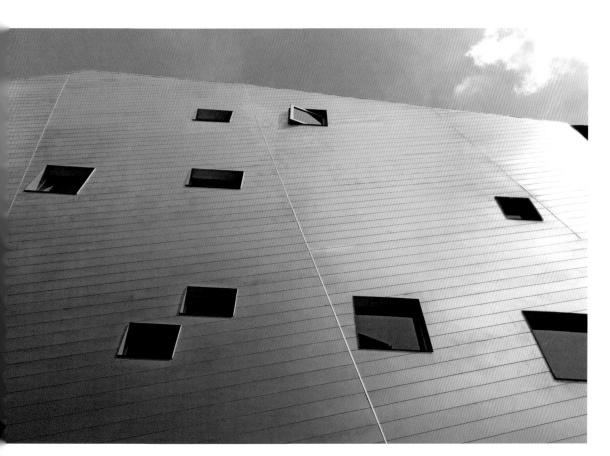

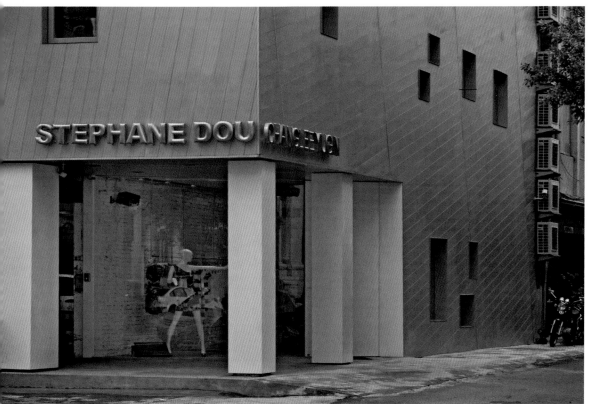

addition to the unique structure of the exterior, the different sizes and shapes of the windows stands out.

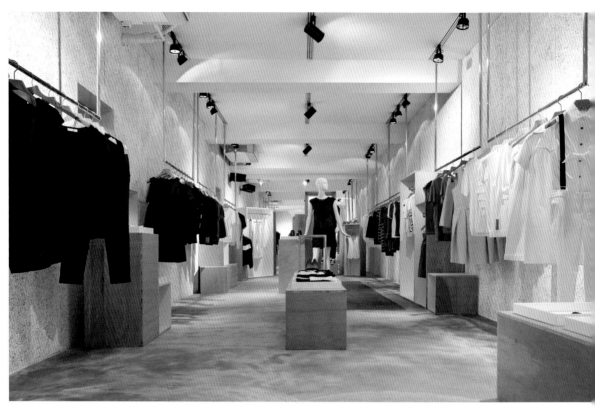

The interior was remodeled to house a gallery based on the former design of a three-story building. The natural cement, plywood, and fiber cement siding give the environment touch of class.

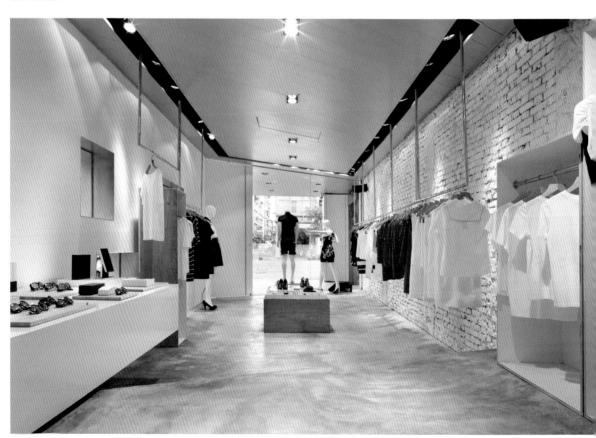

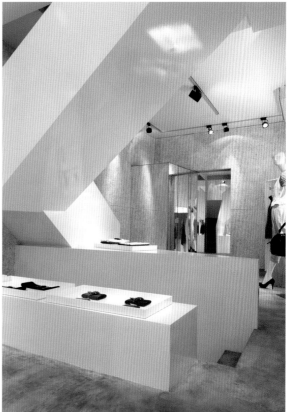
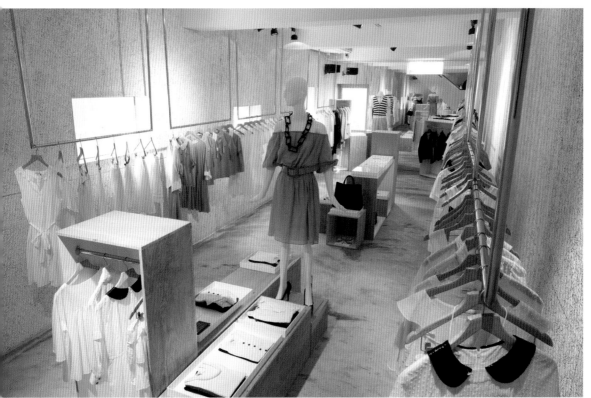

he galvanized steel structure extends from the floor to the ceiling on the second floor. The original brick wall of the building contrasts with the bright white wall on the posite side.

Simone Micheli
Architectural Hero

© Maurizio Marcato

Simone Micheli

Via Aretina, 197r 199r 201r
50136 Florence
Italy
Tel.: + 39 055 691216
Fax: + 39 055 6504498
www.simonemicheli.com

Simone Micheli founded his own architectural studio in 1990. Years later, in 2003, he incorporated design into this work and changed the name of the studio to "Simone Micheli Architectural Hero." Micheli is a lecturer at Polidesign Milan and the Scuola Politecnica di Design in the same city. The company offers services in the fields of architecture, interior design, and visual communication. All the projects designed by the architect are unique and have a strong personality, as well as being sustainable and environmentally friendly. He is considered to be one of the key architects in the field of planning in Europe, and he has drawn up a series of plans for the public administration and for prestigious clients.

Aquagranda Livigno Wellness Park
Livigno, Italy / 2010 / © Jürgen Eheim

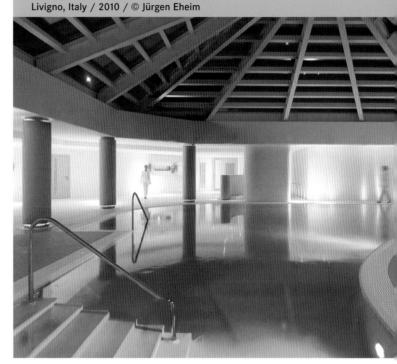

This interior design project revolves around a concept of balance and beauty in terms of both its morphological features and functionality. The Italian architect wanted to research the topic of ancient Roman baths to reveal a world of dreams and sensations.

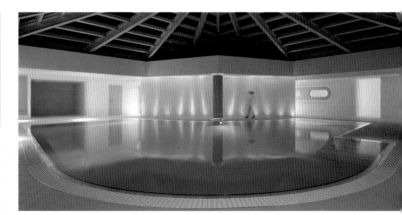

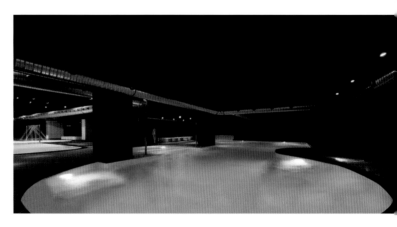

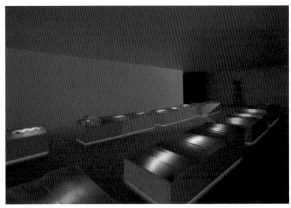

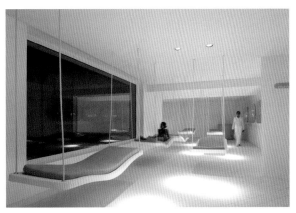

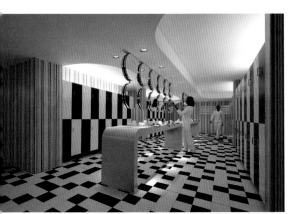

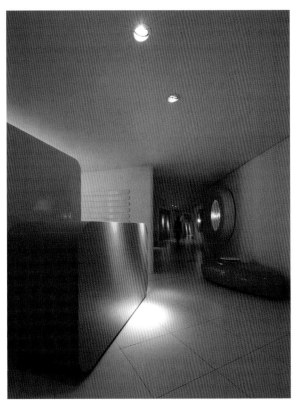

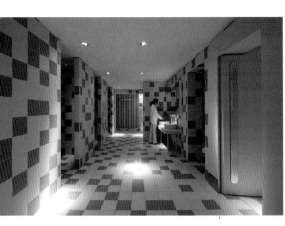

The project is characterized by the use of colors and basic, yet highly functional, furnishings, with a design theme based on plastic forms.

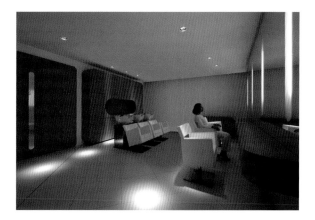
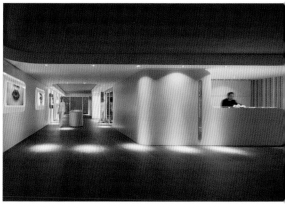

Everything is designed for customer comfort: soft lighting, warm and cold ambiences, videos that animate the Spa, elegance, theatrical spaces, and bright colors.

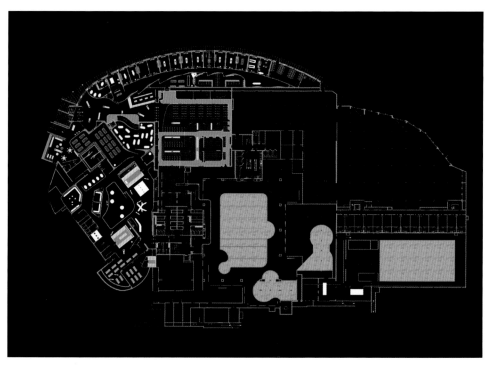

Floor plan

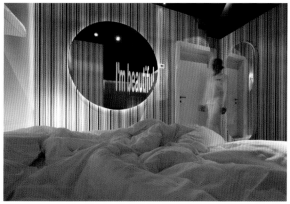

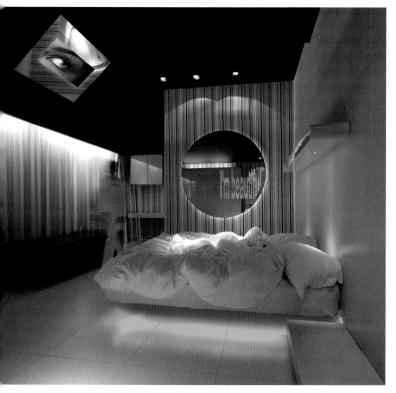

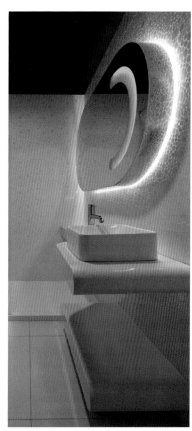

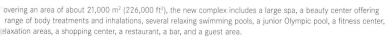

overing an area of about 21,000 m² (226,000 ft²), the new complex includes a large spa, a beauty center offering
range of body treatments and inhalations, several relaxing swimming pools, a junior Olympic pool, a fitness center,
elaxation areas, a shopping center, a restaurant, a bar, and a guest area.

Atomic Spa Suisse
Milan, Italy / 2009 / © Jürgen Eheim

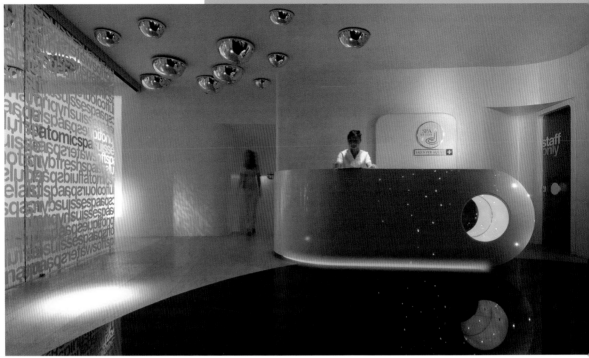

The new health and beauty center for the Exedra hotel is part of the Italian Boscolo hotel chain. The customer wanted their guests to experience a sensation of emotional vertig through a design in which the third dimension, materials, and select colors play a leading role.

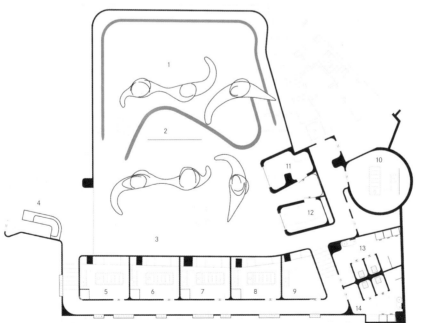

1. Swimming pool
2. Showers
3. Relax zone
4. Reception
5. Cabine 1
6. Cabine 2
7. Cabine 3
8. Cabine 4
9. Cabine 5
10. Cabine 6
11. Turkish bath
12. Sauna
13. Women locker room
14. Men locker room

Floor plan

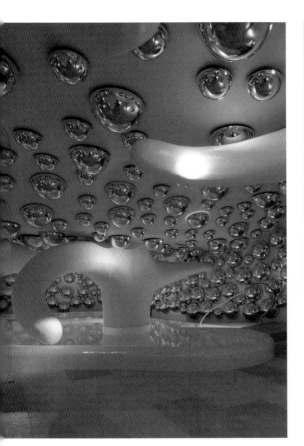
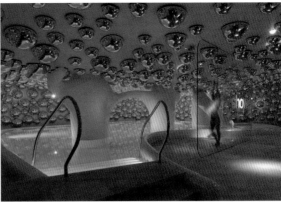
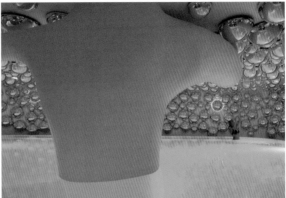
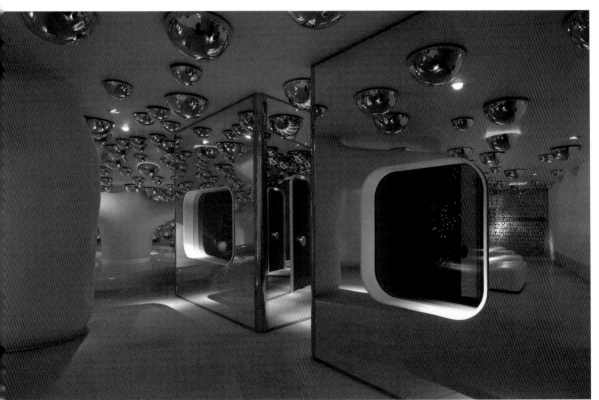

The aim of the architects and the customer was to make a site that will become a benchmark for future international health centers. The smooth plastic forms provide users with a multi-sensory dimension.

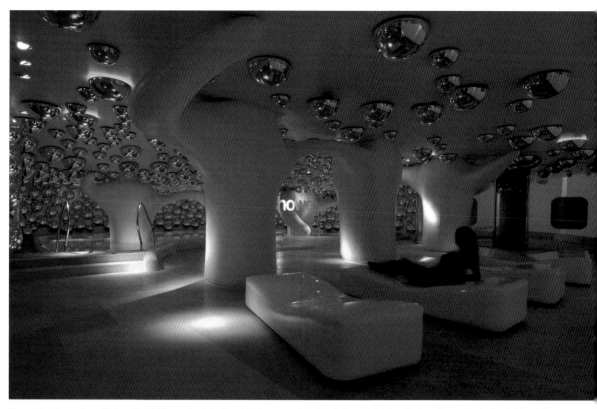

The rounded shapes, the multicolored backlighting and basic furniture introduces users into a futuristic world. Lighting effects, molten metal, circular skylights, LEDs, among other features, help create a dream-like landscape that provide comfort and relaxation.

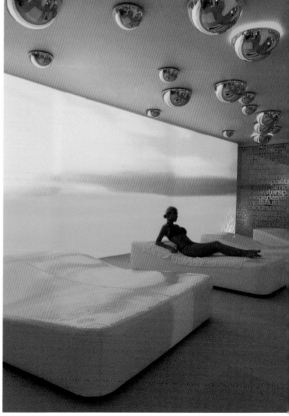

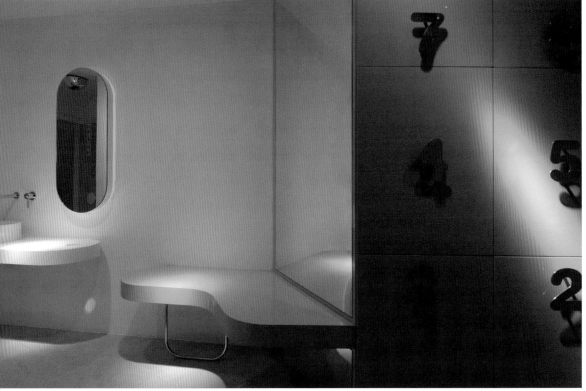

The site consists of a reception area, long corridors, dressing rooms for men and women, treatment rooms, saunas, a Turkish bath, showers, ice machines, a relaxation area, and a sports pool with different water effects and hydro massage jets.

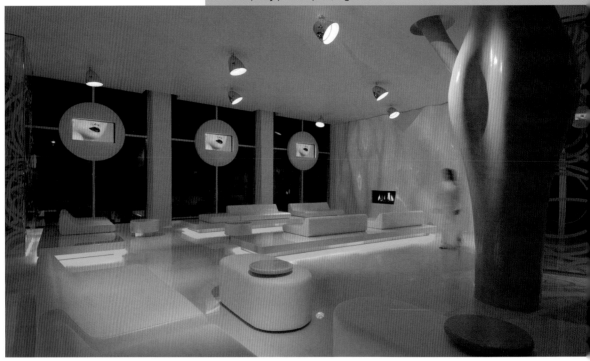

With the aim of starting a new chapter for the Ambient Hotels chain., the group commissioned the architects Giovanni Quadrelli and Simone Micheli to create a space where guests would feel comfortable while marveling at the interior design.

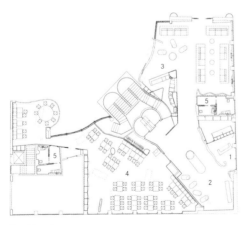

Ground floor plan

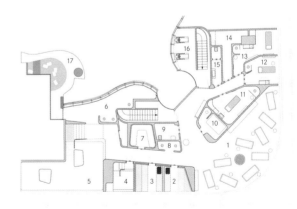

Spa floor plan

1. Relax zone
2. Sauna 50°
3. Sauna 90°
4. Sea water
5. Whirpool bath
6. Sensorial shower
7. Steam bath
8. Shower
9. WC
10. Sunlamp
11. Traitement Cabine 1
12. Traitement Cabine 2
13. Traitement Cabine 3
14. Warehouse
15. WC
16. Gym

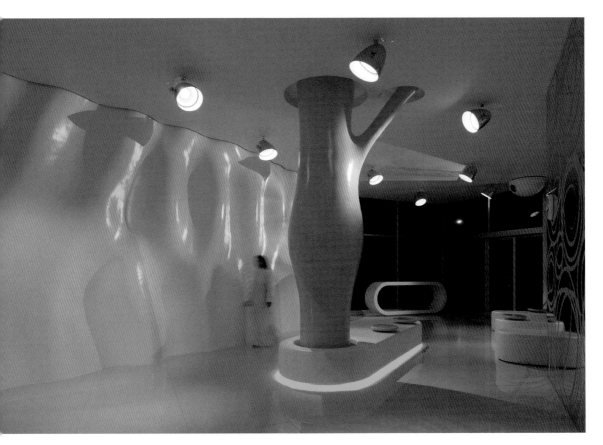

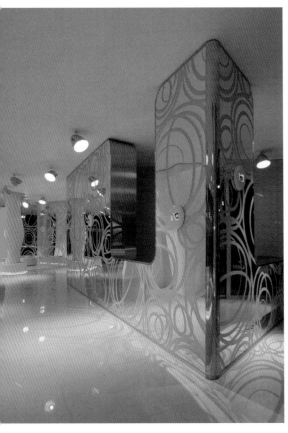

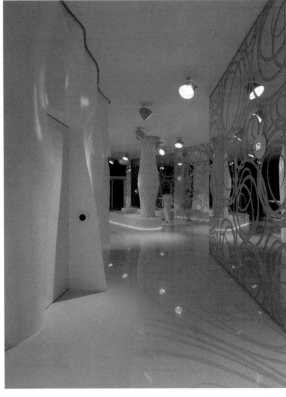

The design focuses on two aspects: the rooms had to fit into the irregular spaces of a luxurious mansion, while it also had to be welcoming.

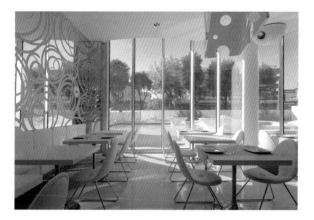

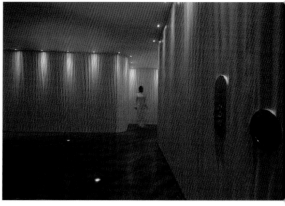

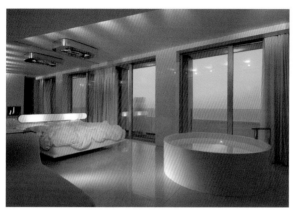

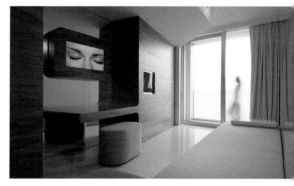

The most important part of the building—the highest and most panoramic part—was devoted to the wellness center, which has a bright, bold, and informal ambience.

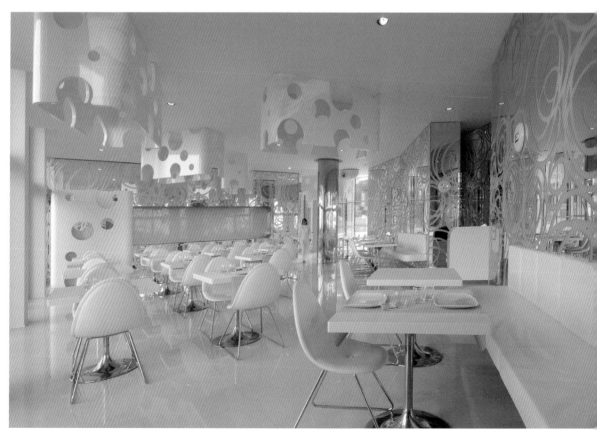

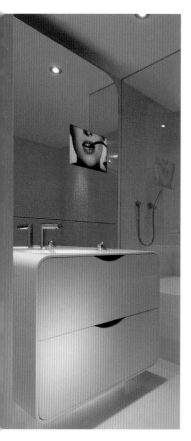
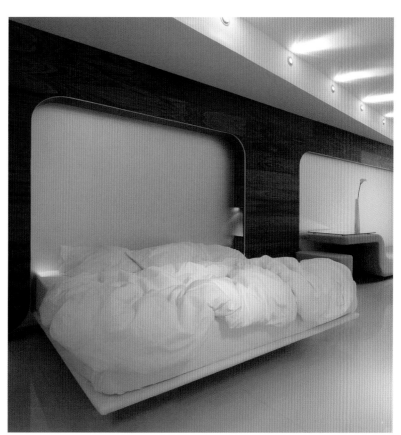
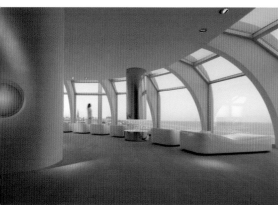
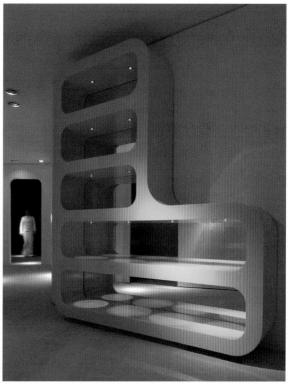
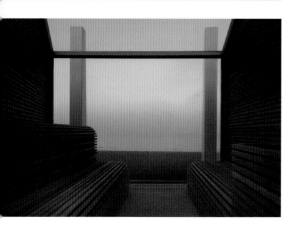

i-Suite revolutionized the traditional hotel lobby. The barriers established by the hierarchy between guest and reception staff were removed, using an interior design scheme characterized by abundant light and rounded shapes.

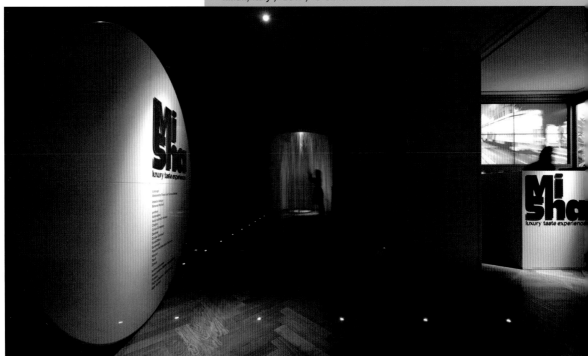

The new restaurant for events, Mi-Sha, opened its doors during the FuoriSalone week in Milan. The inauguration coincided with the closing of Shanghai Expo and the opening of Expo Milan. The design brings together the twin realities of two geographically distant worlds: Milan and Shanghai.

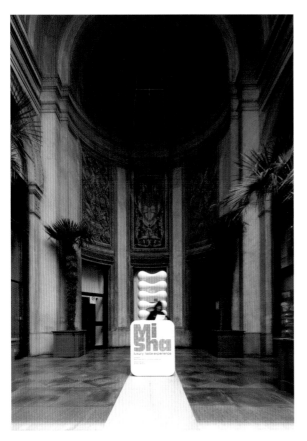

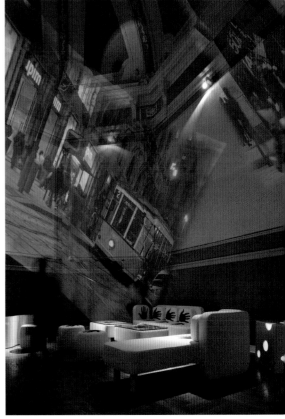

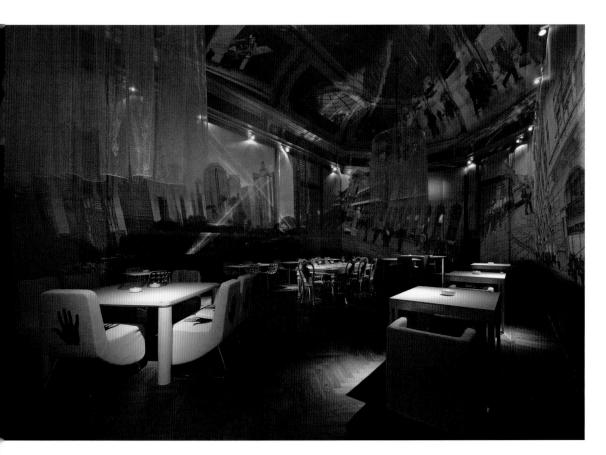

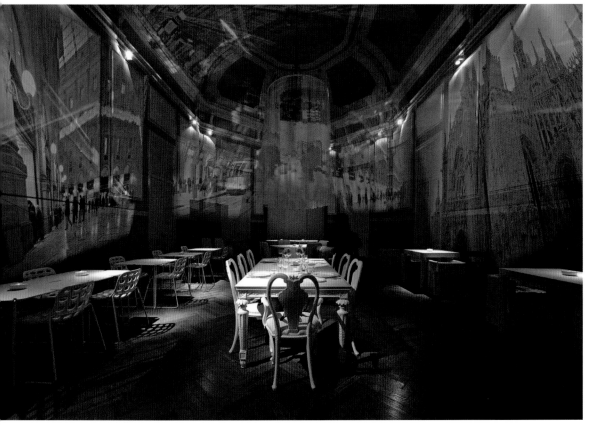

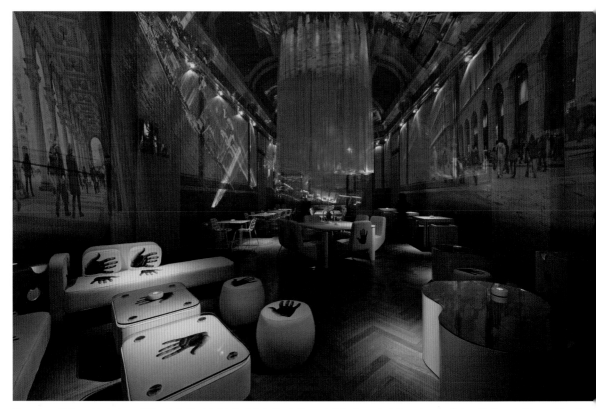

The restaurant is located in the heart of Milan, in the King's hall in the Galleria Vittorio Emanuele II. It offers typical dishes that are a fusion of Italian and Chinese cuisine. The design expresses the identity of two cultures and two traditions extolling the iconic signs of each identity.

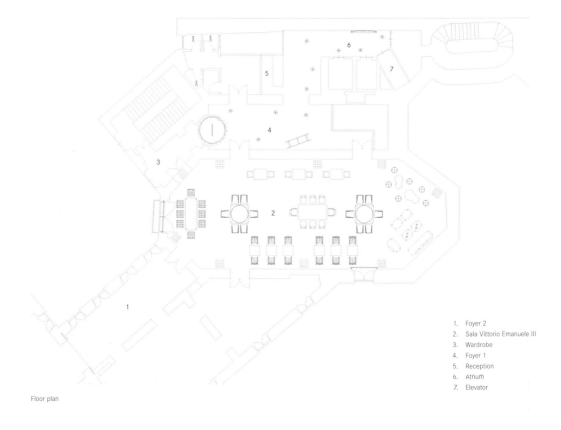

1. Foyer 2
2. Sala Vittorio Emanuele III
3. Wardrobe
4. Foyer 1
5. Reception
6. Atrium
7. Elevator

Floor plan

Ai-Sha is a contemporary expression that places value on the identity of the two cultures. It is a welcoming space and an acclamation of good taste and emotion. The décor uses imagery of both cities and the furniture oscillates between tradition and modernity.

Softroom Architects

Oliver Salway, Chris Bagot

341 Oxford Street
W1C 2JE London
United Kingdom
Tel.: +44 (20) 7408 0864
www.softroom.com

Softroom Architects has undertaken a broad range of projects including buildings, bridges, and interiors for retail, public, residential, and educational uses, as well as transport design and exhibition design. Working with a wide variety of brands and both private and public clients—including the British Museum, the BBC, and Sony, among others—it has built up a portfolio of creative projects with unique style. These include the Virgin Atlantic Clubhouse at Heathrow Airport, repeatedly voted as the best airline waiting room in the world. The studio is directed by Christopher Bagot and Oliver Salway. Its work has been published and exhibited worldwide. Founded in 1995, the company has been awarded prizes from RIBA, the Royal Fine Art Commission, and D&D.

Yotel
New York, NY, USA / 2011 / © Nikolas Koenig

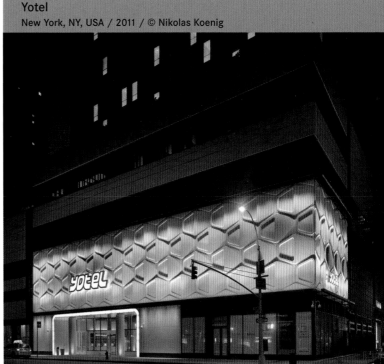

This hotel in Times Square West, in the vibrant theater district of Manhattan, revolves around the concept of "affordable luxury." It is the first time this hotel chain has set up an establishment outside of airport catchment areas.

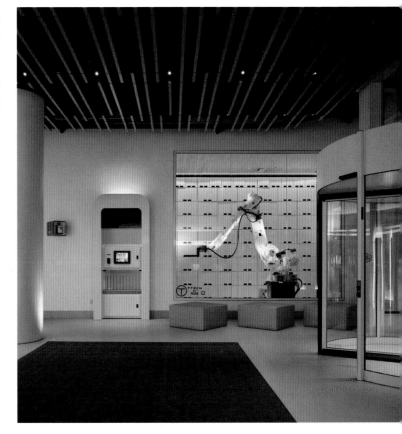

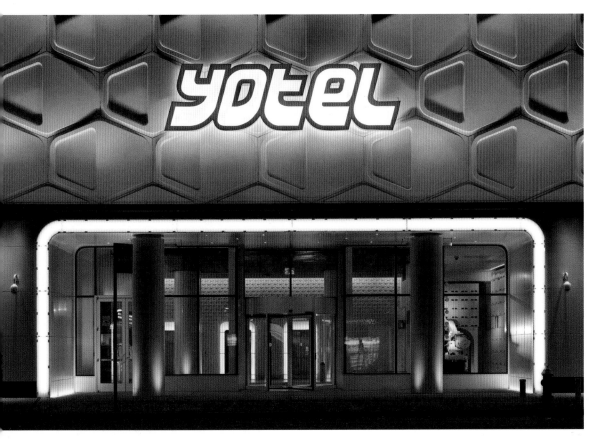

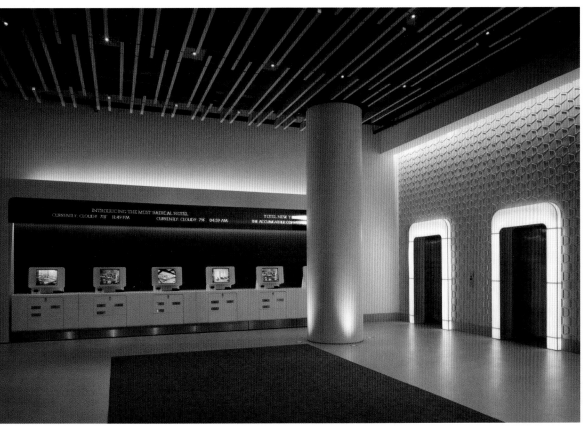

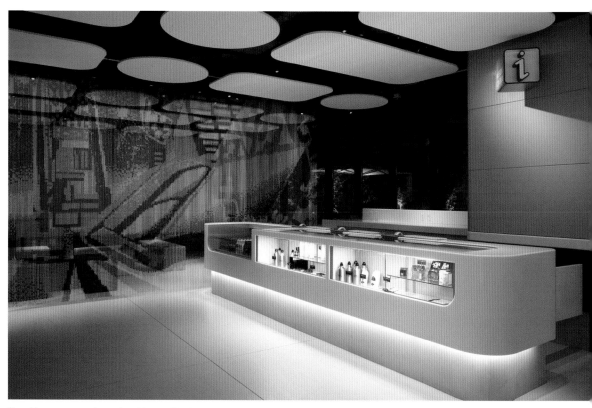

The public spaces are easily transformable areas. They include a bar with DJ box, a restaurant, gym, and space for events and film screenings, as well as the largest open-air terrace of any hotel in New York.

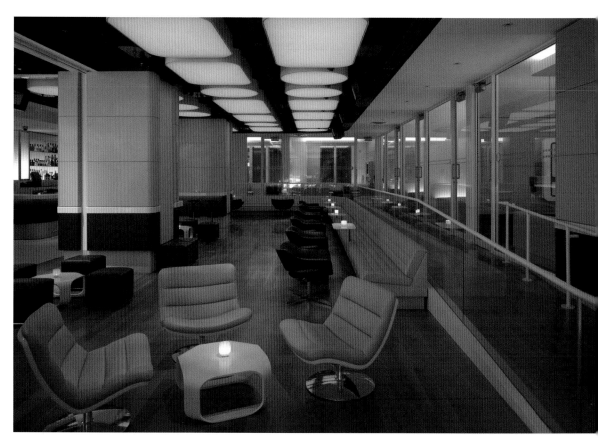

he hotel has 669 rooms, nineteen first class suites, and three VIP suites with balconies, Jacuzzis, and rotating beds, which afford breathtaking views of the Manhattan skyline.

The Virgin Atlantic Clubhouse
London, United Kingdom / 2007 / © Richard Davies

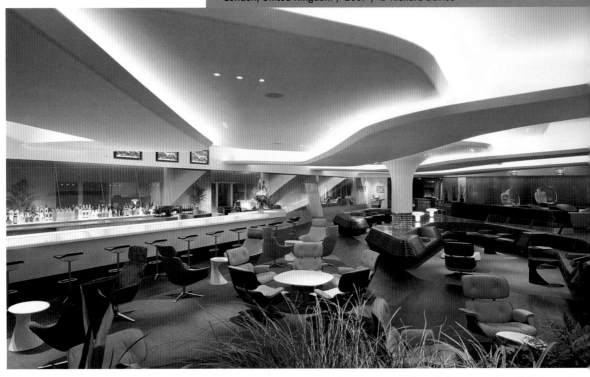

The Virgin-Atlantic waiting room at London's Heathrow Airport is a club offering leisure spaces including a bar, restaurant, library, business center, cinema, hair salon, and spa.

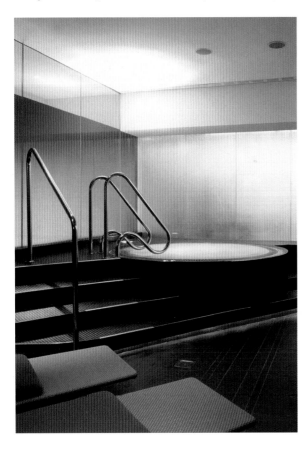

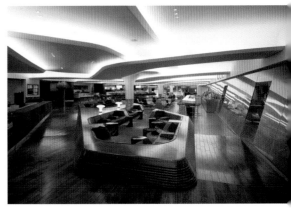

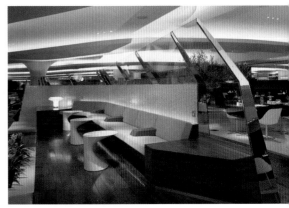

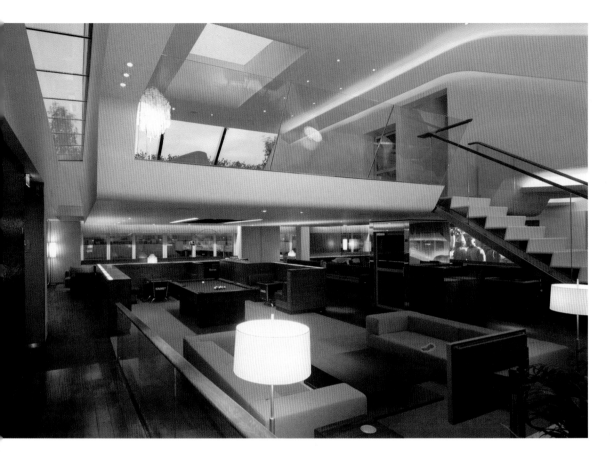

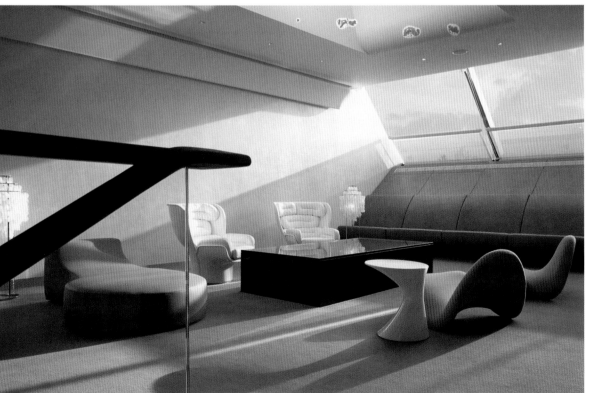

The space was inspired by the landscape of the British Isles and is organized around two sculpturally carved levels with landmarks and views. The configuration encourages an instinctive route for passengers awaiting their flights.

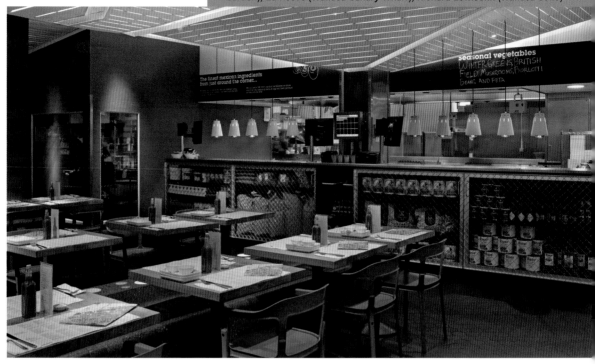

Wahaca is a group of restaurants, each with its own identity, created by the British chef Thomasina Miers. Its designs are inspired by the special energy and color of typical food stalls in Mexican markets.

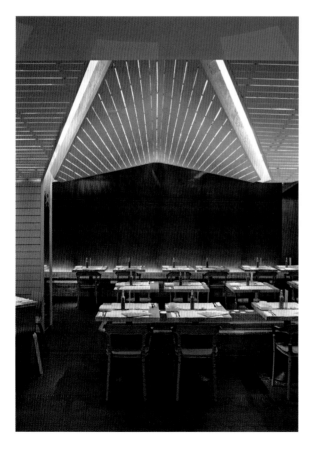

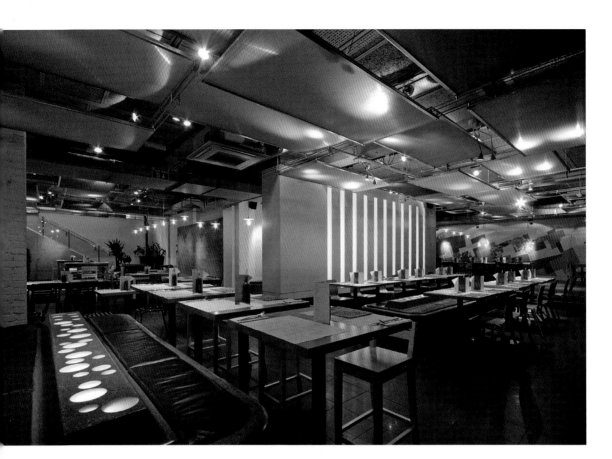

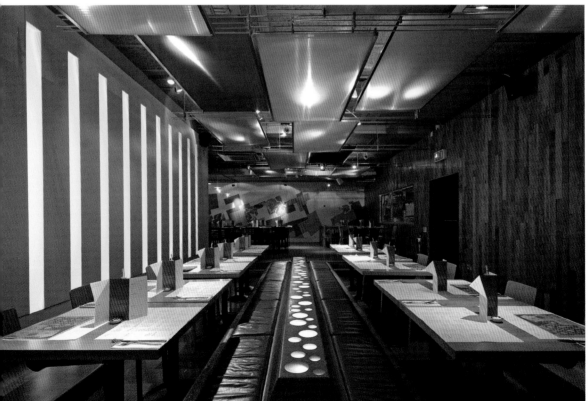

The polished cast concrete seats with exposed edges provide an informal atmosphere. The yellowy light gives a sensation of a warm glow when viewed from the outside.

In this Covent Garden restaurant, a patchwork of polycarbonate panels evokes the colors and organized chaos of market roofs; in Canary Wharf, an abstract wooden canopy is reminiscent of the typical character of market entrances.

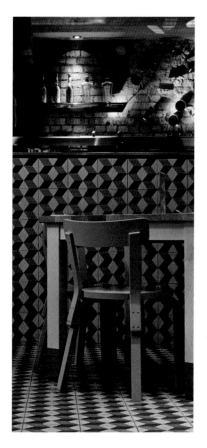

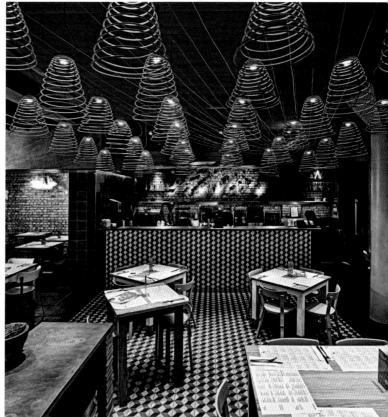

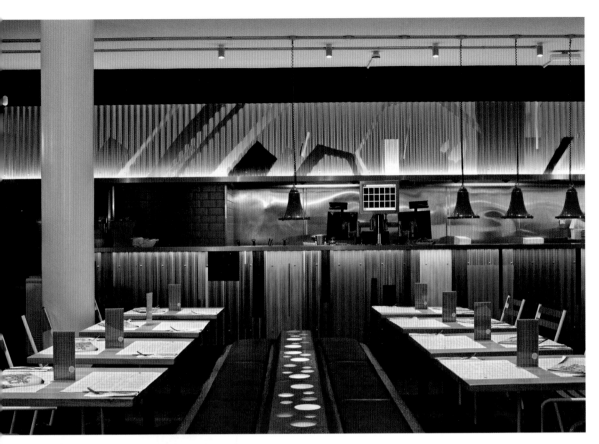

Squire and Partners

© Squire and Partners

Michael Squire

77 Wicklow Street
WC1X 9JY London
United Kingdom
Tel.: + 44 20 7278 5555
www.squireandpartners.com

The Squire and Partners London studio produces refined, craftsman-like work, aimed at achieving a purpose. They recognize that buildings have an essential life expectancy and reject fads in search of timeless quality that fits well into the architectural heritage of the city of London. This particular form of contemporary design, influenced by a predominantly urban character, has been successfully applied in some of the most sensitive locations in central London. One feature that underlies all Squire and Partners projects is the fascination with the expressive and poetic potential of the materials.

Reiss Headquarters
London, United Kingdom / 2008 / © Will Pryce

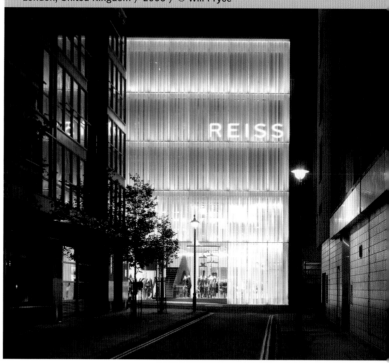

The building for the clothing and accessory brand Reiss has three floors: the design studio, the production center, and administrative offices on the upper floors and a penthouse apartment for the owner on the top floor.

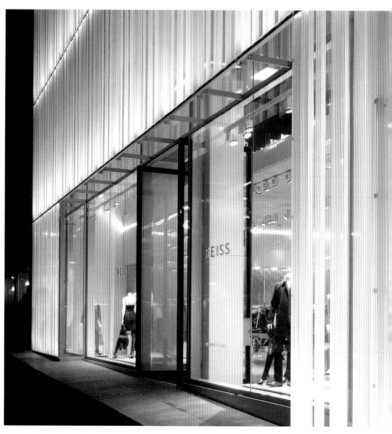

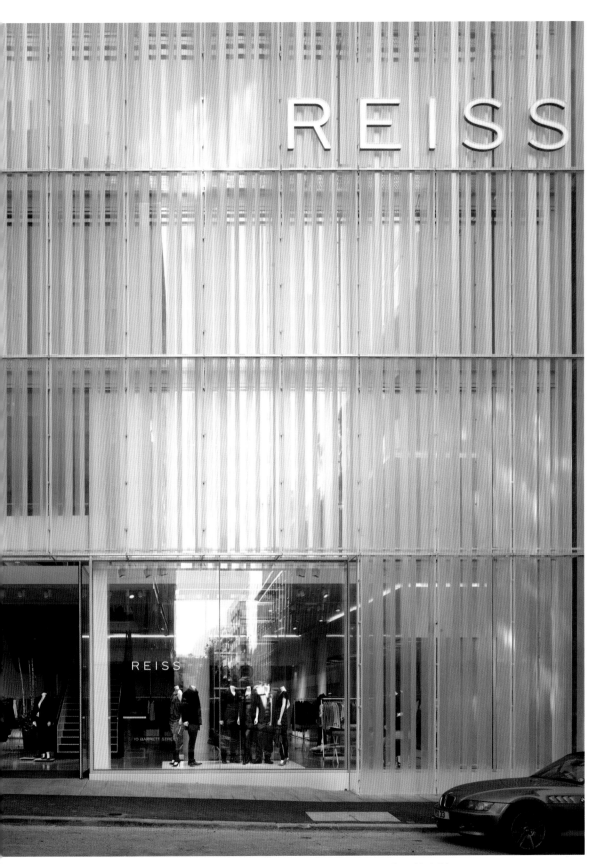

The façade is composed of a double layer of glass behind a sheet of high-tech acrylic that simulates textiles falling on the front of the building.

Section

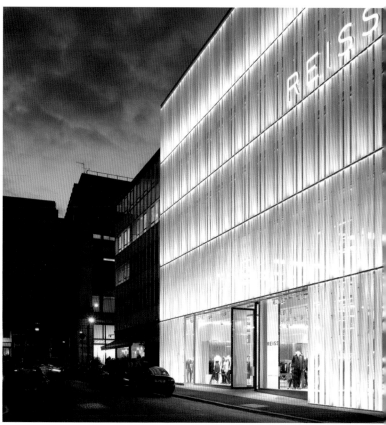

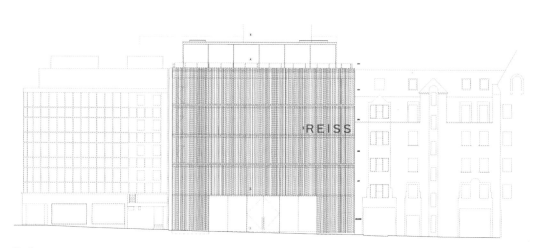

Elevation

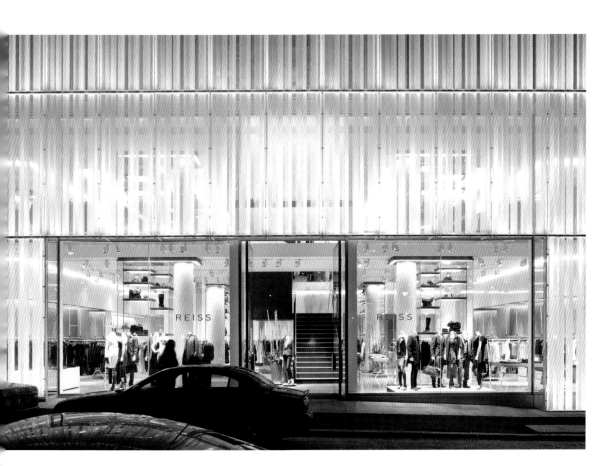

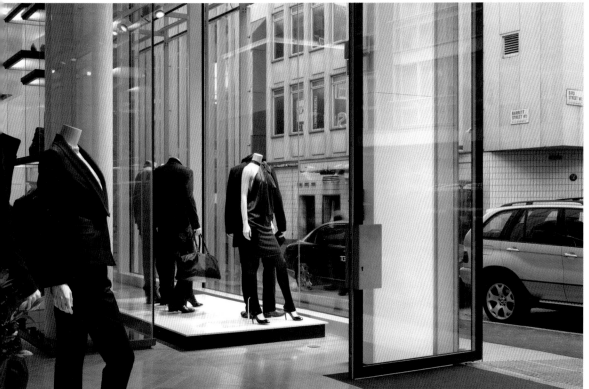

The type of acrylic used conducts the light very well and supports the idea of creating a building that "glows" and is visible from nearby Oxford Street. LED lights have been placed at the base of each vertical panel.

The architects have renovated two apartment buildings, connecting them and turning the combined structure into a contemporary English-style four-star boutique hotel. The challenge has been to fit all the facilities of a forty-bedroom hotel into a small space.

Front elevation

Front elevation

ooden furniture, warm textures, soft and cosy colors, abundant natural light, and a garden that serves as an oasis
the urban fabric of the neighborhood are the hallmarks of this hotel.

Art'otel Hoxton
London, United Kingdom / Not Built / © Squire and Partners

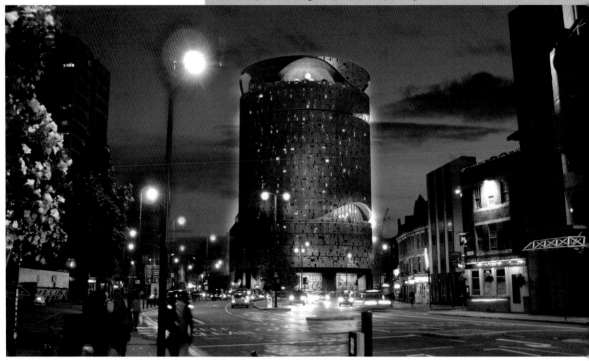

This cylindrical shaped eighteen-story hotel, including four underground levels, not only responds to the type of buildings in the area but also makes the most of the panoramic views of the city. The main body is divided into horizontal sections with subtle breaks in the outer skin of the building, creating openings.

Renderings

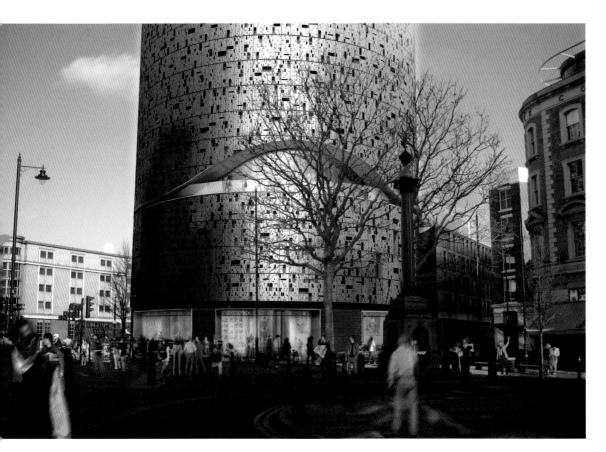

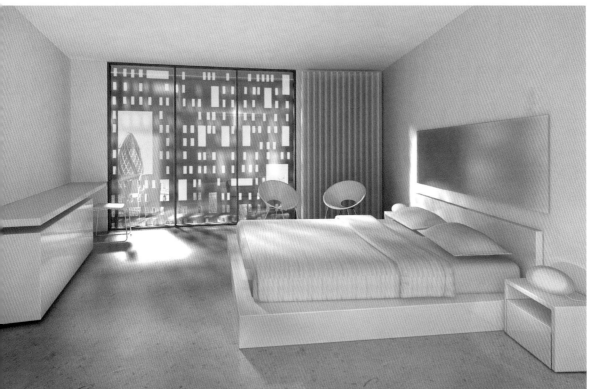

The outer skin of bronze anodized aluminum refers to the brick buildings in the area. The cladding has rectangular perforations that are reminiscent of punched cards to produce textiles, the main industry of the district.

Studio 63 Architecture + Design

Piero Angelo Orecchioni, Massimo Dei

Via Santo Spirito 6
50125 Florence
Italy
Tel.: + 39 055 2399 252
Fax: + 39 055 2658 419
www.studio63.it

Studio 63 was the result of a fateful encounter between Piero Angelo Orecchioni and Massimo Dei that led to the founding of an architectural studio in 1998. The studio progressed slowly but surely, before opening new offices in the city of New York in 2003, another in Hong Kong in 2005, and another in Shanghai in 2008, in addition to creating operative partnerships in Dubai and Singapore. The creative team is made up of very talented professionals from different disciplines, providing a multicultural exchange. A strong identity—the result of extensive research—as well as creative proposals and a deep respect for contemporary language criteria, are the hallmarks of their projects. The studio specializes in retail and hospitality projects.

DEX Showroom
Florence, Italy / 2008 / © Yael Pincus

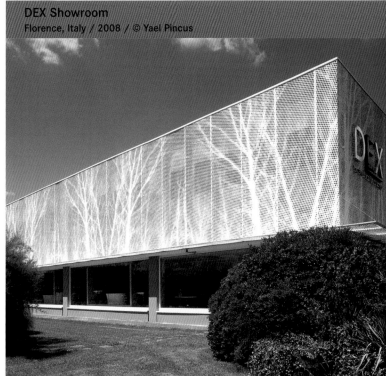

The showroom building was commissioned by the company DEX Spa owned by the Tanini family. Located in Osmannoro, an industrial area to the north of Florence, the project had to stand out from the other warehouses to give the firm a strong identity.

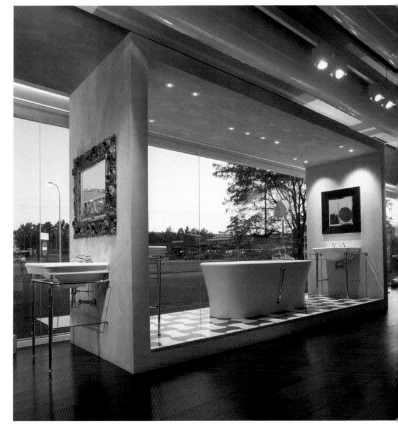

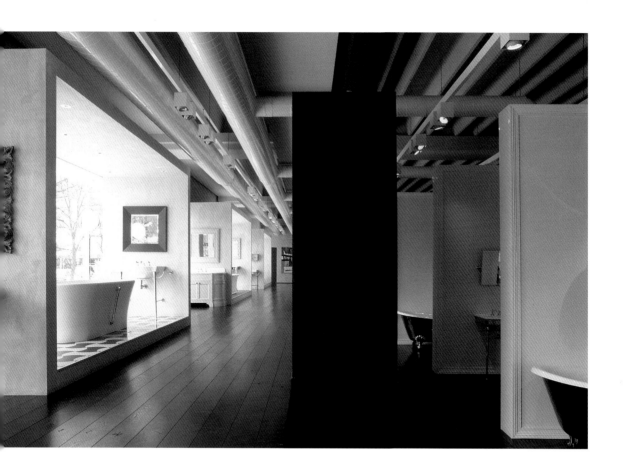

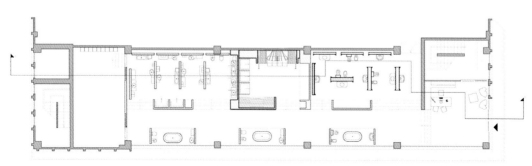

Floor plan

n contrast with most buildings in the area, characterized by their solidity, neon lights, and giant billboards, DEX is elegant and dematerialized.

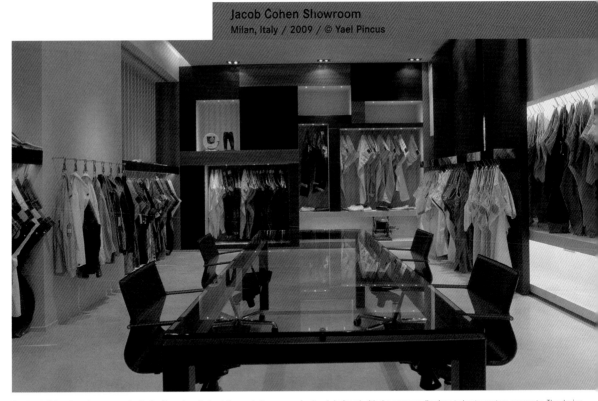

The Jacob Cohen brand was created with the idea of producing tailor-made jeans conceived and designed with the care usually given to haute couture garments. The design concept for the showroom evolved with the same idea—a place where every last detail was cared for.

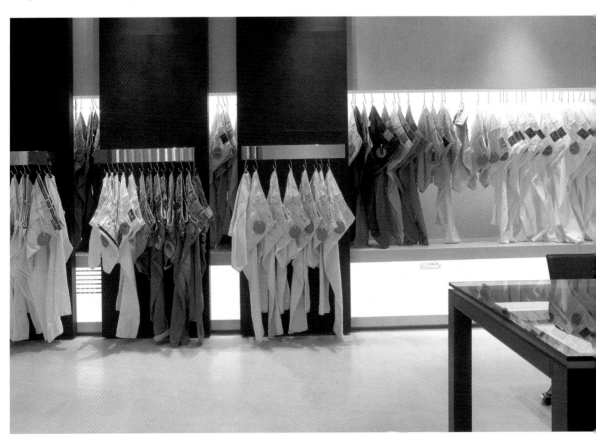

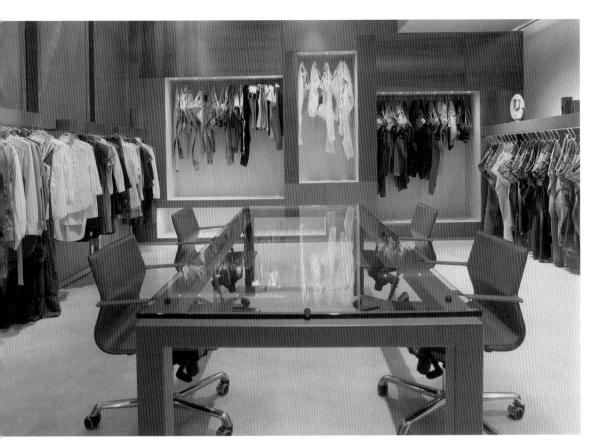

With resin flooring and grey cement walls, the showroom was designed as a neutral container. Its spaces are not completely closed, allowing a continuous flow between them. The wooden strips function as partitions and as containers for the clothing.

Novo Shanghai
Shanghai, China / 2010 / © Studio 63 Architecture + Design

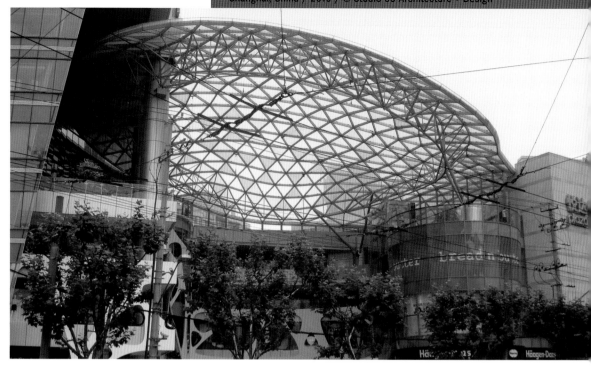

The new store for the Novo brand was designed in-line with the characteristics of the city of Shanghai: a dynamic urban space with continuous motion, full of lights and colors, which reinvents itself. The store was created as a space in continuous movement and with communication between the exterior and interior spaces.

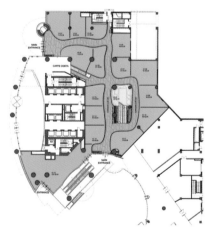

Ground floor plan

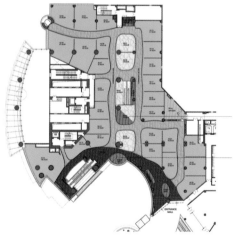

First floor plan

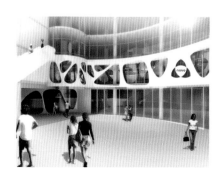

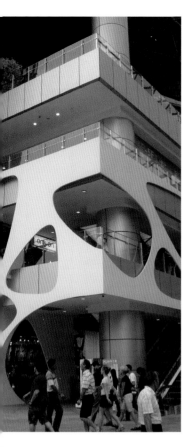
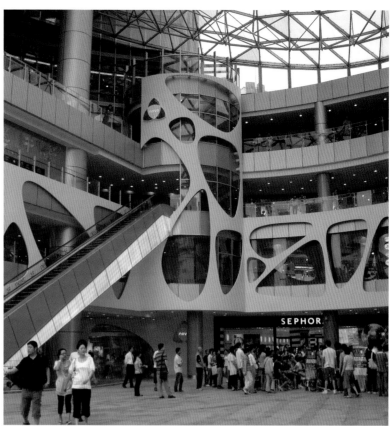
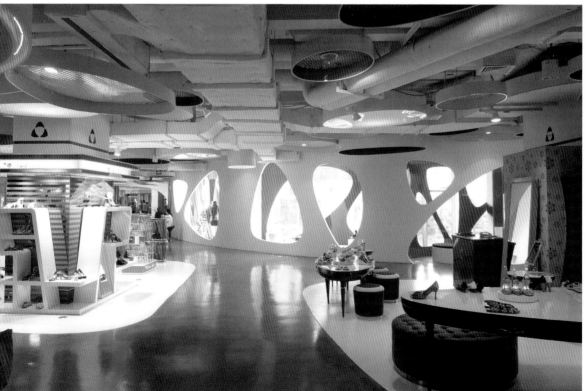

he 4,500 m² (48,437 ft²) space emits a young, dynamic, and technological image, characteristic of the stores. The façade and exterior steps are covered with a membrane-like kin that tells shoppers that there is something important inside.

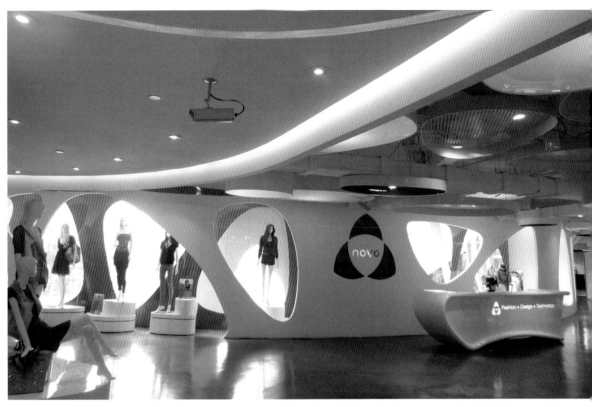

The architect chose the colors red and white for the design because they form a part of the Novo logo. Even the logo appears as part of the design in the texture of the membrane. In the center of the space, a staircase painted bright red has been installed and stands out from other elements.

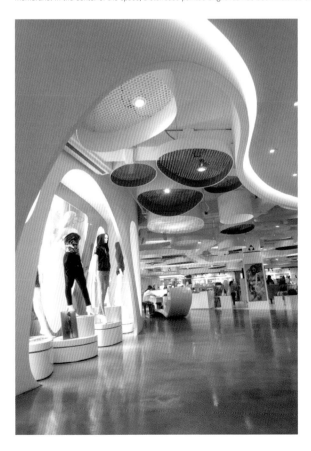

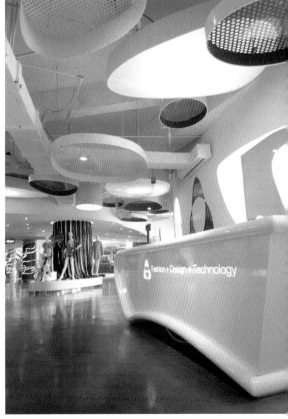

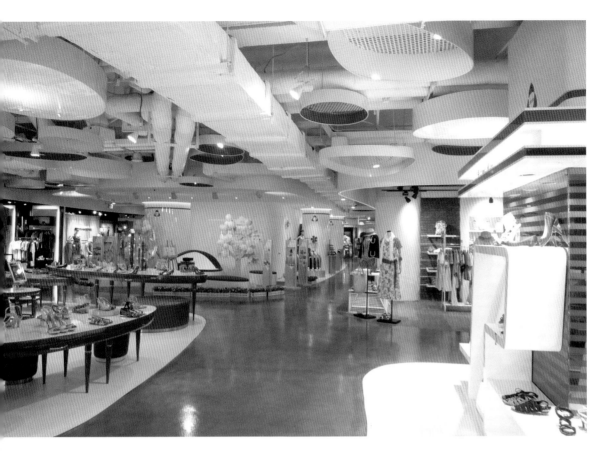

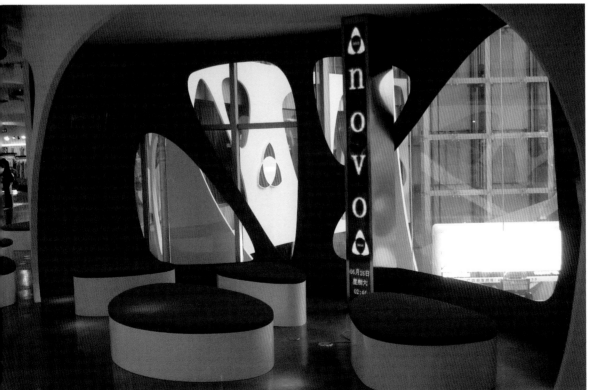

The design is characterized by dynamic, organic, and plastic forms. The roof is covered with large oval-shaped red and black structures, some of which act as sources of light and others as air conditioning vents.

Studio Rodighiero Associati

Massimo Rodighiero

Via Tadino, 8
20124 Milan
Italy
Tel.: + 39 024 54 03 873
Fax: + 39 029 99 81 550
www.sra.it

In 1986, Giovanni Rodighiero founded this studio, which was reborn ten years later as a services and consulting company comprised of Giovanni himself, who brings experience and professionalism, Massimo Rodighiero, who offers expertise and talent, and Francesco Rodighiero, who provides the design and innovation. The studio has obtained important international prizes that have consolidated it in the global landscape. The studio is designed as a specific project consultancy workshop that offers an interdisciplinary approach. Besides the usual activities in the fields of architecture and engineering, it also creates graphics projects, multimedia, websites, product design, etc., incorporating the specific identities of the customers.

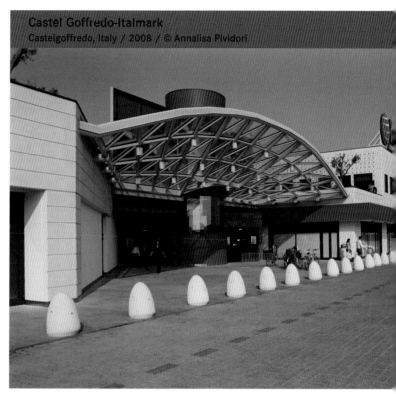

Castel Goffredo-Italmark
Castelgoffredo, Italy / 2008 / © Annalisa Pividori

Strategically located in the historic city center and near the university campus, the swimming center, and new residential neighborhoods, the shopping complex was conceived as a meeting point. With its 20,000 m² (215,000 ft²) of retail space and 3,400 m² (36,597 ft²) of covered walkways, the architectural project was integrated into the urban fabric of Mantua.

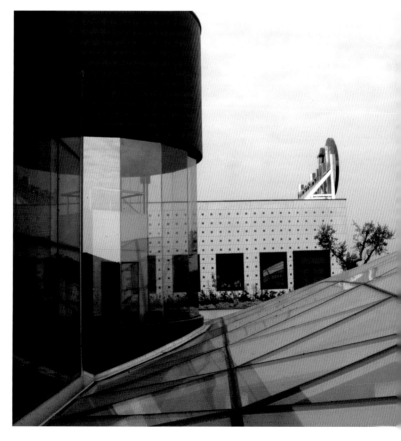

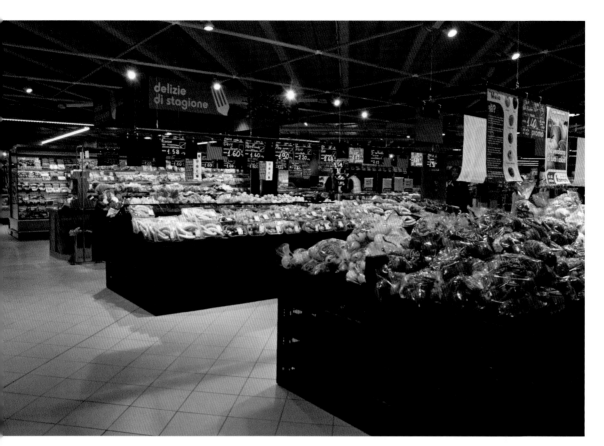

or the interior lining of the building, the design is characterized by the use of blue and
ed. Blue is used to indicate the route of the shoppers and red is the corporate color.

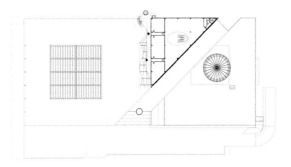

Second floor plan

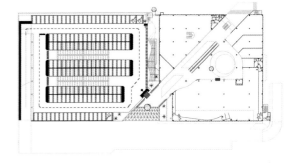

First floor plan

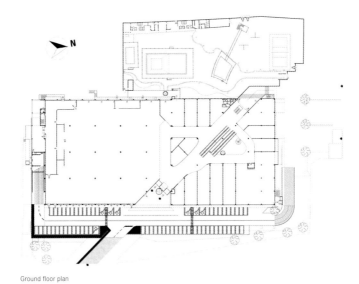

Ground floor plan

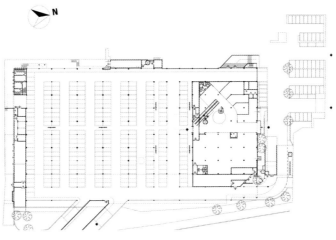

Basement floor plan

The dome and fully glazed gallery are the prominent architectural elements. The dome covers an interior plaza that restores the old concept of the agora as a meeting place. The gallery was built diagonally, which serves to connect it with the rest of the buildings.

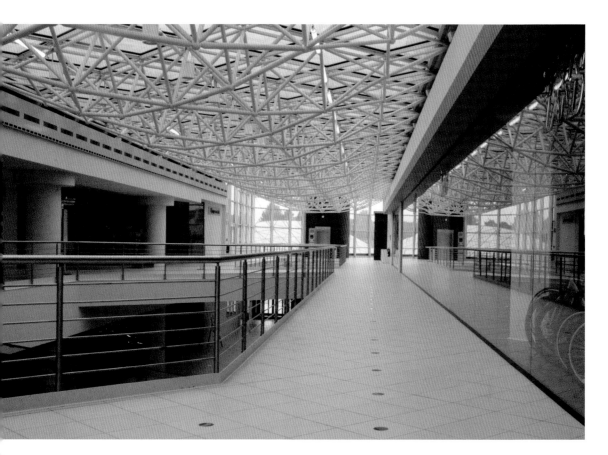

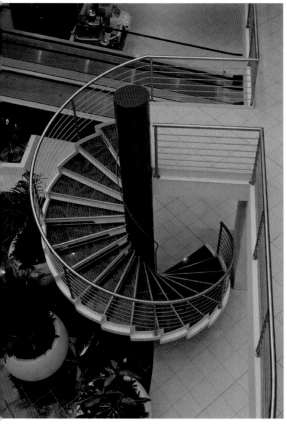

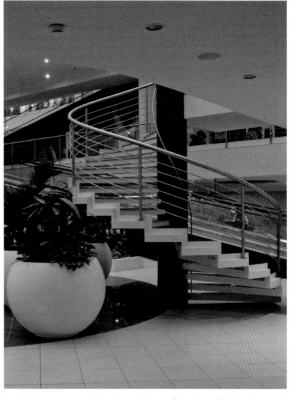

A spherical arrangement of blue tiles reminiscent of the shape of the glass dome and the concept of the square, has been laid on the floor.

The project is the result of the conversion of the former nineteenth century cotton mill into a complex dedicated to commercial and administrative uses. Architectural features were preserved, and materials and access to the site were restored.

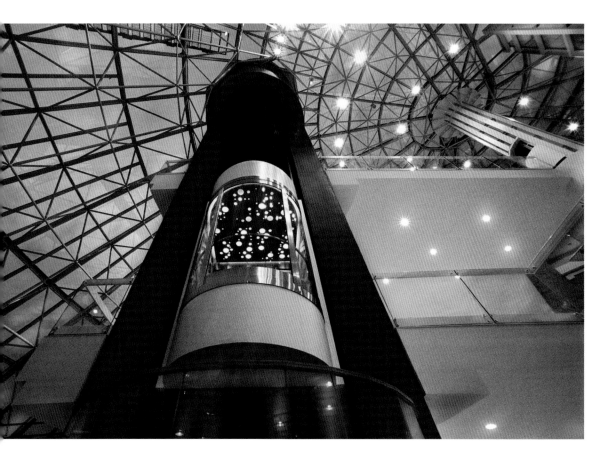

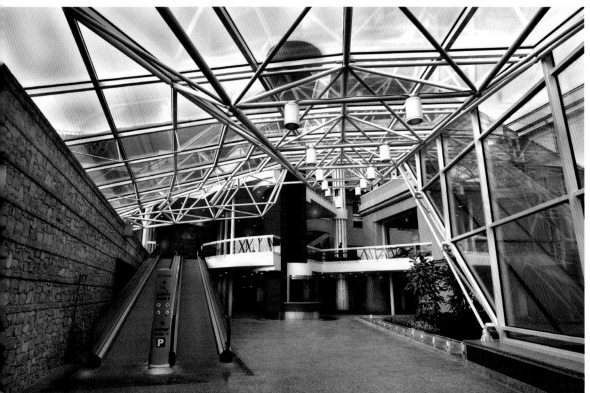

Where the two main buildings meet, a glass cone has been built, the particular shape of which was designed voluntarily to identify it with the mountains near the building complex.

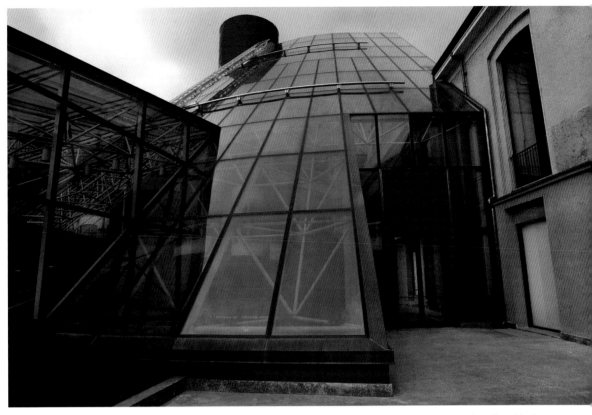

The decorative details were installed and materials have been preserved, such as cast iron and concrete. New materials used are glass, steel, marble, and local stone.

Second floor plan

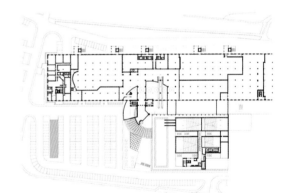

First floor plan

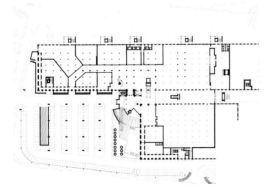

Ground floor plan

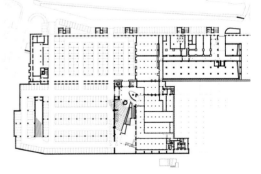

Basement floor plan

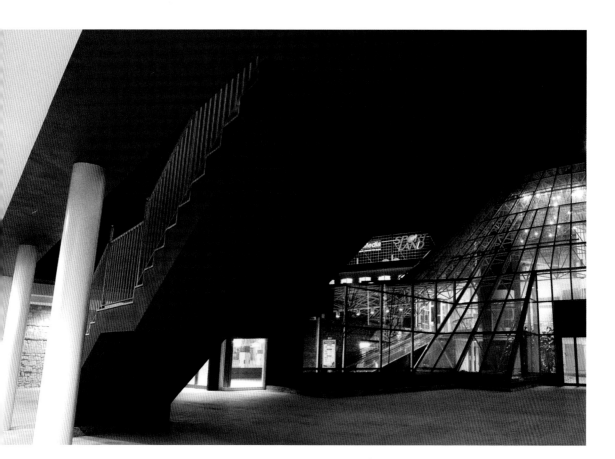

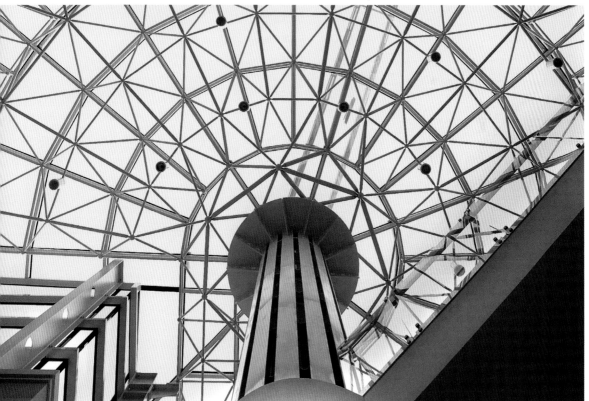

The contrast between old and new is evident in the floor plan, the size, and the construction details.

Studio X Design Group

Lara Rettondini & Oscar Brito

Unit 4, 334 Old Street
EC1V 9DR London
United Kingdom
Tel.: + 44 0 207 033 90 35
Fax: + 44 0 207 033 90 35
www.stxdesign.com

Studio X Design Group is a multidisciplinary team specialized in architecture, design, and communication. Its projects originate from conceptual frameworks that aim to improve the customer experience by producing innovative environments and appropriate design solutions. The firm's work includes entertainment facilities, projects and concepts, construction interventions, and the design of retail and communication premises. Lara Rettondini and Oscar Brito, founding partners of the studio in 2000, have created, developed, and managed concepts and projects of varied scales and contexts for high-profile international clients. Both architects have taught in various universities in the United Kingdom, and their projects have won awards internationally.

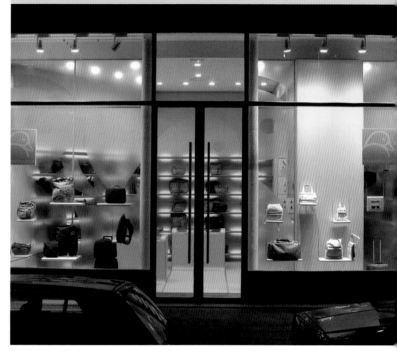

To enter the new Mandarina Duck store in Paris, it is necessary to pass through the closets that become a transition zone. These are defined by a translucent screen, which lets you partially view the interior only through the transparent cuts in the silhouette of the duck logo.

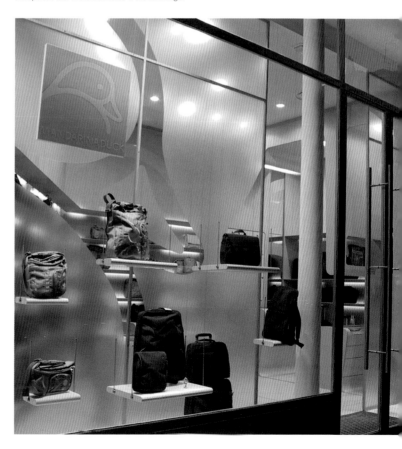

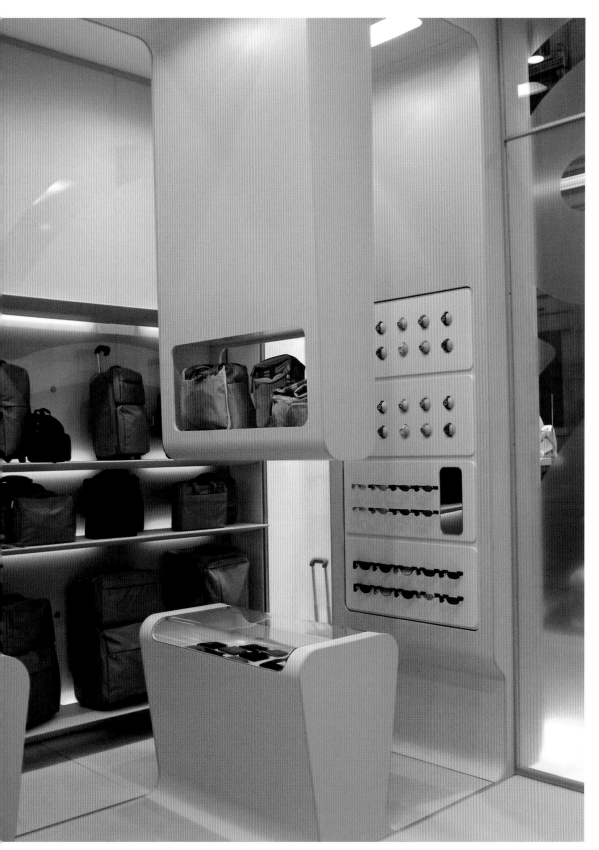

he creation of the Mandaring concept has been designed to update the image of the Mandarina Duck stores worldwide. It is a modular furniture system that has been eveloped with the aim of creating a compact and adaptable spatial structure.

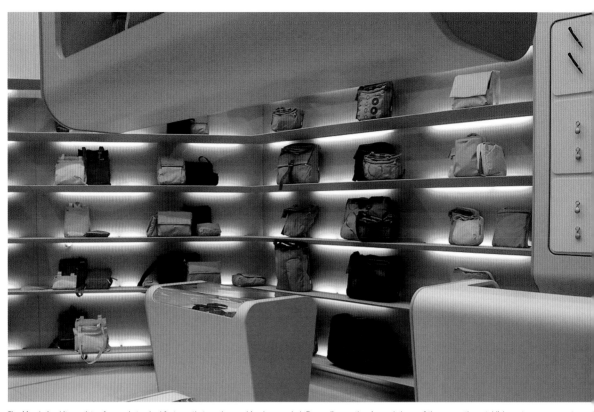

The Mandaring kit consists of several standard features that can be combined as needed. Depending on the size and shape of the space, the establishment can use one, two, o
three modular rings.

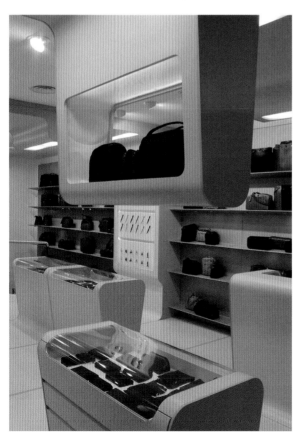

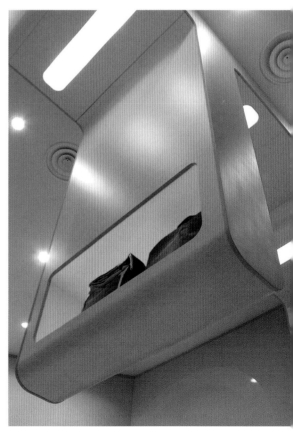

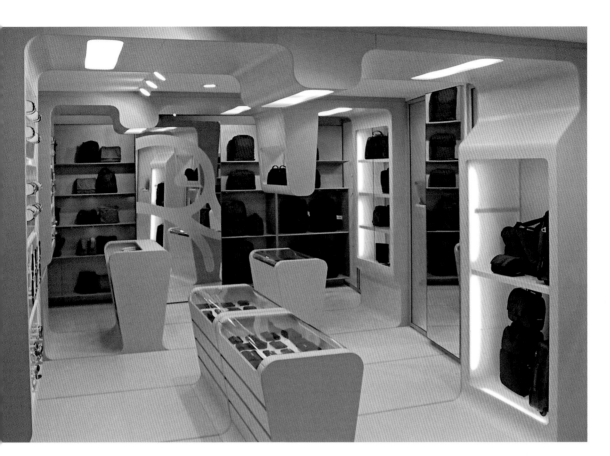

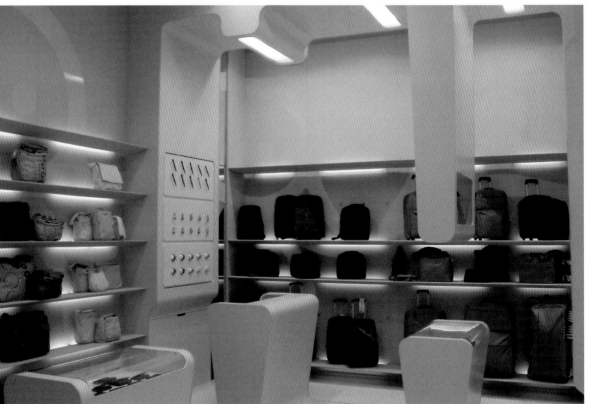

The dynamism, cohesion, and focus of the products center on the concept of colors, materials and shapes, which are designed to stimulate the consumer perception.

Foolding Screens
Shanghai, China / 2007 / © Studio X Design Group

For the creation of the new store on 5th Street in Shanghai, the designers devised a series of easily assembled folding panels. Customer requirements included low production costs and ease of transport, installation, and use. These folding panels are interconnected and serve to define the shopping area.

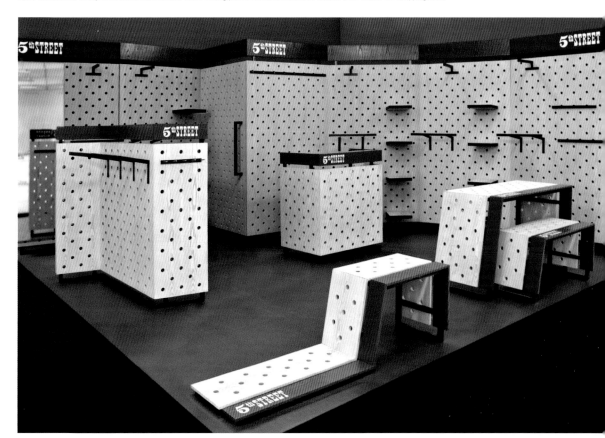

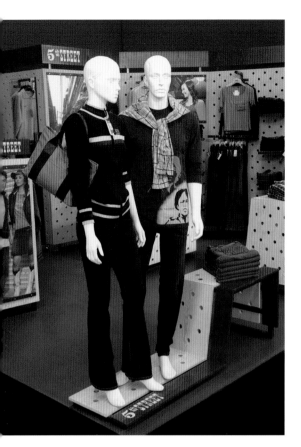

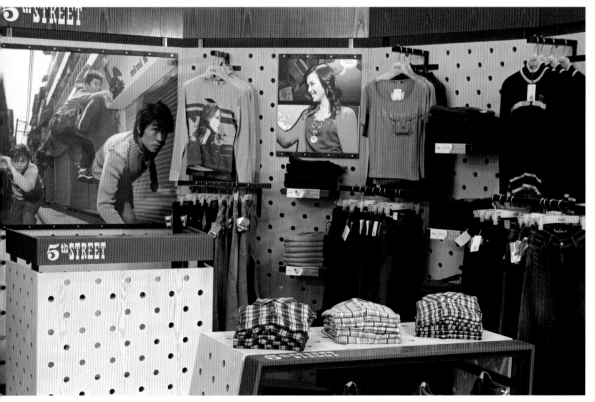

The folding panel furniture is inspired by the fence installations and adapt to any space thanks to their versatility. This modular system changes the angle of the panels altering the flow and dynamism of a space, which is very consistent with the consumers of the brand: urban young people.

Sybarite

© Sybarite

Simon Mitchell, Torquil McIntosh

322 Fulham Road
SW10 9UG London
United Kingdom
Tel.: + 44 0 207 352 49 00
Fax: + 44 0 207 352 49 01
www.syb.co.uk

Sybarite undertakes architecture and design projects inspired by organic forms of nature and technologies typical of other sectors, thus achieving a personal and timeless style. The word "sybarite" sums up its philosophy: sensuality, luxury, and taste. Since 2002, Sybarite has carried out over 300 projects located in various locations around the world. Sybarite has a growing reputation as experts in the field of commercial architecture and boutiques for department stores. It innovates and experiments with design and materials. Sybarite's main objective is to achieve a balance between reality and conceptual projects that satisfy the needs of customers.

Marni Sloane Street
London, United Kingdom / 2003 / © Richard Davies

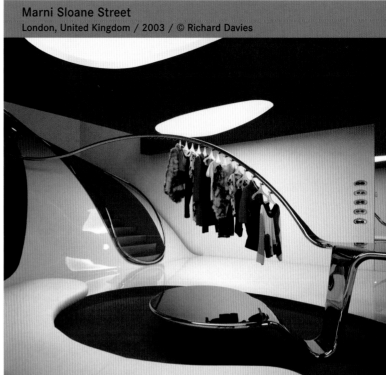

For the design of this two-story boutique, Marni, the designers incorporate organic sculptural elements that create a unique effect of visual connectivity. The gleaming white resin of the first floor extends seamlessly to the second floor, so that both levels have an aesthetic unity.

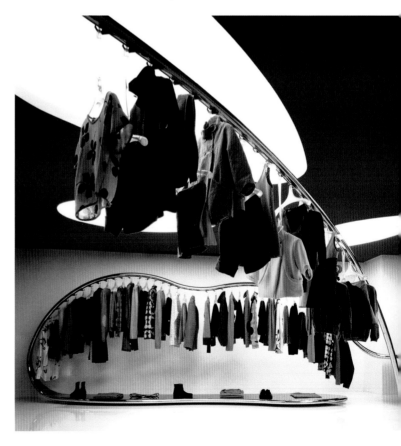

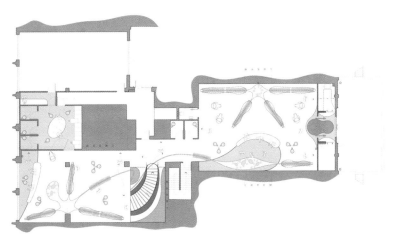

Upper level

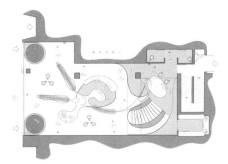

Lower level

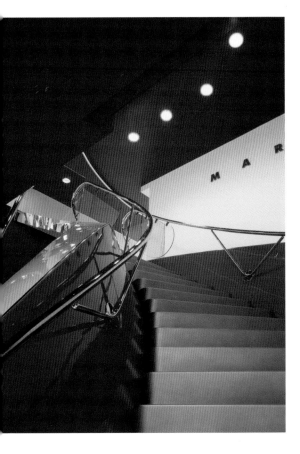

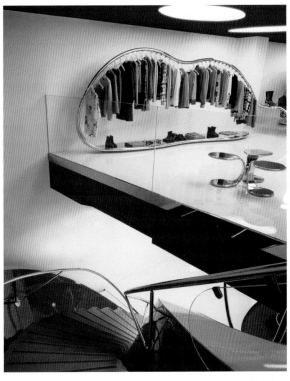

Another key material used in the project is stainless steel, it creates an undulated effect and adds to the flowing sense of movement throughout the three areas of the store. In this space, color plays a major role in its creation. The vibrant red, electric lamps, and carpet help to highlight the shapes and textures.

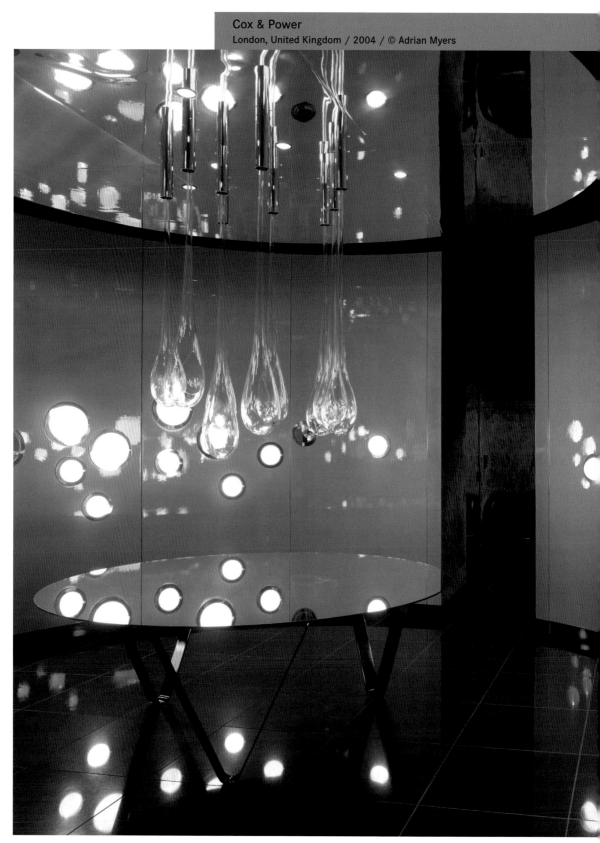

For Sybarite, sources of inspiration for the design of this jewelry store have been the universe, the planets, and stars. The solution to the problem of recreating a universe full of splendor was the insertion of a curved and lacquered wall. This wall contains a series of randomly scattered bright capsules that resemble constellations.

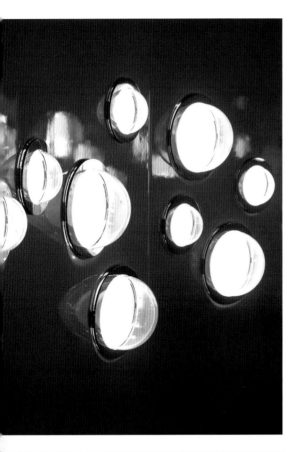

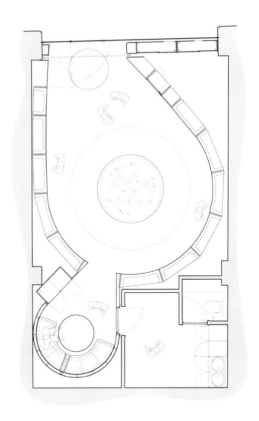

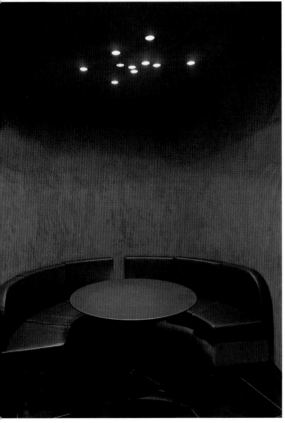

Each showcase was individually construected with a hinge made of stainless steel, methacrylate dome, and a safety lock.

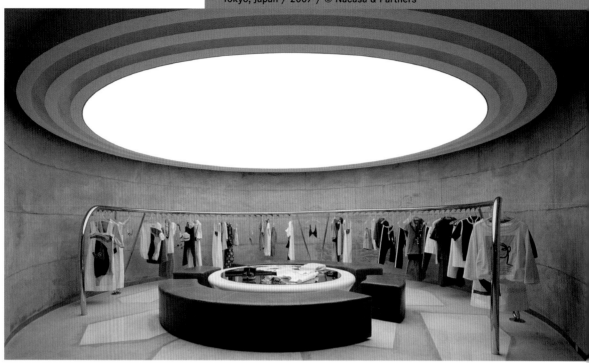

This boutique hotel was designed as a modern temple where texture and light are combined. Hard materials like concrete and stone were used for the walls and floor. The different sections of the store are distinguished and defined by the addition of colored stones and marbles.

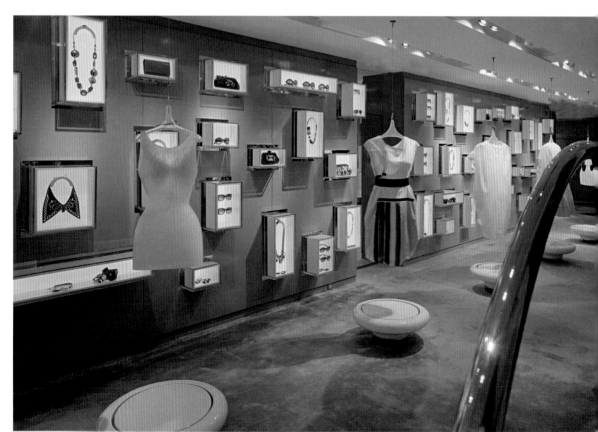

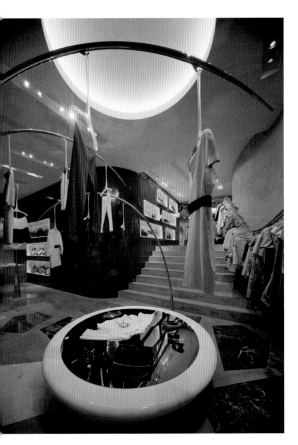

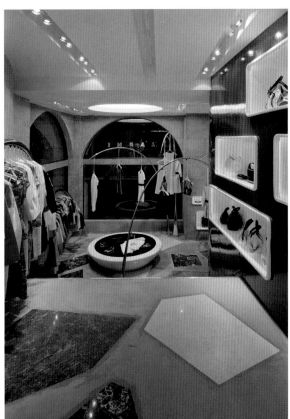

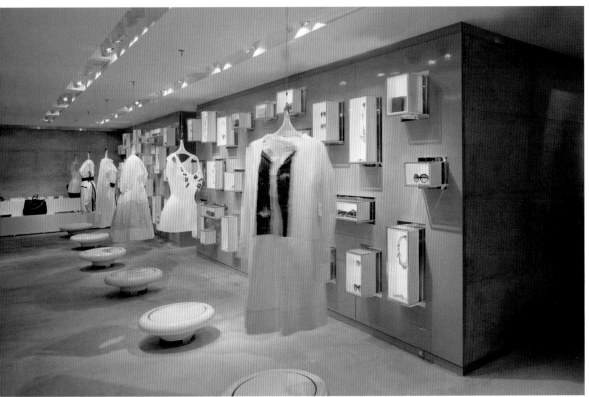

The concrete walls have a series of showcases in different sizes with different finishes (leather, plastic, and fiberglass) to display the shoes, underwear, bags, and accessories. These elements have their own built-in lighting and contrast with the floor and walls.

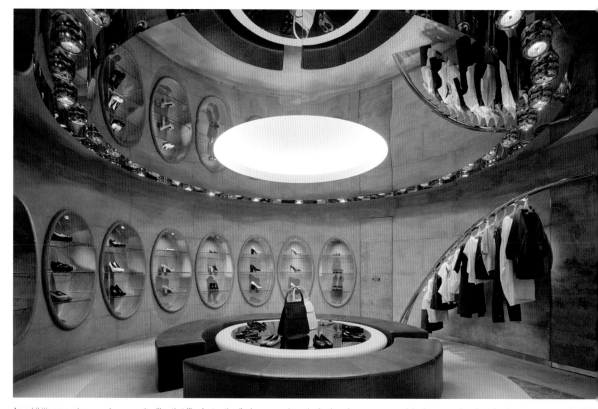

An exhibition room houses a large round ceiling that illuminates the display cases where the leather shoes are arranged. In the center there is a circular structure around which are positioned leather seats.

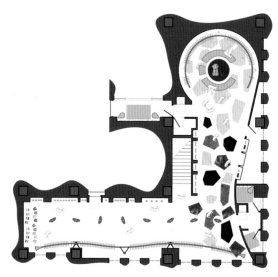

First floor plan

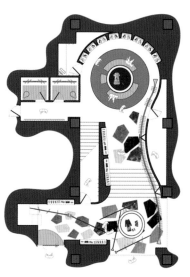

Ground floor plan

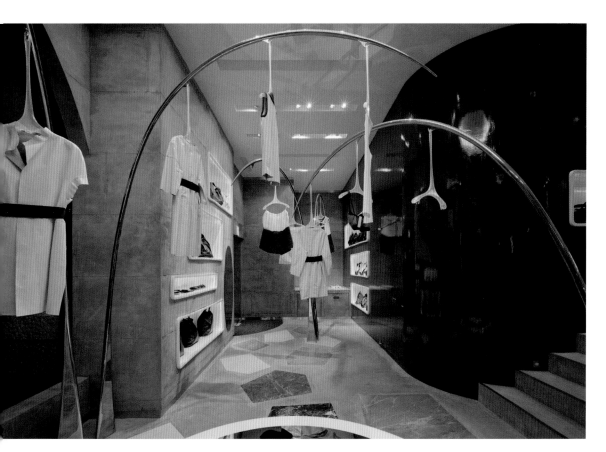

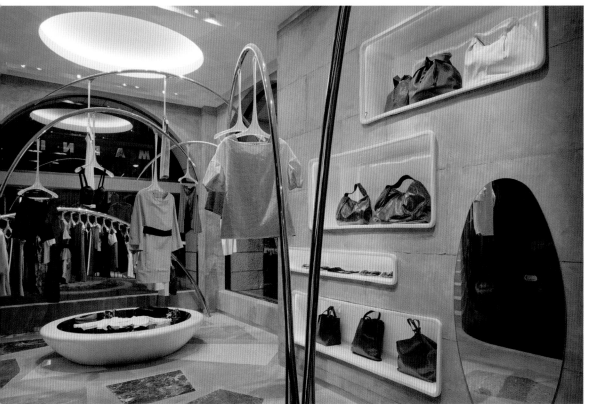

To display the products, a series of mannequins and floating stainless steel sculptures have been created, giving the ensemble a touch of rare originality.

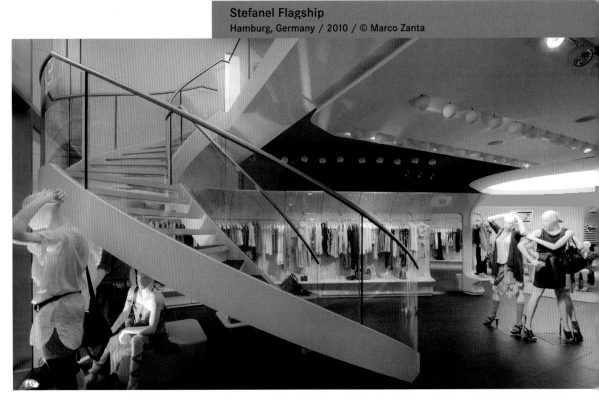

Spread over two floors and 330 m² (3,552 ft²), the premises applies the new concept developed by Sybarite and premiered in Frankfurt in 2009 for the Stefanel stores in Germany. The client wanted a completely new look with a strong and recognizable architectural language that would became the brand identity.

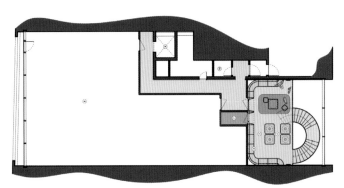

First floor plan

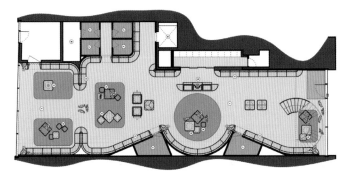

Ground floor plan

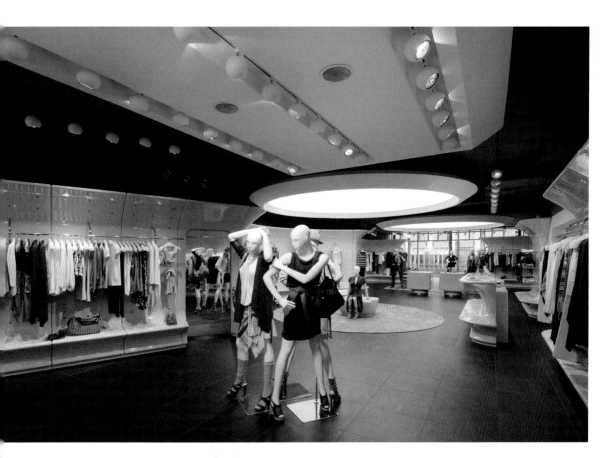

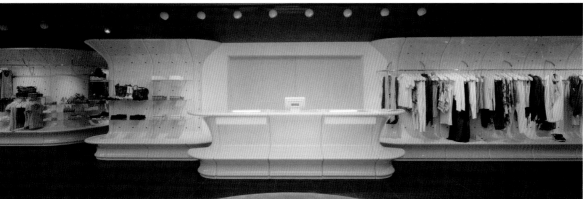

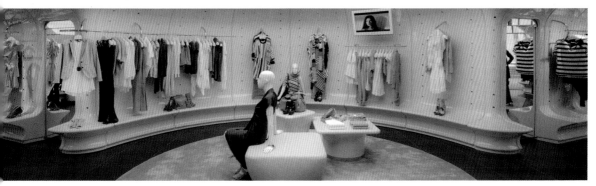

The result of the proposed concept is a modular system that uses natural shapes, perfect curves, and subtle layers of color and texture. Complete flexibility is achieved without sacrificing aesthetics or imagination.

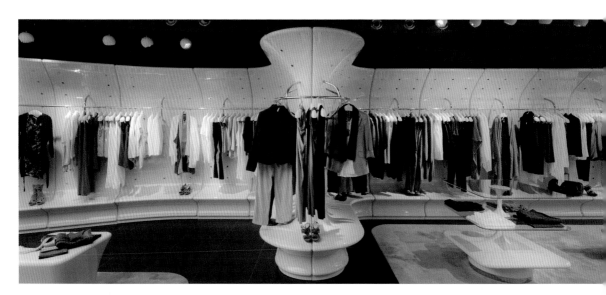

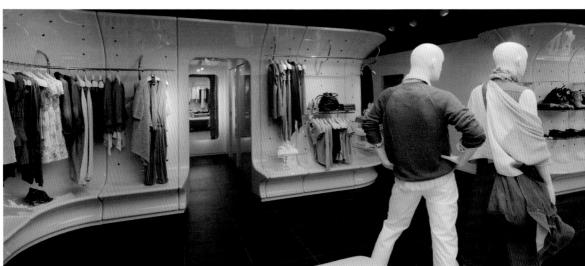

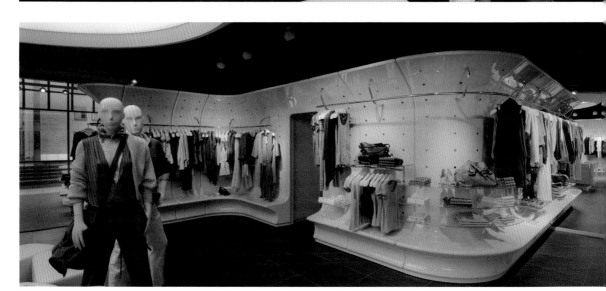

The created module favors repetition and variation as a method of building composition.

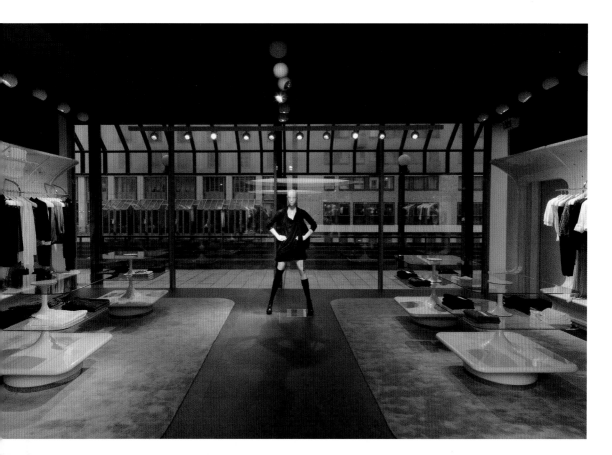

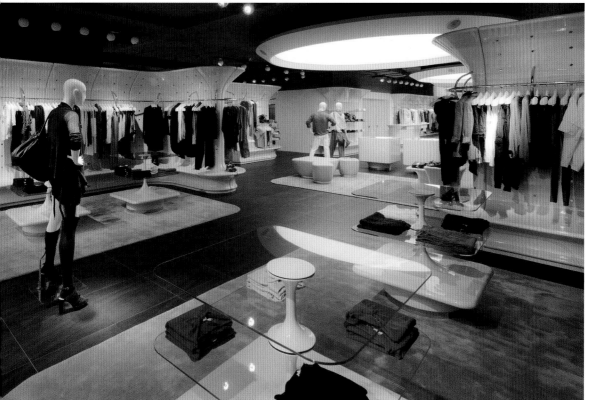

There is a wide range of components that can be customized and tailored to individual establishments.

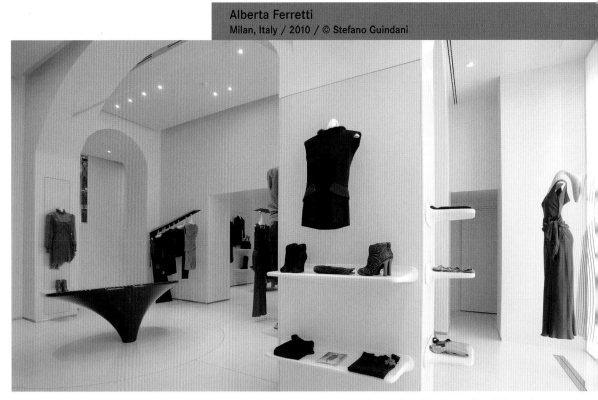

The architectural approach was to create a simple background to highlight femininity and lightness of the Italian brand's clothing. An attractive exhibition method was used, including sculptural elements without supports.

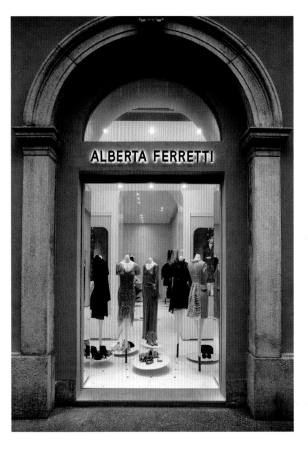

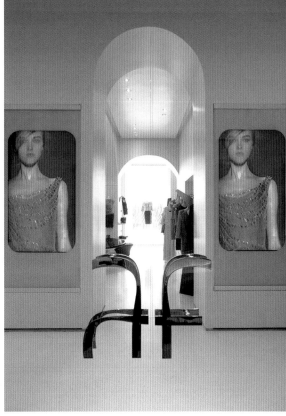

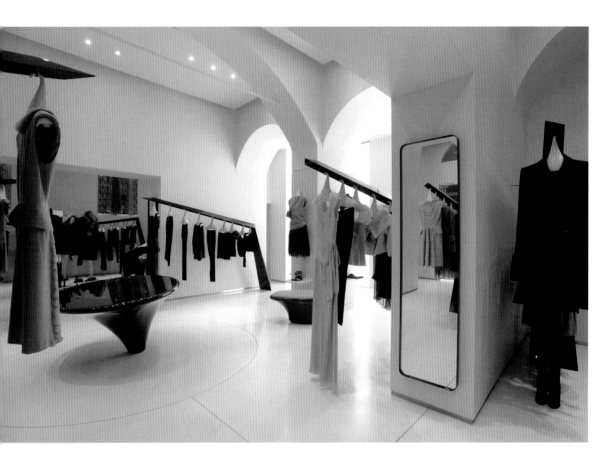

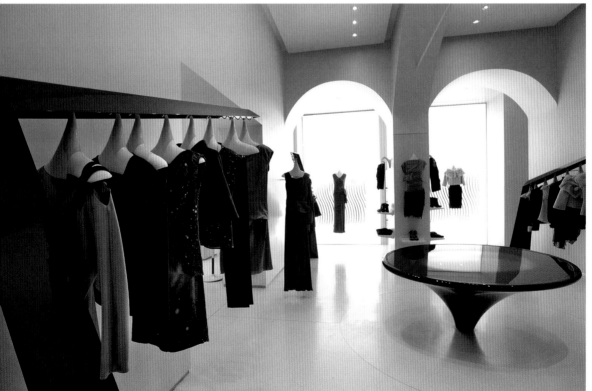

In the design, the structure of the eighteenth century building was respected, so that the original walls were maintained to divide the space into separate rooms connected by arched doorways. According to the concept by Alberta Ferretti, lighting creates atmosphere and makes the clothes stand out

The Jerde Partnership

The Jerde Partnership Team

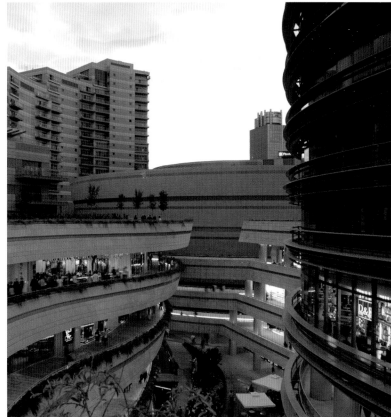 913 Ocean Front Walk
90291 Venice
California
USA
Tel.: + 1 310 399 1987
Fax: + 1 310 392 1316
www.jerde.com

The Jerde Partnership is characterized by an urban architecture and visionary landscape. Its designs catch the attention of millions of visitors, allowing them to experience memorable feelings. Its creations bring lasting, social, cultural, and economic value, as well as promoting investment and the revitalization of cities. The studio was founded in 1977, when founding member Jon Jerdebegan wanted to distance himself from conventional architects who focus on the progress of architectural forms to evolve into the creation of memorable places where people can meet and experience a sense of community. Jerde has now become an international design studio based in Los Angeles with offices in Shanghai, Hong Kong, Seoul, and Berlin.

Kanyon
Istanbul, Turkey / 2007 / © Ali Kabas/The Jerde Partnership

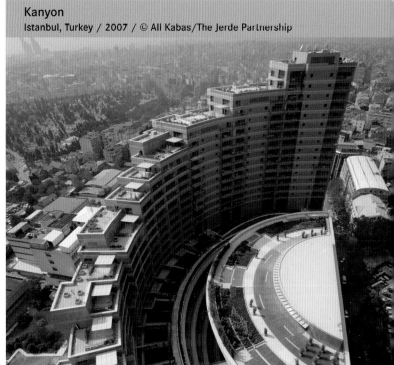

This stately mixed-use complex is located in the Levent business district, surrounded by other large buildings such as the Tower Isbank. The firm has designed an organic and open project that stands out among the density of this area to create a new destination and meeting place.

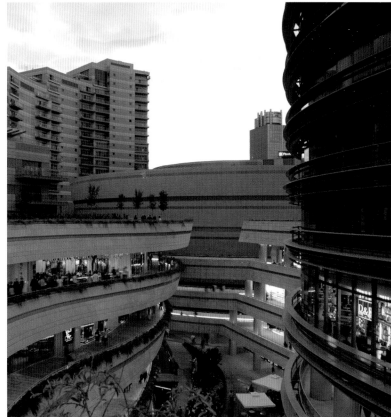

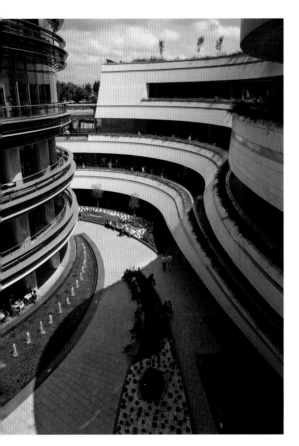
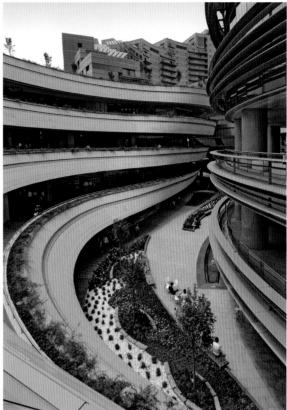

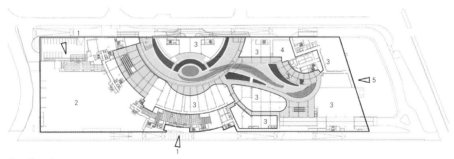

Ground floor plan

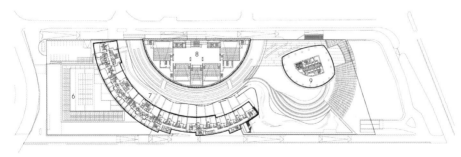

Residential/Cinema floor plan

1. Residential Entrance
2. Supermarket
3. Retail
4. Restaurant
5. Sub. Entrance
6. Residential Amenities
7. Residential
8. Cinema
9. Office

From the entrance, designed as an outdoor pedestrian path, visitors can admire the innovative architectural forms of the buildings.

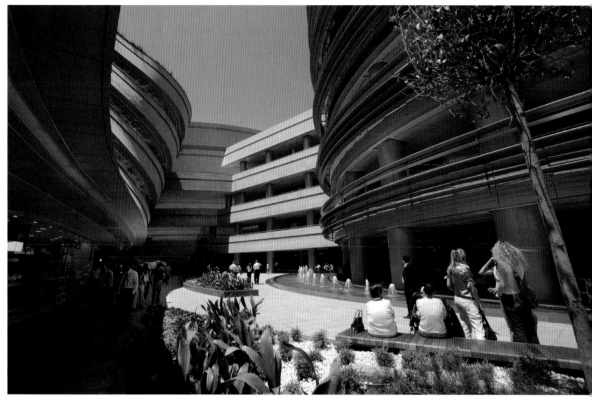

The shopping mall has four levels that accommodate local and international businesses. Heating panels installed on the roofs of the different walkways heat the building, protecting customers from the weather.

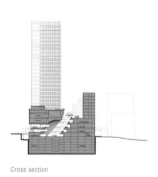

Cross section

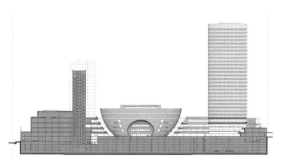

Longitudinal section

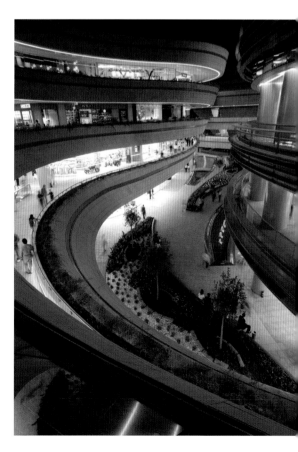

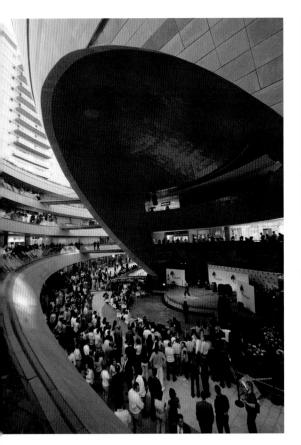
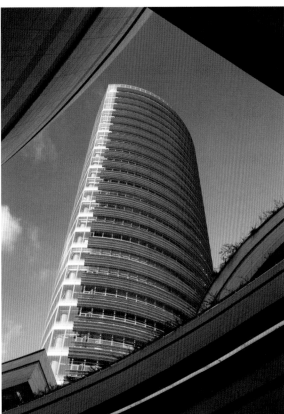
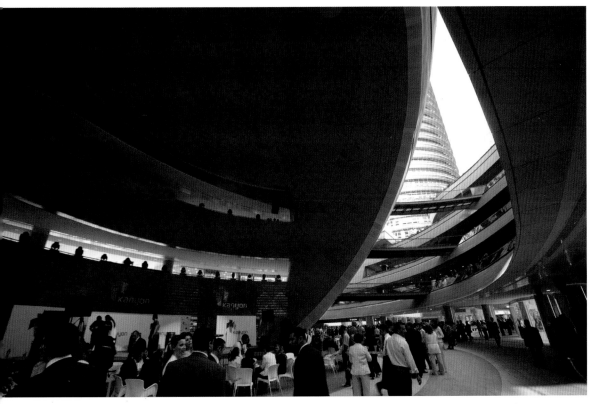

The office tower and entertainment area are located along the boulevard to create a strong urban identity and provide the complex with intimacy away from the busy adjacent street.

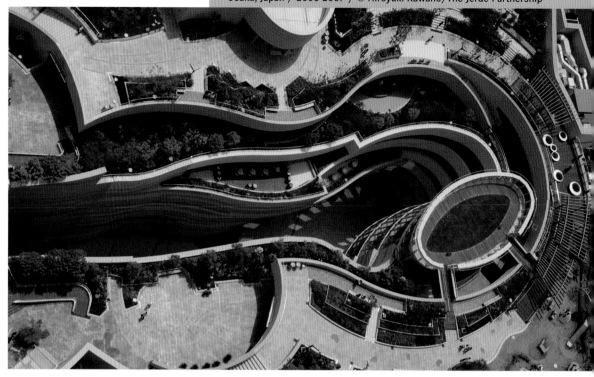

Namba Parks incorporates natural elements that contrast with the hard urban center of Osaka. The architects designed pioneering ecological installations in the Japanese city.

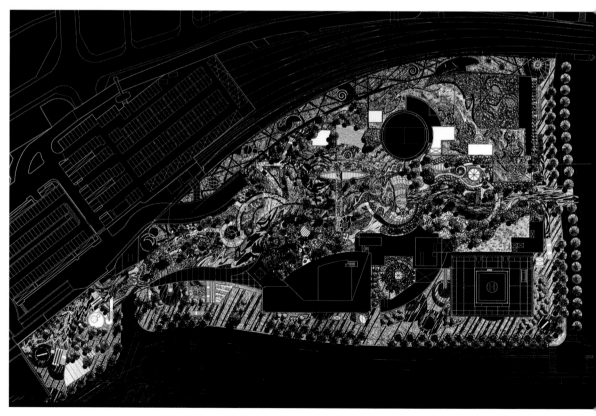

Landscape ilustrative plan

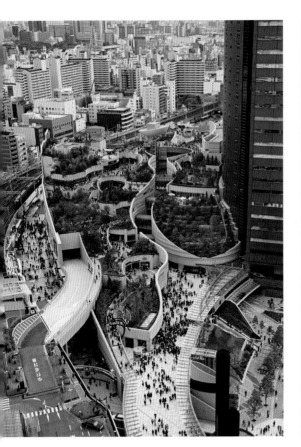

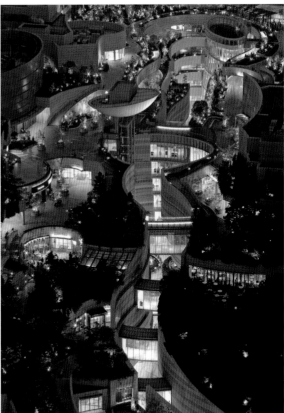

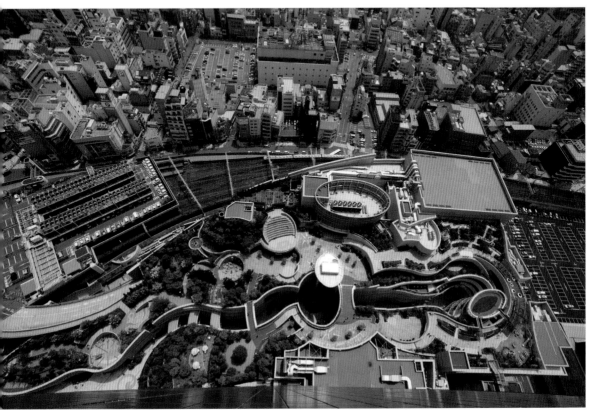

One of the main elements of the complex is a green roof that gradually ascends eight levels. The park offers visitors easy access to this sector.

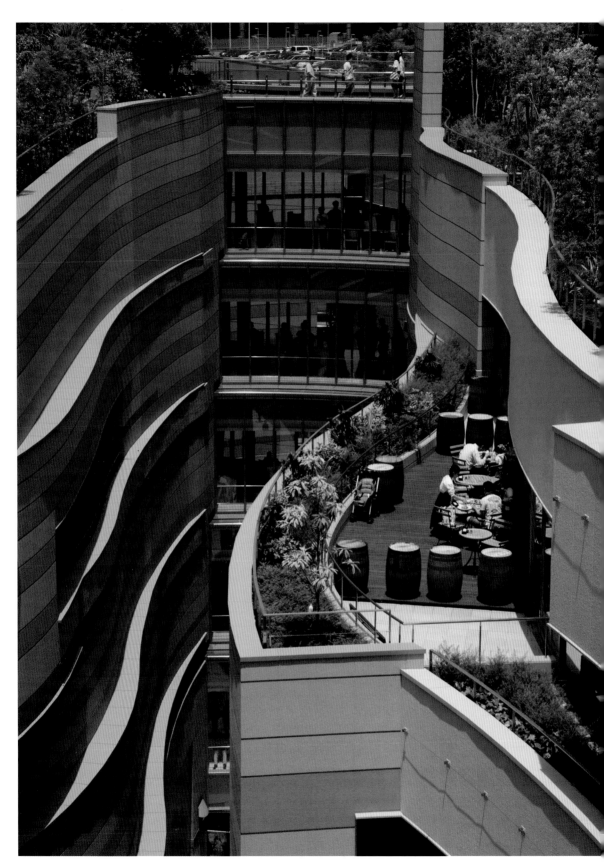

The main circulation of the complex consists of a large canyon that leads to the roof and reinforces the project's connection with nature.

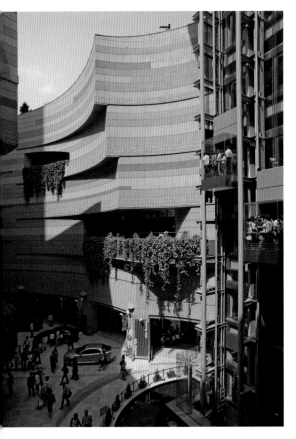
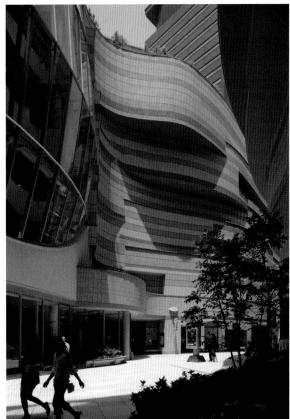
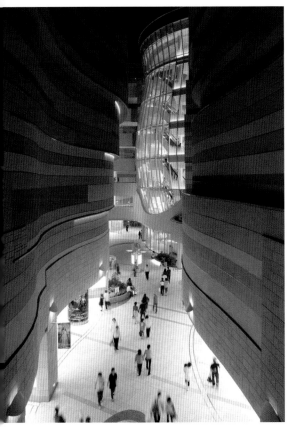
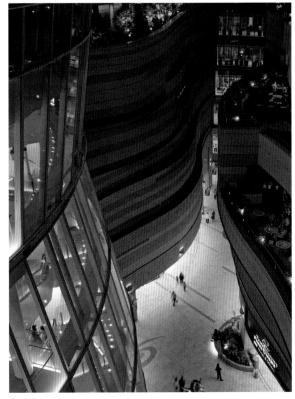

The canyon is a carefully designed footpath carved with bridges, caves, and other areas to explore.

Roppongi Hills
Tokio, Japan / 2004 / © Daici Ano/The Jerde Partnership

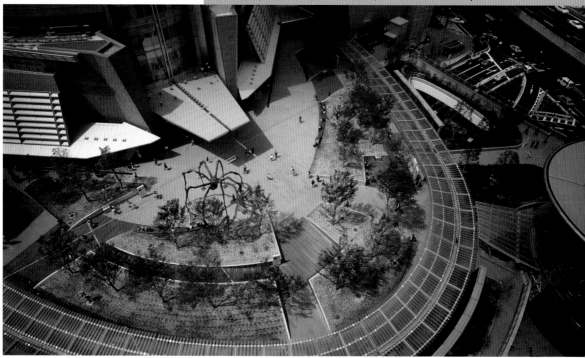

The Roppongi Hills master plan organizes more than sixty-five hectares spread over several buildings of different uses. The volumes are divided into an open park and connected by means of an organic flow.

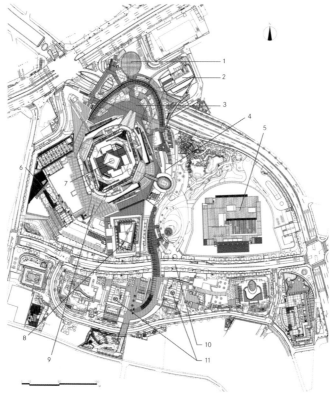

1. Subway rotunda
2. School
3. Deck plaza (district 2)
4. Hillside (district 1)
5. TV Station
6. Hotel
7. Office tower
8. Cinema
7. Westwalk (district 3)
8. Keyakizaka dori (district 4)
9. Residential towers

Site plan

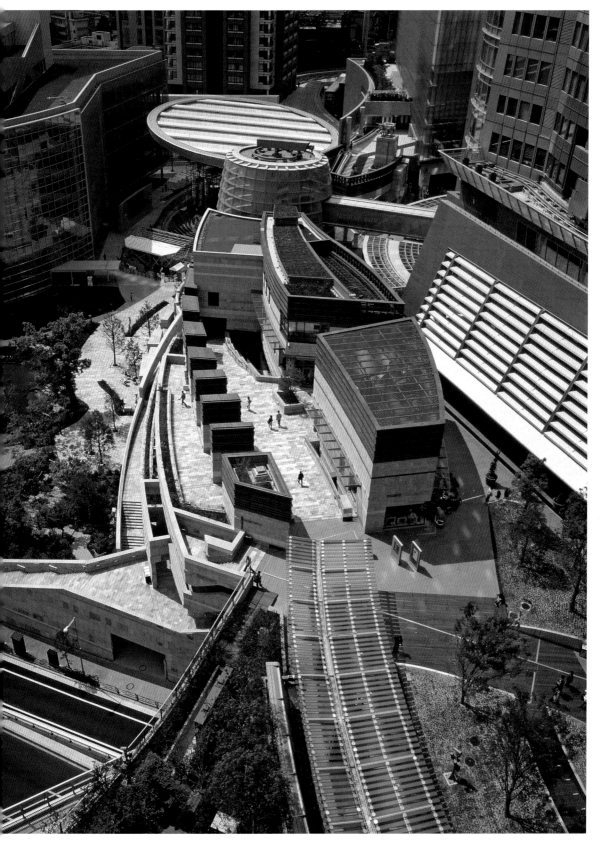

he walkways guide visitors in an orderly manner stand out in the architectural complex. The entrance is located at the north end of the complex, opposite the Roppongi Dori uilding. The complex can be accessed by metro, as a station was built explicitly for its visitors.

The walkways are illuminated mainly by natural light that can improve the view that characterizes the project. The structures of the building created with natural stone stand out, giving the complex a unique appearance.

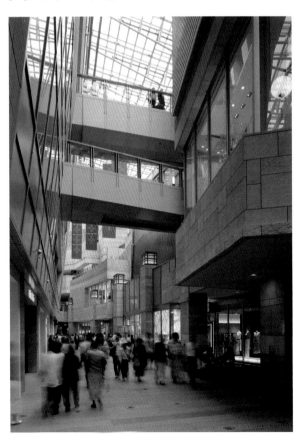

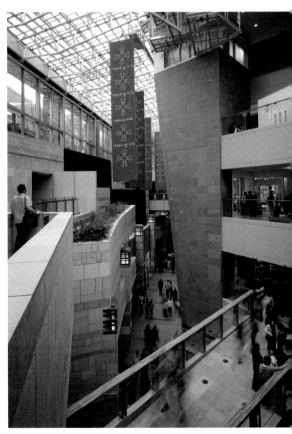

In the picture above, there is a covered walkway that creates an organic flow of movement. Visitors leave the metro station and head for the central courtyard that serves as a meeting place.

Santa Monica Place Santa Monica, CA, USA
2011 / © Babak Bassir/The Jerde Partnership, Macerich, Mark Silverstein

The new shopping mall has replaced the typical suburban style of the buildings of this type to make way for an intimate and urban environment that strengthens the relationship with the environment.

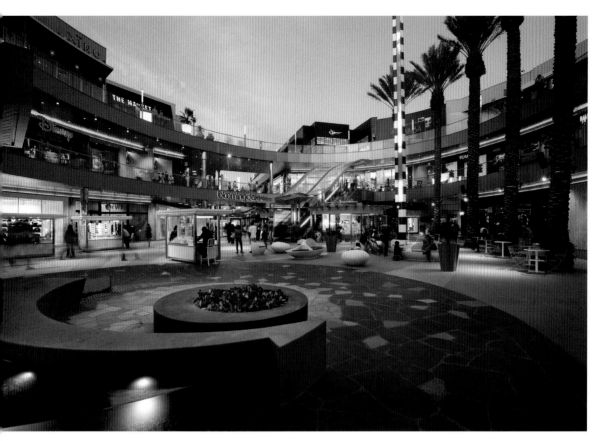

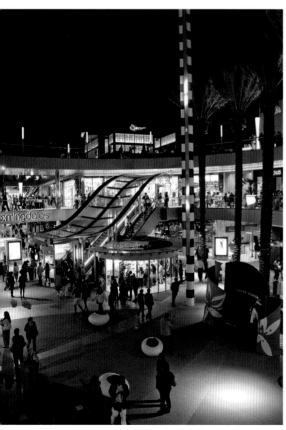

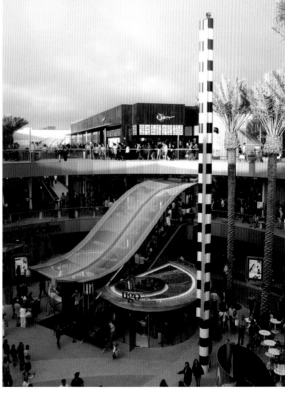

The project is organized around a central plaza designed for concerts, installations, and other public events. It is the starting point for the different levels of commercial premises.

Each of the four entrances to the shopping mall reflects the defined urban character designed by the architects. The western entrance, near the beach and pier, is designed with organic shapes and soft colors.

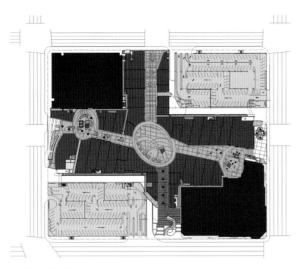

Ground floor plan

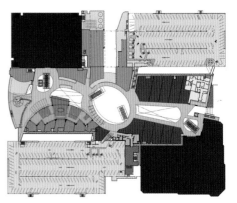

First floor plan

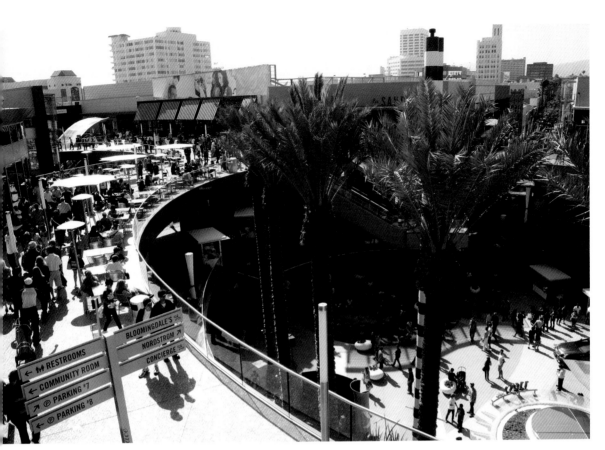

An exterior-interior courtyard, with ten fast food restaurants, is a prominent feature. The restaurants offer different design options, seating, and views of the project.

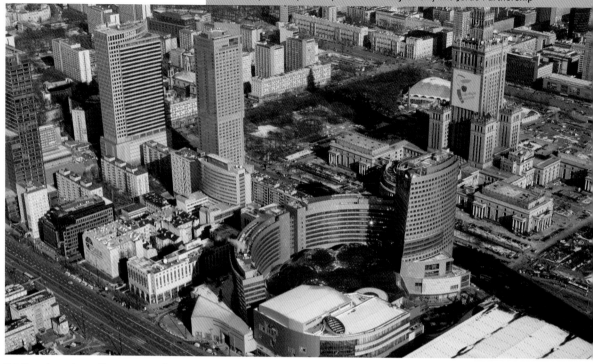

Złote Tarasy is a modern multi-purpose space which has become the new hub of the urban fabric of Warsaw. The project serves as a visual and physical connection of the adjacent buildings, such as the Warszama Centralna train station and the Palace of Culture.

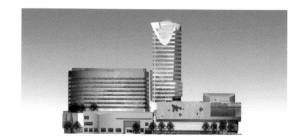

Elevations

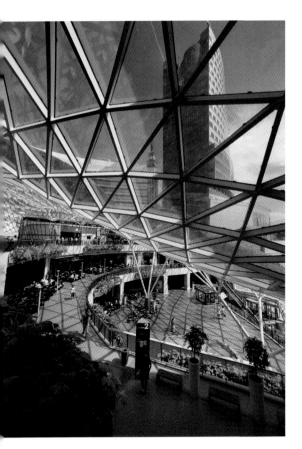

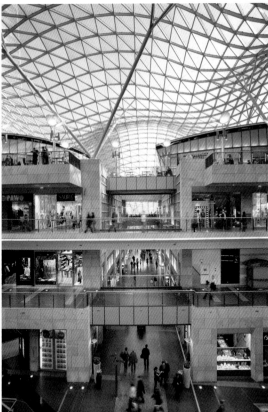

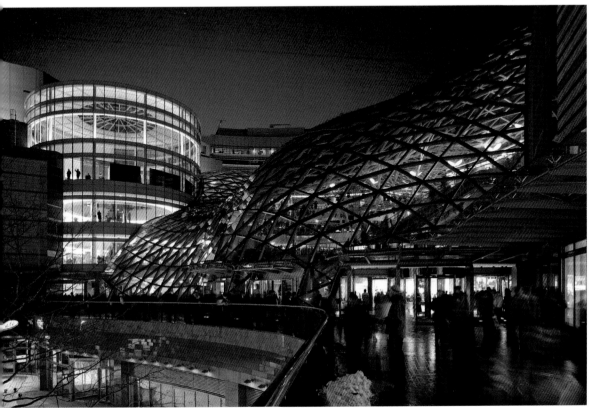

The undulating glass roof creates the image of an open-air shopping mall, as well as conveying the feeling of being outdoors while protecting visitors from the weather.

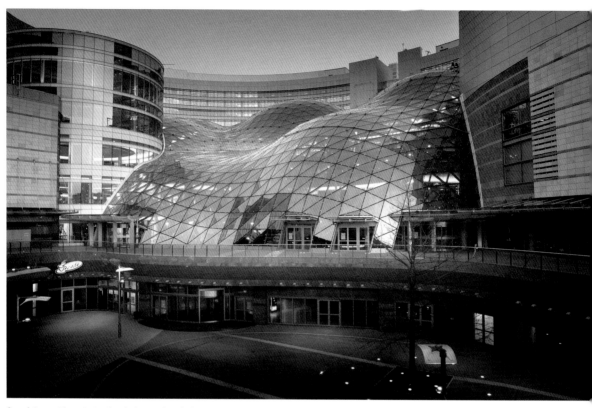

One of the most important actions is the creation of a large square that acts as an extension of the city parks. The undulating glass roof refers to the treetops of Warsaw's historic parks.

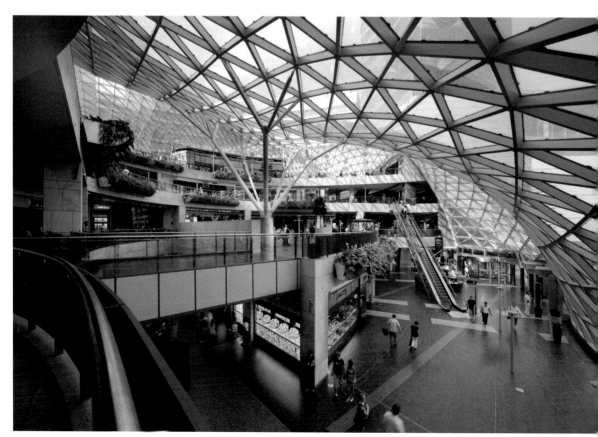

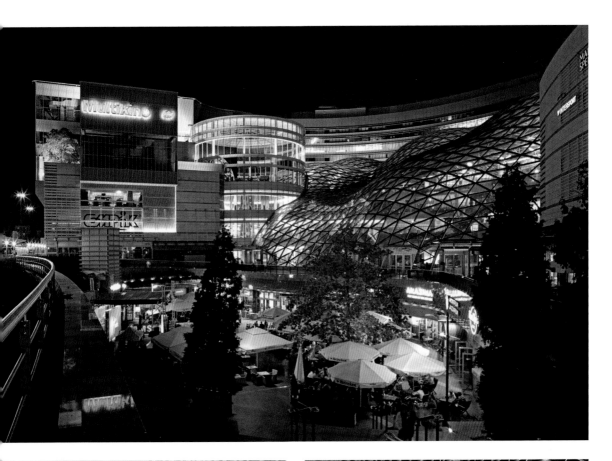

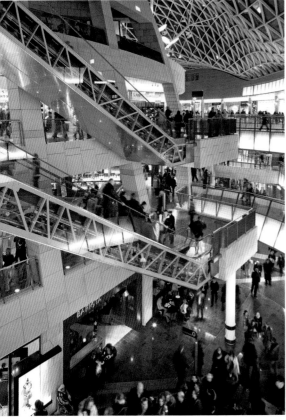

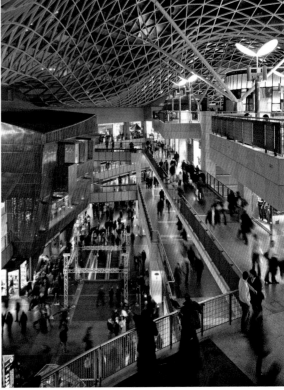

Zlote Tarasy means "golden terraces," rseulting in three levels of shops and an entertainment center.

Torafu architects

Shinya Kamuro, Koichi Suzuno

Chikazawa Bld. 2F
1-9-2 Koyama, Shinagawa-ku
Tokyo 142-0062
Japan
Tel: +81-3-5498-7156
www.torafu.com

Founded in 2004 by Koichi Suzuno and Shinya Kamuro, the studio works with a great variety of products from interior design for stores to exhibition space design, product design, spatial installations, and film making. The studio has received many awards including the 2007 commercial space award from the Boolean Tokyo University Tetsumon Cafe, the DFA (Design for Asia) Grand Prize for the project "Template in Claska" in 2005, and the Grand Prize of the "Elita Design Awards 2011" for the project "Light Loom" at Milano Salone 2011. Their work is also the subject of exhibitions such as those in Haaz Art & Design Gallery in Istanbul about their "airvase" product, as well as in the Axis Gallery and the Spiral Gallery, both in Tokyo.

3M Store
Tokyo, Japan / 2008 / © Daici Ano

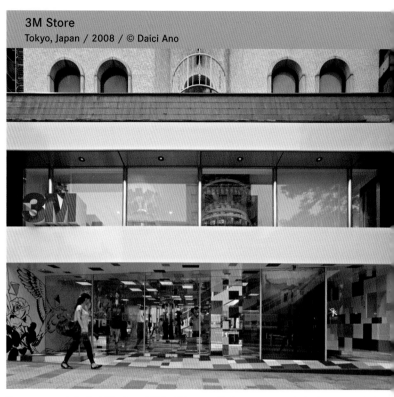

The company producing Post-it® notes and Di-Noc® film opened its first concept store in the Omotesando district for a limited period of time only. For the interior design scheme, almost all the materials used were products made by the brand.

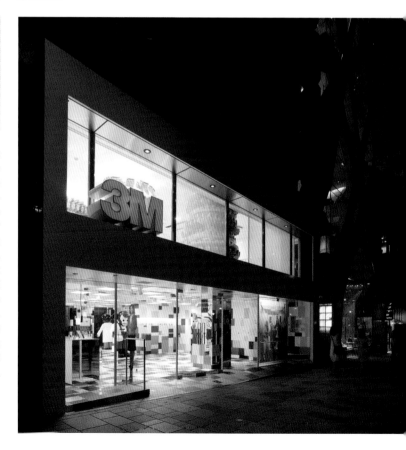

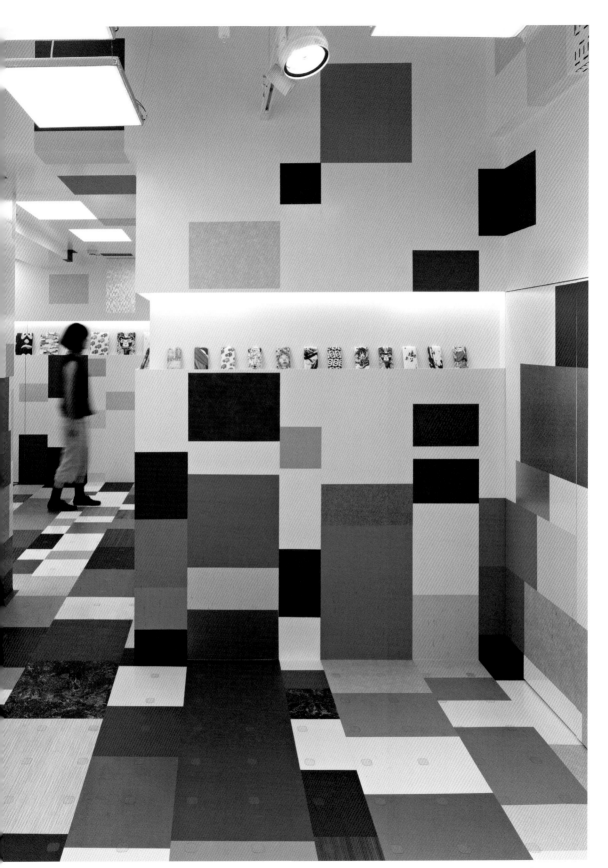

The first floor has an exhibition area presenting the practical uses of 3M products. Customers walk over a tiled floor covered with multicolored sheets of Di-Noc®.

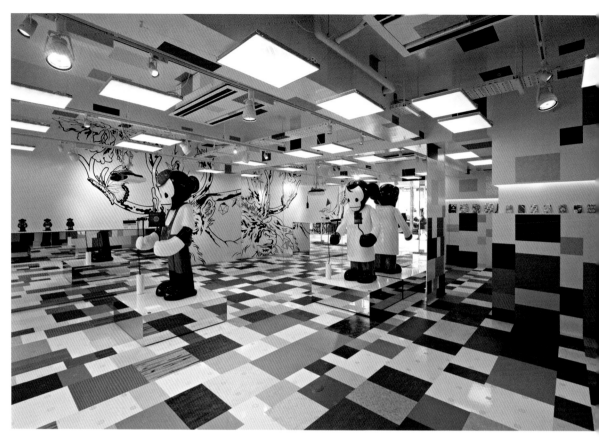

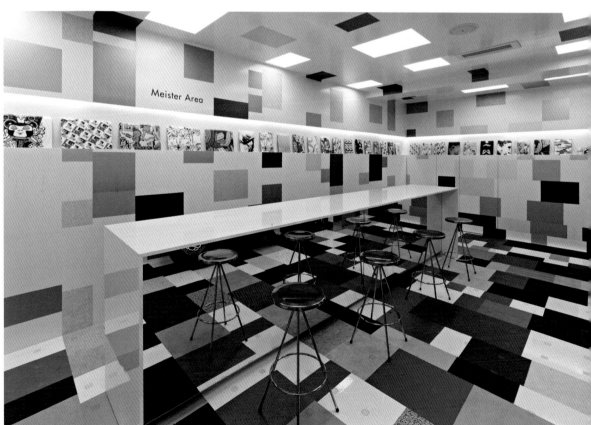

The second floor contains a vast selection of the brand's products displayed on circular shelves, forming a contrast with the bright white walls and floor.

Inhabitant Store Tokyo
Tokyo, Japan / 2009 / © Daici Ano

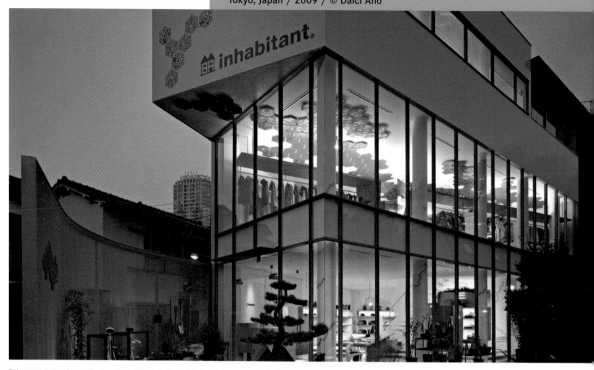

This store, belonging to the brand Inhabitant, is located in Harajuku, a trendy district that is home to the most prestigious clothing and lifestyle brands. The architects found inspiration in the spirit of the brand to devise a space that recreates the spontaneity of a casual stroll through the area.

1. Cashier
2. Shop
3. Fitting room
4. Display space
5. Storage
6. Press room

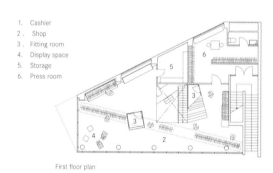

First floor plan

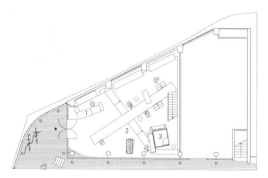

Ground floor plan

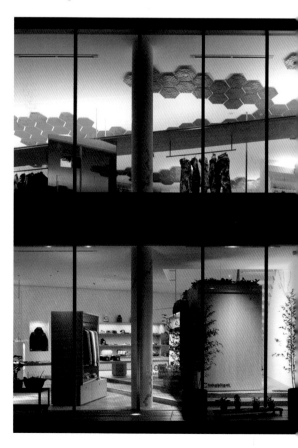

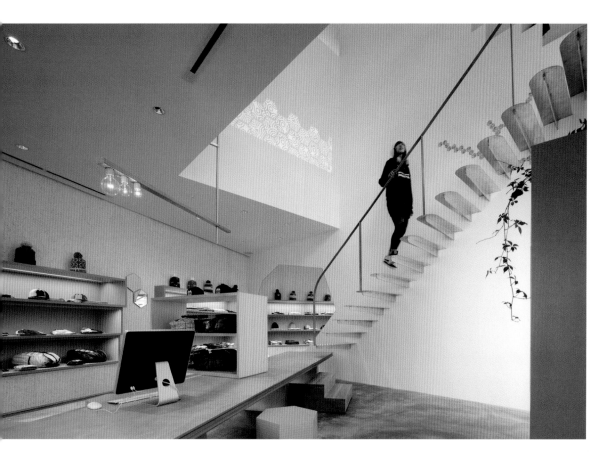

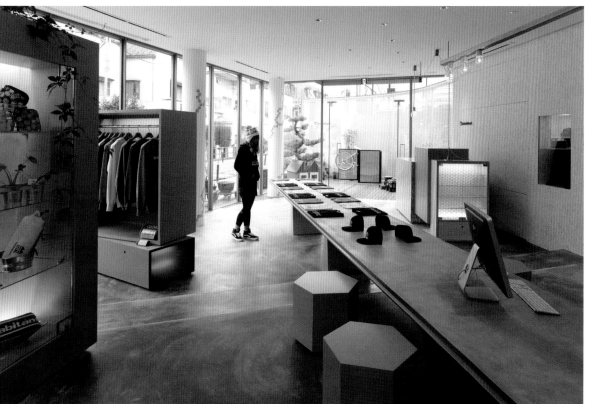

On each of the two levels, spacious platforms cross the space diagonally, flanked by changing rooms and counters.

561

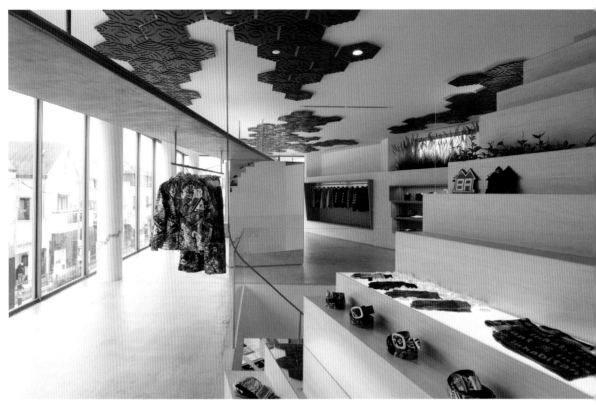

The hexagonal pieces appearing throughout the store on different surfaces—ceiling, walls, columns—have been produced by the artist Asao Tokolo and contain two different types of drawings.

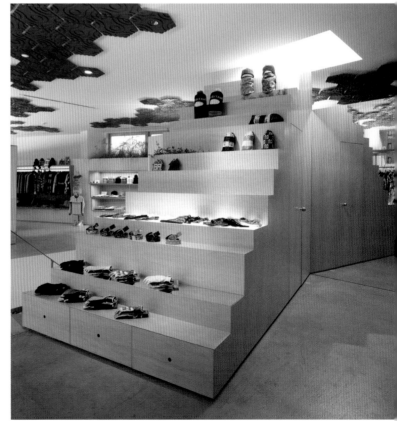

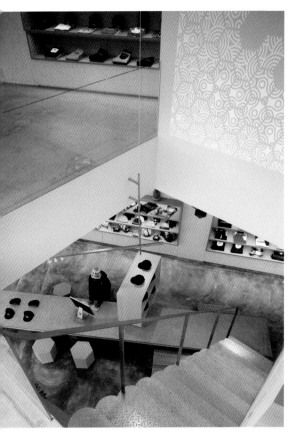

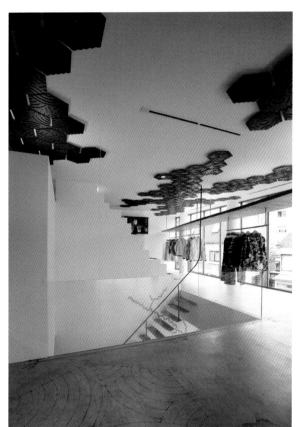

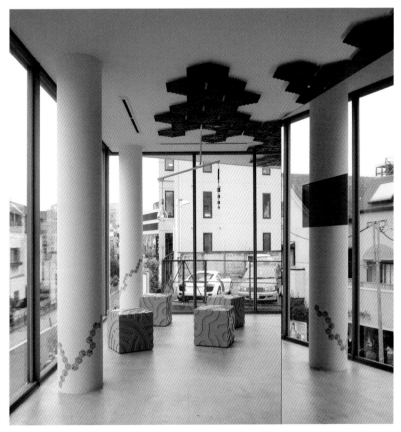

Minä Perhonen "H and Hand" exhibition
Tokyo, Japan / 2005 / © Daici Ano

"The Stage" exhibition space, located on the first floor of the Isetan Shinjuku store, housed a temporary exhibition of four brands, one of which was the Minä Perhonen brand. With the title "H and Hand," it has sought to rediscover the appeal of Japanese artisans.

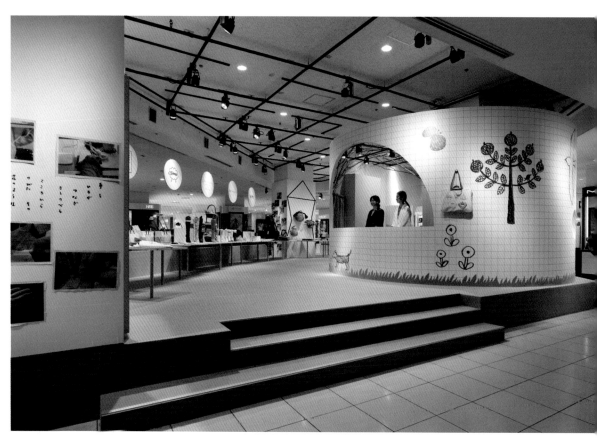

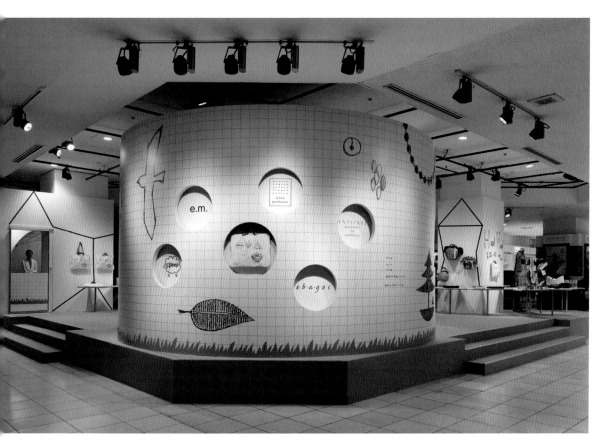

Square-shaped tables of varying sizes display the objects. The wall contains prints that the company has used over time in its fabrics.

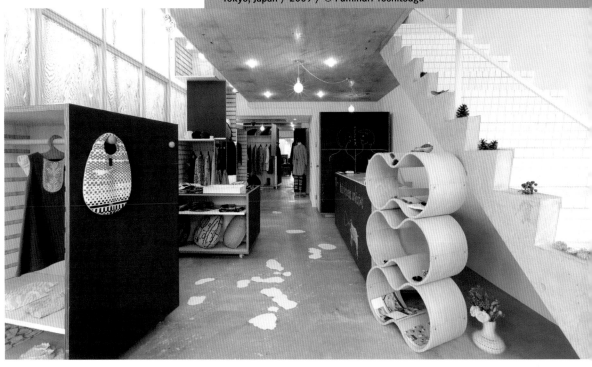

This store of the fashion company Minä Perhonen specializes in selling products launched by the company in earlier seasons. It is named "Arkistot" which means "archive" in Finnish.

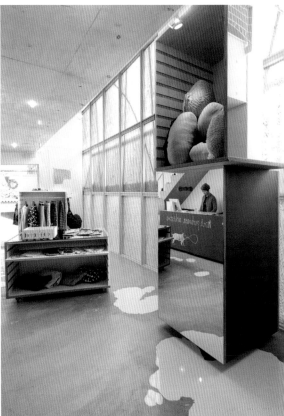

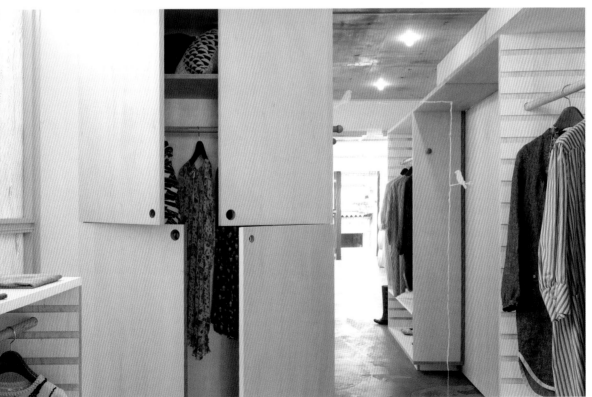

Removable shelves and hangers can be reconfigured, helping to increase the fluidity of the space. Each piece of furniture has one whiteboard surface and another with a mirror to generate interesting imagery effects.

UNStudio

Caroline Bos, Ben van Bekel

Stadhouderskade, 113
PO Box 75381
1070 AJ Amsterdam
Netherlands
Tel: + 31 20 570 20 40
www.unstudio.com

UNStudio was formed in 1999 in Amsterdam by the architects Ben van Bekel and Caroline Bos, who had previously, in 1988, created their own firm under the name of Berkel & Bos Architectuur Bureau. The change came about because of a shift in their ideology, resulting in a new way of looking at architecture. The name comes from the United Network, which refers to the collaborative nature of the studio. The philosophy of the studio is to be in contact with people from around the world with multidisciplinary expertise, from architects to administrative assistants to theorists. Since its creation, a wide array of projects have been developed: public buildings, urban planning, infrastructure, housing, offices, and products.

Galleria Cheonan
Cheonan, South Korea / 2010 / © Christian Richters, Kim Jong-kwan

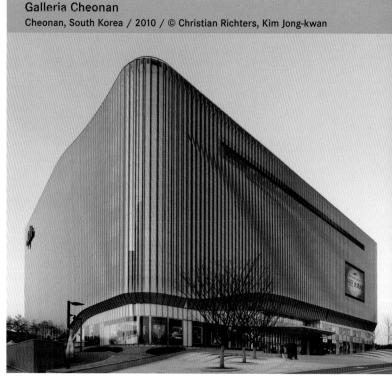

The gallery was built as a prominent landmark that is visible from the main road from Seoul. The architecture of the 66,000 m² (710,418 ft²) building has a changing, dynamic aspect, with moiré effects and special lighting that projects lighting animations.

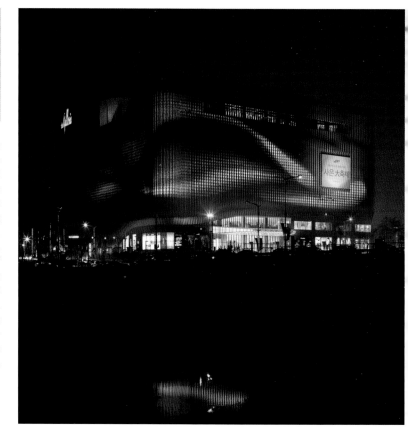

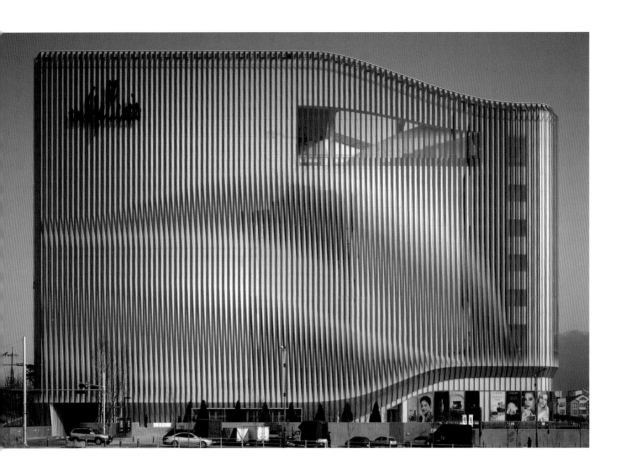

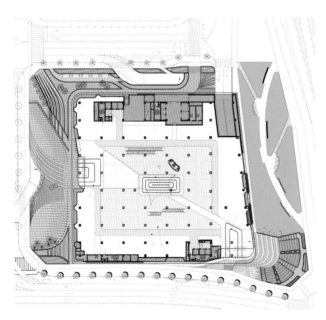

First floor plan

Basement floor plan

During the day, the building is white and reflective black, while at night the colors are used to generate light waves on the façade. The lighting design has been developed in parallel with the architecture.

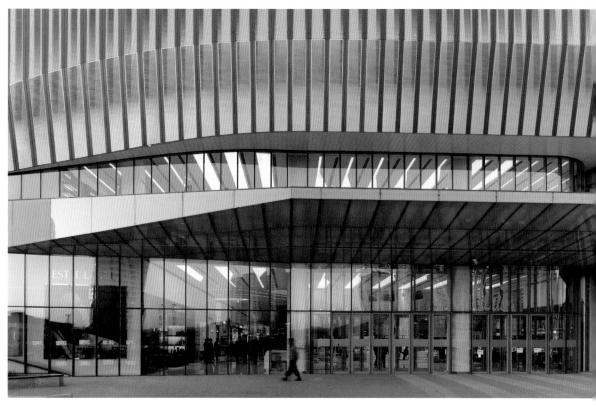

The strategy used by the architects is to create an optical illusion. The façades have two layers of customized profiles, extruded aluminum for the top layer and an aluminum composite coating for the bottom layer. The vertical profiles of the upper layer are straight, while those of the lower layer are at an angle.

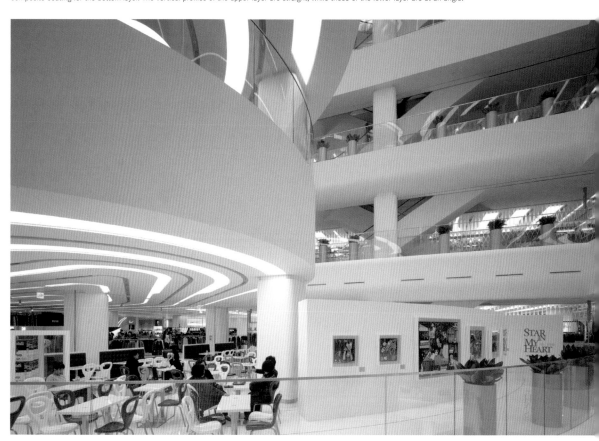

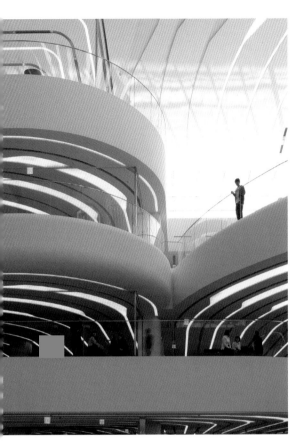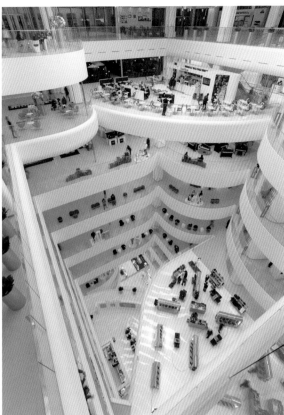

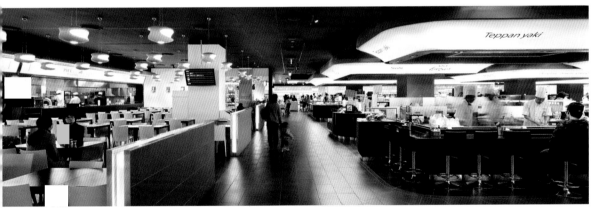

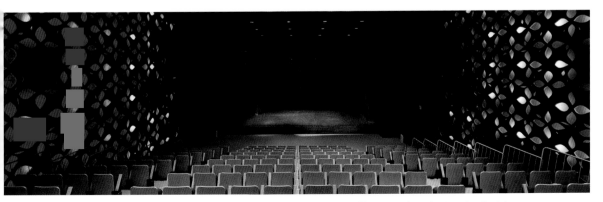

The interior is divided into three levels where different public areas, semi-private spaces, and a basement with a supermarket and restaurant are located.

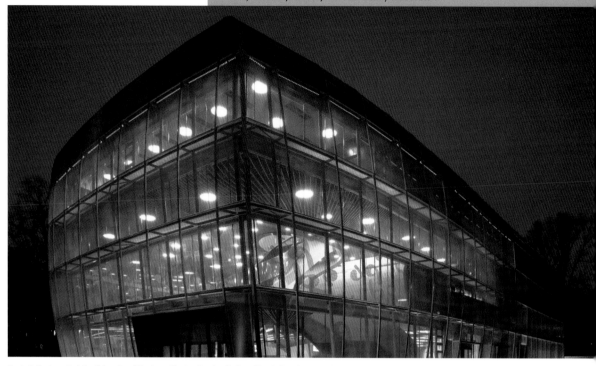

The building is part of the University of Music and Performing Arts in Graz. The design of the new Music Theater is formed by a transparent box with curved edges on its exterior façades. In the interior, undulating forms that simulate a structure that bends and stretches stand out. The spiral is the organizing element of MUMUTH.

Third floor plan

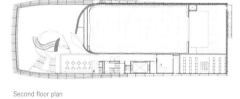

Second floor plan

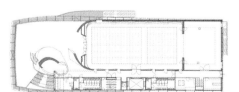

First floor plan

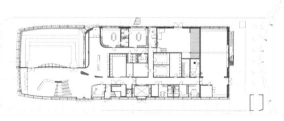

Ground floor plan

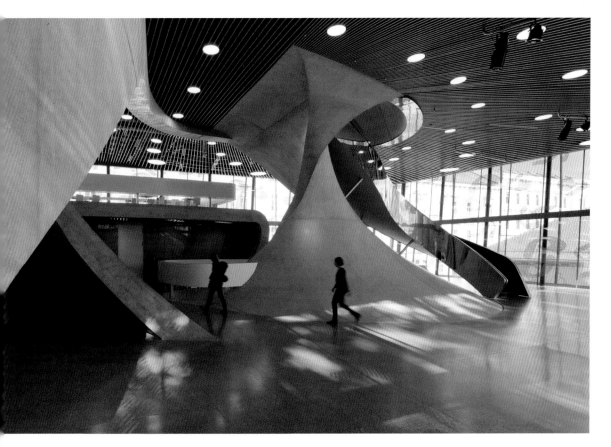

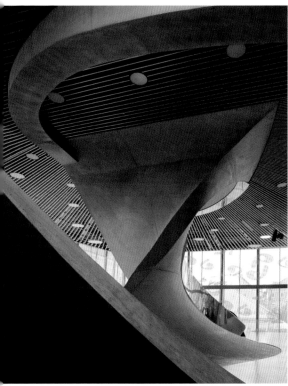

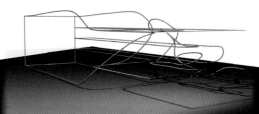

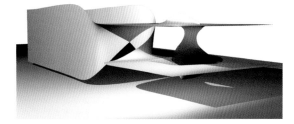

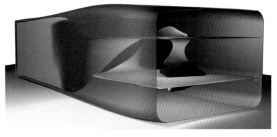

There are two entrances to access the building: one located near the exterior park, used by students and staff, and the other located by the Lichtenfelsgasse, used by the public when there are performances.

Diagrams

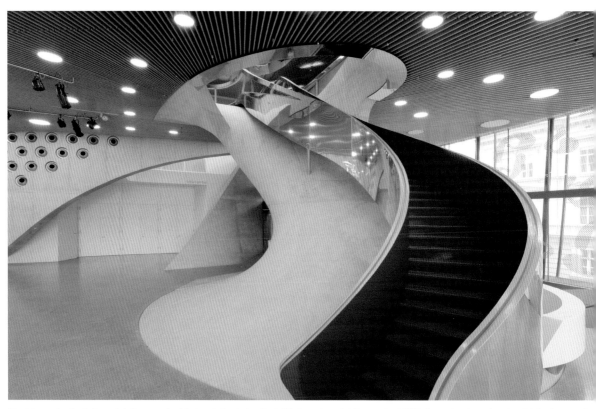

The staircases leading to the main hall are prominent features in the design. The hall features characteristic aspects of UNStudio constructions: elegant, undulating forms, and the use of metals and exposed concrete.

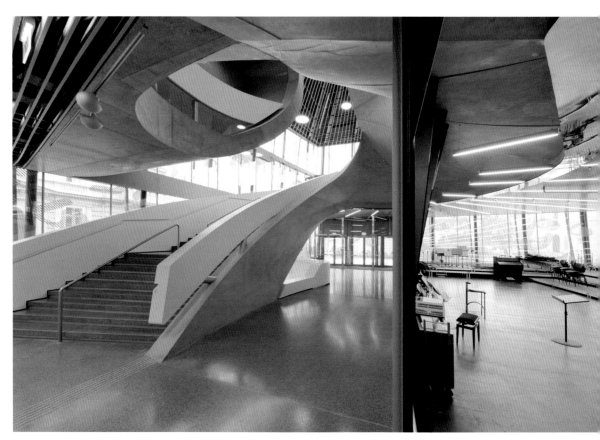

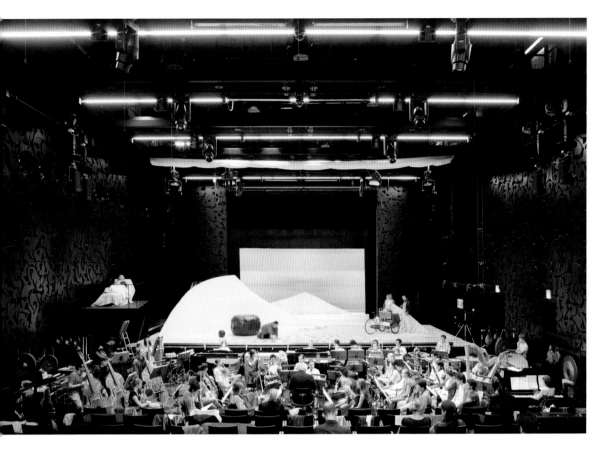

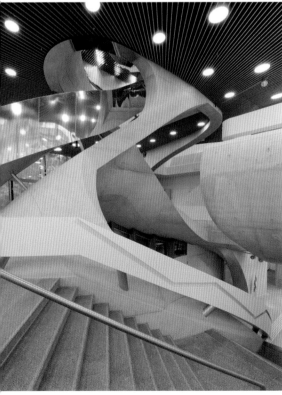

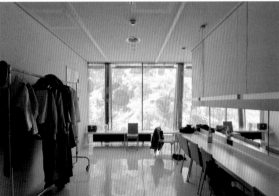

The building is structured to combine a base unit of volume (the theater black box) and a series of volumes based on movements (the lobby and public circulation).

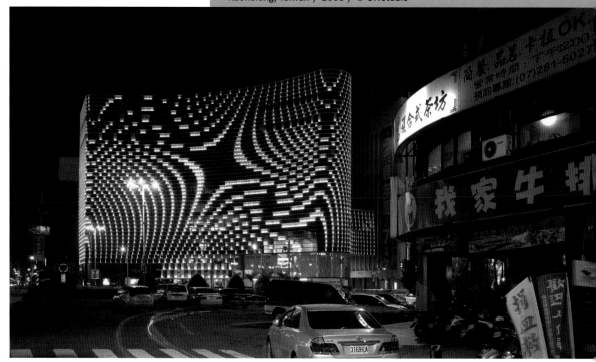

When designing department stores, the architectural studio has used art though color effects and vibrant light. With a futuristic appearance that is illuminated at night, the façade is projected to the exterior by horizontal aluminum sheets and vertical glass rods of different widths.

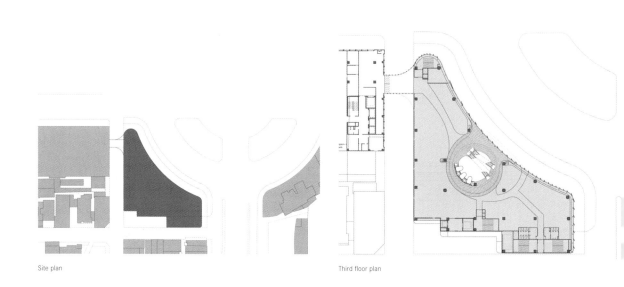

Site plan

Third floor plan

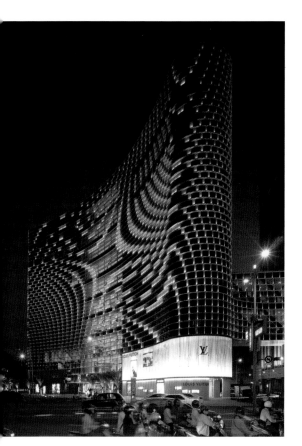

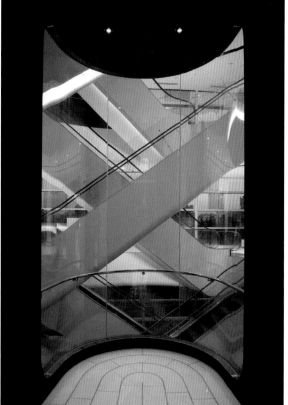

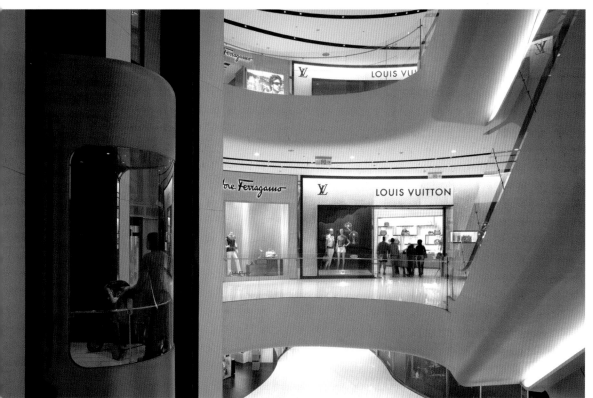

...cting as a sunscreen, the building's façade is fully curved and glazed. The position and size of each of the elements of the façade is derived from a system of twisted frames ...nd related to the internal organization of the building.

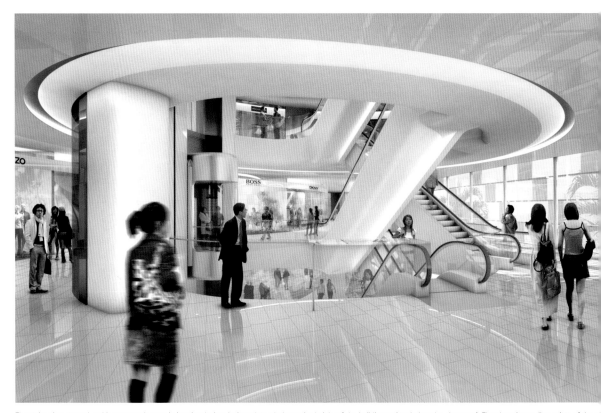

The atrium is a central and important element in interior design. It rises through the entire height of the building to just below the glass roof. The shopping mall consists of three levels and a basement parking lot.

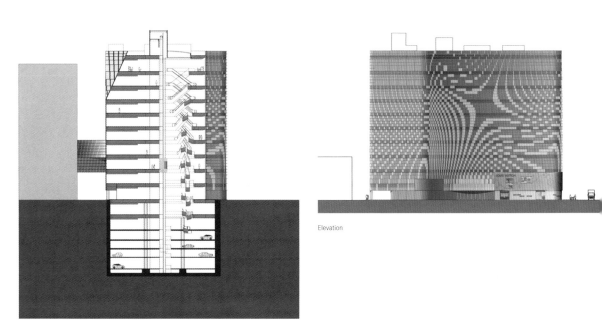

Section

Elevation

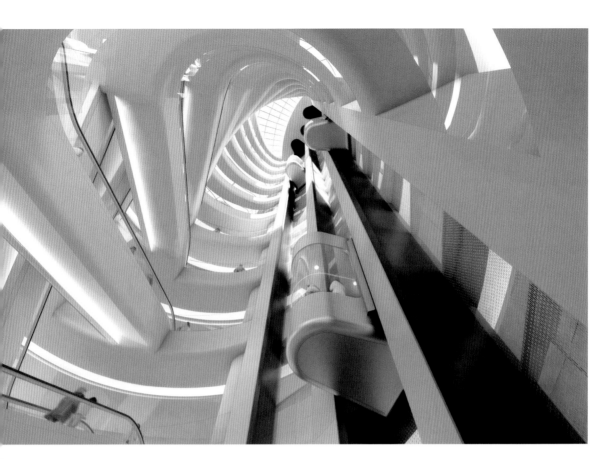

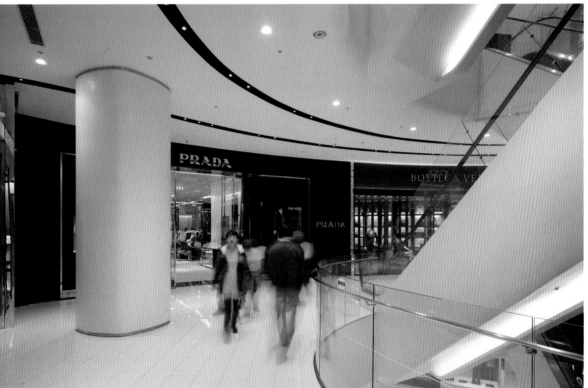

The misleading spatial effect of perspectives is the common thread of all the work carried out by the Dutch studio. The dynamic distribution that is slightly displaced from the escalator makes it look like a rotated spiral-shaped sculpture.

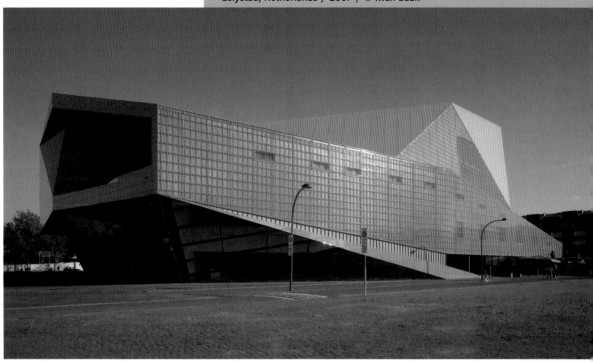

The theater is an extremely colorful building that radiates optimism. The building is part of the master plan for Lelystad created by Adriaan Geuze. The goal is to revitalize the pragmatism of the simple city center, responding to the mission to revive and restore post-war Dutch cities.

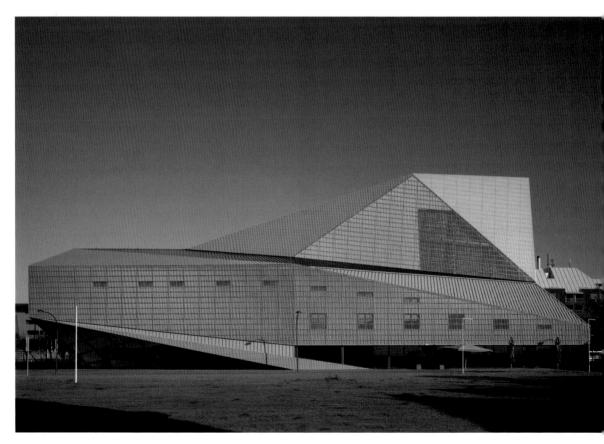

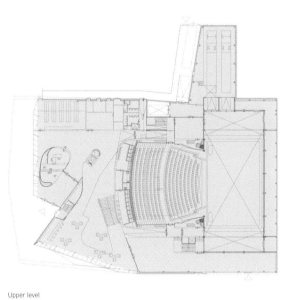

Upper level

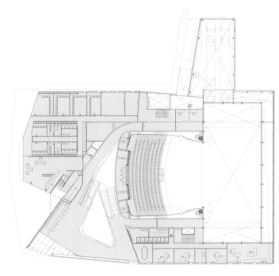

Lower level

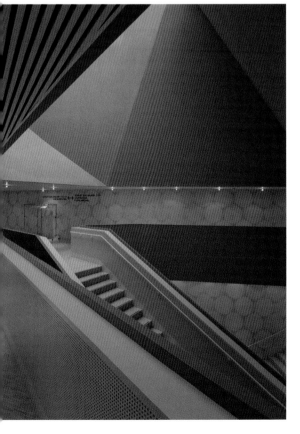

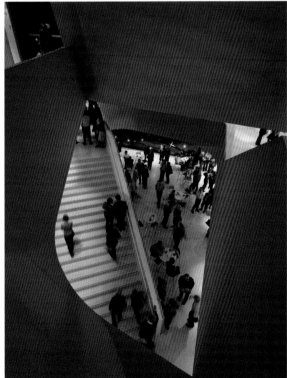

Steel and glass are the materials, and orange and yellow are the colors used on the outside. Concrete, metal, glass, red, pink, white, violet, and cherry were selected for the interior.

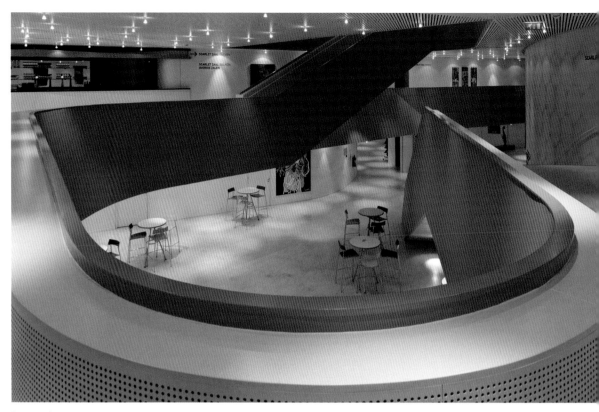

The walls of the interior and exterior are designed to display and rebuild the kaleidoscopic experience of the world of theater, in which one can never be sure what is real and what is not.

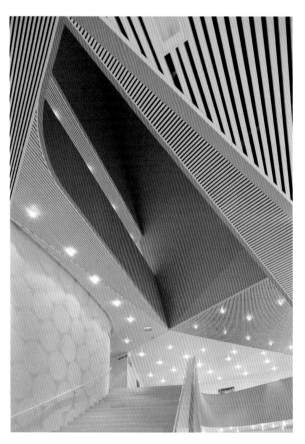

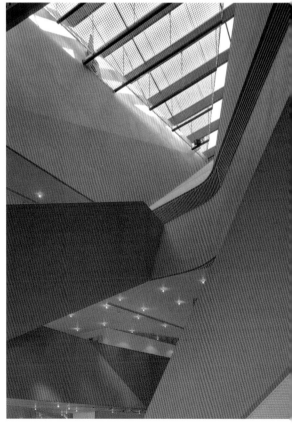

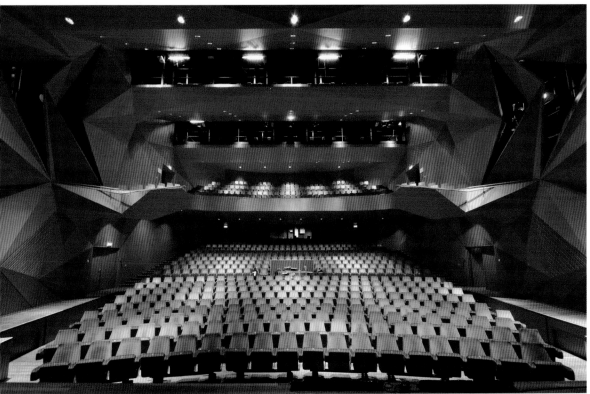

Inside there is a larger and less theatrical space, a tower stage, several multipurpose rooms, a cafeteria, and a restaurant. They are all contained in one volume that protrudes dramatically in several directions.

Yasui Hideo Atelier

Yasui Hideo

4-3-27 Shibuya, Shibuya-ku
150-0002 Tokyo
Japan
Tel.: + 81 3 3498 5633
Fax: + 81 3 5466 7621
www.yasui-atr.com

Shortly after he was born in Shizuoka Prefecture, Japan, Yasui Hideo moved to Gamagouri inAichi Prefecture. In 1981, he received a degree in architectural education at the Aichi Institute of Technology, where he majored in Architectural Engineering and Construction. In that same year, he began working in the architectural studio Takamitsu Azuma Architecture, and in 1985 he moved to the Kitaoka Design office. In 1986, he decided to establish himself as chief architect of his business in Aoyama, later opening an office in Gamagouri in 1992. In the late 1990s, the studio won numerous prestigious awards such as the Nashop Lighting Contest, the IALD International Lighting Designers, and the IIDA North American Lighting Society, to name a few.

Kitayama Monolith
Kyoto, Japan / 2007 / © Nacása & Partners

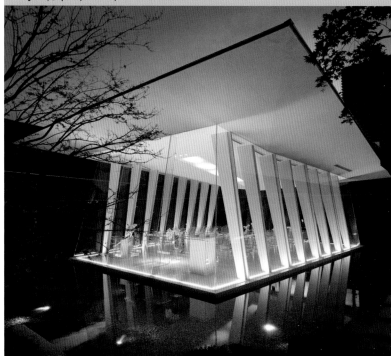

This original restaurant was conceived as a Sukiya, a modern Japanese tea ceremony house. The architecture studio sought to combine Japanese cultural tradition with contemporary architecture.

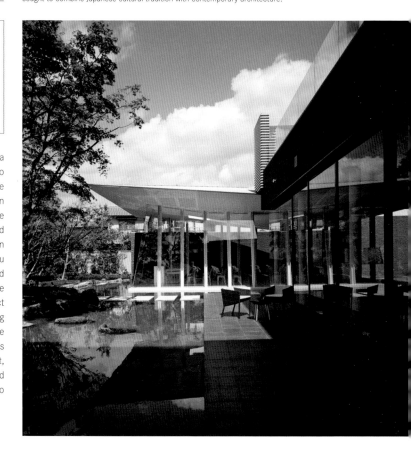

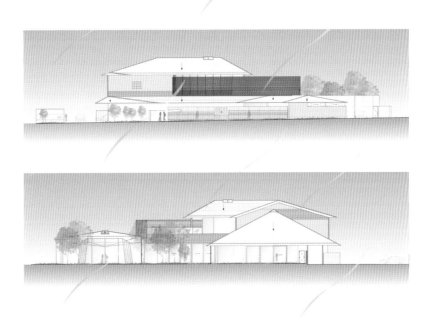

East and west elevations

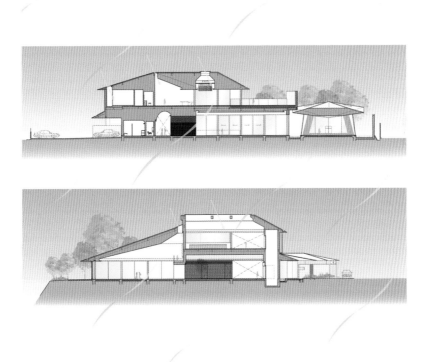

Section A and B

From the entrance to the dining room, the variations in ceiling height change. The design was conceived to attract the admiration of guests with a warm welcome.

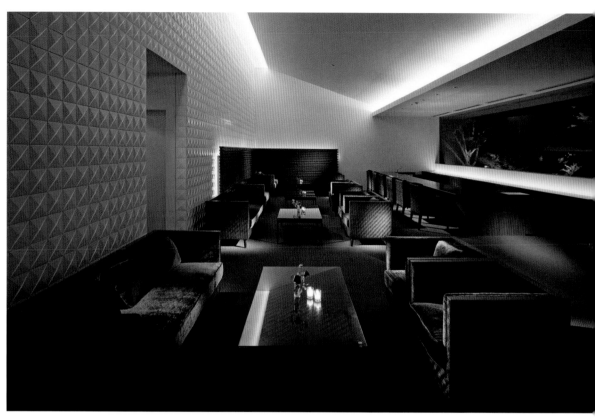

Inside, indirect lighting has been used, producing a diverse atmosphere created by natural and artificial light. This environment changes according to the time of day.

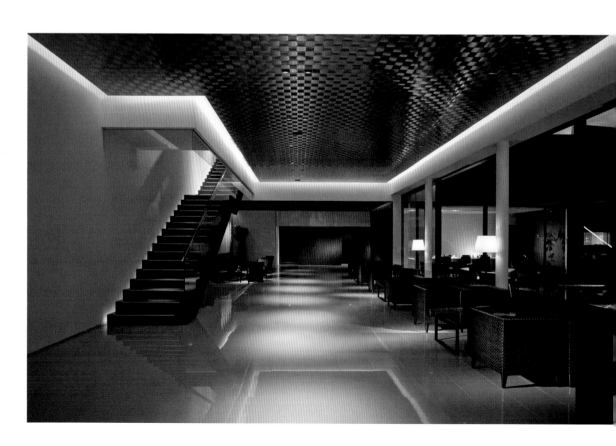

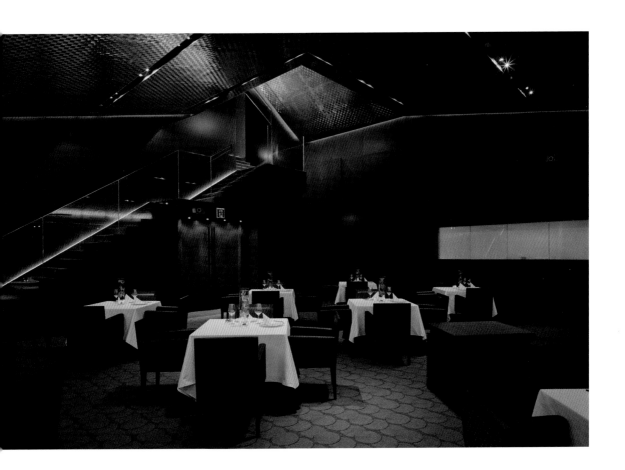

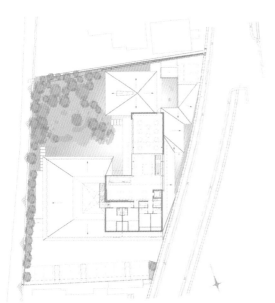

First floor plan

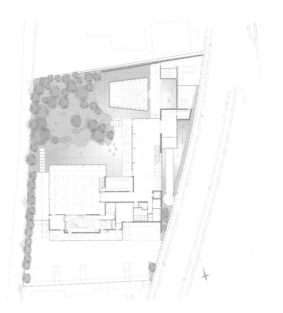

Ground floor plan

A combination of steel and aluminum has been used, replacing the traditional wicker roof.

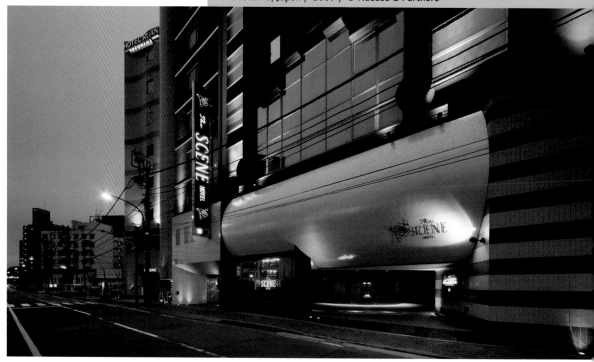

For the renovation of this famous hotel, several designers collaborated on the project. According to this plan, Yasui Hideo Atelier designed all floors differently but with the same common theme: simple and luxurious spaces where the guest feels special.

Tenth floor plan

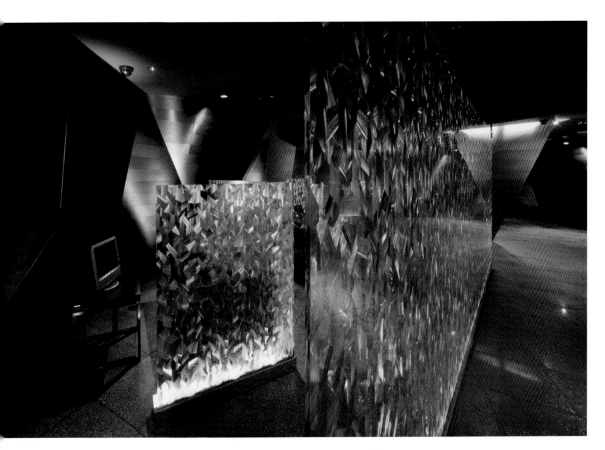

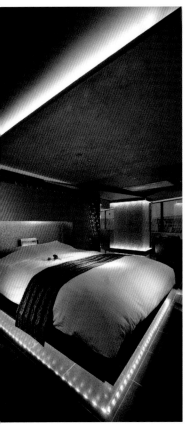

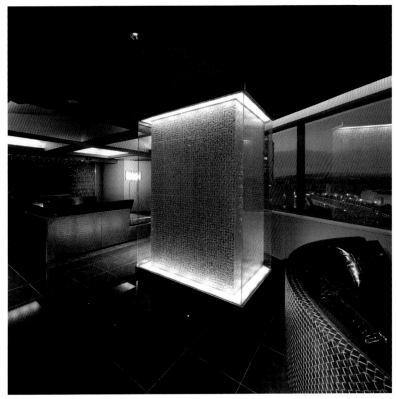

Dramatic, indirect lighting, simple and modern design, minimal decoration, and above all, tiles, are the most prominent design elements in the rooms.

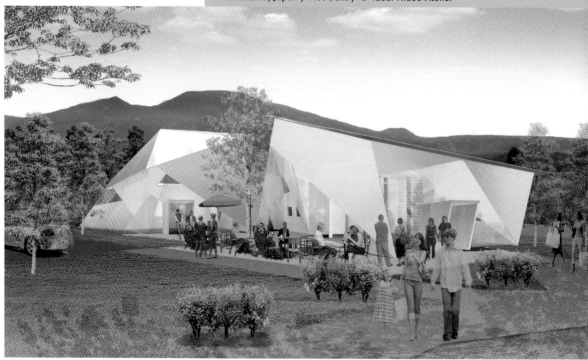

The future Karuizawa Museum will be home to an institution that will convert it not only into an exhibition space, but also into a place to meet people and to become familiar with Japanese pictorial art. The architects drew inspiration from the traditional Japanese artform of origami.

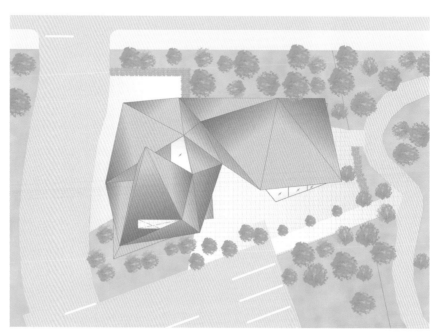

Roof plan

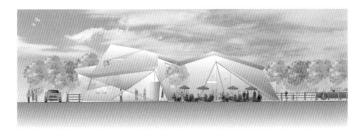

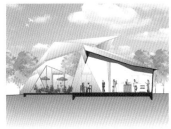

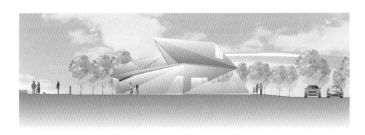

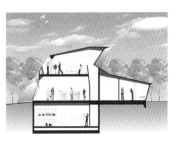

Elevations and sections

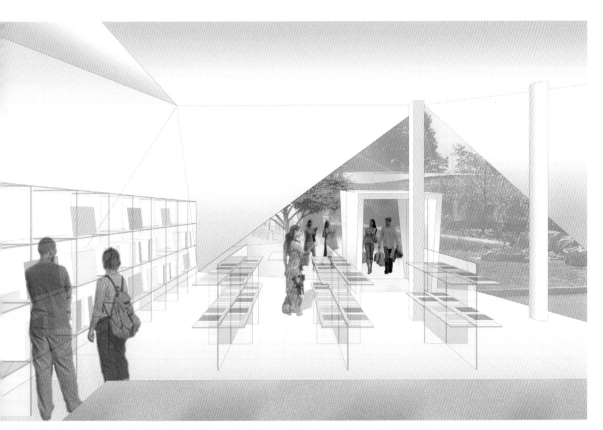

n addition to taking inspiration from origami, Yasui Hideo Atelier has taken into account the environment surrounding the building where the museum is located.